Drawing

A CONTEMPORARY
APPROACH

THIRD EDITION

Drawing

A CONTEMPORARY

APPROACH

CLAUDIA BETTI
TEEL SALE

University of North Texas

Harcourt Brace Jovanovich College Publishers
Fort Worth Philadelphia San Diego
New York Orlando Austin San Antonio
Toronto Montreal London Sydney Tokyo

To my students.
—Claudia Betti.

*For all makers, explainers, and defenders
of art—especially Tom, Rick, and Steve.*
—Teel Sale

Publisher Ted Buchholz
Acquisitions Editor Janet Wilhite
Developmental Editor Barbara Rosenberg
Project Editor Mark Hobbs
Production Manager Annette Dudley Wiggins
Art & Design Supervisor Vicki McAlindon Horton
Picture Research Kevin E. White
Text Designer Paula Goldstein
Cover Designer Eva Thornton Design
Cover Image Louisa Chase, Untitled. 1988. Oil on canvas, 77 × 85 inches.
 Courtesy Brooke Alexander, New York.

Library of Congress Cataloging-in-Publication Data

Betti, Claudia.
 Drawing: a contemporary approach / Claudia Betti, Teel Sale.—3rd ed.

 Includes bibliographical references and index.
 1. Drawing—Technique. I. Sale, Teel. II. Title
 NC730.B43 1991
 741.2—dc20 91-6740
 CIP

ISBN: 0-03-053147-0

Address for editorial correspondence: Harcourt Brace Jovanovich, Publishers, 301
Commerce Street, Suite 3700, Fort Worth, TX 76102

Address for orders: Harcourt Brace Jovanovich, Publishers, 6277 Sea Harbor Drive,
Orlando, Florida 32887. 1-800-782-4479, or 1-800-433-0001 (in Florida)

PRINTED IN THE UNITED STATES OF AMERICA

2 3 4 5 048 9 8 7 6 5 4 3 2 1

PREFACE

Drawing engages us on many levels—emotional, intellectual, and spiritual. This book is dedicated to the imagining mind. The basic assumption of *Drawing: A Contemporary Approach* is that drawing extends the mind and the spirit, that it is an exciting activity that promotes a respect for looking and thinking.

Through our experience we have discovered that drawing can be taught using an approach such as the one set forth in this edition—an approach that offers the student rationally determined problems presented in a logical sequence. These problems, we believe, stimulate the student to make intellectual and emotive responses in their solutions. A series of fundamental and related steps along with diverse techniques lead the beginning artists to discover their own capabilities and powers of observation and execution.

The demarcation lines between drawing, painting, sculpture, crafts, and the commercial areas of art began to be blurred in the 1960s, and this breakdown of barriers has greatly enhanced the role of drawing. "Works on Paper" is now viewed as a major art category with artists, galleries, and museums, according it genre status.

By including illustrations of prints, watercolors, paintings, photography, and even sculpture, we have indicated the incredible range of possibilities open to the contemporary draughtsman. This wide range of art production shows the beginning student the indispensable role of drawing in every aspect of artmaking. Illustrations include both masterworks and student drawings from the classrooms at the University of North Texas.

The word *contemporary* in the book's title has two implications:

First, the method of learning to draw is contemporary in outlook, and second, we have addressed new concepts and current concerns in art in both the selection of art reproduced and in the discussion of it. We have emphasized art's multi-dimensional pursuit of significance, which frequently means going beyond the conventional rules of composition. It is our hope that students will begin to understand contemporary art in relationship with earlier art in terms of continuity and challenge and to see that contemporary art has its roots in a long-standing tradition.

In *Drawing: A Contemporary Approach* the formal art elements are approached through a study of the spatial relationships. The text is built around a series of related problems, each of which is designed to encourage fluency in drawing, give experience in handling media, foster self-confidence, and instill an understanding of the art elements and their role in the development of pictorial space. Further, *Drawing: A Contemporary Approach* introduces to students a vocabulary that allows them to deal with new concepts and current concerns in today's art.

This new edition has several major changes. The historical underpinning of drawing is emphasized in Parts 1 and 2, particularly in Chapters 1, 6, and 7. A new introduction to Part 2 offers an expanded discussion of pictorial space, with added illustrations to indicate the many new approaches used by contemporary artists. Part 3 has been updated to include current art, with its many stylistic and conceptual changes. The final chapter, "A Look at Art Today," is completely new, offering a discussion of the move from Modernism to Post-Modernism. The illustrations throughout the book have been updated, and a new critical vocabulary has been introduced to aid the student in discussions of today's art. Throughout the text, in both our selections of art reproduced and in our discussion of it, we have kept a focus on content and composition.

Our teaching methods are not rigid; we do not promote a single approach. We believe students' involvement in their own work, along with familiarity with concerns and styles of other artists, will lead them to develop an exciting personal expression. We hope *Drawing: A Contemporary Approach* will direct students along an ambitious path that involves growth in visual, intellectual, and aesthetic responses.

Many people have assisted and encouraged us in preparing this text. We are grateful to our colleagues at the University of North Texas, especially to Richard Sale, who has helped in many ways. Our appreciation goes to Janet Wilhite, our editor, Barbara Rosenberg, Mark Hobbs, Vicki McAlindon Horton, Annette Wiggins, and Kevin White.

The photographs of student drawings in this book were taken by Pramuan Burusphat, Danielle Fagan, and Dottie Allen. Finally, we are indebted to our students whom we have taught and who have taught us. This book is written for all those who will make a life around art.

Denton, Texas *C.B.*
1991 *T.S.*

CONTENTS

Preface v

Part 1

INTRODUCTION TO DRAWING **1**

1 **Drawing: Thoughts and Definitions 3**
 Subjective and Objective Drawing 9
 Informational Drawing 12
 Schematic Drawing 13
 Pictorial Recording 14
 Subjective Drawing 17
 The Viewing Audience 18
 Subject and Treatment 20
 Conclusion 27

2 **Learning to See: Gesture and Other Beginning Exercises 28**
 Gesture Drawing 28

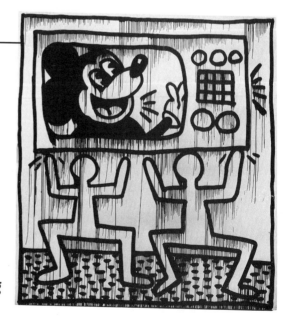

Before Beginning to Draw 34
Types of Gesture Drawing 34
 ≥ *Mass-Gesture Exercises* 37
 ≥ *Line-Gesture Exercises* 39
 ≥ *Mass- and Line-Gesture Exercises* 41
 ≥ *Scribbled-Line Gesture Exercises* 42
 ≥ *Sustained-Gesture Exercises* 44
Other Beginning Exercises 46
 ≥ *Continuous-Line-Drawing Exercises* 46
 ≥ *Organizational-Line-Drawing Exercises* 48
 ≥ *Blind-Contour Exercises* 50
Summary: The Benefits of Gesture, Continuous-Line,
 Organizational-Line, and Blind-Contour Drawing 53

Part 2

SPATIAL RELATIONSHIPS OF THE ART ELEMENTS 55

Introduction to Spatial Relationships of the Art
 Elements 55

3 Shape/Plane and Volume 67

Shape 67
Positive and Negative Space 71
 ≥ *Problem 3.1: Composite Shape Problem* 74
 ≥ *Problem 3.2: Interchangeable Positive and Negative Shapes* 75
 ≥ *Problem 3.3: Geometric Positive and Negative Shapes* 75
 ≥ *Problem 3.4: Invented Negative Shapes* 76
 ≥ *Problem 3.5: Collaged Negative Spaces* 77
 ≥ *Problem 3.6: Enclosed Invented Positive and Negative Shapes* 77
The Shape of the Picture Plane 77
 ≥ *Problem 3.7: The Shape of the Picture Plane* 79
Shape as Plane and Volume 80
 ≥ *Problem 3.8: Shape as Plane and Volume* 84
 ≥ *Problem 3.9: Planar Analysis* 84
 ≥ *Problem 3.10: Rubbed Planar Drawing* 85
 ≥ *Problem 3.11: Basic Volume* 87
 ≥ *Problem 3.12: Modeling and Overlapping* 87
Summary: Different Kinds of Space 89

4 Value 90

Ways of Creating Value 95
Arbitrary Use of Value 98
 ≥ *Problem 4.1: Using Value Arbitrarily* 98

Descriptive Uses of Value 100
 Value Used to Describe Structure 101
 ≈ *Problem 4.2: Using Value to Describe Structure 101*
 ≈ *Problem 4.3: Using Value to Describe Planes 101*
 Value Used to Describe Weight 101
 ≈ *Problem 4.4: Using Value to Describe Weight 103*
 Value Used to Describe Light 104
 ≈ *Problem 4.5: Value Reduction 106*
 ≈ *Problem 4.6: Four Divisions of Value 108*
 ≈ *Problem 4.7: Categories of Light 108*
 ≈ *Problem 4.8: Tonal Drawings 109*
 Value Used to Describe Space 110
 ≈ *Problem 4.9: Using Value to Describe Space 111*
Expressive Uses of Value 111
 ≈ *Problem 4.10: Value Reversal 114*
 ≈ *Problem 4.11: Value Used Subjectively 114*
 ≈ *Problem 4.12: Value Used to Create Abstract Patterns 115*
Summary: Spatial Characteristics of Value 116

5 *Line* **117**

Determinants of Line Quality 118
Types of Line 126
 Contour Line 127
 ≈ *Problem 5.1: Slow Contour 129*
 ≈ *Problem 5.2: Exaggerated Contour 130*
 ≈ *Problem 5.3: Quick Contour 131*
 ≈ *Problem 5.4: Cross-Contour 133*
 ≈ *Problem 5.5: Contour with Tone 133*
 Mechanical Line 133
 ≈ *Problem 5.6: Using Mechanical Line 133*
 Structural Line 135
 ≈ *Problem 5.7: Using Structural Line 135*
 Lyrical Line 136
 ≈ *Problem 5.8: Using Lyrical Line 137*
 Constricted, Aggressive Line 137
 ≈ *Problem 5.9: Using Constricted, Aggressive Line 137*
 Handwriting: Cursive and Calligraphic Line 137
 ≈ *Problem 5.10: Using Handwriting or Calligraphic
 Line 139*
 Implied Line 140
 ≈ *Problem 5.11: Using Implied Line 141*
 Blurred Line 141
 ≈ *Problem 5.12: Using Blurred Line 143*
Summary: Spatial Characteristics of Line 144

6 *Texture* **145**

Traditional Categories of Texture 150
 Actual Texture 150
 Simulated Texture 153

Invented Texture 153
 ≈ Problem 6.1: Using Actual Texture 155
 ≈ Problem 6.2: Using Simulated Texture 157
 ≈ Problem 6.3: Using Invented Pattern 157
 ≈ Problem 6.4: Using Conventionalized or Symbolic
 Texture 158
Twentieth-Century Textures 158
 Additive Materials to Create Texture 158
 ≈ Problem 6.5: Using Papier Collé 162
 ≈ Problem 6.6: Using Collage 162
 ≈ Problem 6.7: Using Assemblage 163
 Transferred Texture 164
 ≈ Problem 6.8: Using Rubbing 165
 ≈ Problem 6.9: Transfer from a Printed Surface 165
Summary: Spatial Characteristics of Texture 166

7 Color 168

Color Media 169
 ≈ Problem 7.1: Using Color Media 170
Color Terminology 170
 ≈ Problem 7.2: Using Local Color 171
Color Schemes 172
 ≈ Problem 7.3: Using a Monochromatic Color Scheme 173
 ≈ Problem 7.4: Using a Complementary Color Scheme 173
Warm and Cool Colors 174
 ≈ Problem 7.5: Using Warm and Cool Colors 175
How Color Functions Spatially 175
Some Early Influences on Contemporary Attitudes Toward
 Color 177
 ≈ Problem 7.6: Studying Influences on Contemporary Color
 Attitudes 178
 ≈ Problem 7.7: Using Symbolic Color 183
 ≈ Problem 7.8: Using Color-Field Composition 183
Summary: Spatial Characteristics of Color 184

8 Spatial Illusion and Perspective 185

Eye Level and Base Line 186
 ≈ Problem 8.1: Using Eye Level and Base Lines 189
Aerial Perspective 190
 ≈ Problem 8.2: Using Aerial Perspective 191
Linear Perspective 191
 ≈ Problem 8.3: Locating Vanishing Points 192
 One-Point Perspective 192
 ≈ Problem 8.4: Using One-Point Perspective 194
 Two-Point Perspective 195
 ≈ Problem 8.5: Using Two-Point Perspective 195
 Three-Point Perspective 197
 ≈ Problem 8.6: Using Three-Point Perspective 198

Multiple Perspective 199
 ▹ Problem 8.7: Using Multiple Perspective 200
Stacked Perspective 200
 ▹ Problem 8.8: Using Stacked Perspective 202
Foreshortening 203
 ▹ Problem 8.9: Using Foreshortening 204
Summary: Spatial Illusion 204

Part 3 _____

A CONTEMPORARY VIEW 205

9 The Picture Plane 207

Contemporary Approaches to the Picture Plane 208
 Dominance of the Edge 209
 ▹ Problem 9.1: Shaped Picture Planes 211
 ▹ Problem 9.2: Confirming the Flatness of the Picture
 Plane 211
 Continuous-Field Compositions 212
 ▹ Problem 9.3: Continuous-Field Compositions 214
 Arrangement of Images on the Picture Plane 215
 ▹ Problem 9.4: Placing Images on the Picture Plane 220
 ▹ Problem 9.5: Crowding the Picture Plane 221
 ▹ Problem 9.6: Filling the Picture Plane 221
Division of the Picture Plane 221
 ▹ Problem 9.7: Composing with a Grid 227
 ▹ Problem 9.8: Dividing the Picture Plane 228
 ▹ Problem 9.9: Using Inset Images 229
 ▹ Problem 9.10: Using Linear Sequence 229
Summary: Personal Solutions / Different Kinds of
 Order 229

10 Thematic Development 230

Individual Themes 231
 ▹ Problem 10.1: A Series of Opposites 236
 ▹ Problem 10.2: Transformation 237
 ▹ Problem 10.3: Transformation / Using Computer Generated
 Images 237
 ▹ Problem 10.4: Visual Narration 239
 ▹ Problem 10.5: Developing a Motif 240
 ▹ Problem 10.6: Formal Development 241
Group Themes 241
 ▹ Problem 10.7: Style / Visual Research Project 243
Shared Themes 244
 ▹ Problem 10.8: Art History Series 249
Summary: Development of a Theme 250

II *A Look at Art Today* **251**

Why Look at Contemporary Art? 251
Definitions of Modernism and Post-Modernism 252
Precursors of Post-Modernism 253
 Pop Art *253*
 Minimalism / Conceptual Art / Earth Art *254*
 Photorealism *254*
Early Development of Post-Modernism 254
 Influences of Feminist Art on Post-Modernism *255*
 European Influence: The Development of
 Neo-Expressionism *257*
Post-Modernism: New Subject Matter, New Strategies 258
 Appropriation and Recontextualization *259*
 Myth and Allegory *260*
 Humor and Irony *262*
 Popular or Commercial Tactics *262*
 Social and Political Themes *263*
 New Ethnicity *265*
 Semiotics: Words and Images / Narrative Content *267*
 Landscape: Illusion and Abstraction *269*
 Abstraction *271*
Conclusion 272

Part 4

PRACTICAL GUIDES 273

I dreamed a dog was walking a tightrope

Guide A: Materials 275

Paper 275
Charcoal, Crayons, and Chalks 277
Pencils and Graphite Sticks 278
Erasers 278
Inks and Pens 279
Paint and Brushes 279
Other Materials 279
Nonart Implements 280

Guide B: Presentation 281

Acetate 281
Plastic Envelopes 282
Lamination 282
Dry Mounting 282
Matting 283
 Materials for Matting *283*
 Instructions for Matting *284*
Summary: Selecting a Method of Presentation 286

Guide C: Keeping a Sketchbook **287**

 Summary: The Advantages of a Sketchbook 292

Guide D: Breaking Artistic Blocks **293**

 Correcting the Problem Drawing 293

 Critical Assessment *295*

 Getting Started 297

Glossary **299**

Suggested Readings **303**

Photographic Sources **307**

Index **309**

Part 1

INTRODUCTION

TO DRAWING

DRAWING: THOUGHTS AND DEFINITIONS

1

Artists are attracted to drawing because it offers us an exciting channel for our imagination. The concentration required in looking and in questioning the appearance of objects and the sheer exuberance of making things has not changed since the earliest drawings were made. We humans have had a long history of making our marks on the world, an impulse that began in prehistoric times and continues to the present. The engaging rock drawing from Tassili-n-Ajjer in Algeria is such a prehistoric work (Figure 1), and while the intent is different from the graffiti drawing done in our time (Figure 2), both drawings share an exuberance of what it is like to be alive. In some deeply satisfying way, mark making affirms our presence in the world. The directness and physicality of drawing are basic to its nature. The notion of mark making is key to the identity of the medium.

Art, especially the discipline of drawing—along with philosophy, history, and literature—helps us interpret our experiences visually, emotionally, and aesthetically. As mature human beings we try to create a wholeness in ourselves; one recognized way of achieving that goal is through the creative process, and for the visual artist, drawing lies at the very core of that process.

From the Renaissance to the end of the 19th century, drawing was regarded as a conservative medium, seldom the subject of innovation. It was seen as a first step in the early idea of a work, a support to painting, sculpture, or architecture. In the Renaissance drawing

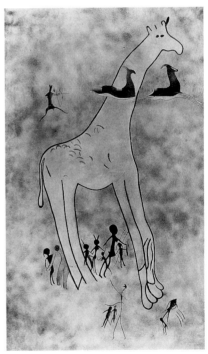

1. *The Large Giraffe.* Adjefou, Tassili-n-Ajjer, Algeria. Prehistoric. Fresco, 5′2⅜″ × 3′5″ (1.6 × 1.05 m).

3

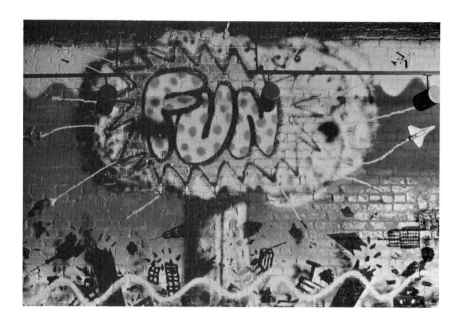

2. Kenny Scharf. *Untitled (Fun)*. 1982. Spray paint on wall. Courtesy Tony Shafrazi Gallery, New York.

was particularly suitable for visually describing the newly emerging disciplines of anatomy, perspective, and geometry, and it required the most stringent intellectual application.

Traditionally we can classify drawings into four types:

1. Those that investigate, study, and question the real world—the visible, tangible world.
2. Those that record objects and events.
3. Those that communicate ideas.
4. Those that are transcriptions from memory—a way of collecting and keeping impressions and ideas, a way of making visible the world of our imagination.

The sketch has been a traditional first step in a long path that leads to a more finished work of art, and while artists still use sketches as preliminary steps (Figures 3 and 4), drawing as an independent activity, as an end in itself, is an emphasis of the 20th century.

Drawing has an infinite variety of purposes: from psychological revelation to dramatic impact, from social commentary to playful, inventive meandering, from accurate transcription to vigorous, informal notation. Increased freedom in all art forms is a characteristic of this century, and certainly, drawing has been a leader in this innovation.

New technologies have been introduced to art in the 20th century, and because drawing has proven to be a flexible discipline for experimentation, it has gained a strength and vitality from its newly found role. We might even classify computer-generated images as drawings: They make use of graphic means, and they are on paper (Figure 5). So as not to limit its definition to pure graphic means (a

3. Andrew Wyeth. Preparatory sketch for *That Gentleman*. c. 1960. Tempera and pencil, 12½ × 22″ (32 × 56 cm). Dallas Museum of Art, gift of the artist. 1962.11

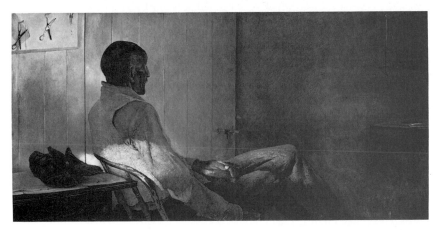

4. Andrew Wyeth. *That Gentleman*. 1960. Tempera on panel, 23½ × 47¾″ (59.7 × 121.3 cm). Dallas Museum of Art, Dallas Art Association Purchase.

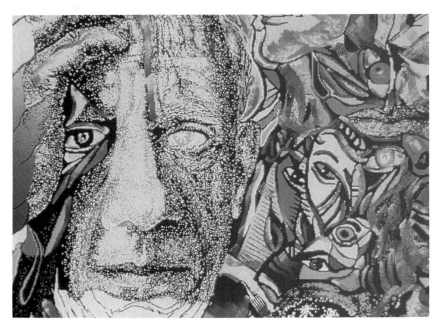

5. Josefa Losada-Stevenson. *Dreaming Picasso 1*. 1989. Color thermal transfer and lithograph from computer generated image, 20 × 17″ (51 × 43.4 cm). Courtesy the artist.

Drawing: Thoughts and Definitions **5**

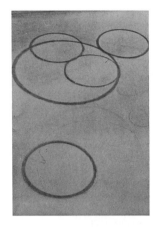
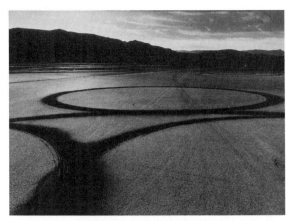
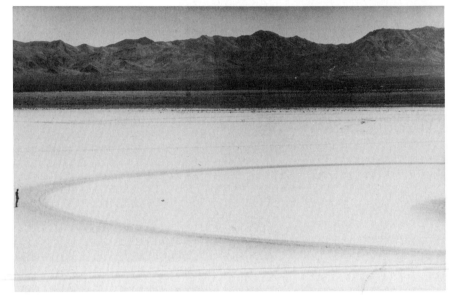

6. Michael Heizer. Three views of *Circular Surface Planar Displacement*. 1971. Earth construction, Jean Dry Lake, Nevada; 400 × 800′ (121.92 × 243.84 m). Courtesy Sam Wagstaff.

more traditional definition), the term *Works on Paper* is used by museums, galleries, and art critics to designate a standard category, but even this expanded classification does not fully cover the role of drawing. As we have seen in graffiti and prehistoric rock drawings, mark making can be done on any surface—clay, glass, fabric, or even on the earth itself. In Michael Heizer's *Circular Surface Displacement* (Figure 6), the lines of the "drawing" are made on the earth by motorcycle wheels.

The immediate past plays a historically important role in the formation of more recent art. Impressionism in the late 19th century pointed the way for drawing in its path toward independence. Certainly in Edgar Degas' body of work, his drawings are not subsidiaries of the paintings (Figure 7). Modernist concerns, those that are still pertinent today, occupied Degas: how to fit the figure into the limits of the paper, how to resolve a composition that is divided, how to

compress an illusionistic three-dimensional form onto a two-dimensional surface. These are only a few of many considerations and problems that face the artist in a single work.

It was the Post-Impressionist Georges Seurat who clearly stated his ambition to make drawings that were equal in importance and in finish to his paintings. He aimed for an independence of draftsmanship, not drawing that was secondary to or preparatory for a painting. In Figure 8, we see one of a group of drawings Seurat made in the 1880's. His work is classically composed using verticals and horizontals and suggests a mysterious isolation. It is exact, thoughtful, exquisitely controlled, and highly poetic.

The first work of an artist to be displayed in a public exhibition was a large drawing by a friend of Seurat, Amán-Jean. It was exhibited in the *Salon des Independants* of 1883. It is difficult for us to realize that not until the mid-18th century were drawings framed and hung on walls. From that time to the end of the 19th century, the nature of drawing's traditional role was firmly established.

7, left. Edgar Degas. *The Tub*. 1886. Pastel on cardboard, $28\frac{5}{8} \times 32\frac{5}{8}''$ (73 × 83.2 cm). Musee d'Orsay, Paris.

8, right. Georges-Pierre Seurat. *At the "Concert Europeen"*. c. 1887. Conté crayon, $12\frac{1}{4} \times 9\frac{3}{8}''$ (31.1 × 23.8 cm). Collection, The Museum of Modern Art, New York. Lillie P. Bliss Bequest.

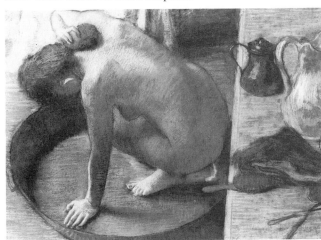

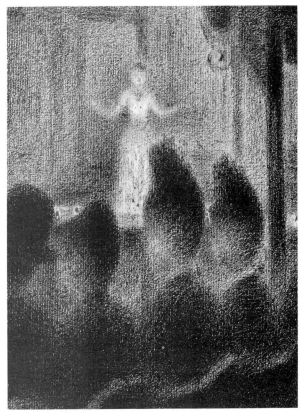

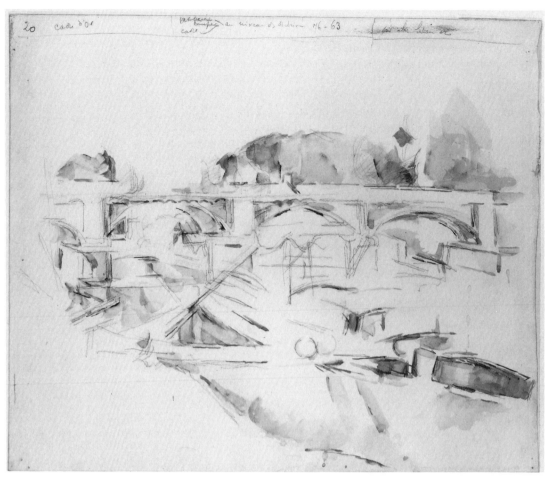

9. Paul Cezanne. *View of a Bridge.* c. 1895–1900. Watercolor over black chalk, 19¼ × 23⅜ (489 × 598 cm). Yale University Art Gallery. The Philip L. Goodwin, B.A. 1907, Collection.

Our aesthetics have undergone radical changes during this fast-paced century. As modern viewers came to accept fragmentation in real life, many drawings that previously were seen as unfinished came to be accepted as complete. It was Paul Cézanne, often acclaimed as the father of modern art, that pointed us in this new direction. He affirmed the role that intelligence and conceptualization play in art; he called art "personal perception." The study of Cézanne's work reveals the concentration and freshness of purpose he brought to each work of art. He aimed at integrating line and color; he saw drawing as a means of structurally organizing space and volume in both his drawings and his paintings (Figure 9). His approach to painting was first to draw in lines and then gradually to construct the planes. In *View from a Bridge* Cézanne requires the viewer's full participation to relate line and shape. His "lost-and-found" line must be filled in mentally by the viewer.

While contemporary artists have not relinquished drawing's traditional functions, they have seriously reconsidered the nature of drawing and its uses. In the years before World War I, a real innovation in drawing was the introduction of collage into fine art by

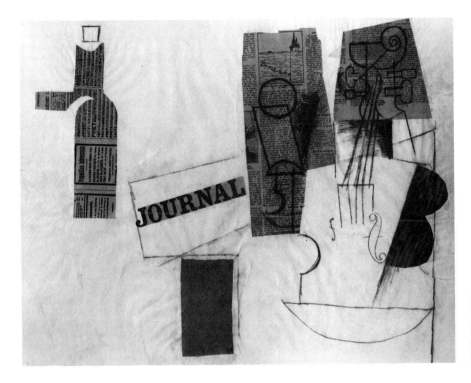

10. Pablo Picasso. *Bottle, Glass and Violin*. 1912–1913. Paper collage and charcoal, $18\frac{1}{2} \times 24\frac{3}{8}''$ (47 × 62 cm). National Museum, Stockholm.

Georges Braque and Pablo Picasso (Figure 10). This technique asks an important art question: What is real, and what is illusion? Collage has been called by some critics the most notable innovation in drawing in three hundred years. In the 1960's artists began an in-depth appraisal of drawing and its role in art. Due to expansive, even explosive, trends in contemporary art, drawing has a wider and more active role than ever before. Many artists in the second half of the century have reputations built primarily on their drawing ability, among them are William Wylie and Claes Oldenburg (see Figures 58, 165, 186, 293, 294, and 316).

The process of creating art may seem complex to the beginning student. A way through this complexity is to recognize that art has certain categories or divisions. The focus here is on *drawing*, one of the major areas of artistic activity. Drawings, however, are not of interest to artists only; illustrators, designers, architects, scientists, and technicians make use of drawings professionally. Just as there are different uses for drawings, there are many types of drawings.

SUBJECTIVE AND OBJECTIVE DRAWING

In its broadest division drawing can be classified as either subjective or objective. *Subjective* drawing emphasizes the artist's emotions. In *objective* drawing, on the other hand, the information conveyed is more important than the artist's feelings. The left half of the drawing by the humorist Charles Addams (Figure 11) is an elevation of the

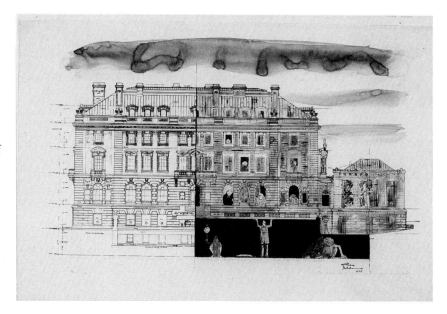

11, right. Charles Adams (United States, 1912–1988). *Embellished Elevation of the Carnegie Mansion.* 1975. Watercolor on photostat, $18\frac{1}{16} \times 25\frac{7}{16}''$ (45.9 × 64.6 cm). Gift of Nino Luciano 1975-87-1. Courtesy of the Cooper-Hewitt Museum, Smithsonian Institution/Art Resource, New York.

12, below. Harmon Goldstone. *Embellished Elevation of the Carnegie Mansion.* 1975. Collage on photostat, $18\frac{1}{16} \times 25\frac{7}{16}''$ (45.9 × 64.6 cm). Location unknown.

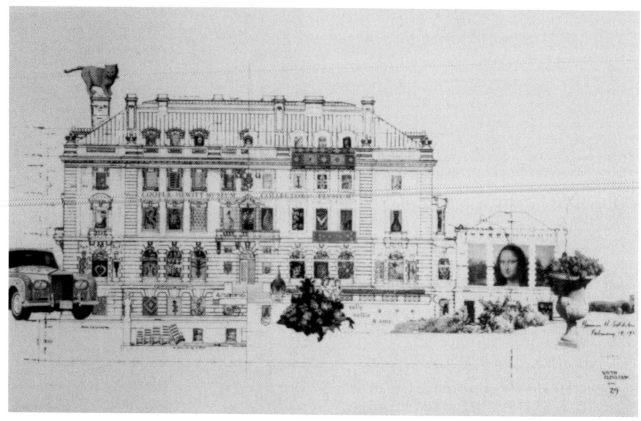

facade of the Carnegie Mansion, and it is concerned with design information—such as measurement, scale, proportion between parts—and thus belongs to the objective category. The right half of the drawing, however, is highly subjective, ridiculous and playful in its embel-

lishment of what is today the Cooper Hewitt Museum. Addams has ensconced his macabre cartoon characters in and under the mansion. A group of artists was invited to commemorate the museum's seventy-fifth anniversary by altering the architectural drawing of the building. In Figure 12 the museum becomes a backdrop for art. The additive images, some of which are art historical, are in sharp contrast to the mechanical rendering of the museum.

Another set of drawings that clearly contrasts the subjective and objective approach can be seen in two skull drawings. For an anatomical illustration (Figure 13), it is important that every part be clearly visible and descriptive. The illustrator has employed such devices as receding spaces, noted by darker value, and small groups of lines to indicate the bulging features of the skull.

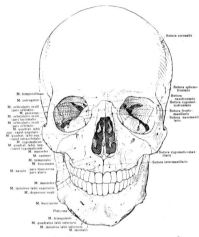

13. The skull; anterior view with muscular attachments.

The skull has always been a popular artistic and literary image because of its loaded content. Luis Cruz Azaceta has depicted his frightening skull using a primitive, crude technique (Figure 14). The lines are drawn with a naïveté that is in startling contrast to the violent content of the work. This highly subjective drawing not only conveys the heightened feelings of the artist but engenders a heightened response from the viewer as well. We are confounded by the skeletal couple within the skull while bloody and penetrating daggers pour down like "deadly rain." Azaceta's work shares its content with other highly expressionistic Latin American folk art, and his rough handling of the medium lends a brutal content to the work. Of course, not all subjective drawings are as extreme, nor are all objective drawings as readily classifiable as the anatomical illustration.

14. Luis Cruz Azaceta. *Deadly Rain.* 1983. Acrylic on canvas, 77 × 94″ (1.96 × 2.40 m). Courtesy Frumkin/Adams Gallery, New York.

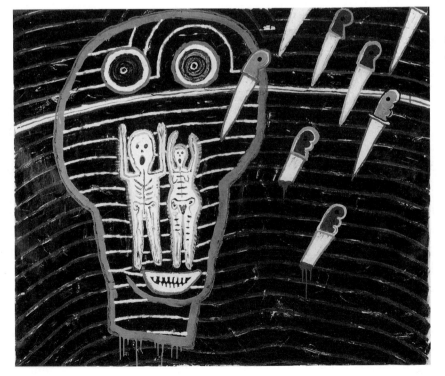

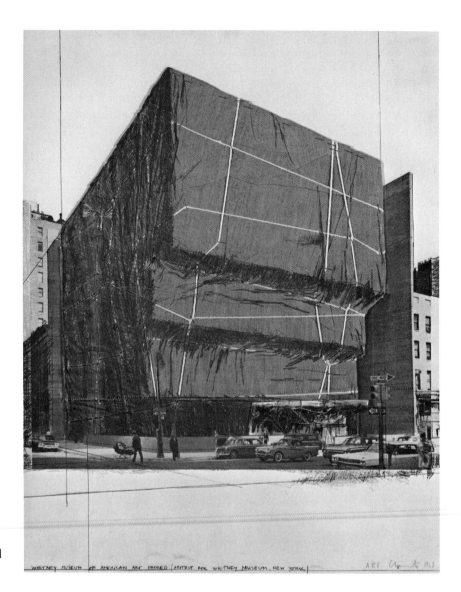

15. Christo. *Whitney Museum of American Art Packed (Project for Whitney Museum, New York).* 1968. Photolithograph and collage, 28 × 22″ (71 × 56 cm). Published by Landfall Press, Inc., New York and Chicago.

Informational Drawing

The objective category is also called *informational drawing.* It includes diagrammatic, architectural, and mechanical drawings. Informational drawings may clarify concepts and ideas that are not actually visible. Many serious 20th-century artists have used art as documentation and information. In Christo's proposal for packaging the Whitney Museum (Figure 15), he combines photography, collage, and drawing to present an accurate visual description of the museum as if it were wrapped. Christo, like Addams, uses a museum as the subject of his art; his project makes a statement on packaging art as a commodity. Christo's plans are frequently carried out; that is, they are not merely proposals, and he documents these projects both in drawing and photography.

Schematic Drawing

Another type of objective drawing is the *schematic,* or *conceptual, drawing.* It is a *mental construct,* not an exact record of visual reality. A biologist's schematic drawing of a molecular structure is a guess used for instructional purposes. Comic-book characters and stick figures in instruction manuals are familiar examples of schematic drawings. We do not think of them as complicated, but they are schematic and conceptual; they are an economical way to give information visually. We know what they stand for and how to read them. They are *conventions,* just as the Western hero riding into the sunset is a literary convention. This conventional schematization is easily understood by everyone in American culture.

At this point the two broad categories of subjective and objective begin to overlap. A schematic, or conceptual, drawing may be objective, like the illustration of stick figures in an instructional manual. It may also be intensely subjective, like a child's drawing in which the proportions of the figure are frequently exaggerated in relation to its environment. Scale is determined by importance rather than by actual visual reality.

Saul Steinberg uses the schematic approach in a subjective manner. In *Main Street* (Figure 16), he employs a number of conventions to indicate movement: The swirling lines in the clouds create a somewhat turbulent sky; the cloud and ball, trailing long shadows, seem to be scurrying along at a quicker pace than the rather static figures, whose thrown-back arms and billowing skirt are the only indicators of motion. Steinberg's humorous intent is intensified by his shorthand style. The emphasis is on idea, on concept, rather than on visual reality. A flourishing movement in contemporary art in-

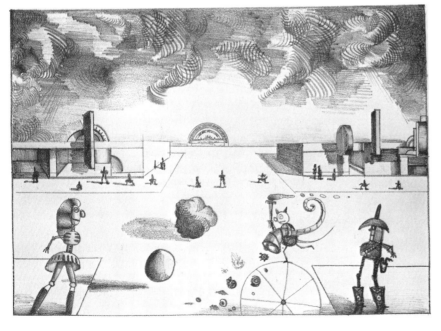

16. Saul Steinberg. *Main Street. 1972–1973. Lithograph, printed in color, 15¾ × 22″ (40 × 56 cm). Collection, The Museum of Modern Art, New York. Gift of Celeste Bartos.*

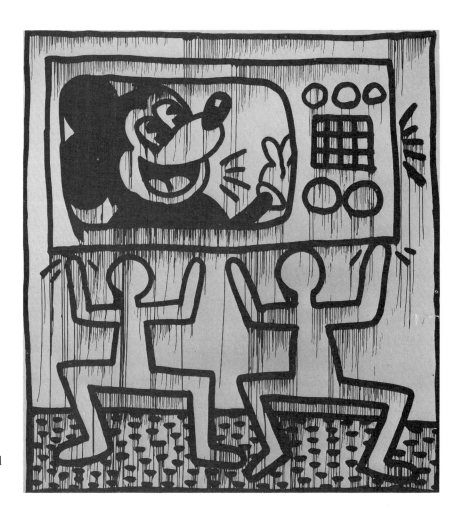

17. Keith Haring. *Untitled*. April, 1982. Marker ink on found painted canvas, 8′1″ × 7′8″ (2.46 × 2.35 m). Private collection.

volves schematized drawings that employ apparently direct and simple drawings to carry sophisticated and subjective expression, such as the Keith Haring drawing in Figure 17. Certainly the Mickey Mouse image is readily recognizable, and the convention of depicting the television set is one with which we are all familiar. The two blank figures are more difficult to decipher: Are they holding up the television set, or are they viewers in front of the screen? It is easy for the viewer to come to subjective conclusions as to the figures' function. Is the artist commenting on our culture? Is Haring making an indictment against a bland world of television viewers, or is the message as playful as the first glance leads us to believe?

Pictorial Recording

Another important category in drawing is *pictorial recording*. The medical illustrator, for example, objectively records an image with almost photographic accuracy. Yet for some artists, imitating certain photographic techniques can lead to highly subjective effects. A number of contemporary artists are concerned with duplicating what the

camera sees—both its focus and distortion. This movement is known as *Photorealism*. The work of these artists suggests a bridge between subjective and objective art, for even in the most photographic drawing or painting, a part of the artist's personal style enters.

In the Photorealist portrait by Chuck Close (Figure 18), the strongest element of subjectivity is the technique used in the drawing: fingerpaint. We associate fingerpainting with children's activities, yet this portrait is far removed from a simple, naïve application of paint. Close is concerned with surface texture and with revealing what he calls the "personal identity of my hand." At first look we think the image may have been generated by a computer, but the structure of Close's work is a result of ordering the image through a use of grids. His innovative approach results in a contemporary look, one not usually associated with portraits. He is as interested in how an image is represented and perceived as much as he is with what is depicted.

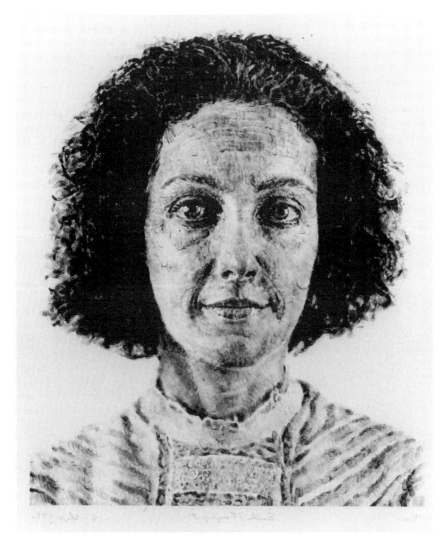

18. Chuck Close. *Emily/Fingerprint.* 1986. Carbon transfer etching, 46 × 36½″ (117.3 × 93.1 cm). Published by Pace Editions and Graphicstudio. © Chuck Close

Another example of pictorial recording can be seen in Claudio Bravo's pastel drawing titled *Pamela* (Figure 19). The subject has been painstakingly and directly observed. The likeness is a result of an intense and accurate observation on the part of the artist. Bravo has faithfully recorded the young girl's appearance and has captured her personality. She seems to be somewhat vulnerable; the direction of her eyes leads us to believe she is not conscious of the artist (as opposed to the direct confrontation between Close's subject and the camera). Bravo has conveyed a tactile sense in the drawing—the texture of hair, scarf, shirt, and jeans is well observed and convincingly rendered. As in the Close portrait, subjectivity and objectivity are combined, but in a much more traditional format and style.

19. Claudio Bravo. *Pamela*. 1978. Pastel, $17\frac{1}{8} \times 11\frac{1}{2}''$ (44×29 cm). Courtesy Marlborough Gallery, New York.

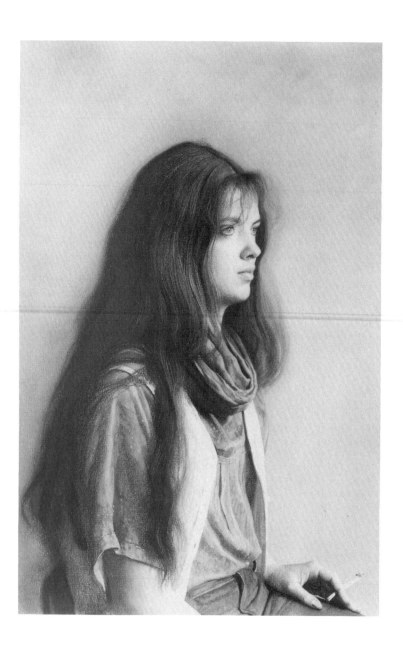

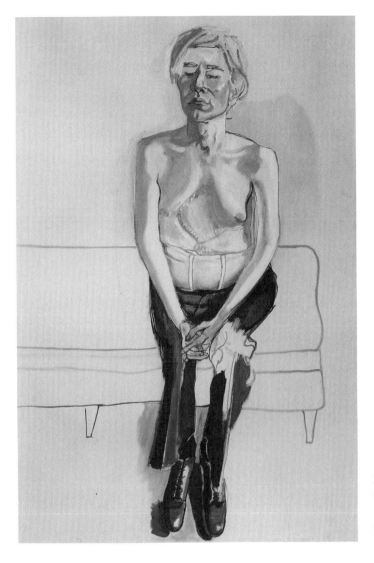

20. Alice Neel. *Andy Warhol*. 1970. Oil on canvas, 5′ × 3′4″ (1.52 × 1.02 m). Whitney Museum of American Art, New York. Gift of Timothy Collins.

Subjective Drawing

Just as in every other human activity, artistic production carries with it a full range of the subjective element. Alice Neel is more interested in the psyche of her sitters than in a direct transcription of visual reality. Although she works from direct observation, she says she is more interested in "what people are like underneath how they look." Neel's style is spontaneous and energetic and obviously highly subjective. In the portrait of Andy Warhol (Figure 20), as in her other works, she uses distortion, an unfinished quality, and an uncomfortable arrangement of limbs and posture as theme and variation. Warhol's eyes are averted, the focus is internal, his vulnerability is suggested by the closed eyes and the scarred body. The psychological truth for Neel is more important than a literal realism.

A drawing, then, may be slightly or highly personal; there are as many degrees of subjectivity as there are artists.

THE VIEWING AUDIENCE

Another set of distinctions involves the question of for whom the drawing is intended. Artists make some drawings only for themselves. These drawings may be preparatory to other work, as we see in Andrew Wyeth's sketch for *That Gentleman* (see Figure 3). The speed with which the sketch is done is in pronounced contrast to the painstaking detail of the finished painting (see Figure 4). The drawing is executed in broadly drawn or brushed shapes; the idea is conveyed economically and deftly. Changes occur in scale and relationships between the parts in the final painting, such as the format being narrowed and elongated.

Drawings not specifically intended for a viewing audience, however, do not prevent our enjoyment of them. Jean Tinguely's *Study of Machine* (Figure 21) gives the viewer an insight into the playful mind of the artist. Tinguely is a sculptor whose machine constructions are highly inventive. Their many moving parts with their unpredictable motions make a wry commentary on the role of the machine in our technological society. Tinguely's lighthearted drawing style conveys this idea of the machine's highly improbable actions. An intimate glimpse into an artist's sketch is often as satisfying as the look at a finished drawing.

Of course, a drawing can also be a final graphic statement intended as an end in itself rather than as a preparation for other work. Claudio Bravo's pastel drawing *Pamela* (see Figure 19) is as ambitious and skillfully finished as any of his paintings.

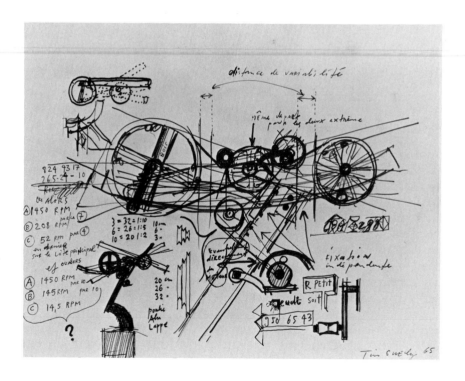

21. Jean Tinguely. *Study of Machine*. 1965. Ink, $12\frac{5}{8} \times 15\frac{7}{8}''$ (32 × 40 cm). Courtesy Iolas-Jackson Gallery, New York.

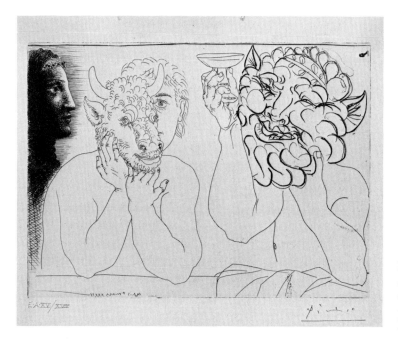

22. Pablo Picasso. *Jeune Homme au Masque de Taureau, Faune et Profil de Femme*. March 7, 1934. Etching, 8¾ × 12⅜″ (22 × 31 cm). Courtesy Edward Totah Gallery, London.

Because his style is so widely recognized, we cannot view a work of art by Pablo Picasso (Figure 22) without many of his other works coming to mind. Perhaps we should say, "Because his *styles* are so widely recognized." In this etching we see three distinct styles, all hallmarks of Picasso's virtuosity as one of the premier draftsmen of this century. Not only is his style a personal one, his themes are stated in a highly personal way. Duality, a favorite subject for Picasso, is relayed by depicting opposite poles—male/female, man/beast, reveler/contemplator—each depicted with an appropriate line quality. The *anima*, the female figure on the left, emerges from a deep recess, certainly an appropriate representation of the unconscious. This figure is drawn in a complex network of lines, while the adjacent figure is simply and delicately presented. We see the man/beast in a transitional state; the lines are more tentative, not so exuberantly drawn as in the third figure, where the Minotaur reigns. In the Minotaur the frenzied, swirling, thick lines describing a drunken, Dionysian state overpower the man-part of the figure with the delicately drawn upper torso and arms. The Minotaur myth is here given an updated, 20th-century, Jungian interpretation.

Some works are more meaningful when viewed in relation to the works of other, earlier artists—that is, when seen in the perspective of art history or in the context of cultural differences. Art about art has always intrigued artists, and contemporary art has a lively concern with this subject. Our understanding of Rico Lebrun's drawing of Maria Luisa (Figure 23) is increased when we know the source of his image, Francisco Goya's *The Family of Charles IV* (Figure 24). Goya, as court painter to Charles IV, suggested as much as he dared about the character of Charles's queen. Lebrun singles out Maria

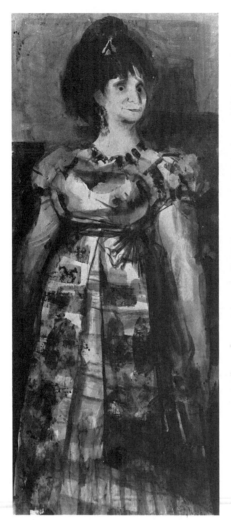 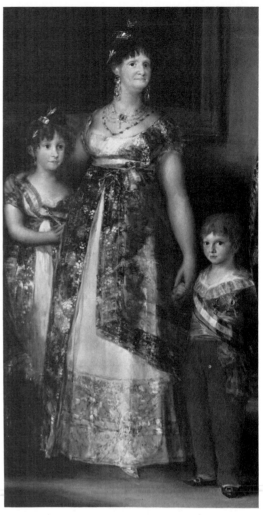

23, left. Rico Lebrun. *Maria Luisa (after Goya)*. 1958. Ink wash, 7′2″ × 3′ (2.2 × .92 m). Private collection.

24, right. Francisco de Goya. *The Family of King Carlos IV* (detail). 1800. Oil on canvas, entire work 11′ × 9′2″ (2.80 × 3.36 m). Museo del Prado, Madrid.

Luisa from the composition and makes a much more explicit and pointed statement about the queen's decadent character. Maria Luisa's face is quickly and deftly noted. The drawing becomes a caricature of a caricature.

SUBJECT AND TREATMENT

Another major determinant in a work of art is the subject to be drawn. Once the subject is chosen, the artist must determine how it is to be treated.

Landscape, still life, and figure are broad categories of subject sources. Nature is a constant supplier of imagery, both for the ideas it can offer and for the structural understanding of form it gives. Two widely different approaches to using natural subjects can be seen in the study *The Spiral Jetty* (Figure 25) by Robert Smithson and in the watercolor *Cedar Water Pool* by Neil Welliver (Figure 26). Smithson

proposes changes to an existing landscape. His choice of a causeway in the form of a spiral is in keeping with the symbolic implications of the work. The spiral is an ancient form symbolic of continuity. For his earth work Smithson chose a site in Utah that the Indians believed to be the hub, or navel, of the world. He proposed a jetty as a man-made form that is subject to the changes that nature imposes. So change and continuity are incorporated into a landscape that itself is continually changing.

Welliver's *Cedar Water Pool* depicts a wilderness in a rather straightforward manner, a contemporary treatment of a traditional theme. The composition is complex, filled with visual information and carefully scrutinized detail. Light and shadow activate the surface of the work, and the structural notation of the granite boulders gives weight to the picture.

The artist may choose an exotic subject, such as Masami Teraoka's allegories, which combine the traditional Japanese style with contemporary Western materialistic ideas (Figure 27). Teraoka looks back to 17th-century Japanese art for technique, style, and image and invests it with a modern message.

Some artists find significance in a commonplace subject, as in Irene Siegel's drawing of an unmade bed (Figure 28). Seigel's treatment of an everyday subject is nearly as texturally rich as the patterns in the Teraoka work. A recurring motif of folds appears in the pillows, sheet, spread, chair, lampshade, and even the flower on the table. Both the exotic and the commonplace may be equally provocative to the artist.

25, left. Robert Smithson. *The Spiral Jetty*. 1970–71. Black and red ink, $12\frac{1}{2} \times 15\frac{1}{2}''$ (32 × 39 cm). Courtesy John Weber Gallery, New York.

26, right. Neil Welliver. *Cedar Water Pool*. 1977. Watercolor, $29\frac{1}{2} \times 29\frac{5}{8}''$ (74.9 × 75.2 cm). Courtesy Marlborough Gallery, New York.

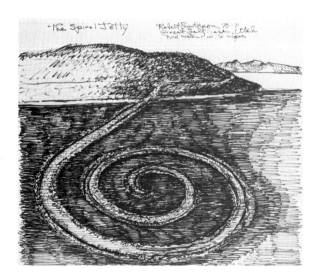

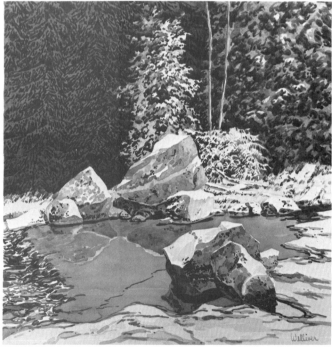

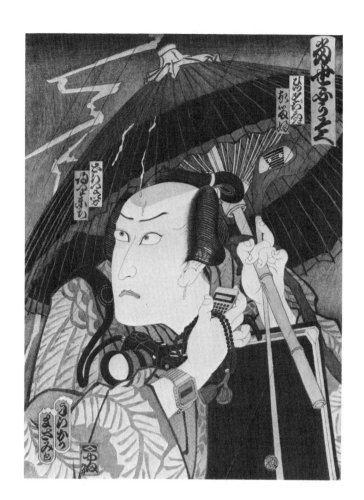

27. Masami Teraoka. *Samurai Businessman Going Home*. 1981. Watercolor on paper, $13\frac{1}{4} \times 9\frac{3}{4}''$ (34×25 cm). Private collection.

28. Irene Siegel. *Unmade Bed, Blue*. 1969. Pencil, $20 \times 40''$ (76×102 cm). Private collection.

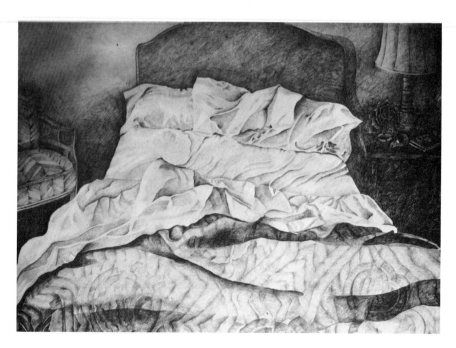

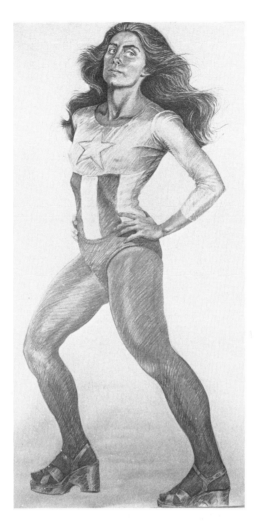

29. Sharon Wybrants. *Self-Portrait as Superwoman (Woman as Culture Hero)*. 1975. Pastel, 12 × 5′ (3.66 × 1.52 m). Courtesy the artist.

An image can be treated symbolically; it may stand for something more than its literal meaning. Sharon Wybrants gives explicit directions for interpreting her drawing by naming it *Self-Portrait as Superwoman (Woman as Culture Hero)* (Figure 29). The image is firmly placed, filling the picture plane with its energy and vitality. The strength of the figure along with the defiantly held head attests to an unmistakably feminist stance; the social comment is obvious. The Superwoman costume humorously lightens the otherwise strident message.

In Figures 30 and 31 a glass of water is given two different treatments by two contemporary artists, Roy Lichtenstein and Ben Schonzeit. Both artists have presented their subject frontally, centralized and balanced within the frame. Both glasses are greatly magnified—the Schonzeit work is monumental in scale, 6 by 4 feet (1.83 × 1.22 m). Here the similarity ends. We are impressed with Schonzeit's ability to portray photorealistically the textural details within the glass. The magnified close-up focuses on the ice cube at the

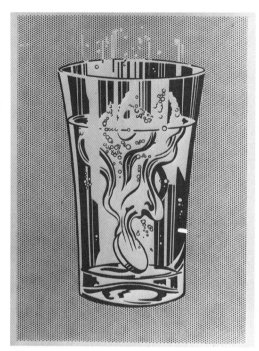 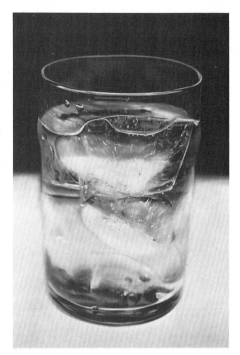

30, left. Roy Lichtenstein. *Tablet.* 1966. Pencil, 30 × 22″ (76 × 56 cm). Private collection. © Roy Lichtenstein/VAGA New York 1990

31, right. Ben Schonzeit. *Ice Water Glass.* 1973. Acrylic on canvas, 6 × 4′ (1.83 × 1.22 m). The Sydney and Francis Lewis Foundation, Richmond, Virginia.

top of the glass, while the back, side, and bottom are blurred due to the shallow depth of field. Each minute detail is convincingly rendered. Lichtenstein, on the other hand, presents his glass in a stylized, abstract manner. We are at once struck by the repeating motifs of stripes and circular patterns (bubbles, tablet, background dots, negative air bubbles above the glass, and curvilinear swirls). The stripes compress the distance between the back of the glass and the front. Lichtenstein's style is readily recognizable—his trademark is the use of the Benday dots, a process associated with commercial reproduction and banal subject matter. His "billboard" style contrasts with Schonzeit's meticulous trick-the-eye textural effect. This contrast illustrates the fact that there is no end to the richness and variety in treatment of the same subject matter.

The manner in which an artist chooses to depict a subject can be extremely simple or highly complex. The image can be an object taken from the real world and then altered beyond recognition. In the oversized comic-book-style prints by Lichtenstein (Figures 32, 33, and 34), we see the bull abstracted through a number of stages. Lichtenstein selects his images from other sources; here he makes a wry comment mirroring the style of Piet Mondrian (Figure 35). Lichtenstein is fond of images that are clichés; he borrows images used by the popular media or by other artists and reinvests them with humor and irony. It is a dizzying path to follow—what looks like a rather simple strategy is layered in its content.

Mondrian's work evolved from recognizable images to a final, purely nonrepresentational stage. He strove for a neutral form using reductive means—line, shape, and color. The arrangement of these

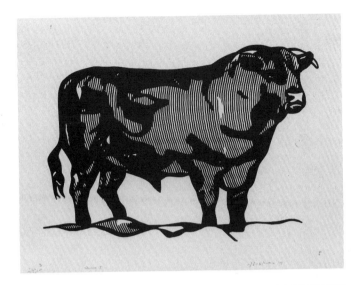

32. Roy Lichtenstein. *Bull I* from *Bull Profile Series*. 1973. One-color linecut, 27 × 35″ (69 × 89 cm). Courtesy Gemini G.E.L., Los Angeles. © Roy Lichtenstein/VAGA New York 1990.

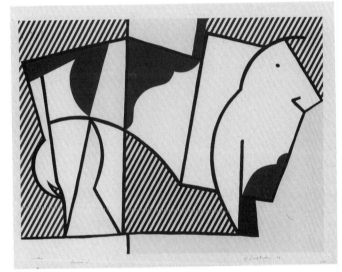

33. Roy Lichtenstein. *Bull III* from *Bull Profile Series*. 1973. Six-color lithograph, screenprint, linecut; 27 × 35″ (69 × 89 cm). Courtesy Gemini G.E.L., Los Angeles. © Roy Lichtenstein/VAGA New York 1990.

34. Roy Lichtenstein. *Bull VI* from *Bull Profile Series*. 1973. Five-color lithograph, screenprint, linecut; 27 × 35″ (69 × 89 cm). Courtesy Gemini G.E.L., Los Angeles. © Roy Lichtenstein/VAGA New York 1990.

35, right. Piet Mondrian. *Composition in White, Black and Red*. 1936. Oil on canvas, $40\frac{1}{4} \times 41''$ (102 × 104 cm). Collection, The Museum of Modern Art, New York. Gift of the Advisory Committee.

36, below. Richard Smith. *Large Pink Drawing*. 1970. Oil pastel and pencil, $2'5\frac{1}{2}'' \times 4'9''$ (.75 × 1.45 m). Collection Betsy Smith.

nonobjective, geometric shapes becomes the subject of the work; associative meaning related to objects in the real world is avoided. Balance and stability, attained through a precise arrangement of vertical and horizontal elements, were crucial concerns for Mondrian.

An artist may deal with compositional options such as shape, scale, and placement. In fact, these compositional concerns may become the subject of the work. In Richard Smith's *Large Pink Drawing* (Figure 36) the pastel and pencil marks themselves are the subject. The rigidly drawn, right-angled form shoots out of the field of vigorously stated, layered marks. The two modes—one using a simple geometric shape and the other asserting the obviously handmade yet uniform lines—reinforce Smith's interest in formal concerns: shape, texture, and edge.

CONCLUSION

The process of drawing develops a heightened awareness of the visual world, an awareness that is both subjective (knowing how you feel about things) and objective (understanding how things actually operate). Perception, the faculty of gaining knowledge through insight or intuition by means of the senses, is molded by subjectivity as well as by the facts of the world.

Drawing affords you an alternative use of experience. It provides a new format for stating what you know about the world. Through drawing you are trained to make fresh responses and are furnished with a new way of making meaning. Finally, drawing teaches you to observe, distinguish, and relate.

The therapeutic value of art is well accepted; the intellectual benefits are many. Art is a way of realizing one's individuality. Creativity and mental growth work in tandem. The making of art, the making of the self, and the development of one's own personal style are all a part of the same process.

We have looked at a few of the many reasons why artists draw and a few of the many means available to an artist; now the exciting process of drawing begins.

LEARNING TO SEE: 2

GESTURE AND OTHER

BEGINNING EXERCISES

Both making and looking at drawings develop memory. (Your visual experience is enriched by learning to see through the practice of drawing.)

The two basic approaches to drawing both involve time. The first approach, called *gesture,* is a quick, all-encompassing overview of forms in their wholeness. The second, called *contour,* is an intense, slow inspection of the subject, a careful examination of its parts. Off-shoots of these two basic approaches are *continuous-line drawing* and *organizational-line drawing.*

GESTURE DRAWING

In drawings we can detect the movement of the artist's hand, sometimes even the movement of the artist's eyes, because eye-to-hand coordination lies at the very core of drawing.

The formal definition of the word *gesture* amplifies its special meaning for the artist: the act of moving the limbs or body to show, to express, to direct thought. There is a physicality of motion in drawing that is not always visually evident in other art forms, and as a result of this physical energy, drawings communicate an emotional and intellectual impact. The gestural approach to drawing is actually an exercise in seeing. The hand duplicates the motion of the eyes, making a movement that quickly defines the general characteristics

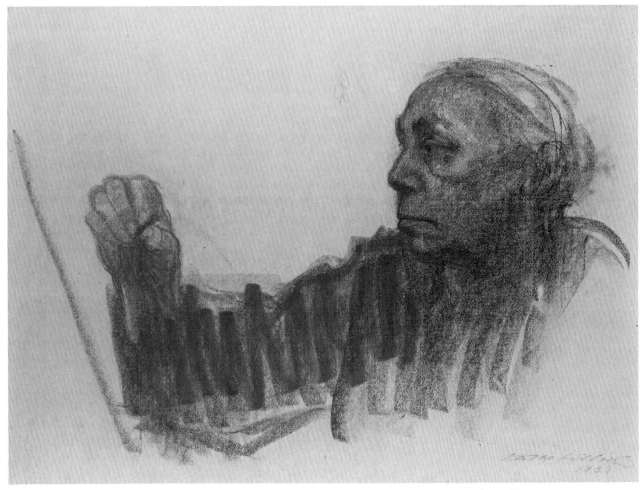

37. Kathe Kollwitz. *Self-Portrait with a Pencil*. 1933. Charcoal on brown laid paper, 18¾ × 25″ (47.7 × 63.5 cm). National Gallery of Art, Washington. Rosenwald Collection.

of the subject: placement, shape, proportion, relationship between the parts, a definition of planes and volumes as well as their arrangement in space.

In Käthe Kollwitz's self-portrait (Figure 37) the gestural mark connecting the hand and head is a carrier of meaning. Not only is this emphatic, quickly stated line symbolic of the energy that flows between the eye and hand of the artist, it is a manifestation of the movement of the artist's hand making the gestural motion of the zigzag.

Gesture is not unlike the childhood game of finding hidden objects in a picture. Your first glance is a rapid scan of the picture in its entirety; then you begin searching out the hidden parts. In Claes Oldenburg's monument drawing (Figure 38) the viewer is first struck by the highly active lines, which give a kinetic effect to the landscape. Our eyes are orchestrated by the movement of the line, weaving through and around the drainpipe building. The marks are not contained within a form; they search out and quickly describe the entire setting. We can detect the quick wrist movements of the artist, who occasionally transforms the scribbles into written notations.

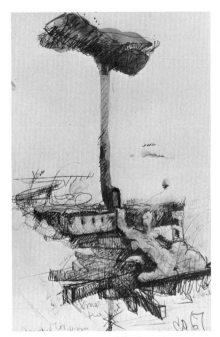

38, above. Claes Oldenburg. *Proposed Monument for Toronto: Drainpipe.* 1967. Pencil and watercolor, 40 × 26″ (101 × 60 cm). Private Collection.

39, right. Suthat Pinruethai. *Pom Pom.* 1988. Monoprint, crayon, oilstick and assemblage, 68 × 74″ (1.73 × 1.88 m). Courtesy Gallery West, Los Angeles.

Gesture is indispensable for establishing unity between drawing and seeing. It is a necessary preliminary step to gaining concentration. We can recognize friends at a glance, and from experience we do not need to look at them further for identification. We perform an eye scan unless something unusual makes us look intently—unusual clothes, a new hairstyle, or the like. For most daily activities, too, a quick, noninvolved way of looking is serviceable. For example, when we cross the street, a glance at the light, to see whether it is green or red, is enough. We may add the precaution of looking in both directions to check on cars; then we proceed.

This casual way of screening information is not enough in making art, however. Even if the glance at the subject is quick, our eyes can be trained to register innumerable facts. In the subject to be drawn, we can train ourselves to see nuances of color, texture, lights and darks, spaces between objects—measurable distances of their height, width, and depth—the materials from which they are made, the properties of each material, and many more things as well.

Through gesture you will learn to translate this information into drawings. Gesture is the essential starting point.

Gesture is more than seeing and organizing; it is a metaphor for the energy and vitality of both the artist and the subject, a good example of which can be seen in the energized, electric work by Suthat Pinruethai (Figure 39). The marks pulsate back and forth across the

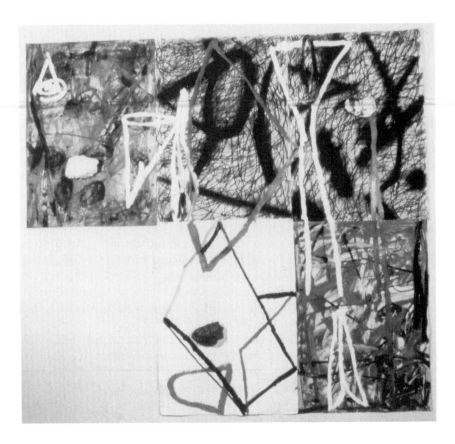

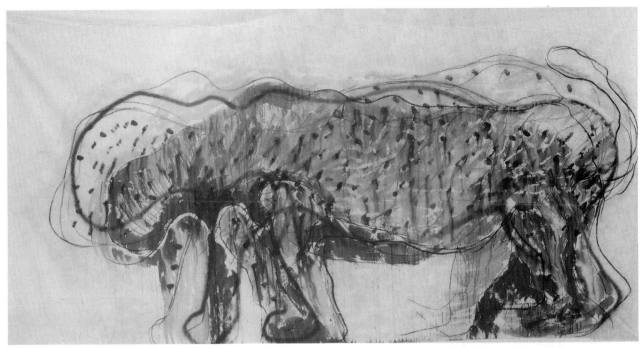

40. Mario Merz. *Animale Terrible.* 1979. Mixed media on canvas, 7'5¾" × 15'6" (2.3 × 4.75 m). Collection Christian Stein, Turin.

five-unit grid; the scribbled, gestural lines not only move across the various units but seem to vibrate from front to back. Some lines seem to be in focus; others are blurred and shadowlike. The last lines that were drawn are the white ones, and it is through them the units are tied together. What can be the meaning of the missing module and of the one, much simpler, composition? Could the drawing be visually akin to the sound of some complex syncopated beat?

Another powerful example of the gestural marks serving as a means of communicating an idea is in Mario Merz's rudely drawn beast (Figure 40), which stands as an implicit metaphor for our brute nature. His use of animal imagery looks back to another fertile 20th-century art period, German Expressionism, and like many of the artists in that movement, Merz sees the artist as a modern primitive, as a "vagabond" or "nomad." Note that this *animale terrible* has no eyes. Merz asserts illogic, disorder, chance, and change in his work, and what better means than the gestural approach to convey this anti-techno-scientific message? The artist has obviously not found this beast in the real, tangible world; rather it comes from the world of his imagination.

Artists throughout history have used the gestural approach to enliven and to organize their work. The 18th-century artist Gaetano Gandolfi used this technique in establishing his composition (Figure 41). He translated the three-dimensional forms of the architectural setting and the groups of figures onto the two-dimensional arched frame of the paper, thereby establishing scale and proportion quickly. The drawing thus becomes a blueprint for further develop-

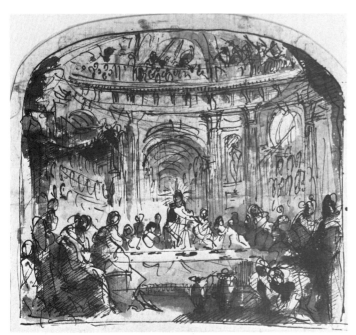

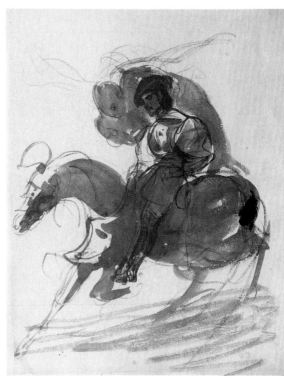

41, left. Gaetano Gandolfi. *The Marriage Feast at Cana*. Late 18th century. Pen and ink with wash, 9¾ × 8⅛″ (25 × 21 cm). The Pierpont Morgan Library, New York. 1979.49

42, right. Eugene Delacroix. *The Constable of Bourbon Pursued by His Conscience*. 1835. Sepia wash over black chalk or pencil, 15½ × 8⅝″ (39.5 × 22 cm). Öffentliche Kunstsammlung, Kupferstichkabinett, Basel.

ment. Gandolfi uses a progression from darker forms in the foreground to lighter ones in the background; by this means he both symbolically and literally highlights Christ, the main character in the drama. Although the front and sides of the figures and the recesses of the complex architectural stage are not explicitly developed, they are certainly indicated in such a way that we read this drawing as taking place in space—the illusion is solidly begun.

The sense of space in the drawing by the 19th-century Romantic artist Eugène Delacroix (Figure 42) is more limited than in the previous drawing. Here the focus is on movement; the forceful application of the swirling, dynamic marks is economically accomplished. We see how fitting the gestural technique is for quick brush-and-wash drawings. The ink wash has dissolved some of the underlying black chalk marks, thereby producing interesting tonal and textural changes. A sense of drama is the result of the contrast between light and dark. The title, *The Constable of Bourbon Pursued by His Conscience*, reveals Delacroix's narrative intent; the constable's conscience, a pale, airy form, seems to have taken little hold on him. Technique and content are perfectly welded.

Honoré Daumier is classified as a 19th-century Realist whose major contribution as a draftsman is unparalleled. He documented the social ferment in the period following the French Revolution. In his hands gesture is a forceful tool for relaying a sense of movement, speed, and agitation of the times (Figure 43). We see how adaptable gesture is for caricature. Daumier's satirical visual criticism of the

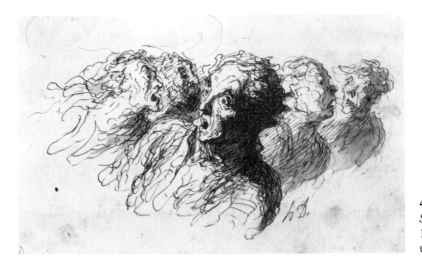

43. Honoré Daumier. *The Riot Scene*. 1854. Pen and wash, 6¼ × 10¼″ (16 × 26 cm). Location unknown.

period is a novel approach. His use of angle and confrontational close-ups could be a precursor of the news camera.

Artists in contemporary times continue to be attracted to gesture as an aid to seeing, but the real attraction of gesture for the artist is the energized mark making gesture provides. In Wolfgang Hollegha's gestural notation of a still life (Figure 44), the marks themselves take priority over the subject. The drawing is infused with vitality and immediacy. The quickly scribbled lines reveal the visual

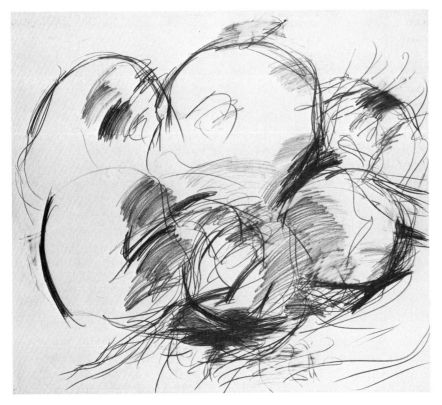

44. Wolfgang Hollegha. *Fruits*. 1963. Pencil, 4′3″ × 5′ (1.3 × 1.5 m). Courtesy the artist.

connection between the artist and the objects and assist in organizing the picture plane. The spontaneously-weighted lines are created by pressure change. They indicate shadow and emphasize the weight of the fruits; in addition, the heavier grouped lines define spatial relationships between the forms.

In all these drawings the strokes convey an immediacy and directness that give us an insight into the artist's vision. Gesture trains the eye and the hand, and it opens the door most effectively to unexplored abilities.

Before Beginning to Draw

Some general instructions are in order before you begin. You may first want to consult Guide A, "Materials," which contains a comprehensive list of materials for completing all the problems in the book. Gesture drawing can be done in any medium, but compressed stick charcoal, vine charcoal, or ink (with 1-inch or 2-inch [2.5 or 5 cm] varnish brush or a number 6 Japanese bamboo-handled brush) are recommended in the beginning. After you have learned the technique of gesture, begin drawing and experimenting with a full complement of drawing implements. Changes in media make for exciting results.

Gesture drawing involves large arm movements, so the paper should be no smaller than 18 inches by 24 inches (46 × 61 cm). Until you have fully mastered the technique of gesture, it is essential that you stand (not sit) at an easel. Stand at arm's length from your paper; placing the easel so that you can keep your eyes on the still life or model at all times. Make a conscious effort to keep the drawing tool in contact with the paper for the entire drawing; in other words, make continuous marks.

In the initial stage while you are becoming acquainted with the limits of the paper and with placement and other compositional options, you should fill the paper with one drawing. Later several gesture drawings can be placed on a page.

The drawings should be timed. They should alternate between 15- and 30-second gestures; then the time can be gradually extended to three minutes. Spend no more than three minutes on each drawing; the value of gesture is lost if you take more time.

When you draw from a model, the model should change poses every 30 seconds for a new drawing. Later the pose is increased to one, then to two, then to three minutes. The poses should be energetic and active. Different poses should be related by a natural flow of the model's movement. The goal is to see quickly and with greater comprehension. Immediacy is the key. Spend at least fifteen minutes at the beginning of each drawing session on these exercises.

Types of Gesture Drawing

You will be working with five types of gesture drawing in this chapter—mass, line, mass and line, scribbled-line, and sustained gesture (Figures 45–54). The distinctions among the five, along with a fuller discussion of each of the types, follows.

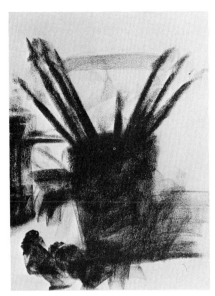

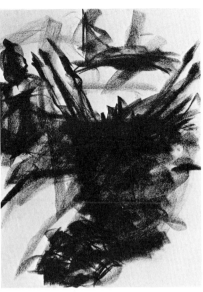

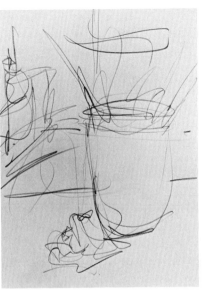

45. Mass gesture of still life. Example by Rick Floyd. 1984. Charcoal, 24 × 18″ (61 × 46 cm). Private collection.

46. Mass and line gesture of still life. Example by Rick Floyd. 1984. Charcoal, 24 × 18″ (61 × 46 cm). Private collection.

47. Line gesture of still life. Example by Rick Floyd. 1984. Charcoal, 24 × 18″ (61 × 46 cm). Private collection.

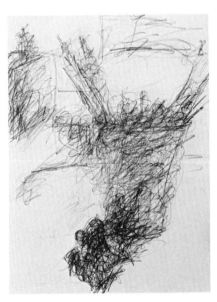

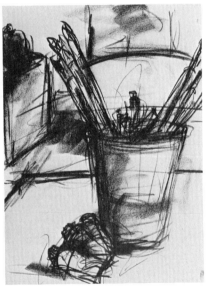

48. Scribbled line gesture of still life. Example by Rick Floyd. 1984. Charcoal, 24 × 18″ (61 × 46 cm). Private collection.

49. Sustained gesture of still life. Example by Rick Floyd. 1984. Charcoal, 24 × 18″ (61 × 46 cm). Private collection.

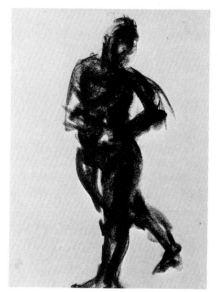

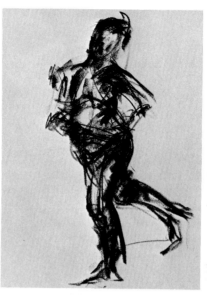

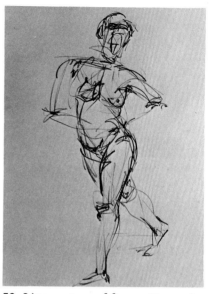

50. Mass gesture of figure. Example by Susan Harrington. 1984. Charcoal, 24 × 18″ (61 × 46 cm). Private collection.

51. Mass and line gesture of figure. Example by Susan Harrington. 1984. Charcoal, 24 × 18″ (61 × 46 cm). Private collection.

52. Line gesture of figure. Example by Susan Harrington. 1984. Conte crayon, 24 × 18″ (61 × 46 cm). Private collection.

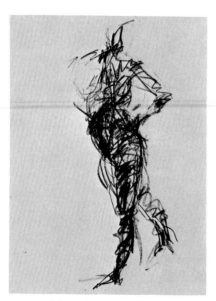

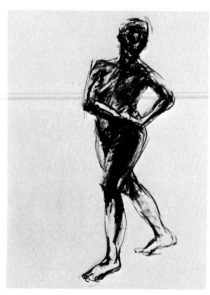

53. Scribbled-line gesture of a figure. Example by Susan Harrington. 1984. Pencil, 24 × 18″ (61 × 46 cm). Private collection.

54. Sustained gesture of figure. Example by Susan Harrington. 1984. Charcoal, 24 × 18″ (61 × 46 cm). Private collection.

Mass-Gesture Exercises

Mass gesture, so called because the drawing medium is used to make broad marks, creates mass rather than line.

Use the broad side of a piece of compressed charcoal broken to the length of 1½ inches (4 cm), or use wet medium applied with a brush. Once you begin, keep the marks continuous. Do not lose contact with the paper. Look for the longest line in the subject. Is it a curve, a diagonal, a horizontal, or a vertical line? Allow your eyes to move through the still life, connecting the forms. Do not follow the edge or outline of the forms. Coordinate the motion of your hand with the movement of your eyes.

In gesture you are not concerned with copying what the subject looks like. You are describing the subject's location in space along with the relationships between the forms. Keep your eyes and hand working together. Your eyes should remain on the subject, only occasionally referring to your paper. This procedure will be uncomfortable at first, but soon you will learn the limits of the page and the location of the marks on it without looking away from the subject.

As you draw from the model, avoid a stick-figure approach. Begin your marks in the center of the forms, in the interior of the body, and move outward to the edges. Note the angles of the various body masses—upper and lower torso, upper and lower legs, angles of arms and head. Indicate the most obvious directions and general shapes first. Go from the large to the small. Begin at the core of the subject rather than at its outer edge.

Remember to keep the marks wide, the width of the charcoal stick or the brush. Try to create shapes as opposed to lines.

If you are drawing from a still life, place the several objects to provide intervals of empty spaces between the various parts. (A tricycle or tree branch, for example, might serve the same purpose, affording intervals of empty spaces between the parts.) In some of your mass gestures, draw in these blank, *negative spaces* first. Emphasize the negative shapes in your drawing. You can use a figure for this exercise as well, but keep your focus on the negative shapes surrounding the figure and on the enclosed shapes (shapes formed between arms and body, for example).

In Henry Moore's *Sheep Drawing 40* (Figure 55), the densely scribbled marks in the background or negative space seem to press down along the sheep's back, defining its outside edge. A reversal takes place in the lower part of the animal's body; the negative space is white and empty, while the curving gestural lines describe the sheep's bulging contours. Marks in the foreground negative space indicate grass and shadow and become more dispersed at the bottom edge of the picture plane. Moore uses a tighter network of lines to describe the face; the marks are more controlled, and they change their directions to indicate the facial structure. So convincing is Moore's spatial description that it is difficult to realize that the white positive space of the wool is literally on the same level as the white negative space surrounding the legs. Note the variety in the size of the marks, loops, and scribbles. In the areas of greatest weight and

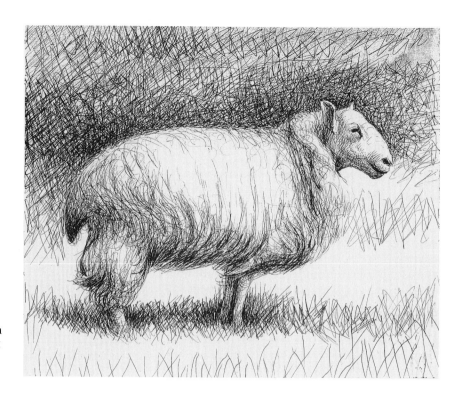

55. Henry Moore. *Sheep Drawing 40.* 1972. Blue-black ball-point pen and pencil on paper, $8\frac{1}{4} \times 9\frac{7}{8}''$ (21 × 25.2 cm). Waddington Galleries, London.

gravity, and in those of deepest space, the lines are more densely grouped; they become lighter and more spread apart as the forms project toward the viewer.

After you have become comfortable with the idea of looking at the shape of the negative spaces between the objects, note the depth between them. You might make an arrangement of variously sized objects, arranging them in deep space. Early in the drawing note the base line of each object. The *base line* is the imagined line on which each object sits. Noting the base line will help you locate forms in their proper spatial relationship to one another.

In drawing it is easier to indicate height and width measurements of objects than it is to suggest the third dimension, depth. You are drawing on a surface that has height and width, so lateral and vertical indications are relatively simple. The paper has no depth, so you must find a way of indicating this important measurement. The use of diagonals, of angles penetrating space, is of prime importance.

Establish the gesture by pressing harder on the drawing implement when you draw the objects farther away; lighten the pressure for those objects nearer to you. By this means you will have indicated a spatial change; the darks appear to be farther back, the lights nearer.

In addition to the important spatial differentiation that mass gesture introduces into the drawing, mass gesture gives an early indication of lights and darks in the composition. These lights and darks unify the drawing. Rhythm and movement are suggested by the placement of the various gray and black shapes.

As you can see, mass gesture helps you translate important general information from the subject onto your paper—information dealing with spatial arrangement, measurement, relationships between forms, and most importantly, your personal response to the subject.

Line-Gesture Exercises

Related to mass gesture is *line gesture*. Like mass gesture, it describes interior forms, following the movement of your eyes as you examine the subject. Unlike mass gesture, it uses lines; these may be thick, thin, wide, narrow, heavy, or light.

Jasper Johns's pencil drawing of a flag (Figure 56) could be an inventory of gestural line quality. The lines range widely from thick to thin, light to dark, tightly grouped to more openly extended. Johns leads the eye of the viewer over the surface of the flag by use of lights and darks. If you squint your eyes while looking at the composition, you will see how the distribution of darks creates an implied movement and how stability is achieved by a concentration of heavier marks at the bottom of the drawing.

In line gesture the lines are tangled and overlapped, spontaneously and energetically stated. They may look like a scribble, but not a meaningless one.

The pressure you apply to the drawing tool is important; vary heavy, dark lines with lighter, looser ones. The darker lines might be used to emphasize those areas where you feel tension, where the heaviest weight, the most pressure, the most exaggerated shape, or the most obvious change in line direction exists.

As in mass gesture, the tool is kept in constant contact with the paper. Draw each object in its entirety even though the objects over-

56. Jasper Johns. *Flag*. 1958. Pencil and graphite wash on paper, $7\frac{1}{2} \times 10\frac{3}{8}''$ (19 × 26 cm). Private collection. © Jasper Johns/VAGA New York 1990.

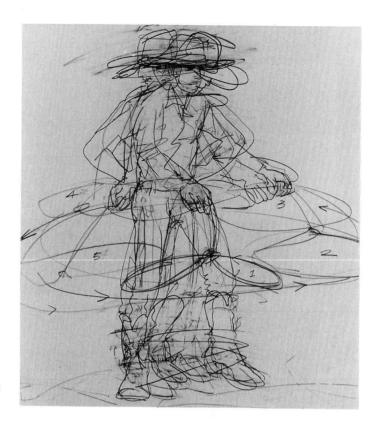

57. Walter Piehl, Jr. *The Merry-Go-Round*. 1988. Pencil, 24 × 16" (61 × 41 cm). Courtesy the artist.

lap and you cannot see the whole form. The same is true when drawing the figure; draw to the back side of the figure; draw the forms as though they were transparent.

It is a challenge for the artist to relay the effect of motion, and gesture is particularly effective in capturing the idea of motion. Have the model rotate on the model stand, making a quarter turn every thirty seconds. Unify the four poses in one drawing. Walter Piehl's rotating figure in Figure 57 depicts a cowboy with his lasso. A feeling of movement is especially pronounced in the two areas of hat and boots.

Experimentation with linear media is encouraged. Any implement that flows freely is recommended. Both found implements and traditional ones are appropriate.

Try to avoid centrally placed shapes every time. Lead the viewer's eyes to another part of the page by different kinds of placement or by a concentration of darks in an area away from the center. Experiment with activating the entire surface of your paper by making the composition run off the page on three or four sides.

A good subject for gesture is fabric. Through a network of a variety of lines, try to convey the idea of folds, pleats, and creases using loose, slashing, gestural marks. Keep in mind the volume of the fabric as it rises and sinks, and try to indicate an idea of the form under the fabric that gives it shape. You may drape the fabric over a chair or some pillows, or you may draw a draped model.

Mass- and Line-Gesture Exercises

This exercise combines mass gesture and line gesture. William T. Wylie demonstrates this in his cartoonlike drawing (Figure 58). Wylie alternates thick and thin lines using compressed charcoal.

The masses or lines may be stated with charcoal or wet media with a wide brush. Begin with either mass or line, and then alternate between the two. Define the more important areas with sharp, incisive lines. Michael Hurson has used mass and line in his *Room Draw-*

58. William T. Wiley. *Familiar Forms.* 1976. Charcoal, pastel, and wax on buff paper, 41½ × 42″ (105 × 107 cm). Collection Mrs. Julia E. Davis, Minnesota.

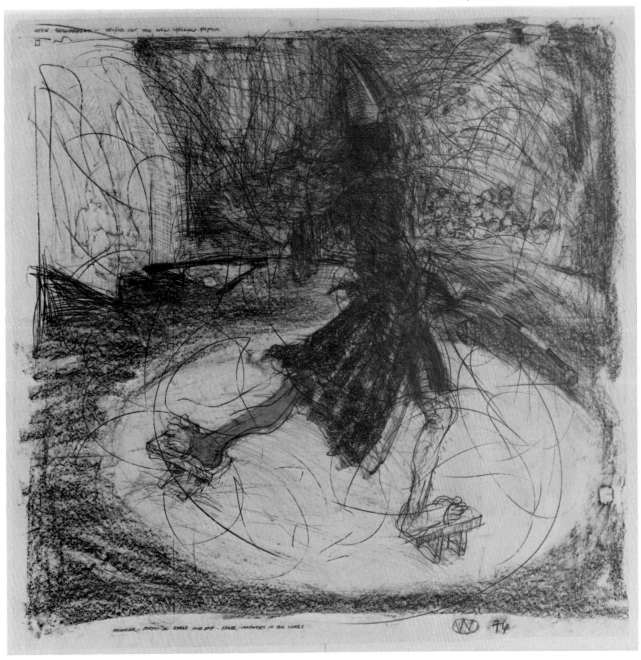

59. Michael Hurson. *Room Drawing (Overturned Chair)*. 1971. Charcoal on paper, $7\frac{1}{2} \times 12''$ (19 × 30 cm). Collection the artist.

ing (Figure 59). The corners of the drawing are activated by the broad, gesturally stated triangles. The base lines of the chairs reinforce this angularity. The furniture is sketchily noted; the white central shape emphasizes the room's emptiness.

Indicating the forms as though they were transparent, restate the drawing; correct and amplify your initial image. You may wish to change the position or placement of the forms or to enlarge or decrease the scale of certain parts. Keep the drawing flexible, capable of change.

Try to fill the entire space, and do not neglect the empty or negative space. Begin laying the wash areas in the negative space, and then add the positive shapes. Let the wash areas or the mass gesture marks cross over both positive and negative space.

Scribbled-Line Gesture Exercises

The *scribbled-line gesture* consists of a tighter network of lines than was used in the preceding exercises. The sculptor Alberto Giacometti's triple-head drawing (Figure 60) is a good example of this technique. The free-flowing ball-point pen builds volume: The multiple, overlapping lines create a dense mass in the interior of the heads. The scribbles begin at the imagined center of the subject; the lines build on one another, moving from the interior to the outside edge of the form. This technique has a parallel in sculpture: the use of an armature or framework to support a volumetric mass of clay or plaster the

sculptor is modeling. It is appropriate that Giacometti would use this scribbled line gesture for his head studies, since he was a sculptor. Drawing was also a major concentration of Giacometti. In his drawings we see the same concerns that occupied him as a sculptor, the ideas of weight and weightlessness and the ideas of spatial location and penetration (see Figure 178).

In a scribbled-line gesture, the outside of the form will be somewhat fuzzy, indefinitely stated. The darkest, most compact lines will be in the core of the form. The outer edges remain flexible, not pinned down to an exact line. As in the other gesture exercises, the drawing tool remains in constant contact with the paper. The scribbles should vary between tight rotation and broader, more sweeping motions.

Negative space is an appropriate place to begin a scribbled-line gesture. The marks will slow down and be somewhat more precise as they reach the edge of the positive shapes. As in the student drawing (Figure 61), the positive shapes will be lighter than the densely filled negative space.

If most of your drawings have begun in the center or top of the page, try to change your compositional approach and consider a different kind of placement, one that emphasizes the edges, sides, or bottom. You can develop a focal point by being more precise in one particular area of the drawing.

By varying the amount of pressure on the drawing tool and by controlling the denseness of the scribbles, you can create a range from white to black.

60, left. Alberto Giacometti. *Diego's Head Three Times*. 1962. Ball-point pen, $8\frac{1}{8} \times 6''$ (21 × 15 cm). Private collection.

61, right. Scribbled-line drawing with emphasis on negative space. Student work. China marker, 24 × 18″ (61 × 46 cm).

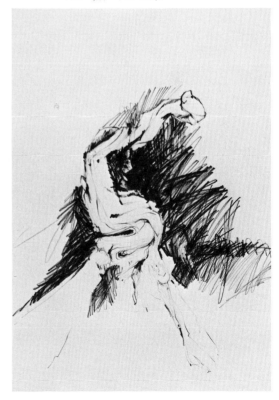

Sustained-Gesture Exercises

The use of *sustained gesture* combines a description of what the object is doing with what it actually looks like. Verisimilitude was not a primary concern in the earlier exercises. Sustained gesture begins in the same spirit as before, with a quick notation of the entire subject. After this notation, however, an analysis and examination of both the subject and the drawing take place. At this point you make corrections, accurately establishing scale and proportion between the parts. In addition to drawing through the forms, you define some precise edges. The result is that the sustained-gesture drawing actually begins to look like the object being drawn.

In *Study after Three-Part Poison* (Figure 62), Mac Adams uses sustained gesture. Traces of the gestural beginning remain in the lower half of the drawing. The upper section is far more refined and precisely drawn. By changing the pressure on the drawing tool, Adams creates a weighty, dominant mass on either side of the table and behind the chandelier. This concentrated mass of lines behind and around the chandelier is in contrast to the delicacy of line and shape in the lamp itself. For Adams the chandelier is a symbol of

62. Mac Adams. *Study for Three-Part Poison*. 1980. Graphite on paper, 5′4″ × 3′4″ (1.63 × 1.02 m). Commodities Corporation, Princeton, N.J.

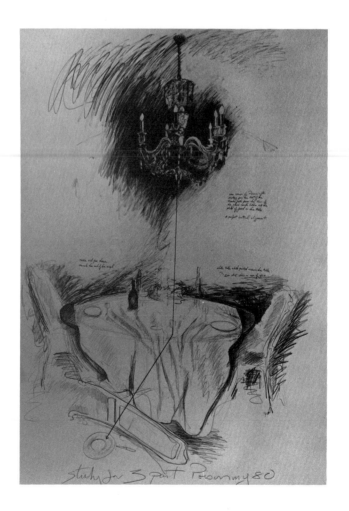

luxury and, therefore, is an inherent danger. He uses this image frequently in his work as a metaphor for art—the danger that lies in seeing art as mere luxury. In this drawing the focal point is clearly the chandelier. In order that the viewer not miss the point, Adams draws a precise arrow directing our eye to the lower left, to a schematically drawn bowl—the container of the poison?

Before drawing a still life, think of a verbal description of what it is doing. If you speak of a drooping flower, an immediate visual image comes to mind. This is a good way to approach sustained gesture. Look at the subject. Is the bottle *thrusting* upward into space? Is the cloth *languishing* on the table? Find descriptive terms for the subject and try to infuse your drawing with a feeling that is commensurate with the verbal description.

If you are drawing a figure, take the pose of the model yourself. Hold the pose for three minutes. Where do you feel the stress? Where is the most tension, the heaviest weight in the pose? Emphasize those areas in your drawing by using a darker line. Lighten the marks where there is less weight. Thinking of the attitude of the model and empathizing with the figure's pose will add variety and interest to the exercises and will help infuse the drawing with an expressive quality.

Quick gestures take from 30 seconds to 3 minutes. The sustained gesture takes longer—5, 10, even 15 minutes, as long as the spirit of spontaneity can be sustained.

In a sustained gesture you may begin lightly and darken your marks only after you have settled on a more definitely corrected shape. Draw quickly and energetically for the first two minutes; then stop and analyze your drawing in relation to the subject. Have you stated the correct proportion and scale among the parts? Is the drawing well related to the page? Redraw, making corrections. Alternate drawing with a careful observation of the subject. Avoid making slow, constricted marks. Do not change the style of the marks you have already made. Give consideration to the placement of the subject on the page, to the distribution of lights and darks; look for repeating shapes; try to avoid overcrowding at the bottom or sides of the paper. Look for a center of interest and by a more precise line or by a sharper contrast between lights and darks in a particular area, create a focal point.

In this exercise, and in those to follow, it is imperative that you stand back and look at your drawing from time to time as you work. Drawings change with viewing distance, and many times a drawing will tell you what it needs when you look at it from a few feet away.

Of all the exercises discussed, you will find sustained gesture the most open-ended for developing a drawing.

Try to keep these nine important points in mind as you work on gesture exercises.

1. Stand while drawing.
2. Use paper at least 18 by 24 inches (46 × 61 cm).
3. Use any medium. Charcoal or ink is recommended.
4. Use large arm movements.

5. Scan the subject in its entirety before beginning to draw.
6. Be aware that the hand duplicates the motion of the eye.
7. Keep your drawing tool in contact with the paper throughout the drawing.
8. Keep your eye on the subject being drawn, only occasionally referring to your paper.
9. Avoid outlines. Draw through the forms.

OTHER BEGINNING EXERCISES

Other exercises that are helpful to the beginning student are continuous-line drawing, organizational-line drawing, and blind contour. Like gesture, these exercises emphasize coordination between eye and hand. They help translate information about three-dimensional objects onto a two-dimensional surface. They have in common with gesture the goal of seeing forms in their wholeness and of seeing relationships among the parts.

Continuous-Line-Drawing Exercises

The line in a *continuous-line drawing* is unbroken from the beginning to the end. The drawing implement stays in uninterrupted contact with the surface of the paper during the entire length of the

63. Jasper Johns. *0 through 9*. 1960. Charcoal on paper, 29 × 23″ (74 × 58 cm). Collection the artist. © Jasper Johns/VAGA New York 1990.

64. Continuous-line drawing. Example by Rick Floyd. 1984. Pencil, 24 × 18″ (46 × 61 cm). Private collection.

drawing. Jasper Johns's charcoal drawing *0 Through 9* (Figure 63) is an example of this technique. The numbers are layered, stacked one on top of the other, all sharing the same outer edges. The numbers are transparent and slightly unintelligible, and the overlapping intersecting lines create shapes independent of the numbers themselves.

Once you make contact with the paper (you may begin anywhere: top, bottom, side), you are to keep the line flowing. The completed drawing gives the effect that it could be unwound or unraveled. Rather than using multiple lines, you use a single line; however, as in gesture, you draw through the forms as if they were transparent. The line connects forms, bridging spaces between objects. Not only are outside edges described, internal shapes are also drawn. A continuous, overlapping-line drawing has a unified look that comes from the number of enclosed, repeated shapes that naturally occur in the drawing. The resulting composition is made up of large and small related shapes.

Again, as in gesture, try to fill the entire surface of your paper. This, too, will ensure compositional unity. Let the shapes go off the page on at least three sides. Vary the weight of the line, pressing harder in those areas where you perceive a heavier weight or a shadow, or where you see the form turning into space, or in those areas of abrupt change in line direction (Figure 64).

Felt-tip pens, brush, pen and ink, and pencil are suggested media for continuous-line drawing. Any implement that permits a free-flowing line is appropriate. Here are some important points to keep in mind when doing continuous-line drawing:

1. Use an implement that permits a free-flowing line.
2. Use an unbroken line for the entire drawing.
3. Keep your drawing implement constantly in contact with the paper.
4. Draw through the forms as if they were transparent.
5. Describe both outside edges and internal shapes.
6. Fill the entire surface of your paper, encompassing positive and negative shapes.
7. Vary the weight of the line.
8. Your lines will overlap.

Organizational-Line-Drawing Exercises

Organizational line provides the framework for a drawing. This framework can be compared with the armature upon which a sculptor molds clay or to the scaffolding of a building.

Organizational lines take measure; they extend into space. Like gestural lines and continuous, overlapping lines, they are not confined by the outside limits of objects. They, too, are transparent; they cut through forms.

65. Alberto Giacometti. *Still Life.* 1948. Pencil on paper, $19\frac{1}{4} \times 12\frac{1}{2}''$ (49 × 32 cm). Collection of the Modern Art Museum of Fort Worth, Gift of B. Gerald Cantor, Beverly Hills, California.

Organizational lines relate background shapes to objects; they organize the composition. They take measurement of height, width, and depth of the objects and the space they occupy. And like gesture, organizational lines are grouped; they are stated multiple times.

To use organizational line choose a still life with several objects; include background space and shapes such as the architectural features of the room—ceiling, juncture of walls, doors, and windows. Begin with horizontal and vertical lines, establishing heights and widths of each object and of the background shapes.

Note Giacometti's use of organizational line in Figure 65. His searching lines extend into space beyond the confines of the objects to the edge of the picture plane. The objects themselves seem transparent; they are penetrated by groups of measurement lines. Multiple lines are clustered at the edges of forms, so the outer edge is never exactly stated; the edge lies somewhere within the cluster.

In your organizational-line drawing, continue to correct the basic shapes, checking on proportion between the parts, on relative heights and widths. Look for diagonals in the composition; state the diagonal lines in relation to the corrected horizontal and vertical lines. Continue to refine the drawing, registering information about scale and space.

By closing one eye (to diminish depth perception) and holding a pencil at arm's length from you, you can measure the height and width of each object and make comparisons between objects. This is called *sighting* and is an important device in training yourself to quickly register proper proportion. It is an indispensable aid for learning to translate three-dimensional objects onto a two-dimensional surface.

In addition to helping you establish correct proportion and placement between the parts, the buildup of multiple, corrected lines creates a sense of volume, of weight and depth in your drawing. After you have drawn for ten minutes or longer, and when you have finally accurately established proper proportion between the parts, you can then darken some of the forms, firmly establishing their exact shape. By this means you will have created a focal point; you will have directed the viewer to look for certain priorities that you wish to be noticed. You can direct the viewer's eyes through the drawing by means of these darker lines and more precise shapes.

Many artists use this analytical approach even though the armature is not readily apparent (Figures 66 and 67). Here are some important points to keep in mind when doing organizational-line drawings.

1. Begin with horizontal and vertical lines, both actual and implied; add diagonal lines last.
2. Establish heights and widths of all objects and background shapes.
3. Allow lines to penetrate through objects, establishing relationships between objects.
4. Correct basic shapes.
5. Check on proportion and relative heights and widths.

66, left. Organizational-line drawing. Example by Susan Harrington. 1984. Pencil, 24 × 18″ (61 × 46 cm). Private collection.

67, right. Organizational-line drawing. Example by Rick Floyd. 1984. Pencil, 18 × 24″ (46 × 61 cm). Private collection.

6. Lines should continue past objects into negative space.
7. When you have established proportions, darken some of the forms, establishing their exact shapes.

Blind-Contour Exercises

In contrast to the immediacy of the gestural approach, which sees forms in their wholeness, the contour approach is a slower, more intense inspection of the parts. A contour line is a single, clean, incisive line, which defines edges. It is, however, unlike outline, which states only the outside edge of an object. An outline differentiates between positive and negative edges. A contour line is more spatially descriptive; it can define an interior complexity of planes and shapes. Outline is flat; contour is *plastic*, that is, it emphasizes the three-dimensional appearance of a form.

A quick way to understand the difference between contour and outline is to look at Figure 68. If you were drawing a pencil using contour line, you would draw a line at the edge of every shift in plane. The ridges along the length of the pencil, the juncture of the metal holder of the eraser with the wood, the insertion of the eraser into its metal shaft—all are planar changes that would be indicated by contour line.

In addition to structural, or planar, edges, contour line can indicate the edge of value, or shadow, the edge of texture, and the edge of color.

There are a number of types of contour, several of which are discussed in Chapter 5, "*Line*," but this chapter will concentrate on working with *blind contour*, an exercise that involves not looking at your paper.

Some general instructions are applicable for all types of contour drawing. In the beginning use a sharp-pointed implement (such as a 2B pencil or pen and ink). This will promote a feeling of precision, of exactness. Contour drawing demands a single, incisive line. Do not retrace over already stated lines, and do not erase for correction.

In blind contour, keep your eyes on the subject you are drawing. Imagine that the point of your drawing tool is in actual contact with the subject. Do not let your eyes move more quickly than you can draw. Keep your implement in constant contact with paper until you come to the end of a form. It is imperative to keep eye and hand coordinated. You may begin at the outside edge of your subject, but when you see that line turn inward, follow it to its end. In a figure drawing, for example, this technique may lead you to draw the interior features and bone structure without completing the outside contour. Remember to vary the pressure on the drawing tool to indicate weight and space, to imply shadow, and to articulate forms.

Draw only where there is an actual, structural plane shift or where there is a change in value, texture, or color. Do not enter the interior form and aimlessly draw nonexistent planes or make meaningless, decorative lines. (In this regard, contour drawing is unlike a continuous, overlapping-line drawing, where you can arbitrarily cross over shapes and negative space.) When you have drawn to the

68. Outline and contour. Student work. Pencil, 18 × 24″ (46 × 61 cm).

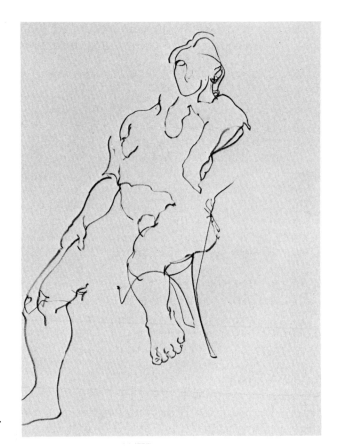

69. Blind contour of figure.
Example by Susan Harrington.
1984. Pencil, 24 × 18″ (61 × 46 cm).
Private collection.

end of an interior shape, you may wish to return to the outside edge. At that time you may look down and realign your drawing implement with the previously stated edge. With only a glance for realignment, continue to draw, keeping your eyes on the subject. Do not worry about distortion or inaccurate proportions; proportions will improve after a number of sessions dedicated to contour.

For this exercise choose a complex subject; in the beginning a single object or figure is appropriate; such as a bicycle, typewriter, or skull. Distortion and misalignment are a part of the exercise. Do not, however, intentionally exaggerate or distort. Try to draw exactly as you see. If you have a tendency to peep at your paper too often, try placing a second sheet of paper on top of your drawing hand, thereby obscuring your view of your progress.

Blind-contour drawing should be done frequently and with a wide range of subjects—room interiors, landscape, figure, still lifes (Figures 69 and 70). Here are some important points to keep in mind when doing blind-contour exercises:

1. Use a well-sharpened pencil or pen and ink. Later felt-tip markers and grease pencils can be used, but in the beginning use a sharp-pointed implement.
2. Keep your eyes on the subject.

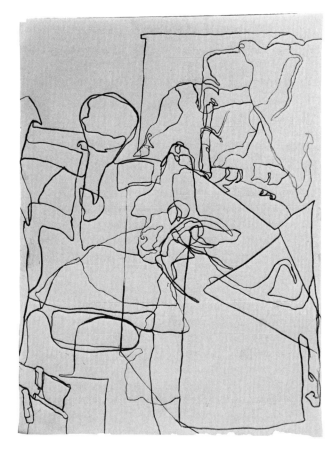

70. Blind contour of still life. Example by Rick Floyd. 1984. Pencil, 24 × 18″ (61 × 46 cm). Private collection.

3. Imagine that your drawing tool is in actual contact with the subject.
4. Keep eyes and hand coordinated. Do not let your eyes move more quickly than your hand.
5. Draw only where there is an actual structural plane shift, or where there is a change in value, texture, or color.
6. Draw only existent planes. Do not make meaningless lines.
7. Do not retrace over already stated lines.
8. Do not erase for correction.
9. Remember that contour line is a single, incisive line.
10. Vary the weight of the line to relay information about space and weight and to offer contrast.

SUMMARY:
The Benefits of Gesture, Continuous-Line, Organizational-Line, and Blind-Contour Drawing

Gesture drawing is a manifestation of the energy that goes into making marks. It is a record that makes a visual connection between the artist and the subject drawn, whether that subject be from the real

world or from the world of the imagination. It can take place in the initial stages of a drawing and can serve as a means of early thinking about one's subject; it is an idea generator. Gestural marks can be the subject of the drawing or the carrier of an idea in the drawing. Gesture drawing, then, encourages empathy between artist and subject. The gestural approach gives the drawing vitality and immediacy. It is a fast, direct route to that part of us that has immediate recognition, that sees, composes, and organizes in a split second. Through gesture drawing we bring what we know and feel intuitively to the conscious self, and this is its prime benefit.

These basic approaches—gesture, continuous-line, and organizational-line drawing—train us to search out underlying structure. They are a quick means of noting planes and volumes and locating them in space. They help us to digest the whole before going to the parts, to concentrate in an intense and sustained way. The three approaches furnish a blueprint for a more sustained drawing and provide a compositional unity early in the drawing.

Contour drawing, on the other hand, offers a means to a slow, intense inspection of the parts. It refines our seeing and leads us to a more detailed understanding of how the parts relate to the whole.

These beginning approaches introduce some ways of translating three-dimensional forms onto a two-dimensional surface. We are made aware of the limits of the page without our having to refer constantly to it. These approaches offer a means of establishing unity in the drawing, placing shapes and volumes in their proper scale and proportion; they introduce lights and darks as well as a sense of space into the drawing; they suggest areas for focal development, and they provide rhythm and movement.

Finally, these beginning approaches provide a flexible and correctable beginning for a more extended drawing. They give options for developing the work and extending the drawing over a longer period of time. They point to a route to a finished drawing.

Part 2

SPATIAL

RELATIONSHIPS OF

THE ART ELEMENTS

Space has been treated differently in different eras and cultures. We all have a subjective response to space; each of us experiences and interprets space in an individual way. A child's idea of space differs from an adult's. The flattened space in a Mixtec codex, or manuscript book (Figure 71), contrasts the illusionistically deep space in a Renaissance drawing by Federigo Zuccaro (Figure 72), although both were produced during the same period. In the Mixtec panel the space remains flat because of the use of unmodeled, or flat, value shapes and outline. The figures share the same base line (the imaginary lines on which they stand). Hieroglyphs in each unit form a repeating pattern, which further flattens the space. The background is empty; the main focus remains on the positive figures and their static and symbolic relationship with one another. We see an example of *hierarchical space* in the lower right panel. The sacrificial victim is on a much smaller scale than the priest and god; the figures stand in symbolic relationship. The Mixtec artist was governed by a hierarchy of forms, both in his art and in his culture.

By contrast the Renaissance artist depicts a stepped progression of space. This effect is achieved by placing the figures and buildings in realistic proportion with one another, by making objects diminish in size as they recede into the distance, and by using darker washes and more precisely drawn lines in the foreground. The picture plane is penetrated by the diagonal lines (on the ground and in the building on the right) that point to a deep space. Column, figures, and

71. *Nine Pairs of Divinities*. Mixtec codex, Mexico. 14th–16th century. Vatican Library, Rome.

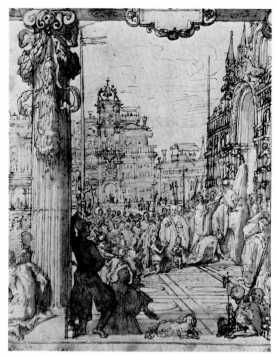

72. Federigo Zuccaro. *Emperor Frederic Barbarossa before Pope Alexander III*. Late 16th century. Pen and ink, wash over chalk, $10\frac{3}{8} \times 8\frac{1}{2}''$ (26 × 21 cm). Pierpont Morgan Library, New York. 1973.29.

building seem to be washed by a gentle light; soft grays and whites indicate various volumes. Unlike the Mixtec artist, Zuccaro had as a goal the depiction of realistic, albeit idealized, space.

Let us look at some drawings to help clarify some new terms with which to start building an art vocabulary. In some drawings artists translate objects as they exist in real space, which has height, width, and depth, onto a flat surface, which has only height and width. The space conveyed can be relatively *flat* or *shallow*, or it can be *illusionistic*, that is, giving the impression of space and volume, or it can be *ambiguous*, not clearly flat or clearly three-dimensional.

In A. R. Penck's work (Figure 73), his figures are stated in minimal terms; they are flat shapes; no depth is suggested. Penck even dispenses with overlap, a common device for conveying the idea of arrangement of forms in space. The shapes resemble cut-out

forms with jagged edges. The work is abstract but highly personalized. Penck (a pseudonym; the original Penck was a geologist who studied the Ice Age) works in an autobiographical mode. His crossing over from East Germany to the West provided him with an archetypal theme of passage. The bleak images produce a powerful impact of primitive and mythic import. We classify this artist's space as flat, two-dimensional space.

In Figure 74 Sue Hettmansperger has chosen forms that in the real world are flat strips of paper. She conveys an illusion of volume by using cast shadows. The undulating forms advance toward the viewer. The strips seem to have been peeled off their background surface. The plane behind these bulging shapes is absolutely flat. Although the subject is simple, the resulting drawing is rather complex with its interplay of cylinders and triangles created by a light source

73. A. R. Penck. *T.III.* 1981. Dispersion on canvas, 6′7″ × 9′2½″ (2.01 × 2.81). Collection Martin Sklar, New York.

that falls across the paper from the upper left. The forms seem to press out of the picture plane.

In addition to being relatively flat or illusionistically volumetric, the space conveyed can be *ambiguous,* neither clearly flat nor clearly three-dimensional. Ambiguous space is a combination of both two- and three-dimensional elements. The sketch of

Picasso by Jasper Johns (Figure 75) incorporates collage, watercolor, and drawing and combines illusionistic space with flat outline. The photograph is partially flattened by an overlay of transparent gray paper that repeats the profile and by a line that traces the features. A flat, displaced, somewhat smaller profile appears on the right side of the drawing, overlapping the four drawings

74. Sue Hettmansperger. *Untitled.* 1975. Watercolor and pencil, 23 × 25″ (58 × 64 cm). NCNB National Bank.

75. Jasper Johns. Sketch for *Cup 2 Picasso/Cup 4 Picasso.* 1971–1972. Collage and watercolor, $15\frac{1}{2} \times 20\frac{1}{4}''$ (39 × 51 cm). © Jasper Johns/ VAGA, New York, 1990

of cups. The space in this segment of the sketch is very shallow, even though the two cups on the lower right have some indication of background. The composition has an integrated spatial organization due to the repeating shapes of the profiles (even the two negative shapes on either side of the cup with the written notation suggest profiles), the repeating grid patterns, and the distribution of grays and blacks throughout the drawing. This combination of illusionistic space and flat outline has the effect of spatial ambiguity.

The concept of space has undergone radical changes since the last quarter of the 19th century. Not only has the artist's concept of space changed, our ideas concerning real, physical space have changed. We have only to consider what speed alone can do to alter one's perception of space to realize that we have a very different spatial sense from that of our predecessors. Not only have theories about space changed, the very definition of our place in the cosmos is in contrast to our placement a hundred years ago.

Impressionism marks the time when artists began to lay claim to a painting as an object in its own right, autonomous, separate and different from its earlier function as imitative of the real world. And it was at this moment that art's release from its limited function of illusion began. The Impression-

ists declared in their work and in their writings that visual reality is not only the imitation of the surface appearance of objects, but that visual reality is in a state of flux, altered by the quality of light and captured by the changing viewpoints of the constantly moving eye. These artists were scientific in their investigation of the properties of light and color, and they experimented with how (rather than what) we perceive.

It is interesting to note that one of the major influences on the spatial innovations of the Impressionists were the 18th-century Japanese Ukiyo-e artists—painters of the floating world (Figure 76). The Impressionists were attracted to the very different spatial arrangement in Eastern art: the use of flat, unmodeled areas of color and pattern, an unexpected eye level, a sort of bird's-eye view, and cut-off edges. (This compositional device was particularly suited for the newly emerging camera.) And Japanese subject matter, like that of the Impressionists, dealt with intimate scenes. These works strongly influenced pictorial space in Western art.

New ideas of pictorial space, along with new scientific discoveries in the perception of light and color, occupied both the Impressionists and their successors, the Post-Impressionists. In their intense concentration on light and color, the Impressionists minimized the illusion of volumetric forms

76. Isoda Koryusai. *A Courtesan Playing the Samisen*. c. 1785. Hanging scroll, ink and gold on silk, $48 \times 24\frac{9}{16}''$ (121.9 × 62.4 cm). Kimbell Art Museum, Fort Worth, Texas.

77. Georges Seurat, French, 1859–1891. *Sunday Afternoon on the Island of La Grande Jatte*. 1884–1886. Oil on canvas, $81\frac{3}{4} \times 121\frac{1}{4}''$ (207.6 × 308 cm). Helen Birch Bartlett Memorial Collection, 1926.224. Photograph © 1990, The Art Institute of Chicago. All Rights Reserved.

existing in an illusionistic three-dimensional space. The Post-Impressionists sought to revitalize pictorial space by recreating solids and voids while having them occupy a limited depth (Figure 77). Georges Seurat sought to synthesize the findings of the Impressionists with ideas of traditional illusionistic space and structure. He placed his figures in an arrangement of diminishing perspective while unifying and flattening the surface of the painting with a pattern of colored dots. By this means he reconciled the flatness of the picture plane, maintained modern concerns of light and color, and introduced the objective of weight and volume into the composition. Seurat was interested

78. Marcel Duchamp. *Virgin No. 1*. 1912. Pencil, 12½ × 9″ (31.8 × 22.9 cm). Philadelphia Museum of Art, A. E. Gallatin Collection.

in classical structure; he was especially attracted to Egyptian stacked perspective, where forms at the bottom of the picture plane are read as being closer to the viewer and those at the top are seen as occupying a deeper space.

The artist who was most influential in establishing 20th-century concepts of space was Paul Cézanne. His space is not recognizable as natural space, but one can discern his complex idea of illusionistic space integrated on a flat surface (See Figure 9). The planes or edges of the objects slide into one another, thus joining surface and depth. His work is constructed with intersecting volumes. This new way of depicting volumes as they exist in space opened the way for the revolutionary look of Cubism.

Abstraction was a logical consequence of the developments that took place at the turn of the century. Forms had been distorted, segmented, and analyzed; along with the revision in the way objects were depicted, space had to be dealt with in new ways. In Cubism (Figure 78) natural objects were reduced to geometrical abstractions. The Cubists followed Cézanne's directive to "treat nature in terms of the cylinder, and the sphere and the cone," in other words, to interpret forms in their simple and broad dimensions.

In addition to introducing reductive, abstracted forms, Cubists shattered the traditional idea of perspective by combining multiple views of the same object in a single composition. They drew side, top, inside,

outside—collapsed and simultaneous views of a single subject and of the space surrounding it. The resulting space is highly ambiguous, combining flat shapes with modeled volumes. The Cubists not only described objects in new ways, they depicted space itself as if it were made up of tangible planes and interlocking shapes. The work is complex in its arrangements; in a Cubist composition relationships proliferate—not only relationships among objects, but relationships between objects and space. These works could be considered as visual equivalents of Albert Einstein's theory of relativity. Cubism is closely linked with the "new ideas in the air," not only in art but in the world. It grew out of a volatile time in our century.

As we have seen, pictorial space has become more and more conceptualized in this century. Surrealism was another influ-ential movement that disrupted the expecta-tion of a logical, rational illusionistic space handed down to us by Renaissance artists. Surrealistic space is disjunctive, exagger-ated (Figure 79). Surrealism has an evocative power of eliciting an otherworldly space, which comes from the world of the subcon-scious. Scale shifts and unexpected juxtapo-sitions characterize this style.

The Abstract Expressionists carried the idea of pictorial space in another direction. Their vigorous, painterly attacks resulted in surfaces of rich complexity that force us to think of space in a totally new way. The painted surface is a record of the intensity of the process of painting itself. The images are not "images of" anything; they are a result of action. Rather than looking out into space, it is as if the artist were looking downward from an airplane to the flat surface of the

79. Max Ernst. *"...hopla!hopla!..."*. 1929. Collage, $4 \times 5\frac{5}{8}''$ (10.2 × 14.3 cm). Collection of the Modern Art Museum of Fort Worth, Museum Purchase, The Benjamin J. Tillar Memorial Trust.

80, left. Franz Kline. *Untitled.* 1954. Oil on paper, 11 × 8½″ (28 × 22 cm).
Collection of the Modern Art Museum of Fort Worth, Museum Purchase,
The Benjamin J. Tillar Memorial Trust.

81, right. Tom Blackwell. *High Standard's Harley.* 1975. Acrylic on board,
22 × 15 (56 × 38 cm). Collection Louis K. and Susan Pear Meisel, New
York.

earth. This radical change from looking through a deep illusionistic space to looking through a skein or web of paint makes a real departure in the viewer's spatial response to the work. Franz Kline's startling black-and-white configurations (Figure 80), boldly executed, seem like patterns on the earth seen from miles away. It is up to the viewer to interpret these works. Artists frequently do not title their works so as to leave them even more nonreferential.

Art has taken diverse directions in the latter half of the 20th century, exhibiting a proliferation of styles, philosophies, and ideas. The result is a stylistic pluralism.

Rather than one style replacing another in a historically linear fashion, today many styles exist side by side; therefore, we see all types of pictorial space currently in use.

An innovative use of pictorial space, and one peculiar to contemporary art, is that of the Photorealists. Tom Blackwell's *Hi-Standard's Harley* (Figure 81) is a study in representational clarity. The composition is tied together by a wide range of textures, all accurately represented, from the dull rubber tire to the reflective chrome and plastic surfaces. The picture plane is crowded with a multitude of small shapes in the foreground and larger, simple, blurred, value shapes in

82. Dorthea Rockburne. *Stele*. 1980. Conte crayon, pencil, oil, and gesso on linen, 7'7¼" × 4'3¼" (2.32 × 1.30 m). Private collection.

the background. Blackwell, in true Photorealist style, faithfully records the patterns that a camera sees—both its focus and distortion. Duplicating what the camera sees and how a photograph looks results in a space that is three-dimensionally illusionistic and flat at the same time. An unmistakable photographic flatness to the surface of these art works combines with the volumetric illusion that ultimately results in a distinctive new combination.

Minimalism, or Reductivism, focuses on art's formal properties such as line or shape, as in Dorothea Rockeburne's *Stele* (Figure 82). The space in this drawing is limited. The work has a presence that is self-contained; that is, it is stripped of references outside the drawing itself. Limited modeling is used in depicting the folds of paper, but these volumes are contradicted by the insistence of the rigid black outline that dominates the right side of the composition. (Actually, this black line is a continuation of the rectangle, which is lighter on the left half of the drawing.) The resulting space is therefore ambiguous, a combination of two-dimensional and three-dimensional elements. Rockeburne confronts the viewer with questions concerning perception such as the "location" of the rectangle.

In Andrea Way's *Shots* (Figure 83) the space of the drawing seems to take place on a videolike screen. A shallow sense of space is achieved by the use of small and large triangular shapes, which activate the black background. Light and dark rectangular shapes

83. Andrea Way. *Shots*. 1986. Ink on paper, 36 × 51½″ (91.4 × 130.8 cm). Collection of George T. Moran.

84. Frank Stella. *Diavolozoppo 4x*. 1984. Oil, urethane enamel, fluorescant alkyd, acrylic, and printing ink on canvas, etched magnesium.

seem to occupy two levels of space, while a web of finely drawn diagonal shapes unifies and connects the horizontal shapes. Way created rules for her drawings so that, as she claims, she can constructively depart from them. She merges "systems," imposing one on top of the other. The resulting space is a continuous one. If we imagined the drawing to be expanded in any direction, we know we would see a continuation of the "program," a contemporary innovation.

We could not have a discussion of pictorial space without including the contemporary artist Frank Stella, whose entire body of work has dealt with reinvigorating space as it is used in abstract painting (Figure 84).

85. David Salle. *The Mother Tongue.* 1981. Oil and acrylic on canvas and masonite, 9′4″ × 7′2″ (2.84 × 2.18 m). Collection of Doris and Robert Hillman, New York.

Our traditional concept of the rectangle as background for a two-dimensional work of art is subverted by Stella's curved and expressively colored shapes that tilt out from the wall and occupy, rather than depict, actual, projective, three-dimensional space. His works are on a large scale, eccentric and exciting. Stella has written that it is an emotional impact of space that he seeks; he believes that this emotive, new approach to pictorial space is "an antidote" to what he sees as the "barren imagery of abstraction."

Post-Modernism, a late 20th-century development, is an attitude more than a style and employs the full range of pictorial space, flat, ambiguous, and illusionistic (sometimes even in the same composition). One particularly interesting development has been the overlay of images; even more innovative is the fact that the images are unrelated by technique. In David Salle's large-scale work (Figure 85), a rectangle has been divided into two seemingly unrelated divisions. In the upper half we see a number of figures drawn directly on top of one an-

other. The central figure is gagged and bound; the figure on the right seems to be a relative of the well-known figure in Edvard Munch's *The Scream.* He is being bombarded by music from a loudspeaker; notes are crashing into his head. The mute, animalistic condition of the group is paralleled by a pack of dogs in the lower right corner. The apocalyptic nature of the work is conveyed by the brutal handling of the figures. This spatially confusing composition is in complete opposition to the insistently gridded lower half with its monotony of circles, uniformly and rigidly painted on Masonite. Even if we had not been given the clue by the loudspeaker box and by the title *The Mother Tongue,* we could not escape the association of the lower section with a loudspeaker system. The jumbled and erratic space is supportive of Salle's message of cacophony. The mute figures seem unaided by their mother tongue; they are victims of technologically generated, maddening sounds.

A final example underscores the extremes to which artists' use of space has been

86. Jennifer Bartlett. *White House.* 1985. Oil on canvas, wood, enamel,
paint, tar paper. Fences: wood, enamel, and metal. Pool: plywood and
paint. 120 × 192 × 120″ (3.05 × 4.88 × 3.05 m). Saatchi Collection, London.

taken in current art. Jennifer Bartlett's *White House* (Figure 86), like other recent works, is composed of actual three-dimensional painted objects that coexist with their two-dimensional counterparts on canvas. (A three-dimensional actual fence and model house stand in front of their two-dimensional depiction.) An interesting relationship is established between the two kinds of representation. You have only to compare the media required for this piece with that used in more traditional work to realize the enormous changes in the handling of space that have taken place in this century.

Even in this cursory survey of some of the major changes in the presentation of pictorial space in the 20th-century, you begin to get some idea of the importance for the artist of the handling of space. Whether the emphasis is on flat, shallow, illusionistic, actual, or ambiguous space, the concept of space is a challenge of lasting interest to artists.

Part 2 deals with the spatial relationships of the art elements: shape, value, line, texture, and color. Beginning with shape we will consider the way the elements can be used to create different kinds of space.

3

SHAPE/PLANE
AND VOLUME

SHAPE

An object's shape tells you what that object is. A shape is a configuration that has height and width and is, therefore, two-dimensional. Shapes can be divided into two basic categories: geometric and organic.

Geometric shapes are created by mathematical laws. They include squares, rectangles, triangles, trapezoids, hexagons, and pentagons, as well as circles, ovals, and ellipses. Tarrence Corbin offers a veritable storehouse of geometric configurations in *Cluster: Tristan Und Isolde* (Figure 87). The shapes seem to have been captured in this position only for a fleeting moment; they appear in the very act of change. Some forms, especially the balls, look as if they were suspended in space. This *tour de force* of spatial and compositional control is matched by an exquisite handling of the medium. In his complex and startling drawing the artist points us to the grandness of his theme by choosing as the title a medieval story of love separated by death, a legend of mutability.

Organic shapes, sometimes referred to as *biomorphic* or *amoeboid*, are free form, less regular than geometric shapes. The sculptor Eva Hesse is known for her use of coils and organic, ropelike shapes.

87. Tarrence Corbin. *Cluster: Tristan und Isolde*. 1985. Charcoal and collage on paper, $55\frac{1}{2} \times 59\frac{1}{2}$ (1.41 × 1.51 m). The Arkansas Art Center Foundation Collection. Lent by Barrett Hamilton, 1985.

88. Eva Hesse. *Untitled*. 1965. Ink, gouache, watercolor, and pencil on paper, $11\frac{3}{8} \times 16''$ (28.95 × 40.64 cm). Estate of the artist.

This interest is seen in her drawing (Figure 88). Here the shapes are described by varied lines; the heavier marks at the bottom of the composition lend weight to the forms, while the shape on the upper right is lighter and seems to be suspended in air. These amorphous shapes with thin valvelike connections suggest the internal workings of some animated machine.

89. Romare Bearden. *Interior with Profiles*. 1969. Collage, $3'3\frac{3}{4}'' \times 4'1\frac{7}{8}''$ (1.01 × 1.27 m). First National Bank of Chicago.

Usually we find a combination of geometric and organic shapes in an artist's work. In *Interior with Profiles* (Figure 89), Romare Bearden combines geometric and amoeboid shapes in a well-integrated composition. The figures in Bearden's collage are built of organic shapes, while the background is predominately geometric—squares and rectangles. Texture is an important element in Bearden's work. Shapes are created both by textural patterns and by flat and modeled values in the hands (and in the still-life objects in the background). The collage is organized along horizontal and vertical axes, which both flatten and stabilize the composition. The figures remind us of an Egyptian frieze. There is a timeless quality in Bearden's work that comes from his faultless sense of balance and rhythm. Unity is achieved by repetition of shape and value. Spatially, the work is very complex; it is difficult to locate exactly each figure in relationship to the other. This ambiguity of placement is further reinforced by the illogical scale between the parts.

As you have seen, shapes can be made by value, line, texture, or color. They may even be *suggested* or *implied*. In the drawing *Egyptian Ballet—Horns and Hands* (Figure 90), Leonard Baskin suggests or implies by minimal use of line the shape of the man-goat figure. The negative white space is conceptually filled by the mythic creature's body. Although the shape of the figure is not explicitly shown, we imagine it to be there. Baskin develops three focal points named in the title, horns and hands. Somewhere between head and hand the goat has undergone a transformation, and this transformation is left for the viewer to construct. The richly rendered centers of interest are in bold contrast to the white void that spans the space between them. Placement of the developed areas is crucial: The head is centralized; below the head a dark value shape leads our eyes to the hands, which are asymmetrically placed. The hand in the center points to the one on the right; a black shape under the thumb directs the movement back into the picture plane, away from the edge.

Perception is such that we fill in an omitted segment of a shape and perceive that shape as completed, or closed (Figure 91). In doing so, we tend to perceive the simplest structure that will complete the shape rather than a more complex one (Figure 92). We also group smaller shapes into their larger organizations and see the parts as they make up the whole (Figure 93).

Peter Plagens's drawing (Figure 94) seems to be a commentary on perception. The aggressive, heavy, open, circular form seems out of keeping with the wispy, faint scribbles in the background. Even the firmly centered shape is not enough to inhibit the implied movement in the work. It seems that like many modern artists, Plagens is purposefully questioning the rules of composition and of perception; he defies the viewer to complete the circle.

Shapes of similar size, color, value, or form attract each other; this is one way an artist organizes the picture plane. In the Corbin

90. Leonard Baskin. *Egyptian Ballet—Horns and Hands*. 1971. Ink and wash, 40 × 27½" (101 × 70 cm). Courtesy Kennedy Galleries, New York.

91. Incomplete shapes are perceived as completed, or closed.

92, near right. The four dots are perceived as forming a square rather than a more complex shape.

93, far right. Smaller shapes are perceived as part of their larger organization.

94. Peter Plagens. *Untitled (48-76)*. Pastel, oil pastel, and gouache; $31\frac{7}{8} \times 46\frac{7}{8}''$ (81 × 119 cm). Courtesy Nancy Hoffman Gallery, New York.

composition (see Figure 87), we see this kind of attraction and tension between shapes; it is the major formal theme of the drawing. Our eyes are directed through the piece by like attracting like. Normally small shapes tend to recede and large shapes advance; however, in this composition, because of the overlap, the large shapes seem to be predominantly background shapes. If you look intently at the uniformly shaped circles, you can interpret them as holes or openings into the shapes behind them, rather than as forms floating in the foreground. This work presents an analytical challenge to the viewer.

POSITIVE AND NEGATIVE SPACE

On the *picture plane*—the surface on which you are drawing—there is another distinction between shapes, that between positive and negative. *Positive shape* refers to the shape of the object drawn. In Robert Longo's drawing (Figure 95), the dark, isolated, positive shape of the jacket is the subject of the work. This somewhat menacing form is at first glance difficult to identify; it overpowers the figure below. There is nothing in the empty background (negative space) to give further information. The man is unidentifiable; his coat seems unforgettable.

 Negative space describes the space surrounding the positive forms. Negative space is relative to positive shapes. In Richard Diebenkorn's drawing (Figure 96), a woman is reclining on a bed; the bed is on the floor and in front of a wall. The floor forms a *ground* for the *figure* of the bed; the bed and wall form a ground for the figure of the woman. Thus, the floor and wall are negative to the bed, and the bed in turn is negative to the figure.

95, right. Robert Longo. *Untitled.* 1978. Charcoal on paper, 30 × 40″ (.76 × 1.02 m). Collection Robert Halff.

96, below left. Richard Diebenkorn. *Untitled (Girl Looking in Mirror).* 1962. Ink and pencil, 17 × 12⅜″ (43 × 31 cm). San Francisco Museum of Modern Art, purchased through anonymous funds and the Albert M. Bender Bequest Fund.

97, below right. Paul Wieghardt. *The Green Beads.* 1951. Oil on canvas, 39⅜ × 20″ (101 × 77 cm). Location unknown.

98, left. Dmitri Wright. *Untitled*. 1970. Stencil print, 23⅞ × 36⅛″ (61 × 92 cm). Brooklyn Museum, gift of the artist.

99, right. Donald Sultan. *Black Tulip*. 1983. Charcoal and graphite on paper, 38 × 50″ (96.5 × 127 cm). Private collection, New York.

In real life we are conditioned to search out positive shapes, but this habit must be altered in making art. On the picture plane all shapes, both positive and negative, are equally important. Combined, they give a composition unity. Paul Wieghardt's integration of positive and negative shapes is so complete that it is nearly impossible to classify each shape as either positive or negative (Figure 97). The progression of space in the Wieghardt painting does not follow the logical recession seen in the Diebenkorn drawing. Shapes that we logically know are more distant (note the placement of the woman on the right) are, in fact, perceptually on the same plane. Notice the relationship between the laps and legs of the two women. Wieghardt uses shapes of similar size, value, and form to attract each other and by this means creates a tight, interlocking composition.

In Dmitri Wright's stencil print (Figure 98), we see a changing emphasis from the positive images to the negative space surrounding them. The print has the look of a photographic negative. Reverse values and spatial dislocation of the objects contribute to a feeling of emptiness. Wright has used a blueprint as the base for the stencils. The geometric shapes and words behind the figures and implements create a second level of space, which further enhances and complicates interpretation of the print.

In the Donald Sultan work (Figure 99), positive and negative shapes switch with each other. Viewing the image one way, we can see the black shape as positive; viewing it another way, we see the black shape as background to the white forms. This positive/negative interchange is signatory of Sultan's style. The rich, matte-black medium has a strong physical presence, and the powdery residue enlivens the white spaces. Sultan purposefully chooses images that can be interpreted as either abstract or concrete, such as the tulip with its head turned inward to the leaves, creating a composite shape that is more than the sum of its parts.

The terms *positive/negative* and *figure/ground* are interchangeable. Other terms are *foreground/background, figure/field,* and *solid/void*. Negative space is also called *empty space* or *interspace*.

100, left. Composite shape. Student work. Charcoal, 28 × 39″ (71.1 × 99 cm).

101, right. Composite shape. Student work. Charcoal, 28 × 39″ (71.1 × 73.7 cm).

PROBLEM 3.1
Composite Shape Problem

Draw a silhouette of two combined objects so that they create a composite shape. Have the objects overlap in one or more areas so that enclosed positive and negative shapes occur. We have an example of this merging of forms in the Sultan drawing of the tulip; the flower shape combines with the leaf shape to create a unified, single, composite shape (see Figure 99).

In the student drawing (Figure 100), the two objects—a tree and a light pole—are analogous forms. Both are branched, and both emerge from a trunk; the spiky forms of the tree contrast with the circular shapes of the light. The negative white space is activated by smudges and powdery deposits from the charcoal.

In the second student drawing, a hunter bearing a gun is joined with an animal (Figure 101). Here the negative space is filled in; the positive forms remain empty or white. Spatially this drawing is interesting because, although man and animal are on the same plane, we read the drawing as if the hunter is located in a different space. This hierarchy of space (where objects lower on the picture plane are seen as occupying foreground space and objects higher on the picture plane are in a deeper space) is a convention that has been used throughout history. The two incidences of this type of *stacked perspective* that come most readily to mind are Egyptian space and the space used in cartoons or in children's drawings.

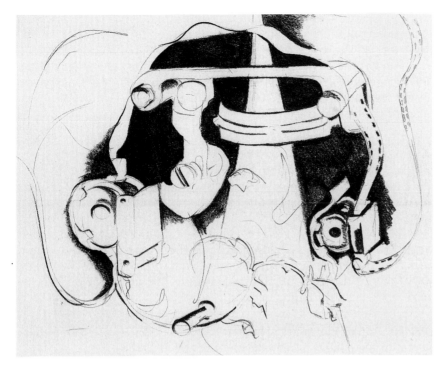

102. Interchangeable positive/negative shapes. Student work. Conté crayon, 18 × 21″ (46 × 61 cm).

PROBLEM 3.2
Interchangeable Positive and Negative Shapes

Make an arrangement of several objects or use a figure in an environment. In this drawing, emphasize the negative spaces between the objects by making them equal in importance to the positive shapes (Figure 102).

In a second drawing place emphasis on negative space. This time try to make the positive and negative shapes switch off with one another; that is, see if you can make the positive forms seem empty and the negative shapes positive. In other words, try to make the positive shapes recede and the negative shapes advance.

PROBLEM 3.3
Geometric Positive and Negative Shapes

Make a quick, continuous-line drawing of a still life. You may wish to refer to the description of this technique in Chapter 2. Redraw on top of the drawing. Regardless of the actual shapes in the still life, reduce both positive and negative shapes to rectangles and squares. Repeat the problem, this time using ovals and circles. You will, of course, have to force the geometric shapes to fit the actual still-life forms.

Look carefully at the subject. Which shapes are actually there? Which shapes are implied? Which types of shapes predominate? In asking these questions you are giving yourself some options for the direction the drawing is to take. You may note that circular forms predominate, and you may or may not choose to emphasize a circular

motif in the drawing. In making this quick analysis, you are bringing to consciousness information that will be helpful as you extend the drawing.

Repeat the initial procedure, using landscape as a subject. Draw only organic forms in both positive and negative shapes. One way to ensure that negative spaces form enclosed shapes is to make the composition go off the page on all four sides.

PROBLEM 3.4
Invented Negative Shapes

Choose any subject—landscape, still life, or figure. In your drawing invent some negative shapes that relate to the positive shapes of your subject.

In Rufino Tamayo's *The Water Carrier* (Figure 103), the symmetrical composition is structured around the shape of the water container. The woman's skirt and upper torso repeat the shape, while variations of the form fill the background. The shape structures the work both visually and conceptually.

103, left. Rufino Tamayo. *The Water Carrier*. 1956. Watercolor with pencil, $25\frac{3}{4} \times 19\frac{3}{4}''$ (66×50 cm). Courtesy Sotheby's, New York.

104, right. Collage shapes. Student work. Collage and ink, $24 \times 18''$ (61×46 cm).

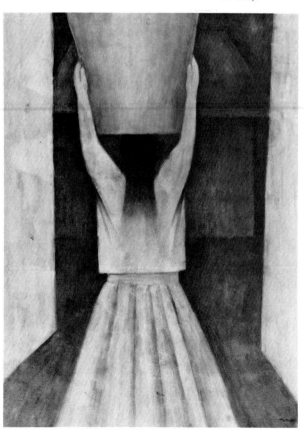

105. Enclosed shapes defined by texture. Student work. Pen and ink, 19 × 25″ (48 × 64 cm).

PROBLEM 3.5
Collaged Negative Spaces
Begin by making a collage of torn paper to represent the negative spaces in a still life. Then impose a simple line drawing of the still life, allowing line to cross over the collage shapes. This procedure will help integrate the positive and negative areas. Use enclosed shapes in both positive and negative spaces (Figure 104).

PROBLEM 3.6
Enclosed Invented Positive and Negative Shapes
For this drawing you are to invent a subject. It may be taken from your memory of a real object or event, or it may be an invented form or abstraction, but it should be a mental construct. Look back at the discussion of conceptualized drawings in Chapter 1 to refamiliarize yourself with their nature.

Once you have thought of a subject, draw it by using enclosed shapes in both positive and negative space. Define the shapes by outline, by texture, or by flat value. Fill the entire page with enclosed shapes. There should be no leftover space (Figure 105).

THE SHAPE OF THE PICTURE PLANE

The shape of the picture plane has an effect on the type of composition chosen. Irving Tepper centralizes his image in a squarish format (Figure 106); the placement of the cup is slightly off center—the tar-

106. Irving Tepper. *Third Cup of Coffee*. 1983. Charcoal on paper, 43¾ × 51½″ (111.1 × 130.8 cm). The Arkansas Art Center Foundation Collection, 1984.

get area of the coffee seems perfectly located. A centralized image can present the artist with a problem of how to handle the four corners, but Tepper has resolved the drawing by using a variety of circular shapes and interesting groupings of abstract lines that reverberate outward from the saucer. The viewer looks directly down into the cup, and this unusual point of view has the effect of transforming it into an abstract interplay of spherical forms. It is interesting to note that Tepper is a sculptor who works in clay.

Neil Jenney's image in Figure 107 conforms to its eccentrically shaped frame. The tree branches are particularly suited to the chopped-off format; the angle of the limbs points to the lopsided

107. Neil Jenney. *Window #6*. 1971–1976. Oil on panel, 1′3¾″ × 4′9½″ (1.01 × 1.46 m). Private collection.

structure, while the enclosed negative shapes—the intervals between limbs and edges of the frame—establish a secondary theme. We are reminded of the so-called "window into space," the spatially illusionistic goal for painting by Renaissance artists. Jenney has certainly updated the window; it is an unmistakably 20th-century version.

PROBLEM 3.7
The Shape of the Picture Plane

In your sketchbook draw four or five different formats to be used as picture planes—a long horizontal, a square, a narrow vertical, a circle, and an oval. Quickly draw a composition in each unit, using the same subject in each of the formats. Change the composition according to the demands of the outside shape. You will have to adjust your composition from format to format, changing the relationships of size, shape, and value. Each different outside shape demands a different response of the internal forms. You may use still-life landscape or nonobjective images.

In Figures 108 and 109 the student has chosen a subject from art history. The second drawing has been elongated to fit a more vertical format.

108, above. Shapes changed to fit the shape of the picture plane. Student work. Litho stick and felt-tip marker, 18 × 24″ (46 × 61 cm).

109, right. Shapes changed to fit the shape of the picture plane. Student work. Ink, 40 × 20″ (102 × 51 cm).

110. Cross-shape form made from an opened box.

111, left. Diagram of a cube.

112, right. Cube diagram with interior lines erased.

113. Clarence Carter. *Siena*. 1981. Acrylic on canvas, 6′6″ × 5′ (1.98 × 1.52 m). Courtesy Gimpel/ Weitzenhoffer Gallery, New York.

SHAPE AS PLANE AND VOLUME

It has been difficult to speak of shape without occasionally referring to volume. *Volume* is the three-dimensional equivalent of two-dimensional shape. Shapes become volumetric when they are read as *planes*. In the graphic arts and in painting, volume is the illusion of three-dimensional space. Volume defines *mass,* which deals with the weight or density of an object.

The way shape becomes volume can be seen in an illustration of a cube. If you take a cube apart so that its six sides, or planes, lie flat, you have changed the cube from a three-dimensional form into a two-dimensional shape (Figure 110). This new cross-shape is made up

of the six planes of the original box and is now a flat shape. If you reassemble the cube, the reconnected planes (the sides, top, and bottom) once again make volume. If you make a representation of the box seen from below eye level with one of its corners turned toward you, it will be composed of only three visible planes. Even if you draw only these three planes, the illusion of three-dimensionality remains (Figure 111). If you erase the interior lines, leaving the outer outline only, you have again changed volume into a flat shape (Figure 112).

The key word here is *plane*. By connecting the sides, or planes, of the cube, you make a *planar analysis* of the box. You make shape function as plane, as a component of volume.

In Clarence Carter's painting *Siena* (Figure 113), an illusion of volume is conveyed by the use of connecting shapes or planes. A monumental effect is achieved by seemingly simple means; the smaller, connected shapes of the stairs lead to the middle ground occupied by the two smaller buildings set at an angle. Smaller, fainter steps climb to the larger, more frontally placed building in the background. Carter achieves an architectural unity by interlocking planes, by the progression of small to larger shapes, and by the distribution of lights and darks.

In the human figure, planes are, of course, much more complex and subtle than those of a geometric volume, but Henry Moore has used interlocking planes to create the effect of rounded volumes in his *Family Group* (Figure 114). The figures have been dehumanized by this imposition of an illusionistically three-dimensional grid. Larger, heavier, more dimensional forms are indicated by dark line, while secondary, less important planes are drawn with a fainter line.

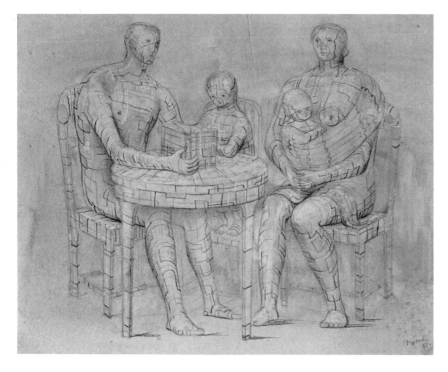

114. Henry Moore. *Family Group.* 1951. Chalk and watercolor, 17 × 20″ (43 × 51 cm). Collection D. B. Wilkie, Christchurch, New Zealand.

115. Edward Ruscha. *Chop.* 1967. Pencil, $13\frac{1}{4} \times 21\frac{7}{8}''$ (34 × 56 cm). Collection of the Modern Art Museum of Fort Worth, gift of the Junior League of Fort Worth.

We have one more way to transform shape into volume: modeling. *Modeling* is the change from light to dark across a surface to make a shape look volumetric. By means of modeling Edward Ruscha converts what is normally conceived of as a flat image into a floating, dimensional shape (Figure 115). The word *Chop* appears to be a ribbon unwinding in space. Ruscha's intent of divorcing the word from its semantic function is further enhanced by such an unexpected presentation.

You can clearly see the modeling technique in Fernand Léger's pencil drawing (Figure 116). Figure 117 reduces the Léger composition to shape. By comparing the two you can see how modeling trans-

116, right. Fernand Léger. *Three Women.* 1920. Pencil, $14\frac{1}{2} \times 20''$ (37 × 51 cm). Rijksmuseum Kroller-Muller, Otterlo, Netherlands.

117, below. Shape analysis of Fernand Léger's *Three Women.*

118. Diego Rivera. *Study for a Sleeping Woman*. 1921. Black crayon on white laid paper, 24 × 18″ (612 × 460 mm). Courtesy of the Fogg Art Museum, Harvard University, Cambridge, Massachusetts. Bequest of Meta and Paul J. Sachs.

forms shapes into volume. The shading from light to dark is more pronounced on the women's forms. A spatial contradiction is the result of the combination of flat, cut-out shapes with illusionistically rounded forms. Léger has also used contradictory eye levels; for example, we see the women from one vantage point, the rug and floor from another—as if we were floating above the scene—and the tabletops from yet another. The composition is structured by means of repetition, repetition of volumes and shapes.

Another means the artist uses to create a sense of volume is overlapping shapes. In Diego Rivera's *Study of a Sleeping Woman* (Figure 118), the figure of the woman is constructed by a progression of forms, one overlapping the other from feet to the dark shape of the hair. The viewer's eye level is low; we look up to the figure. The full, organic shapes are given volume by limited use of modeling concentrated at those points of maximum weight. The compact, compressed form is well suited to the proportions of the paper. The simple volumes are the primary means by which a feeling of monumentality and timelessness is achieved.

The following problems will help you think about shape and volume in new ways. Remember to change the size and shape of your format to help further your compositional abilities.

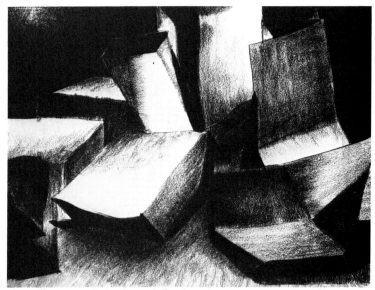

120. Planes into volume. Student work. Charcoal, 18 × 24″ (46 × 61 cm).

119. Shape as plane. Student work. Conté crayon, 24 × 18″ (61 × 46 cm).

PROBLEM 3.8
Shape as Plane and Volume

Using paper bags, a stack of boxes, or bricks as your subject, draw the edges of planes rather than the outside outline of the objects. Concentrate on the volumetric aspect of the objects, that is, on how shapes connect to create volume. In one drawing use line to define planes. You may wish to develop a focal point using shading in one small area of the drawing (Figure 119). The second drawing should be primarily tonal, more volumetric where planar change is indicated by the use of white, gray, or black shapes (Figure 120).

PROBLEM 3.9
Planar Analysis

With your own face as subject, make a planar analysis in a series of drawings. Begin by drawing the larger planes or groups of planes; then draw the smaller units. Work from the general to the specific.

After you have become familiar with the planar structure of your face, construct a three-dimensional mask from cardboard or bristol board. The sculptured mask should be life size, made to fit your face. Keep a sketch pad handy to redraw and correct the planar relationships. This interplay between stating the form two-dimen-

sionally and making a three-dimensional model will strengthen your understanding of the process involved in creating the illusion of volume.

Cut out the planes and use masking tape to attach them to one another. Making a three-dimensional analysis is an involved process. Look for the most complex network of planes. Note how the larger shapes can be broken down into smaller, more detailed groups of planes.

When you have completed this problem, you will have gained a real insight into how larger planes contain the smaller planes and how large planes join one another to create a volume.

Paint the mask with white paint. You have now deemphasized the edges of the planes to create a more subtle relationship between them. Place the mask under different lighting conditions in order to note how different light emphasizes different planes (Figure 121).

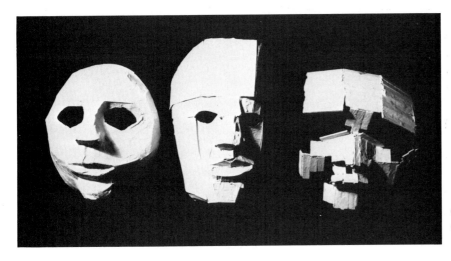

121. Planar analysis. Student work. Cardboard masks, left: 7 × 6½″ (18 × 17 cm), middle: 9 × 7″ (23 × 18 cm), right: 7 × 6½″ (18 × 17 cm).

PROBLEM 3.10
Rubbed Planar Drawing
Read through all the instructions carefully before beginning to draw. Spend at least an hour on this drawing.

Use a 6B pencil that is kept sharp at all times. To sharpen the pencil properly, hold the point down in contact with a hard, flat surface. Sharpen with a single-edge razor blade, using a downward motion. Revolve the pencil, sharpening evenly on all sides. Use a sandpaper pad to refine the point between sharpenings. Draw on white charcoal paper.

Use a model and warm up with several line-gesture drawings to acquaint yourself with the pose. Use a light line to establish proportions and organizational lines. Again, as in the head study, analyze the figure according to its planar structure. Begin drawing the largest planes. What are the figure's major masses? Upper torso, lower torso, upper legs, lower legs, head? Work from the general to the specific.

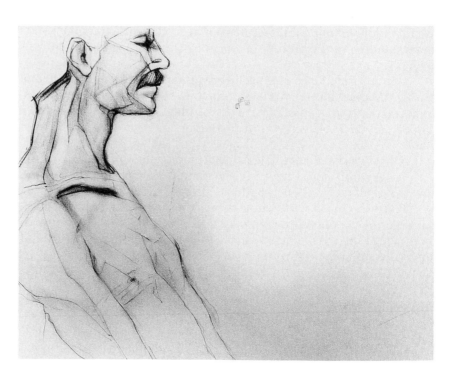

122. Planar rubbed drawing. Student work. Charcoal pencil, 18 × 24″ (46 × 61 cm).

123. Planar rubbed drawing. Student work. Charcoal pencil, 24 × 18″ (61 × 46 cm).

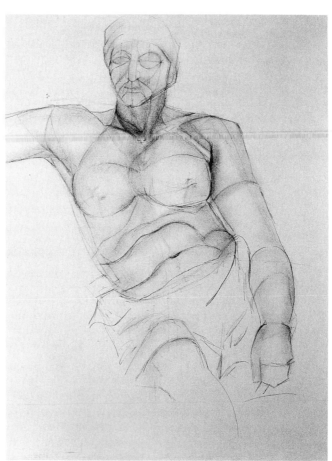

Determine where the figure turns at a 90-degree angle from you and enclose that plane. Look for the major volumes of the body and draw the planes that make up these volumes. After you have drawn for three or four minutes, rub the drawing with a clean piece of newsprint. Replenish the newsprint squares often. Rub inward toward the figure. Two warnings: Do not rub the drawing with your fingers, because the oil from your hands will transfer to the paper and make splotchy marks. Do not rub the drawing with a chamois skin because it removes too much of the drawing. Redraw, not simply tracing the same planes, but correcting the groupings. Alternate between drawing and rubbing. Continue to group planes according to their larger organization.

This technique is different from the continuous movement of the gesture and overlapping-line drawings. Here you are attempting to place each plane in its proper relation to every other plane. Try to imagine that the pencil is in contact with the model. Keep your eyes and pencil moving together. Do not let your eyes wander ahead of the marks.

When viewed closely, this drawing might resemble a jigsaw puzzle, each plane sharing common edges. When you stand back from the drawing, however, the planes begin to create volume, and the result will be a more illusionistically volumetric drawing than you have done before. The rubbing and redrawing give the planes a roundness and depth (Figure 122 and 123).

This exercise is actually an exercise in seeing. Following the instructions will help you increase your ability to concentrate and to detect planes and groups of planes that are structurally related.

PROBLEM 3.11
Basic Volume

The preceding problems provided you with some experience in drawing a volumetric form. For this problem use a different subject for each drawing—landscape, still life, figure in an environment. Think in terms of basic volumes. Render the subject in a quick, light, overlapping line; then impose volumes regardless of the actual forms in the still life. You will have to force volumes to fit the subject; for example, you might choose either a cylinder or a cube to represent the upper torso of a figure. Remember to register which volumes are actually there and which ones are implied. Look for repeating volumes to help unify your composition. As in the planar analyses, you should go from the large to the small, from the general to the specific. Remember, there are two bridges between shape and volume: When shapes are stated as planes they appear volumetric, and modeling over a shape creates volume.

PROBLEM 3.12
Modeling and Overlapping

Arrange several objects in deep space. Then draw these objects, exaggerating the space between them. Arrange large and small shapes on your paper, overlap shapes, and use different base lines for

each object. In your drawing try to distinguish between foreground, middle ground, and background.

Think in terms of the different levels of negative space— horizontal space between the objects, vertical space above them, and diagonal space between them as they recede into the background. Imagine that between the first object and the last are rows of panes of glass. Due to the cloudy effect of the glass, the last object is more indistinct than the first. Its edges are blurred, its color and value less intense, its texture less defined. A haze creates a different kind of atmosphere between the first and last object. The illusion of depth through atmospheric effects such as those just described is called *aerial perspective*.

An extension of the preceding problem is to model negative space. Use a still life or figure in an environment and concentrate on the different layers of space that exist between you and the back of the still life or figure. Make the shapes change from light to dark; model both positive and negative space; different lights and darks will indicate varying levels. This modeling of negative space is a plastic rendering of the subject, an illusionistically three-dimensional description of objects in the space they occupy. Your drawing should show a feeling for the different levels of space. Note in Ronald Milhoan's pastel drawing (Figure 124) that values are not confined to a single object; they cross over both positive and negative forms. A rich surface texture has been achieved by varying the direction of the chalk and by erasure and rubbing. In your drawing use the eraser as a drawing tool; try to imagine that the eraser can actually model space; use it to "reach inside" the picture plane to the various levels of space.

124. Ronald Milhoan. *Windowcase.* 1975. Pastel, 24 × 30" (61 × 76.2 cm). Collection of Pensacola Junior College, Pensacola, Florida.

125. Ambiguous space. Student work. Pencil, 19 × 25″ (48 × 64 cm).

SUMMARY:
Different Kinds of Space

A shape is two-dimensional if it has an unchanged or unmodulated value, color, or texture over its entire surface. Uniformity in color, value, or texture will make an otherwise volumetric form appear flatter. A form outlined by an unvarying line creates a two-dimensional effect.

Shapes functioning as planes, as the sides of a volume, give an illusion of three-dimensionality. Shapes can be given dimension by tilting them, truncating them, making them move diagonally into the picture plane.

When both flat, two-dimensional shapes and three-dimensional volumes are used in the same drawing, the result is ambiguous space (Figure 125). If a shape cannot be clearly located in relation to other shapes in the drawing, ambiguous space again results.

If a line delineating a shape varies in darkness or thickness, or if the line breaks, that is, if it is an implied line, the shape becomes less flat. Imprecise edges, blurred texture, and the use of modeling tend to make a shape appear volumetric. Modeling, the change from light to dark across a shape, transforms it into volume, creating the illusion of three-dimensionality.

V A L U E

126. Value scale, from 100 percent white to 100 percent black.

Value is the gradation from light to dark across a form; it is determined both by the lightness and darkness of the object and by its natural color—its *local color*—and by the degree of light that strikes it. This chapter is concerned not with color, or hue, but with value, the range from white to black as seen in the scale in Figure 126. An object can be red or blue and still have the same value. What is important in determining value is the lightness or darkness of the color. This approach is an achromatic one.

It is difficult to learn to separate color from value, but it is an essential task in art. We have two good examples of this separation in everyday life—in black-and-white photography and in black-and-white television.

If you squint while looking at an object or at color television, the colors diminish, and you begin to see patterns of light and dark instead of color patterns. When the value is the same on both the object and its background, you easily lose the exact edge of the object; both object and negative space are united by the same value. Although value can be confined to a shape, it can also cross over a shape and empty space; it can begin and end independently of a shape.

Robert Kogge depicts the objects' actual values in his compact still life (Figure 127). He has carefully observed and translated the local value of the objects onto the canvas. A light source (from left front and slightly above the still life) creates minimal shadows, and, while suggesting the curvature of the rounded objects, the ultimate effect of the even lighting is to flatten the objects in their tense prox-

127. Robert Kogge. *Untitled.* 1989. Graphite on canvas, 24 × 36″ (60.9 × 91.4 cm). O. K. Harris Works of Art, New York.

128. Teel Sale. *Polar States* from the Suite, *Antarctic States.* 1988. Linocut, 16½ × 36″ (42 × 91.4 cm). Collection of the artist.

imity on the picture plane. Kogge sets up an interesting spatial paradox in the work: First, a uniform texture created by use of graphite on canvas tends to flatten the otherwise illusionistically three-dimensional objects; second, although the forms are modeled from light to dark to depict rounded volumes, the space from foreground to background is extremely compressed. Note that the baseboard in the lower right of the picture plane seems to exist on the same level as the small objects on the lower left. Kogge's tightly knit composition is held together by a meticulous handling of values; this spatial tension results in a contemporary look.

Artists can reject actual appearance and create their own value patterns, their own kind of order. Teel Sale uses a stark reduction of value in her narratively structured environment (Figure 128). The theme is duality, and what better means than black and white to

carry that message? Coldness and heat, reflection of light and absorption of it are only two sets of symbols easily conveyed by black and white. The artist builds on preset associations of blackness and whiteness in her symbolically charged work. Value is both the formal and symbolic conveyor of meaning in this print from the suite *Some Antarctic States*.

A further example of how artists create their own order can be seen in the three rabbits in the accompanying figures. All three images are isolated and centralized in an empty space. The first two suggest a ground by use of cast shadow. The Renaissance artist Albrecht Dürer was governed by actual appearances in his careful rendering (Figure 129); texture, lighting, and careful notation of details and of structure testify to his close, accurate observation. The value patterns are dark with small areas of contrasting whites. The young hare's alert pose is reinforced by his angular placement on the page and by the tilt of his ears.

Wayne Thiebaud's rabbit (Figure 130), on the other hand, is absolutely stabilized within the picture plane; it is strangely isolated, its forms generalized. Value is gently modulated from white to gray. Repeating, undulating shapes ripple across the surface. The rabbit seems to be sitting in a pool of light; its cast shadow is the darkest, most clearly defined shape in the composition. The value patterns are theatrically exaggerated by this intense light. As if to point out how

129, right. Albrecht Dürer. *Young Hare.* 1502. Watercolor, $9\frac{7}{8} \times 8\frac{7}{8}''$ (25 × 23 cm). Graphische Sammlung Albertina, Vienna.

130, left. Wayne Thiebaud. *Rabbit* from the portfolio, *Seven Still Lives and a Rabbit,* published by Parasol Press, Ltd., New York. 1970. Lithograph, $22\frac{1}{4} \times 30''$ (57 × 76 cm). Brooklyn Museum.

131. Beth van Hoesen. *Sally.* 1979. Etching and drypoint printed *á la poupée*, $11\frac{9}{16} \times 13\frac{3}{4}''$ (29 × 35 cm). San Francisco Museum of Art, Ruth and Moses Lasky Fund Purchase.

crucial value is to the composition, the shadow cast by the ear reads as a value scale. Whether Thiebaud actually set up artificial lighting or invented it in the drawing, his manipulation of lights and darks is an intense and personal one.

Beth Van Hoesen has chosen a middle value range for her print (Figure 131). The gray background decreases sharp value contrasts. The transition from white to black is very subtle; the rabbit's curved forms grow faintly darker as they recede into space. Because of eye contact with the rabbit, we feel identification with the subject.

As you have seen, the same subject can be treated by a different value range to attain strikingly different results. Each of the three rabbits is done in a different medium, yet value is the primary means used to organize the compositions.

Value describes objects, the light striking them and their weight, structure, and spatial arrangement. Value can also be expressively descriptive. So value has two functions: It is objectively as well as subjectively descriptive. Susan Hauptman's drawing (Figure 132) is a study in representational clarity. The composition is built with a wide range of values, all visually accurate, from the wrinkled, lightweight scarf to the glass, shell-shaped vase. Values cross over positive shapes and empty space in the upper third of the drawing; the white tabletop disappears, reappears, and disappears again in the background space. The texture, or tactile quality, of the drawing is a result of a virtuosic handling of values. While Hauptman's drawing is unquestionably representational—illusionistic, both spatially and

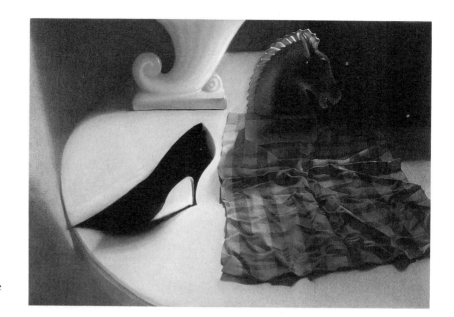

132. Susan Hauptman. *Still Life.*
1985. Charcoal and pastel on
paper, $31\frac{1}{2} \times 43\frac{3}{4}''$ (80 × 111 cm).
Private collection. Courtesy of the
Allan Stone Gallery, New York.

133. Jóse Luís Cuevas. *Autoretrato como Rembrandt.* 1962. Lithograph, $15\frac{3}{4} \times 21\frac{1}{2}''$ (40 × 55 cm). Courtesy Galeria de Arte, Mizrach S. A., Mexico City.

texturally—it is highly subjective; an atmosphere of mystery pervades the work.

Unlike Hauptman, José Luís Cuevas has subordinated appearances to expressive content in his *Autoretrato como Rembrandt* (Figure 133). The whites and blacks are more extreme; the blacks in the background project the whites into stark relief. Cuevas's work has a surreal quality. The eyes in the stuffed head confront the viewer in a way that is evocative of Rembrandt's haunting eyes. The darkness of the eyes seem to penetrate the viewer; a concentrated stare relays the inward examination that also formed the basis of the psychological portraits by the Dutch master. We are reminded of the stretch of time and sensibility that separates today's world from the 17th century.

WAYS OF CREATING VALUE

In the graphic arts there are two basic ways to define a form—by line or by placement of two values next to each other. Most drawings are a combination of line and value, as in Robert Straight's *Crossfire* (Figure 134). Value shapes are sparsely distributed throughout the picture plane; they are concentrated at the edges and lower corners, and these geometric shapes, along with darker-valued wide lines, guide the viewer through the composition. Straight creates differing values of light and dark by areas of subtly hatched lines and by smudging. (Note areas of fingerprints that activate the expanse of the white surface of the paper.)

Mary Bauermeister in Figure 135 has created value shapes by density, or closeness, of lines and by pressure exerted on the drawing tool. The busy, complex design is activated by short, squiggly lines

134. Robert Straight. *Crossfire.* 1974. Pastel and mixed media, 27 × 40″ (68 × 102 cm). Location unknown.

135. Mary Bauermeister. *Drawing No. 16, Three Pergaments.* 1964. Ink and collage, 19½ × 23½" (50 × 60 cm). Courtesy Galeria Bonino, New York.

136. Georges Seurat. *Ensemble* (study for *La Parade*). 1887. Pen and ink, 5 × 7⅜" (13 × 19 cm). Courtesy Sotheby's, London.

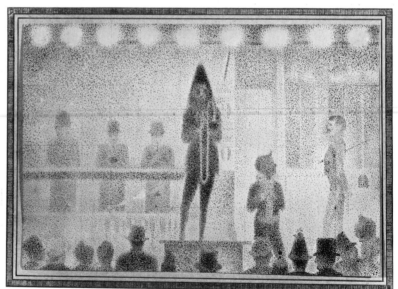

that congregate as if by some magnetic force. The darker, heavier, less electrically charged lines stabilize and quieten the otherwise fractured surface.

A drawing may be exclusively tonal, as in the 19th-century artist Georges Seurat's small drawing for *La Parade* (Figure 136). The subtle value range is a result of brilliant control over the medium. The same texture throughout the confined shapes produces a relatively flat

space. The composition is evocative of an Egyptian frieze with its top and bottom borders; horizontal/vertical format; staggered, rigidly defined levels of space; and frontal disposition of the figures. The theatrical lighting throws the audience in relief while flattening the onstage figures.

Other examples of all tonal compositions can be found in Figures 113 and 143. Both Carter and James Casebere make use of strict, stripped-down, unmodulated value with no textural embellishment; shape and value relay the intent of light and volume.

Tonal quality can also be made by smudging, by rubbing and erasing, or by washes made with wet media. In the Robert Rauschenberg work (Figure 137), we see a distinctively 20th-century technique of creating value, the use of transfered images from magazines or newspapers. Large areas of wash unify the disparately scaled images and tie the large "Combine," as Rauschenberg labels his transfer pieces, into a cohesive whole.

Tonal variation can also be effectively achieved by stippling. Guillermo Meza uses this technique in his pen-and-ink drawing *Giantess* (Figure 138), in which the figure with its exaggerated forms dwarfs the small island in the background. A powerful plasticity is

137. Robert Rauschenberg. *Untitled (Combine).* 1973. Mixed media, 5 × 2′ (1.52 × .61 m). Collection of the Modern Art Museum of Fort Worth, Museum Purchase, The Benjamin J. Tillar Memorial Trust.

138. Guillermo Meza. *Giantess.* 1941. Pen and ink, $25\frac{5}{8} \times 19\frac{7}{8}''$ (65 × 50 cm). Collection, The Museum of Modern Art, New York. Gift of Edgar Kaufman, Jr.

139. Giorgio Morandi. *Nature Morte au Gros Traits.* 1931. Etching, 9⅝ × 13¼″ (25 × 34 cm). Courtesy Harriet Griffin Gallery, New York.

the result of careful modeling from light to dark. Eye level—the figure is seen from an ant's eye view—is a major contributing factor in establishing scale.

Cross-hatching is another means of creating value. In his still life (Figure 139), Giorgio Morandi constructs an ordered arrangement using cross-hatching. Background and foreground are uniformly cross-hatched, thus flattening the space. The bottles are defined by groups of angled lines, which indicate planar change; the still-life contours are strengthened, and thus flattened, by outline. Morandi's value patterns create an otherworldly effect; the objects seem strangely isolated and lonely.

ARBITRARY USE OF VALUE

Artists sometimes ignore the natural laws of value, such as the way light falls across a form, and use value *arbitrarily*—to create a focal point, to establish balance between parts, to call attention to a particular shape, or otherwise to organize the composition. These uses of value are based both on the artist's intuitive responses and the need to comply with the demands of the design. In other words, arbitrarily stated values are light and dark patterns that differ from local values.

In *Portrait of a Man* (Figure 140) Rico Lebrun focuses attention on the subject's face by use of value. The gestural suggestion of the body with its massive bulging shapes is an intriguing foil to the treatment of the head. Darker, heavier lines, which direct the eye to the head, also carry the message of gravity and weight.

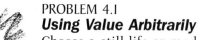

PROBLEM 4.1
Using Value Arbitrarily

Choose a still life or model as your subject, from which you are to make two drawings.

140, left. Rico Lebrun. *Portrait of a Man.* 1939. Ink and chalk. Private collection.

141, below. Arbitrary use of value. Student work. Ink, charcoal, pencil, collage; 15 × 15″ (38 × 38 cm).

In the first drawing fill the page using background shapes. (Remember, continuous overlapping lines will create some repeated shapes.) Using black, white, and two shades of gray, arbitrarily distribute values within the defined shapes. Continue the values to enclose shapes, and keep the values flat, unmodulated. Lead the viewer's eyes through the picture plane by the location of dark shapes. Add grays, establishing a secondary pattern. Base your decisions according to compositional demands rather than on the actual appearance of the subject (Figure 141).

In the second drawing, rather than using only flat shapes and values, model some of the shapes to give them a more volumetric appearance. Again you can direct the eyes of the viewer through the

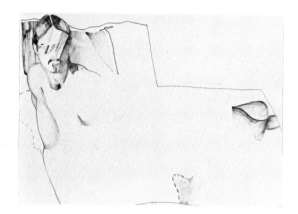

142. Flat shapes and modeled value. Student work. Pencil, 18 × 24″ (46 × 61 cm).

picture plane by the distribution of these modeled areas. You should have a major focal point and minor focal areas. A combination of flat shapes and modeled volumes in the same drawing results in ambiguous space (Figure 142).

DESCRIPTIVE USES OF VALUE

Value can be used to describe objects in physical terms of structure, weight, light, and space.

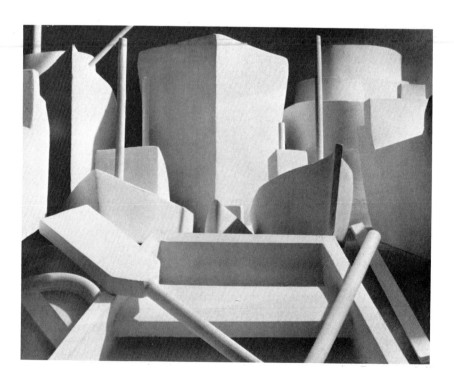

143. James Casabere. *Boats.* 1980. Black and white photograph, 16 × 20″ (41 × 51 cm). Courtesy Michael Klein Inc., New York.

Value Used to Describe Structure

Value can describe the structure, or planar makeup, of an object. Light reveals structure, but values can be distributed according to an analysis of an object's planes; that is, value describing structure need not depend on the natural laws of light. In James Casebere's photograph (Figure 143), the planar structure is pronounced. Light does, in fact, make a differentiation between adjoining planes. There is, however, more than one light source, one from the upper right and another from the lower right.

PROBLEM 4.2
Using Value to Describe Structure
In this drawing you are to reduce the figure to two values—black and white—and to two basic planes—front and side. Carefully examine the figure to determine where head, arms, legs, and upper and lower torso face you and exactly where these forms turn away from you at a 90-degree angle. In other words, imagine the figure to be composed of only two planes, front and side. Draw a line separating the planes, placing a flat value within the planes that recede, leaving the rest of the figure white (Figure 144). Here you are using value to describe both the structure of the figure and its recession into space.

144. Planar reduction. Student work. Charcoal, $17\frac{1}{2} \times 8''$ (44 × 20 cm).

PROBLEM 4.3
Using Value to Describe Planes
Use a skull or head as subject and make a drawing that emphasizes the planar aspects. Do you remember the drawings on planar analysis in Chapter 3? In this drawing you are to group lines within the planes to create value. A change of line direction indicates a change of plane. Make your marks change directions just as the planes change. Make the strokes run vertically for those that are parallel to you and diagonally for those planes that turn into space. This change in direction will emphasize the juncture of planes and will be more illusionistically dimensional than the drawing in the preceding problem (Figure 145).

Value Used to Describe Weight

The weight, or density, of an object can be defined by value. We sense the pressure of gravity in all objects in real life. The artist frequently enforces this sense by placing darker values at points of greatest pressure or weight or at places where the greatest tension occurs. In Danielle Fagan's conté crayon drawing (Figure 146), the outer edges are fuzzy; the interior forms seem dense and weighty.

145. Value used to describe plane. Student work. Pen and Ink, 15 × 7″ (38 × 18 cm).

146, right. Danielle Fagan. Example of value used to describe weight. 1979. Conté crayon, 18 × 24″ (41 × 61 cm). Collection Sandra Fergason-Taylor.

147, below. Philip Pearlstein. *Female Model on Ladder.* 1976. Sepia wash on paper, 29½ × 41″ (75 × 104 cm). Courtesy Frumkin/ Adams Gallery.

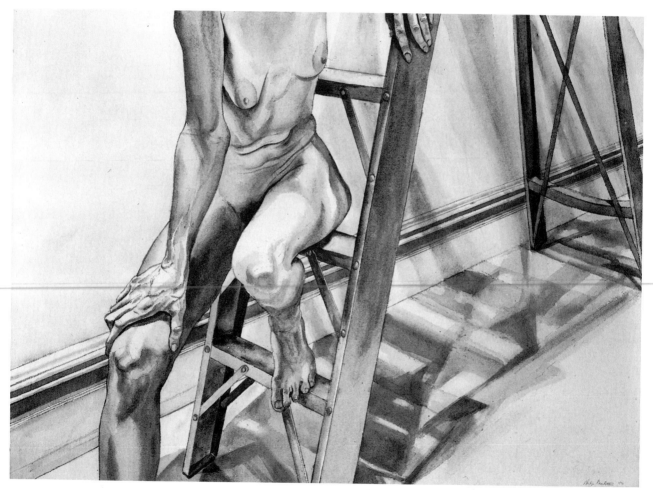

Philip Pearlstein, in his *Female Model on Ladder* (Figure 147), gives volume to the shapes by depicting the effects of light and shadow, which in turn adds to the sense of weight and gravity. Key areas in which a heavy, darker-value line creates the illusion of weight are where the hand presses into the leg, where the thigh spreads on the ladder step, and in the folds of the stomach and the sag

of the breast. There is one area where value could be used to create weight and gravity; the foot of the ladder between the model's legs seems to float. The back foot of the ladder is tied to the floor by the use of value connecting the ladder to its cast shadow.

Now is a good time to introduce an important point: Sometimes one can draw things exactly as they appear, but if the light, arrangement of objects, or point of view are not properly composed, the drawing will look wrong. Sometimes the artist has to change things in the drawing for it to appear visually correct. This license to rearrange and alter is an important lesson for the beginning student to learn. A typical problem area for the artist can be where a background edge intersects a foreground edge, such as at the corner of an object. In his drawing Pearlstein maintains the clarity and separation of the figure, ladder, and baseboard by controlling the intersection of foreground and background shapes. Pearlstein's interest in the structure of the human figure is conceptually fortified by the ladder, with its complex pattern of cast shadows. Figure and ladder are analogous forms; the pose of the model reiterates the triangularity of the ladder shapes. The ladder becomes a visual metaphor for the framework of the figure. The expressive quality of the work is conveyed primarily by means of value—a cool, detached, analytical approach to a figure in an environment. The headless figure reinforces the impersonal theme of model in a studio.

PROBLEM 4.4
Using Value to Describe Weight

Make a first drawing beginning in the imagined center of the figure. Revolve your drawing tool to make a heavy, weighty mass of tangled line, moving outward from the central core. Exaggerate the model's weight; double the mass. The outside edge of the figure should be fuzzy and ill defined, while the center should be darker, as in Figure 148.

148. Value used to describe weight. Student work. Charcoal, 18 × 24″ (46 × 61 cm).

Make a second drawing, again use value to describe weight and mass. Begin exactly as in the first drawing, filling the form from the inside out. As you reach the outer edge of the figure, lighten your marks; then, using a sharper, defined line, make contact with the horizontal contours of the figure as in the cross-contour student study (see Figure 193). Imagine that you are coating the figure with a thin webbing or that you are wrapping it in line, as you would a mummy. As the body's surface changes, so does the line change.

A sculptor who uses this technique to promote a sense of weight and mass in his drawings is Henry Moore (see Figure 176). The drawing entitled *Row of Sleepers* is from a large series of air-raid shelter drawings done during World War II.

In a third drawing the technique will be fingerprint; using black acrylic you are to make a stippled drawing by applying the paint with your thumb. Lightly establish the figure on the page, keeping the initial thumbprints small and widely spaced. After you have lightly laid out the figure in its proper scale, proportion, and placement, begin applying darker, larger prints. Imagine that your paper has depth and that you are applying slabs of clay to an armature. This technique is related to a sculptor building up a mass of clay. Use greater pressure in those areas where you perceive the greatest weight and gravity, creating a buildup of value. Lighten the pressure and use less paint in the areas where weight and gravity do not play a role, such as at the top of the shoulder or the top of the arm. You will be more successful in your depiction of weight if you imagine that you are actually constructing a three-dimensional figure.

Refer to Chapter 1, to the large-scale image of the human face by Chuck Close (see Figure 18). The visual force of the drawing stands in contrast to the intimacy of medium. Close maps the surface variations of his subject using a version of the pointillist technique so closely identified with the Post-Impressionist Georges Seurat.

Value Used to Describe Light

Light falling on an object creates patterns that obey certain rules. If light falls from one direction onto the object, the value patterns created can reveal the structure of the object, its volumetric and its planar aspects; for example, a sphere under a single light source will have an even change in value over its surface. In the graphic arts, modeling—the gradual transition from light to dark to create spatial illusion—is called *chiaroscuro*. This gradual value change can readily be seen in Fagan's still-life drawing in Figure 149.

Cylinders, cones, and organic volumes change gradually from light to dark over their surfaces, while cubes, pyramids, and other angular forms change abruptly from light to dark on their surfaces; that is, their planes are emphasized by light (Figure 150).

Generally light as it falls over a form can be reduced to six categories: highlight, light, shadow, core of shadow, reflected light, and cast shadow (Figure 151). Within a single form or volume we may see parts of it as light against dark and other areas as dark against light.

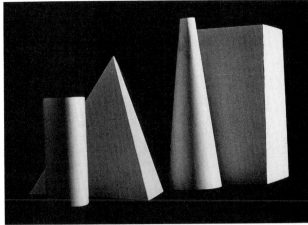

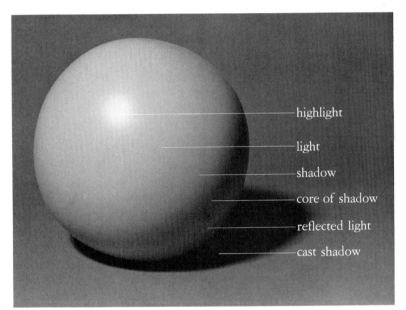

highlight

light

shadow

core of shadow

reflected light

cast shadow

149, above left. Danielle Fagan. Example of value used to describe light. 1979. Conté crayon, 18 × 24″ (46 × 61 cm). Courtesy the artist.

150, above right. Light on rounded and angular forms.

151, left. Six categories of light as it falls over a form.

Some areas may seem to disappear into the background; that is, if a light-valued object is set against a light background, the edge of the object will disappear. Values can cross over both objects and negative space, causing the edge of the object to seem to disappear.

Multiple light sources can result in ambiguous space because the form revealed by one light may be canceled by another. We see this effect in *Raising of Lazarus* (Figure 152) by the realist painter Alfred Leslie. The figure on the left is hit by a strong raking light, creating complex value patterns on the drapery, while the figure on the right is illuminated by two bright sources, one in front, one in back of the figure. This double lighting flattens the wrapped figure and diminishes its volumetric aspect.

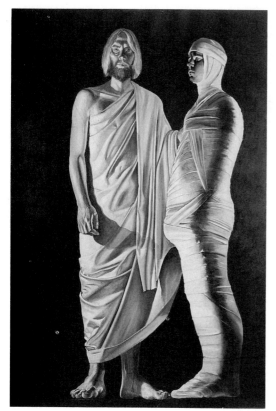

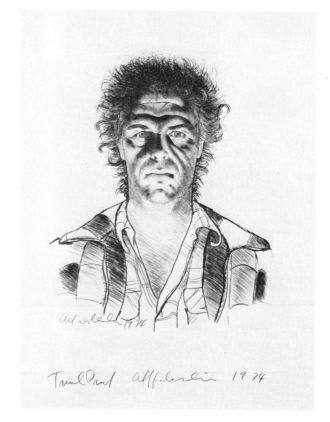

152, left. Alfred Leslie. *Raising of Lazarus.* 1975. Oil on canvas, 9 × 6' (2.74 × 1.83 m). Bayly Art Museum, University of Virginia, Charlottesville.

153, right. Alfred Leslie. *Alfred Leslie.* 1974. Lithograph, 40 × 30" (102 × 76 cm). Published by Landfall Press, Inc., Chicago.

In another work by Leslie, his self-portrait (Figure 153), under-lighting produces striking contrasts, which result in a very different mood from that produced by natural light. There is a sense of drama, even of apprehension, as we view the drawing. This tense effect is gained by Leslie's use of value. The stylized hair and shirt contrast with the visual accuracy of the facial features.

PROBLEM 4.5
Value Reduction

Set up a still life of several objects with nonreflective sur-faces. Study the subject carefully, and on a value scale from one to ten (see Figure 126), find its midpoint value. Squint your eyes to re-duce color effects so that you see only patterns of light and dark. This drawing is to be a value reduction. You are to reduce all values in the subject to either black or white. Note both the actual values of objects and the light patterns on them, and classify these values as either black or white: Values from one to five will be white, from six to ten, black.

Draw the subject lightly in pencil; then use black acrylic or ink to make everything that is darker than the midpoint value a flat, unmodulated black. Erase the pencil lines, leaving the rest of the drawing white. Values will cross over objects and negative space;

value will not necessarily be confined to an object. The finished drawing will be spatially flat, very dramatic, and somewhat abstract (Figure 154).

Make a second drawing again, using only two values to create a high-contrast study. The subject can be invented or taken from memory. Do not draw from direct observation. Aim for an expressive content. Use a medium that can be dissolved by wash, such as a grease pencil and turpentine or pastel and turpentine. In Lydia Martinez's drawing (Figure 155) a grid format is unified by dark values that cross over both figures and negative spaces.

155. Lydia G. Martinez. *Untitled.* 1976. Lithographic crayon with turpentine, 19 × 25″ (48 × 63 cm). Collection of the Artist.

156, left. Value study on toned paper. Student work. Charcoal, 25 × 19″ (64 × 48 cm).

157, above. Light range limited to no more than six values. Student work. Pencil, 19 × 25″ (48 × 64 cm).

PROBLEM 4.6
Four Divisions of Value

Carefully observe the light patterns on a still life. Coat your paper evenly with charcoal of four or five on the value scale (see Figure 126). If necessary go over the paper twice to create a smooth-textured drawing surface.

Choose four divisions of value—the gray of your paper, a darker gray, white, and black. The actual light patterns on the subject will govern your decisions. Try to divide accurately the values in the subject according to the light patterns on it. Indicate the blacks and dark grays with compressed charcoal, and erase the whites with a kneaded eraser. Now begin to model the values. Values should again cross over objects and negative space as in Figure 156.

PROBLEM 4.7
Categories of Light

In this drawing you are to use a value range of six to depict the categories of light referred to in Figure 151. Set up lighting conditions using only one light source, so that you have a highlight, light, shadow, core of shadow, reflected light, and cast shadow. After care-

fully observing the actual light patterns on the still life, make four value scales of six values each, using these techniques: scribbling, stippling, cross-hatching, and making parallel grouped lines. Density, or closeness of marks, and amount of pressure exerted on the tool are the means to value change. Now choose one of the value techniques and draw the still life with six values (Figure 157). Use no more than six values, and make the transitions gradual and smooth; try to match accurately the actual values in the still life in your value scale.

It is taxing to train the eye to see actual patterns of light and dark, but it is a rewarding exercise. Your ability to see will be enhanced, and your power of concentration will be multiplied in doing these problems.

PROBLEM 4.8
Tonal Drawings

Using fruit or vegetables as your subject, make two all-tonal drawings. In the first use a light value scale to organize your drawing as in Figure 158. In the second expand the value scale to include more darks as in Figure 159. In these two student drawings note how within a single form or volume we may see areas as light against dark or as dark against light. In your drawing allow values to cross over both objects and negative space so that occasionally edges seem to disappear.

158, left. Light close value study. Student work. Watercolor, 30 × 30″ (76 × 76 cm).

159, right. Dark value study. Student work. Watercolor, 30 × 30″ (76 × 76 cm).

160. Sharron Antholt. *Tracing a Stranger Self*. 1988. Charcoal on paper, 39 × 56″ (99.1 × 142.2 cm). Courtesy the Artist.

161. Value used to describe space. Student work. Charcoal pencil, 15 × 24″ (38 × 61 cm).

Value Used to Describe Space

As in depicting light, artists may comply with nature to describe space as it actually appears, or they can promote the feeling of space by the use of value. Spatial depiction has many manifestations; there is no single way to indicate space. The handling of space is a result of the artist's view, tempered by culture and personality.

One approach to the depiction of space is to use a progression of values from dark to light or light to dark. In Sharron Antholt's charcoal drawing (Figure 160), we see a depiction of hallways and cells of

a Buddhist monastery, a physical means to a metaphysical purpose. Space and light are used symbolically as metaphors for a world in which *being* takes precedence over *action*. The highly atmospheric work is one of solemnity and sublimity. The spiritual dimension Antholt invokes is a result of a masterful control of value. Perspective and value combine to create a deep sense of space.

PROBLEM 4.9
Using Value to Describe Space

Focus on a spatial progression in a drawing that has three distinct levels of space: foreground, middle ground, background. Keep in mind that you are trying to describe a deep, illusionistic space. In the student drawing (Figure 161) objects on a desk resemble monumental objects in a landscape. This is because of the low eye level and an exaggerated perspective. The sense of space is well developed; the objects seem well established in their positions except for the glass on the left. It is too large for its middle ground placement. The curving desktop directs us to the background space, but the glass blocks this movement. Value is created by a dense overlay of line. Lighting is ambiguous and contributes to our unsettled feeling.

EXPRESSIVE USES OF VALUE

The most exciting aspect of value is its use as a forcefully expressive tool. You have read about the principles of value, the observation of natural appearances, and the way this observation can help you use value. Your attitude as an artist and your intellectual and emotional responses are the primary determinants of how you use value. Actual appearance can be subordinated to expressive interests. Value is a strong determinant in the depiction of emotions. An example is pathos. Striking contrasts of light and dark help to achieve the special *angst* of Howard Warshaw's *Red Man* (Figure 162). Fluid lines and layered washes envelop the somewhat transparent form. This expressive style is in contrast with Ellen Soderquist's gently modeled figure (Figure 163). Here the white paper sets off the tonal gradations of natural light on the smooth skin of the model; the controlled modeling results in a classical detachment. The artist's sensitive eye and confident drawing technique encourages the viewer to inspect the forms closely. A limited high-value range is used for describing the minute anatomical detail; especially important is the white space surrounding the figure. The outer edge of the torso from armpit to hip is implied; the white negative space crosses over into the positive form. By this subtle device, a conceptual contrast is established. Even though the negative space is empty, we interpret the space surrounding the hand to be a deeper space than the space adjacent to the hip. Soderquist's drawing is a good example of the issue of figure/ground relationship. One of the most important distinguishing characteristics of drawing is the way the paper surface, or developed atmosphere

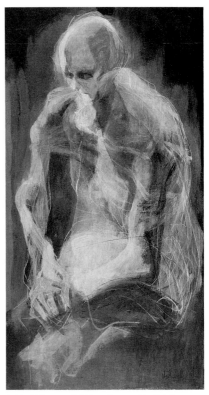

162. Howard Warshaw. *Red Man.* 1967. Acrylic on paper, 5′5″ × 3′ (1.65 × .91 m). Courtesy Francis Warshaw, Carpinteria, California.

163. Ellen Soderquist. *Fragment I: She Went This Way.* 1982. Pencil on paper, 31 × 53″ (78.7 × 134.6 cm). Courtesy the artist.

164. Susan Harrington. *Passim.* 1989. Oil and encaustic on paper, 44 × 30″ (111.8 × 76.2 cm). Courtesy the artist and Barry Whistler Gallery, Dallas.

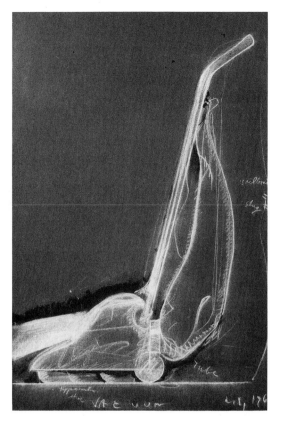

165. Claes Oldenburg. *Plan for Vacuum Cleaner, from Side.* 1964. Chalk and wash on gray paper, 40 × 26″ (102 × 66 cm). Courtesy the artist.

of a drawing, becomes the space out of which the image emerges or, as is the case with the Soderquist drawing, dissolves.

Susan Harrington combines the two extremes of the value scale in her two-part drawing (Figure 164). The space in the upper section is ethereal; the temple/house/structure seems to be precariously balanced, as if on a cloud. On close inspection one detects a faint image of a large reclining figure dissolved into the whiteness of the paper. A tiny figure, schematically drawn and darker than the other images, is placed at the juncture of the divided picture plane and overlapping the reclining figure; it contrasts sharply with the lower half of the drawing, which is aggressively stated. Dark-valued lines create a dense mass, a sort of composite form—is there a kneeling figure on the left? Because of the two value systems in each of the two segments of the drawing, two contradictory kinds of space result—one light and airy, dreamlike, almost a trace of memory; the second one is thick, heavy, and oppressive; it appears to advance menacingly outward toward the viewer. The juxtaposition of the two creates a tremendous tension in the work.

In the two examples just discussed we see the importance of value in creating pictorial space, and we see how that space can be used to expressive ends.

A final look at the way value can create mood is through the use of *value reversal.* This technique creates unusual spatial effects. In Claes Oldenburg's study (Figure 165), the chalk lines defining the

166. Value used subjectively. Student work. Conté crayon. 24 × 18″ (61 × 46 cm).

vacuum cleaner are drawn on a dark ground. This gives the effect of a photographic negative, of space being mysteriously reversed. The commonplace object becomes ghostlike and supernatural. We are presented with an eerie vanishing act.

PROBLEM 4.10
Value Reversal

Using a subject of your choice, make a drawing in which the value patterns are reversed. Draw on either toned paper or on a neutrally colored paper (gray or tan). Some white medium such as conté, crayon, chalk, pastel, or white ink is a good choice. Think in terms of reversing values, using white for black. You can achieve a range of whites by layering washes or by varying the amount of pressure placed on the drawing tool. Try for the effect of a photographic negative as in the Oldenburg drawing (see Figure 165).

The subject of the student drawing in Figure 166 is a machine part seen from close-up; the machine seems to loom, as if in a landscape. The student has not used a true value reversal, but she has used toned paper which, along with somber values and strategically placed whites, contributes to the expressive quality of the drawing.

PROBLEM 4.11
Value Used Subjectively

In this project you are to make a series of related drawings in which you subordinate visual appearances to emotive content. Proj-

167. Value used subjectively. Student work. Charcoal and eraser, 18 × 24″ (46 × 61 cm).

ect a strong feeling onto your subject using a value pattern that will underscore your attitude. In Figure 167 the student has chosen a charged, expressionistic subject, a loaded theme of the embrace of death. The figures are created by interlocking patterns of abstract shape. The heavy, dark outlines lock the figures in place. Value and texture have been forcefully applied: The surface has been erased, smeared, and smudged, an approach that goes hand-in-hand with the heavy theme.

PROBLEM 4.12
Value Used to Create Abstract Patterns

In this project you are to use value to create abstract, nonobjective shapes. Use the same media and techniques in a series of related drawings. We have seen that drawings dealing with nonrecognizable subjects need not lack in expressive content. Formal

168. Value used to create abstract patterns. Student work. Pastel and turpentine, 22 × 30″ (56 × 76 cm).

169. Value used to create abstract patterns. Student work. Pastel and turpentine, 22 × 30″ (56 × 76 cm).

development does not rule out a subjective approach.

Emphasize patterns of light and dark as in the student drawings (Figures 168 and 169). Note how the wash created by turpentine and pastel produces a gradual value transition. The viewer is guided through the picture plane not only by the value patterns but by the attraction of like shapes. You may use any combination of line and tone. Use mixed media to create a rich surface quality.

SUMMARY:
Spatial Characteristics of Value

Of all the art elements, value has the greatest potential for spatial development. When value defines light, structure, weight, or space, it is being used three-dimensionally. A combination of these approaches may result in ambiguous space.

If more than one light source is used, each source may cancel volumetric qualities revealed by another. As a result, the drawing may have a sense of ambiguous space. A combination of flat value and modeled value also produces ambiguous space.

Flat patterns of light and dark confined within a given shape make the space seem shallow. Uniform lines within a shape keep the shape flat. In the same way, a uniformly textured surface pattern has a tendency to flatten.

On the other hand, volumes with gradual transitions from light to dark are seen as three-dimensional. When value defines the edges of planes and these planes behave according to the rules of perspective, the resulting space is illusionistic. Movement from the foreground in a stepped progression of value planes produces a three-dimensional space. Irregular lines to build lights and darks make a drawing more dimensional than do uniform patterns of line.

LINE

5

Drawing is an ideal tool for formative thinking and for idea generation; no element is more suited to this rewarding activity than line. Line can be put to analytical use; it is the ideal means for converting abstract thinking into visual form; no better means can be used for translating the world of three dimensions into a world of two dimensions. And finally, line can be put to the most playful use—everyone enjoys doodling.

We have stressed the figure/ground spatial issue in previous chapters, and we will continue to give concrete problems and discuss specific works that deal with this basic issue throughout the text. Line is a key element in establishing the relationship between the surface of the paper and the emerging or dissolving images on it. Line can be an economical and sophisticated indicator of space.

Frequently line quality is the most indicative element of an artist's style. Line is the one art element that can most easily stand alone to convey the artist's intent. Just an an artist's sensitivity determines the kind of value patterns chosen, an artist's personality is the strongest determinant of the quality of line used. In the last chapter you read how value must be compatible with the feeling and meaning of a work. In the same way, the type of line an artist uses must correspond in character to the basic content and mood of the work.

You have had considerable experience already in using line in problems in the preceding chapters. You have used gestural line, structural line, organizational line, analytical measuring line, directional line, outline, scribbled, tangled, and wrapping lines, continu-

ous overlapping lines, cross-hatched lines, and lines grouped to make value. This chapter deals with line quality, with the ways line can be used both objectively and subjectively as a carrier of meaning.

DETERMINANTS OF LINE QUALITY

A first step in becoming sensitive to line is to recognize the inherent qualities of various linear drawing tools. While materials sometimes can be made to work in ways contrary to their nature, recognizing the advantages and limitations of a medium is an important first step in learning to draw. From everyday experience we are acquainted with some linear tools that move effortlessly to create line: pencil, felt-tip marker, ball-point pen, and pen and ink. And we have used some media that produce a grainy, abrasive line: charcoal, chalk, and conté crayon. China markers and lithographic pencils contain grease and can easily be smudged or dissolved. (See Guide A on materials for further discussion of drawing media.)

The surface on which a line is drawn is another strong determinant of the quality of that line. An example is the comparison between a line drawn on glass and one drawn on brick.

In the print *Dedalus* (Figure 170) by Mimmo Paladino, the lines are incised, or cut, into linoleum and printed. This produces a "negative" line. Instead of the line's lying on the surface there is a reversal in the relationship between the line and its background. The gouged lines vary from the rather flowing line describing the seated figure to the primitively gouged and scratchy lines throughout the composition. Line not only describes edge, but it also furnishes texture and value in the otherwise dark design.

170. Mimmo Paladino. *Dedalus.* 1984. Linocut, 3'2¼" × 4'5¼" (97 × 135 cm), edition of 65. Courtesy Waddington Graphics, London.

The quality of an incised line is different from a painted one; both kinds are found in Vince Falsetta's glazed ceramic cube (Figure 171). The sophisticated black object contrasts with the naïvely drawn, playful two-dimensional images. Each planar face seems randomly composed; however, Falsetta's process is to impose a general structure before beginning to work and only minimally modifying or revising as the work progresses. The cube is subtly tactile; to handle it is like reading braille. Some of the lines are indented, others slightly raised; the splattered paint resembles raised punctuation marks across the surface.

Lines can be created in experimental ways, as in Richard Smith's *tondo,* or round, composition (Figure 172). Smith is an artist whose work crosses over the traditional categories of painting, drawing, and sculpture. He is interested in the spatial positioning of pictorial elements; particularly important are his faceted, shaped picture planes with their joined individual units. Sometimes, as in this work, he employs tying; in other work folds and cuts are used. Smith sees "shaping as a way of drawing"; the linear elements are strings, cuts, and folds. It is interesting to note that Smith uses the analogy of tent- and kite-making in his fabrication of art—both tents and kites have affinity with space.

171. Vince Falsetta. *Untitled.* 1988. Glazed painting on ceramic cube, 10 × 10 × 10″ (25.4 × 25.4 × 25.4 cm). Courtesy of the artist.

172. Richard Smith. *The Late Mister.* 1977. Acrylic on canvas with metal rods and string, 55″ diameter (1.4 m). Courtesy Feigan Inc., New York.

The surface that receives the mark affects the line quality just as does the tool that makes it, so the student must learn to assess both implement and surface. It is difficult, for example, to make a clean, crisp line with pen and ink on newsprint because of the paper's absorbency.

The strongest determinant of line quality, however, is the sensitivity of the artist. An artist's linear style is like handwriting; just as we are able to identify a person's handwriting, familiarity with the artist's style makes the work identifiable. Picasso's subjects, along with his drawing style, make his work easy to recognize (see Figure 22).

Another artist whose line quality is a trademark of his style is Henri Matisse (Figure 173). In Matisse's distinctive pen-and-ink drawing, the line flows effortlessly across the page. The white ground of the paper is activated by the forms that weave across the surface. Matisse's line is the manifestation of his wish to make art that is as "comfortable as an armchair." He effects a relaxed mood, while at the same time relaying a wealth of information. References to space reverberate throughout the composition: We see a model, her back reflected in a mirror in the background, a door to another room, a window to an outside space, and in the lower right corner a shorthand transcription of the scene just described, an even more abstract handling of space than the dominant composition—and a notation of the artist's hand holding the pen, a reference to yet another space. What a rich source of spatial ideas this single, seemingly simple drawing contains!

173. Henri Matisse. *Nude in the Studio.* 1935. Pen and ink, 17¾ × 22⅜″ (46 × 57 cm). Location unknown.

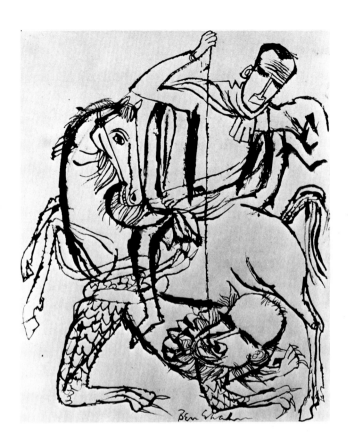

Ben Shahn and George Grosz are 20th-century social commentators with different views of the human condition; their art reflects these differences. Shahn's indignation at injustice is aptly stated by his heavy lines like those of an editorial cartoon. In the brush drawing in Figure 174 he depicts the news analyst Ed Murrow slaying the dragon, McCarthy, the instigator of the communist "witch hunts" in the 1950's. The linear quality is jagged; the figures are likewise contorted. Lines convey the tension of the subject matter. The heroic figure of Murrow contrasts with the scratchily drawn, defeated McCarthy. Exaggerated lines are appropriate for exaggerated commentary.

There are no heroes in Grosz's work (Figure 175). His caustic accusations are conveyed by his crabbed line. The dominant "willful possessors" fill the composition, crowding out the common people. Disparity in size (note the difference in scale between the crippled veteran and the bankers in the foreground) and disparity in line quality (in the depiction of the "bad guys" and "good guys") are extreme. The child is insubstantial, the table edge cuts through its foot, rendering its form transparent. The regimentation of society is shown in the geometric, severely ordered cityscape. Even the background figures are statically placed along a horizontal/vertical axis. The idea of a world gone askew is reinforced by the angularity of the three figures at the table. Grosz's subjects do not invoke sympathy; indeed, he presents them for condemnation.

174, left. Ben Shahn. *Ed Murrow Slaying the Dragon of McCarthy.* 1955. Brush drawing, 12¼ × 9½″ (31 × 24 cm). Location unknown.

175, right. George Grosz. *Exploiters of the People* from the series for *The Robbers* by Friedrich von Schiller. 1922. Lithograph. Print Collection, The New York Public Library, Astor, Lennox and Tilden Foundations.

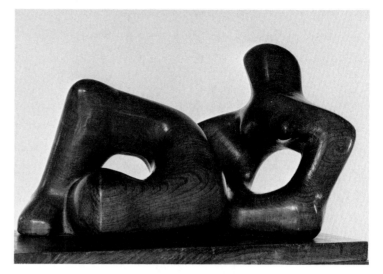

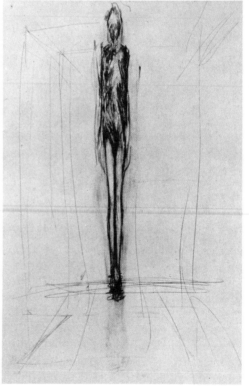

176, above. Henry Moore. *Row of Sleepers.* 1941. Pencil, wax crayon, watercolor wash, pen and black ink, $21\frac{1}{4} \times 12\frac{5}{8}''$ (55 × 32 cm). Collection British Council, London.

177, top right. Henry Moore. *Reclining Figure.* 1935–1936. Elm wood, length 42″ (107 cm). Wakefield Museum, Yorkshire, England.

178, near right. Alberto Giacometti. *Standing Female Nude.* 1946. Pencil, $19\frac{5}{8} \times 12\frac{5}{8}''$ (50 × 32 cm). Location unknown.

179, far right. Alberto Giacometti. *Walking Man.* c. 1947–1949. Bronze, height 27″ (69 cm). Hirshhorn Museum and Sculpture Garden, Smithsonian Institution, Washington, D.C.

Both Shahn and Grosz portray passionate convictions, and the linear technique of each artist helps carry his message.

Henry Moore is a contemporary sculptor whose drawings relay the same message as his sculpture. His art explores the idea of weight and mass (Figures 176 and 177). Moore's subjects are connected to the earth from which they seem to emerge. His drawings are studies in the sculptural aspects of a form; his line feels around the volumes,

encasing them as if they were cocoons. His figures, both sculpted and drawn, have a roundness and solidarity that makes them resemble mountains. They are in sharp contrast to Alberto Giacometti's weightless figures (Figures 178 and 179).

Giacometti's analytical, nearly transparent line drawing is in complete accord with his sculpture. His sculpture, unlike Moore's, is linear; in both drawings and sculpture he makes use of attenuated line. Space penetrates and diminishes his subjects, unlike Moore's sculptures, where even the voids seem substantial. We see the same ideas operative in both drawing and sculpture.

Artists from prehistoric times to the present have left a rich storehouse of various types of line. Remember the vital line quality in the paleolithic painting in Chapter 1 (see Figure 1). In contemporary art a reinvigorated use of line has been introduced. The mute scribbles in Antoni Tápies's mixed media work *Lit Noir (Black Bed)* (Figure 180) and the lines resembling those generated by a computer in Victor Newsome's drawing (Figure 181) are two examples.

180, left. Antoni Tápies. *Lit Noir.* 1989. Mixed media on canvas, 78 × 118″ (200 × 300 cm). Courtesy Galerie Lelong, Paris.

181, below left. Victor Newsome. *Untitled.* Pencil and ink on paper, $13\frac{1}{2} \times 17\frac{1}{4}''$ (34.3 × 43.8 cm). Foundation Collection, Arkansas Art Center, Little Rock.

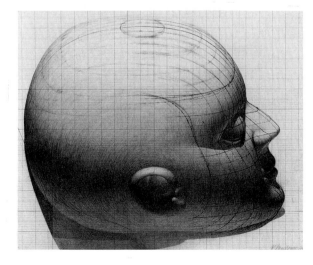

Let us look at some uses of line peculiar to art in the past quarter of the century. Minimalist artists such as Sol Lewitt focus on reductive means. Their work is a *deflation* of art activity. Art is stripped down with a concentration of one or two of the elements that go into its making. Lewitt is particularly important to our discussion of line because his works are pared down to this prime element. His work has no literary focus; it is reductive, intellectual, and analytical in character. He, like other Process artists, establishes a process, a procedure, laying down rules for the execution of the art piece. He conceptualizes the organization of the work, follows his own preset directions. We might call his finished pieces responses to simple commands. Artists such as Lewitt see this conceptualized approach as a viable organizational factor equal to, if not superior to, traditional visual, pictorial means of composing a work of art. In Process Art the viewer is able to recreate intellectually the process or action that went into the making of the work. Lewitt's title, *Wall Drawing— Part-Two with Ten Thousand Lines 12" Long* (Figure 182), sums up the entire process. Actually, anyone could carry out the instructions; it is not required that the artist actually execute the work. The work is finished when the instructions have been carried out. Yet the work, like Lewitt's, may have a visual presence that is elegant in its clarity.

Artists who occupy the extreme opposite end of the scale from the Minimalists come from the Neo-Naïve, Bad Painting, and New Imagist styles. Their work is often characterized by crude figuration and expressionistic handling—they reject accepted norms of the

182. Sol LeWitt. *Wall Drawing Part Two with Ten Thousand Lines 12" Long* (detail). 1971. Graphite on wall, entire work 9'4" × 46'8" (2.84 × 14.22 m). Courtesy John Weber Gallery, New York.

183, left. Jonathan Borofsky. *Stick Man.* 1983. 4-color lithograph, 4'4½" × 3'1¾" (134 × 96 cm). Courtesy Gemini G.E.L., Los Angeles.

184, right. Richard Diebenkorn. *Untitled.* 1070. Charcoal, 25 × 18" (64 × 46 cm). Courtesy M. Knoedler & Co., New York.

"right" way to paint or draw. Jonathan Borofsky's work (Figure 183) exemplifies one approach; his images frequently derive from dreams and appear in tandem with serial numbers. Borofsky says he continues his obsessive counting to provide a conceptual unity to his varied works.

Line is an indispensable element whether used abstractly, as in the Modernist work by Richard Diebenkorn (Figure 184), or to depict recognizable subject matter, as in the Post-Modernist piece by Al Souza (Figure 185). Diebenkorn uses a taut line to divide the picture plane asymmetrically. This linear pattern holds the field in tension; both lines and shapes seem to push and pull inward and outward at the same time. Diebenkorn's imagery developed from landscape, moved to abstraction, and presently deals with nonobjective forms.

A technique that has found much favor with Post-Modernist artists is that of overlaid images. In Souza's work *Arc de Triomphe* we see three separate overlays: the golf players, the rocking chair, and a series of tree limbs. It is impossible to assign a definite location in space for all three layers, although the golf scene forms a field for the other images. The images are not integrated by color, by style, or by

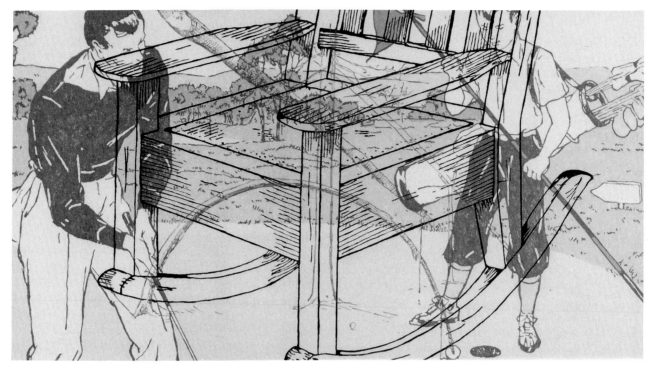

185. Al Souza. *Arc de Triomphe.* 1986. Oil on canvas, $22\frac{1}{2}'' \times 41''$ (57.2 × 104.1 cm). Courtesy the artist and Barry Whistler Gallery, Dallas.

scale. This overlaying of images runs counter to normal ways of representing objects and the space they occupy. It is a distinctive innovation of the Post-Modernists.

In the last two decades of the century, line seems to have been given an even more important role in artists' development of space. We have seen how adaptable line is in conveying ideas and how suited line is for generating intellectual and visual thinking. Now let us begin our investigation of the many types of line available to the artist.

TYPES OF LINE

We have looked at only a few of the many functions of line. In our study of line we will categorize some line types and learn to use as well as recognize them in other artists' work. A reminder: Seldom does an artist confine the use of line to one particular type. This statement is attested to by William T. Wiley's humorous drawing (Figure 186). Wylie, with his tongue-in-cheek drawing, even points out the role of line for an artist with a sign in the upper left of the drawing: "Suite out a line, sweet out a line" (Sweet Adeline). Wylie's works are filled with both visual and verbal puns. His dual roles as artist/magician and artist/dunce are favorite ones.

Contour Line

Chapter 2 discussed basic approaches to drawing. As you may recall, in contrast to the quick, immediate gestural approach, which sees forms in their wholeness, is the slower, more intense contour approach. Contour involves an inspection of the parts as they make up the whole. Contour, unlike outline, is spatially descriptive. It is plastic, emphasizing the three-dimensionality of a form.

Juan Gris's *Portrait of Max Jacob* (Figure 187) is a masterly use of contour; every line is fluently drawn. Slow and accurate observation is the key. The composition is subtly unified by a sidewise figure-eight shape; the clasped hands find their echoes in the bow tie and in the eyes. The form builds from the hands to the head. The geometric framework of a background shape interrupts further upward movement. The lightly stated, sensitive curve of the head directs us back to the ears, where yet another set of curving lines leads us to the tie; the V of the vest points to the hands. We are again at our starting point.

Not only is the composition contained; we feel that the sitter himself is self-contained. Contour line is here used to describe change of plane, change of texture (between shirt, vest, coat, for example),

186, left. William T. Wiley. *Mr. Unatural Eyes the Ape Run Ledge.* 1975. Colored pencil and wax on paper, 36 × 28¾″ (91 × 73 cm). Collection Roberta and Nancy Mollers, Chicago and Houston.

187, right. Juan Gris. *Portrait of Max Jacob.* 1919. Pencil, 14⅜ × 10½″ (36.5 × 26.7 cm). Collection, The Museum of Modern Art, New York. Gift of James Thrall Soby.

188, above. Juan Gris. *Personnage Assis.* 1920. Pencil on paper, 13½ × 10⅝″ (34.3 × 27 cm). Foundation Collection, Tabriz Fund, 1987, The Arkansas Art Center, Little Rock.

189, right. Slow contour. Student work. Pencil, 24 × 18″ (61 × 46 cm).

change of value (note the ridge line of the nose), change of color (between eye and pupil). This pure contour has been drawn with sensitivity and precision. Gris has used a contour of varying width. Heavier, darker lines create accents (usually where the line changes direction the mark is darker); lighter lines describe the less dominant interior forms.

Not all contour drawings are drawn from life, however. An interesting pairing with the portrait of Max Jacob (see Figure 187) is another Gris drawing, the abstracted, mental construct *Personnage Assis (Seated Person)* (Figure 188). In the first drawing Gris used intermittent dark lines; in the second one, the darker lines are not accents; in fact, they play the dominant role in the composition, and, spatially, they set up a series of interchanging foreground, middle ground, background planes. It would be impossible to assess a definite location for nearly any shape in the drawing. It reminds us once again of that ever-present issue in drawing: figure/ground relationships.

Five variations of contour line will be discussed: slow, exaggerated, quick, cross-contour, and contour with tone. The same general instructions given in Chapter 2 for blind contour are applicable for all types of contour. For review here are the steps in contour drawing:

1. Use a sharp-pointed implement (such as a 2B pencil or pen and ink).
2. Keep your eyes on the subject you are drawing.
3. Imagine that the point of your drawing tool is in actual contact with the subject.
4. Do not let your eyes move more quickly than you can draw.
5. Keep your implement in constant contact with the paper until you come to the end of a form.
6. Keep your eye and hand coordinated.
7. You may begin at the outside edge of your subject, but when you see that line turn inward, follow it to its end.
8. Draw only where there is an actual, structural plane shift or where there is a change in value, texture, or color.
9. Do not enter the interior form and draw nonexistent planes or make meaningless lines.
10. Do not worry about distorted or inaccurate proportions; they will improve after a number of sessions dedicated to contour.
11. Use a single, incisive line.
12. Do not retrace already stated lines, and do not erase for correction.
13. Keep in mind line variation in weight, width, and contrast.
14. Keep the drawings open and connected to the ground.
15. Draw a little bit of everything before you draw everything of anything.

PROBLEM 5.1
Slow Contour

Using a plant or figure as subject, begin on the outside edge of the form. Where the line joins with another line or where the line turns inward, follow, imagining that you are actually touching the object being drawn. Exactly coordinate eye and hand. Do not look at your paper. You may only glance briefly for realignment when you have come to the end of a form. Do not trace over already stated lines. Draw slowly; search for details. Try to convey spatial quality through variation in pressure and in width of line. Make several drawings, spending as much as an hour on a single drawing. With practice your drawings will be accurate in proportion and detail (Figure 189).

If you find a particularly worrisome area, skip to the bottom or top of the paper, and isolate an extended study of the problem area.

Line width and variation have been mentioned throughout the book. In a second drawing, experiment with different found implements, creating contour line of various widths by turning the implement as you draw and by changing pressure on the implement. Keep in mind the spatial differentiation that comes from the use of thick and thin, dark and light lines. Note that a line of varying width is generally more subjective than a line of maintained, or unvarying, width. Make two slow-contour drawings, one in which you keep the line the same all along its length, and another in which you vary the line. The manner in which an artist varies the line is very personal; the line quality will change from artist to artist.

190. Exaggerated contour. Student work. Pen and ink, 36 × 18″ (91.4 × 45.7 cm).

PROBLEM 5.2
Exaggerated Contour

In the blind contour line exercises in Chapter 2 you were warned to avoid intentional distortion. Exaggerated contour line takes advantage of these distortions. It even intentionally *promotes* them (Figure 190).

Your subject in this problem is a model standing or seated on a high stool. Lightly dampen your paper before you begin to draw. Use pen and ink. Begin by drawing the feet of the model. Use a contour line. Draw until you have reached the middle of the page (you should be at knee level on the figure). Now you must radically reduce the scale of the figure in order to fit it in the remaining space. The resulting drawing will look like an ant's-eye view. There should be a monumental feeling to the figure. Note the different kind of line quality that is a result of the dampened paper. You will have a darker line along those forms where you exerted more pressure or where you have lingered, waiting to draw. This line of varying width is one you should intentionally employ from time to time.

191. Quick contour. Student work. Charcoal pencil, 24 × 18″ (61 × 46 cm).

PROBLEM 5.3
Quick Contour

The quick contour line technique is a variation of basic contour drawing. It requires less time than the more sustained contour drawing, and you may look at your drawing more frequently than in a slow contour. The inspection of forms, however, is just as intense. Quick contour drawing might be considered a shorthand version of slow contour drawing. A single, incisive line is still the goal; however, the movement of the line is faster, less determined. In quick contour drawing you are trying to catch the essence of the subject.

In the student drawing (Figure 191) note the speed with which the figure was drawn. Hands and glasses seem to have been drawn more slowly and deliberately, while the lines describing the shoulder were drawn more quickly. No doubt that area of figure was less interesting to the student, while the complex areas of hand and eyes were more challenging. Note also the lines of varying width and how they seem to give a spatial feeling to the drawing that would be absent in a contour line of maintained width.

Make several quick contour drawings. Experiment with different media, keeping in mind the importance of a single, precise line. Make several drawings of the same subject; a self-portrait would be a good choice. Begin with a one-minute drawing, then a three-minute one, then a five-minute drawing.

192, right. Cross-contour. Student work. Ink, 24 × 18″ (61 × 71 cm).

193, below left. Cross-contour. Student work. Charcoal and chalk, 24 × 18″ (61 × 46 cm).

194, below right. Contour with tone. Student work. Charcoal pencil, 24 × 18″ (61 × 46 cm).

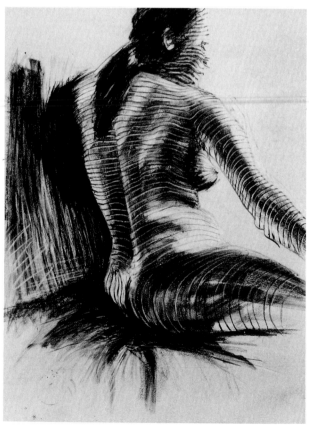

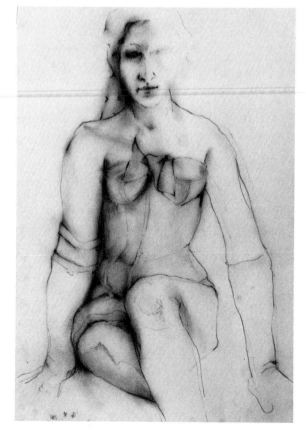

PROBLEM 5.4
Cross-Contour

Cross-contour lines describe an object's horizontal contours, or cross-contours, rather than its vertical edges. They emphasize an object's turn into space. You are familiar with contour maps which describe the earth's land surface. Henry Moore's air-raid shelter drawings are excellent examples of this technique (see Figure 176).

Draw a draped fabric. Keep your implement continuously in contact with the surface of your paper. Carefully observe the drapery's cross-contours and indicate accurately its undulating shape (Figure 192). By grouping the cross-contour lines more closely, you can control the value changes across the form.

The cross-contour line technique is particularly effective for teaching yourself to see the complex spatial changes that occur across a figure. Repeat the problem using a model; imagine that the line is a thread that wraps the shape horizontally, encasing its mass (Figure 193). Another recommended exercise is making detailed cross-contour studies of legs, arms, front torso, back torso.

Notice the interweaving of horizontal and vertical threads in Newsome's drawing (see Figure 181).

PROBLEM 5.5
Contour with Tone

After you have mastered the art of contour drawing, you can add value or tone. Be selective in your placement of value. In the student drawing (Figure 194) value is used to indicate the figure's turn into space and to indicate light source. Make a drawing that is primarily contour; add value for focal development.

Mechanical Line

Mechanical line is an objective, nonpersonal line that maintains the same width along its full length. An example would be an architect's ground plan in which various lines indicated different materials or levels of space.

Steve Gianakos uses a number of drafting techniques in his work (Figure 195). The carefully plotted arcs and angles are structurally meaningless; however, they do seem to make some tongue-in-cheek remark on architectural drawings. The gorillas have satirical, autobiographical significance for Gianakos, who studied industrial design. Note the mechanical application of line; each individual line is unvarying, deliberate, and controlled.

PROBLEM 5.6
Using Mechanical Line

Draw multiple views of an object—top, bottom, sides—using mechanical line. You may keep the views separate, or you may overlap and superimpose them. Keeping in mind that mechanical line

195. Steve Gianakos. *Gorillas #10.*
1983. Ink and colored pencil on
paper, 3′4″ × 5′ (1.02 × 1.52 m).
Courtesy Barbara Toll Fine Arts,
New York.

196. Jacques Villon (French, 1875–
1963). *Baudelaire on a Pedestal*
(Baudelaire avec Socle). 1920.
Etching, $16\frac{1}{4}$ × 11″ (41.5 × 28.1 cm).
Gift of Mr. and Mrs. Frank B.
Hubachek, 1974. 266. Photograph ©
1990, The Art Institute of Chicago.
All Rights Reserved.

remains the same throughout its length, use a drawing tool that will produce this kind of mark, such as pencil, felt-tip marker, ball-point pen, or lettering pen.

Structural Line

Structural lines indicate plane direction and reveal planar structure. Structural lines build volume and create a three-dimensional effect. Although a drawing can be made using only structural lines, these lines are usually found in combination with either organizational line or contour line. Structural lines can be grouped and are then perceived as value.

Jacques Villon's *Baudelaire avec Socle* (Figure 196) is based on sculpture. Villon enhances the three-dimensional effect by a buildup of planes. The background is flattened out by an overall texture and is further flattened by intersecting horizontal and vertical lines. The head is set at an angle, and the structural lines are also set at angles to each other. The empty white base and blank table are in contrast with the complex planar analysis.

Structural line can also be put to more abstract use as in Marcel Duchamp's pencil-and-wash drawing (Figure 197). Here an idea of simultaneity and sequential motion is conveyed by the use of structural and diagrammatic line. Change, the recurring theme of this highly esteemed artist, is given graphic form.

PROBLEM 5.7
Using Structural Line
Make several hand studies using structural lines to indicate the changes of planes, to create values, and to build volume. You can use parallel lines, cross-hatching, or grouped contour lines as in the

197. Marcel Duchamp. *La Mariée Mise A Nu Par Ses Celibataires.* 1912. Pencil and wash, $9\frac{3}{8} \times 12\frac{5}{8}''$ (23.8 × 32.1 cm). Musee National d'Art Moderne, Paris.

finished student drawing (Figure 198). Values can be created by a weighted line or by more densely grouped lines.

Lyrical Line

Pierre Bonnard, Edouard Vuillard, Henri Matisse, and Raoul Dufy are some artists who use lyrical, decorative line. Lyrical lines are like arabesques; they can be ornately intertwined or flow gracefully across the page. Contour line and decorative line can be combined to produce a lyrical mood, as in Dufy's relaxed drawing on canvas entitled *The Yellow Violin* (Figure 199). The viewer is presented with two kinds of space: The music and the frame behind it define a wall parallel to the picture plane, while the tabletop is seen from an extreme, high level. Space seems compressed at the bottom of the picture plane with the heavy, bulging table teetering precariously on its tiny,

198, above. Structural line. Student work. Pencil, 18 × 24″ (46 × 61 cm).

199, right. Raoul Dufy. *The Yellow Violin*. 1949. Oil on canvas, 39½ × 32″ (100 × 81 cm). Art Gallery of Ontario, gift of Sam and Ayala Zacks, 1970.

balled feet. This point of view makes us feel giddy, lighthearted; it reinforces a mood of lightness and gaiety. The repeating curvilinear line establishes a rhythmic pattern, fitting for the musical theme.

Generally, the more deliberately controlled a line, the more objective it is. The more spontaneously a line is stated, the more subjective it is. Lyrical line falls under the subjective category and is characterized by sensitivity of expression.

PROBLEM 5.8
Using Lyrical Line

Choose a room interior as subject of a lyrical drawing. Create decorative linear patterns, using a free-flowing implement: either brush and ink, or pen and ink. Try drawing in time to music. The goal is spontaneity. Take a playful, relaxed attitude.

Constricted, Aggressive Line

A constricted line makes use of angular, crabbed, assertive marks. Such marks are aggressively stated. They may be ugly and scratchy, carriers of a bitter expression; they can convey the feeling of tension (see Figures 174 and 175).

PROBLEM 5.9
Using Constricted, Aggressive Line

An incised line is a good choice for this problem, as cutting or scraping can be aggressive acts. Note the abused surface and rugged line quality in Jean Dubuffet's drawing (Figure 200). The images are scratched into the surface, a technique called *grattage*. Dubuffet's line quality is at one with his primitive intent.

For this drawing, you may use black scratchboard (a clay-coated, prepared paper), or you may coat a piece of bristol board with a layer of gesso over which you then apply a coat of black ink. The drawing implements can be a collection of found objects or discarded drawing tools, such as old pens, palette knives, or mat knives. Razor blades can also be used as scrapers; any sharp implement will serve.

Draw a scene that depicts a situation toward which you feel great antipathy. Use constricted, aggressive lines to convey a strong, negative feeling. Aim for a drawing style and a line quality that will underscore a bitter message.

Handwriting: Cursive and Calligraphic Line

Calligraphy, or handwriting, is highly developed in Eastern art. Calligraphic line makes use of a free-flowing, continuous movement. In Masami Teraoka's watercolor (see Figure 28), the inserts in the upper right and lower left are filled with calligraphy drawn with ink and brush. Instrument, media, surface, and technique all have special importance in calligraphy. The technique is related to gesture; the

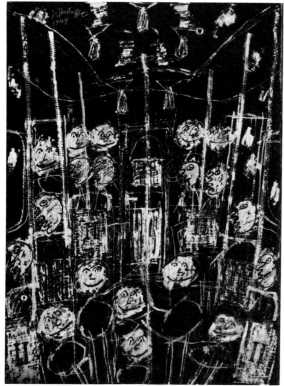

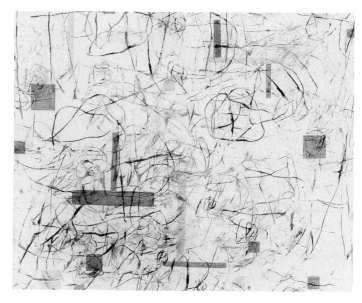

200, left. Jean Dubuffet. *Subway.* 1949. Incised ink on gesso on cardboard, 12⅝ × 9⅞″ (32.1 × 23.5 cm). Collection, The Museum of Modern Art, New York. The Joan and Lester Avnet Collection.

201, right. Louisa Chase. *Untitled.* 1987. Oil on canvas, 78 × 84″ (1.98 × 2.13 m). Courtesy Brooke Alexander, New York.

variations of the line encompass the full range from bold to delicate, from thick to thin, and they are sweepingly graceful.

Louisa Chase's indecipherable marks are not legible even on close examination (Figure 201). The handwriting makes the work evocative and enigmatic. The rigid geometric forms seem to be pushed back into the picture plane. Mute scribbles impose a diametrically different order from the primary-colored shapes in their well-conceived placement (see Cover for color detail). It is as if something had gone awry in a Piet Mondrian painting (see Figure 35). We could be witnessing a graffiti attack on a modern Purist work.

Mark Tobey, an American artist, was greatly influenced by Eastern calligraphy and adapted the technique to his linear intertwinings (Figure 202). He called these overall textural patterns "white writing." An unusual spatial ambiguity is found in his work due to the shift of scale in the layers of writing and also the change in medium in the central section and frame or border. An interesting question arises: Is the lighter section on top of or behind the black border? Tobey's writings are "a diary of a human hand," a provocative revelation.

A large number of contemporary artists combine word and image; the relationship between the visual arts and literature is long standing. Artists' interest in words manifests itself in a variety of forms. Some artists use words in a narrative context; others, such as Claudia Betti, use found texts to generate ideas and images

202, left. Mark Tobey. *Remote Field.* 1944. Tempera, pencil and ink on cardboard, 28½ × 30⅛" (71.4 × 76.5 cm). Collection, The Museum of Modern Art, New York. Gift of Mr. and Mrs. Jan de Graff.

203, right. Claudia Betti. *The Origins* from *The Second Mexico Series.* 1986. Mixed Media, 6 × 8" image on 22 × 30" stonehenge paper. Collection of the artist.

(Figure 203). Betti began her drawing entitled *Origins* with a translated text—translated from the Popol Vuh, an ancient Mayan account of the creation of the world. (The poem begins: "Let there be light!") The first layer of written words is in Spanish; two separate English translations are overlaid onto the Spanish, and then Betti begins to obliterate the text, allowing new shapes to take form. These shapes are analogous to a world in flux; the words break out of their confining, rectangular format. The resulting image is like a palimpsest, a document that has been written upon several times, remnants of this kind being a major source for the recovery of lost works from antiquity. In the original, Betti centralized the small image on a larger piece of paper. The distance between viewer and art is thus compressed and more intimate than if the image were larger, requiring a more distant viewing space.

PROBLEM 5.10
Using Handwriting or Calligraphic Line
Practice writing with ink and a bamboo-handled Japanese brush. Hold the pen near the end, away from the brush, and at a 90-degree angle to the paper. (Your paper should be on a horizontal surface.) Change scale, making the transitions of the marks gradual and graceful. Apply different amounts of pressure to create flowing

204. David Hockney. *Celia-Inquiring.* 1079. Lithograph, 40 × 29″ (101.6 × 73.7 cm). © Gemini G.E.L., Los Angeles, California.

motions. Turn the brush between your fingers as you write. Experiment with the way you hold the brush and with the amount of ink loaded onto the brush.

After you have practiced and have the medium under some control, make a composition using written words, layering them; obscuring their legibility, only occasionally allowing them to be read. Choose a text that is appealing to you—a poem, a passage from a novel, or your own, original writing.

To differentiate the layers, you may want to use black, white, and sepia ink on a light gray or buff-colored paper. Or you may tone your paper with a light-valued wash before beginning to write. (Note the layered effect in the center of Tobey's drawing.)

Implied Line

An implied line is one that stops and picks up again. It is a broken contour; the viewer conceptually fills in the breaks. We discussed implied shape in Chapter 3. Refer again to the Baskin drawing (see Figure 90) to freshen your memory.

In David Hockney's print (Figure 204), the artist makes use of a fragmented, or implied, line. This approach is more concentrated in the lower half of the drawing where hand, dress, and chair dissolve

into a series of accent marks. The individual shapes are not clearly defined. Hockney makes use of a weighted broken contour.

Implied line results in an interchange between positive and negative shapes. It brings the negative space into the implied positive shapes, creating spatial ambiguity. This lost-and-found line requires a viewer's participation since line and shape must be filled in mentally.

PROBLEM 5.11
Using Implied Line

Choose a still life as subject for an implied-line drawing. Alternate drawing between the left and right side of the still life; leave the opposite side empty. Create implied shapes. Be conscious of the pressure on your drawing tool, lightening the pressure as the line begins to break. The lines should change from light to dark along their length. Use a minimal amount of line to suggest or imply shape.

Blurred Line

Blurred lines are smudged, erased, or destroyed in some way, either by rubbing or by erasure. They are frequently grouped to form a sliding edge; they are not as precisely stated as implied lines. Blurred and smudged lines are much favored by present-day artists because they create an indefinite edge, thereby resulting in an ambiguous space.

Marcia Isaacson in *Bellsmith's Family Members* (Figure 205) uses blurred and erased lines to build the connected forms of the woman and dog. The lines that are grouped in a single direction create a

205. Marcia Isaacson. *Bellsmith's Family Members.* Pencil on paper, 29¼ × 41½″ (74 × 105 cm). Minnesota Museum of Art, Saint Paul.

206. Willem de Kooning. *Woman.* 1952. Pastel and pencil, 21 × 14″ (52 × 36 cm). Private collection, Boston.

volumetric buildup. At the edge where two forms meet, Isaacson uses erasure. The blurred lines serve to tie the two figures together and create a spatial ambiguity between the woman and the dog. The insistently drawn pencil lines contrast with the accurately rendered focal point of the woman's face. It is confusing as to which figure is in front and which recedes. Not only do we sense a spatial ambiguity between woman and dog, we also feel at loss as to how to interpret the family relationship suggested in the title of the drawing.

We have mentioned several artists who have a distinctive line quality, a signature by which we recognize the artist. The Abstract Expressionist Willem de Kooning is one such artist. Blurred, erased, repeated gestural marks signify his work (Figure 206). He creates a spatial ambiguity through a textural surface of built-up and erased line in both his drawings and paintings. His style gives us a strong clue as to why the Abstract Expressionists were called Action Painters. De Kooning's technique is extremely subjective; the richness and ambiguity of women is a continuing theme in his art.

PROBLEM 5.12
Using Blurred Line

With a soft pencil and a white plastic eraser make a drawing in which you use blurred, smudged, and erased line. Use the eraser as a drawing tool, making sweeping motions that go counter to the pencil marks. Erase and blur the already established lines. Alternately redraw and erase until the drawing is finished. You might choose a single object and repeat it several times as in Figure 207. The student chose recognizable objects (ribbons and a box of tissues), but the final result seems quite abstract.

A toned ground is a good surface for a blurred-line drawing. Develop clusters of line (using both erasure and lines created by charcoal or conté crayon) where the forms converge. By this means the positive and negative shapes will merge; the positive shapes will dissolve into the ground of the toned paper. Allow some of the connections to be implied. You might compose your drawing so that a light, positive shape adjoins a light, negative shape; a dark, positive shape adjoins a dark, negative shape. This will ensure an ambiguity of edge. This problem is related to our discussion of implied line and shape.

207. Erased and blurred line. Student work. Pencil, 12 × 10″ (30 × 25 cm).

SUMMARY:
Spatial Characteristics of Line

Although each problem in this chapter has generally been confined to the use of one kind of line, most artists do not limit their line so severely. You should experiment, employing several linear techniques in the same drawing.

Subjective lines are generally more dimensional than objective lines. This is because a subjective line changes width, changes from light to dark, and is more suggestive of space than a flat line of maintained width. Outlining makes shapes appear flat; contour line is more dimensional than outline.

A contour line of varying width and pressure is more dimensional than one of uniform weight. A discontinuous, or broken, line is more spatial than an unvarying one.

When line is stated primarily horizontally and vertically, that is, when it remains parallel to the picture plane, a shallow space results. If, however, lines penetrate the picture plane diagonally, a three-dimensional space is produced. Generally, a buildup of lines is more volumetric than a single line.

If lines are grouped in a single direction to create value, the resulting space is flatter than if the lines are not stated uniformly. Lines that create a repeating pattern of texture make a flatter space than those stated less predictably.

Again a reminder: You must analyze all the lines in a drawing in order to determine the entire spatial effect. Look at the line's spatial characteristics. Is it dark, light, thick, thin? Analyze the line quality in terms of contrast, weight, thickness, and movement, and determine what information concerning edge the line defines.

Finally, line is the most direct means for establishing style. It is, as we have said, as personal as handwriting. And like handwriting it should be practiced, analyzed, and refined throughout your drawing career.

TEXTURE

6

A rt depends on the strong relationship between the senses of sight and touch, between our visual sense and our tactile sense. We can imagine how a surface feels simply by looking at it, and we can also imagine how a surface looks by touching it. This mental sight-and-touch relationship is vital in all the arts, but it is especially important in the graphic arts, where we must rely on visual textures more than on actual tactile ones. Painting and sculpture are far more tactile than the graphic arts.

In art until the mid-19th century, texture was primarily tied to the transcription of local or actual textures of the subject being depicted. In the Renaissance the ideal for a painting was that it be a "window into space"; this meant that brush strokes were disguised; a smooth surface was the goal so that the spatial illusion of a penetration of the picture plane was not disturbed. Surface texture underwent radical change with the Impressionists. In the introduction to space we discussed art's release from its limited function of illusion, and we looked at some examples from this period to see how a uniform texture of broken brush strokes served to flatten forms and to create an ambiguous space.

The 20th century has seen a number of influential developments in artists' use of texture, beginning in the years before World War I, when the Cubists invented the technique of _collage_—the addition of any flat material to the surface of a work. These avant-garde artists also introduced the idea of adding sand and other substances to paint to create a more pronounced surface texture. Other innovations were

followed by the development of the technique of *assemblage* (added dimensional material resulting in either high or low relief). More recently, technology has expanded artists' options for texture, such as transferred and photocopied images. Formal and technical developments in collage and construction have been amplified by contemporary artists. Textural possibilities have been broadened, allowing for a wider range of expressive and material options.

We have only to look at the work of contemporary artists to see how far textural experimentation has been carried in this century. In many artists' work texture is the primary element in establishing meaning and in organizing the work on a formal level. Anselm Kiefer, a German Neo-Expressionist and one of the most prominent European artists working today, has broken all textural constraints in his art. He incorporates lead, straw, plants, iron, and other objects and materials that are either embedded in the paint or affixed to the surface. He burns, scorches, and melts the materials to a disturbing effect. These tortured materials are his means of "practicing alchemy"— the secret, medieval "science" of transforming base material into gold. Kiefer's desired goal is that of spiritually transforming society. He resurrects German—even Nazi—themes, demanding that his viewers take a new look at history. He is deconstructing history and our interpretation of it. Art is a metaphor to this end. (Deconstruction is a critical stance that asks us to re-evaluate our accepted and unquestioned values.) *Shulamite* (Figure 208) is based on a biblical figure, a Jewish beauty, whom he conflates with Margarete, the Aryan heroine in Goethe's *Faust*. Both are innocents who are led to tragedy: Kiefer indicates Margarete by the straw for her hair. (In the legend Margarete lies on a bed of straw in prison. Her innocent love of Faust

208. Anselm Keifer. *Shulamite (Sulamith).* 1983. Oil, emulsion, woodcut, shellac, acrylic and straw on canvas, $114\frac{1}{4}'' \times 145\frac{3}{4}''$ (290 × 370 cm). Saatchi Collection, London.

209. Julian Schnabel. *Saint Francis in Ecstacy.* 1980. Oil, plates, bondo on wood, 96 × 84″ (244 × 213 cm). Private collection, courtesy Pace Gallery, New York.

leads her to despair, and she kills her own baby.) Kiefer bases his painting on the crypt-like building, a Nazi design, proposed as a memorial to German soldiers. He has subverted the original intent of that commemoration by writing Shulamite's name in the upper left corner. The painting now becomes a memorial for the Jews who were murdered during the Nazi reign. We see in this powerful work how texture is the key to understanding the symbolism, how, as Kiefer says, these symbols "link our consciousness with the past," and how through them "we recollect our origins." Kiefer's texture is physically and psychically dense.

An American Neo-Expressionist, Julian Schnabel, deals with literary themes taken from classical mythology and biblical sources. He dramatizes his work by the attachment of antlers, tree branches, dishes. Schnabel's signature texture is broken crockery, which he embeds in plaster (Figure 209). The broken plates jut out menacingly from the surface; while defining shape, they also fragment the image. Textures not found in fine art appeal to Schnabel. He has made a series of paintings on black velvet, a textural taboo in the art world, with its tawdry associations of kitsch souvenirs.

Another development in late-20th-century art, and one that deals specifically with actual texture, is the emergence of the *object* as a distinct genre. This novel development introduced a new kind of art formulation. Although these objects are three-dimensional, they are not strictly sculpture; they do not deal primarily with volume, mass, intervals, and voids.

210. Dottie Allen. *All There Is*. 1986. Mixed media. Museum of Fine Arts, Houston.

Artists' one-of-a-kind books fall into this category, a crossover between drawing, painting, printmaking, photography, and sculpture. In these objects—cubes, boxes, trays, containers, books—real texture on real objects has displaced the illusionistic function of texture. Dottie Allen's book entitled *Hard Choices/All There Is* (Figure 210) is made of materials associated with neither books nor art, but out of more base materials that avoid connotations of art. Pages are formed of layered pieces of glass, acetate, and mirror, which are held together by soldered lead and encased in a glass container. These dimensional pages are then embedded in another glass case filled with dirt clods. Allen's theme, as she says, is "Ashes to ashes, dust to dust. . . ." Blurred, confusing words and images are photographed and drawn—incised—on the layered sheets, backed by crazed and pitted mirrors, and are legible only when held up to the light. Actual, real-life texture plays a leading role in all of Allen's work: the dirt clods, the leaded holders, the double, blurred images resembling photographic negatives, the mirrors. All function on a formal, design level, but more importantly, these textures are crucial to the work for their symbolic role. At first look, the viewer sees confusing double images; it is only by holding the pages and looking through them, having them illuminated by real, literal light that we can decipher the message. The viewer is also illuminated, so to speak, and given a tactile reward in actually handling the work.

We have seen only a few examples of the heightened role of texture in contemporary art. Artists have taken a radical departure from the modernist trends of mid-century art. Let us now turn to the role of texture in the graphic arts. The emphasis in drawing is more on visual textural effect. The contrasts between rough and smooth, between coarse and glossy, or between soft and hard can be communi-

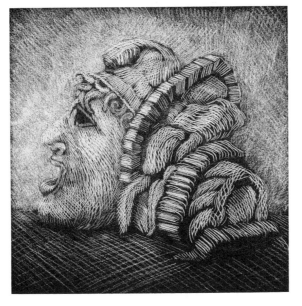

211, above. Ellen Lanyon *Endangered.* 1982. Acrylic and graphite on canvas, 4 × 12′ (1.22 × 3.66 m). Private collection, New York.

212, left. Sy Ross. *Untitled.* 1983. Pencil on colored construction paper, $17\frac{1}{2}$ × 18″ (44 × 46 cm). Courtesy Serra di Felice Gallery, New York.

cated without actually using glossy or rough media. Ellen Lanyon conveys the idea of various tactile surfaces in her combination painting/drawing (Figure 211). An array of textures unfolds, like time, across the picture plane—from the illusionistically drawn fish to the more schematically depicted flowers. Lanyon is interested in the integration of the natural with the supernatural, the ordinary with the sublime—"a world as it is . . . alive and in transformation." With this stated concern, texture becomes a necessary tool. (We need to be reminded that the illustration is twice removed from the actual work; we see a reproduction of another reproduction, a print of a photograph. And even though the actual work is in color, the tactile message comes through.)

The textural quality in the pencil drawing by Sy Ross (Figure 212) depends on the surface texture on which it is drawn, the texture inherent in the medium and the artist's control of that implement. A white pencil is the sole medium, yet Ross achieves a diversity of tex-

tures by his handling of the tool. These linear effects are even more noticeable since the marks are on dark paper; the value reversal points out the many changes in textural quality throughout the work. The textural quality of a work depends on the surface on which it is drawn, any additions made to the surface, the texture inherent in the medium, and the way the artist controls the medium.

In addition to reinforcing the content of a work, texture gives information about materials and media. In this role it surpasses the other elements. Some basic categories of texture, beginning with the traditional ones of actual, simulated, and invented, will lead us to a clearer understanding of this element.

TRADITIONAL CATEGORIES OF TEXTURE

Actual Texture

Texture in its most literal meaning refers strictly to the sense of touch. This is the category of actual texture. For the artist, however, the visual appearance of a work, its surface quality, is most important. While this type of texture may have only a subtle tactile quality, it has a visual quality that contributes to the textural character of the work. We see how important texture is in Henry Whiddon's ink drawing of grass (Figure 213). The drawing can be read on two levels—one

213. Henry Whiddon. *Grass Series: SEBO.* 1980. Ink, 20 × 32″ (51 × 81 cm). Courtesy the Artist.

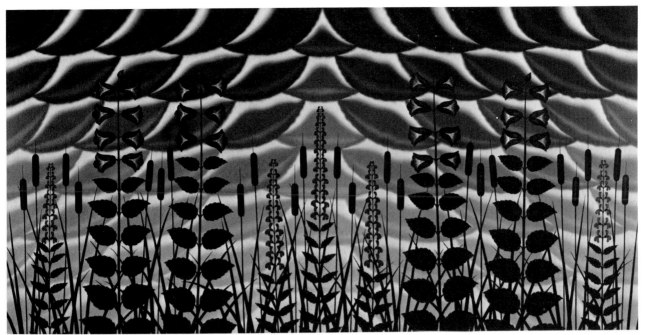

214. Roger Brown. *Celebration of the Uncultivated—A Garden of the Wild.* 1980. Oil on canvas, 5 × 10′ (1.52 × 3.05 m). Montgomery Museum of Fine Arts, Alabama.

as referring to a field of grass and the second, and most important, as a formal means; that is, the use of texture to organize the picture plane. While the blades of grass overlap, the uniformity of the lines creating the textural pattern tends to compress the space. The swaying linear motion activates the surface in a continuous-field composition.

Actual texture refers to the surface of the work (smooth or rough paper, for example), the texture of the medium (such as waxlike crayons, which leave a buildup on the surface), and any materials, such as fabric or paper, added to the surface.

Pattern painters, such as Roger Brown, are greatly dependent on texture in their work. An example of the texture of the tool dominating the work is Brown's *Celebration of the Uncultivated—A Garden of the Wild* (Figure 214). The pillowlike, softer shapes that create a repeating pattern in the background were made by an airbrush. A fuzzy, diffused edge is characteristic of this medium, which allows the artist a great deal of control over the thickness or thinness with which the paint is applied. The plants are flat, dark shapes that form a frieze along the bottom half of the painting. The background cloud/leaf shapes are modulated from light to dark within the individual shapes, and the shapes lighten as they meet the plants. The softness of the billowing forms contrasts with the precisely delineated plants; this textural reduction provides unity in the work.

An example of the actual texture of a medium, one not easily recognizable without knowledge of the technique used, is *Smoke Drawing* (Figure 215) by Otto Piene. Texture is created by holding the

215, right. Otto Piene. *Smoke Drawing.* 1959. Smoke, $19\frac{7}{8} \times 28\frac{1}{8}''$ (50 × 71 cm). Courtesy the artist.

216, below left. Tschang-Yeul Kim. *Waterdrops #23.* 1976. Oil on canvas, $39\frac{3}{8} \times 28\frac{3}{4}''$ (100 × 73 cm). Private collection.

217, below right. Alan Magee. *Smoke Balls.* 1981. Watercolor, 18 × $13\frac{1}{2}''$ (46 × 32 cm). Collection Linda Bacon, Ross, California.

paper above a candle flame and controlling the carbon deposits that collect on the paper. This technique is called *fumage*. A stencil blocks out the white areas. By shifting the stencil and by controlling the thickness of the carbon deposits, overlapping dark and light circles are created. We sense a deeper space in the center of the work, where the carbon deposits are thicker and where the circles seem to collide.

Texture, as we have seen, not only conveys information about the artist's medium but also gives information about subjective and expressive intent.

Finally, any real material added to the surface of the work is, of course, actual texture; but for our purposes we have created a new category for this additive material, which we will discuss later.

Simulated Texture

Simulated texture, as its name implies, is the imitation of a real texture. It has traditionally been used to represent actual appearance, and many contemporary artists continue to use texture in this way. Simulation can range from a suggested imitation to a highly believable trick-the-eye *(trompe-l'oeil)* duplication. In Tschang-Yeul Kim's *Waterdrops #23* (Figure 216) we see a contemporary handling of this *trompe-l'oeil* technique. The illusionistic drops are standing on the picture plane in a highly orderly fashion. We question whether the picture plane is horizontal or vertical. If the surface is vertical, the drops are about to fall; if the surface is horizontal, the drops are resting on the canvas. The artist has not disguised the texture of the canvas ground; he has, however, created an extremely illusionistic image on that ground.

In Alan Magee's *Smoke Balls* (Figure 217) we see another realistic transcription of the objects. Magee's intent is to present objectively the textured surfaces of the packet and of the smoke balls. The objects in this still life occupy a shallow but believable space; Magee has duplicated a two-dimensional object (the letter) and three-dimensional objects (the smoke balls). Conceptually what is their relationship? The real function of smoke balls or smoke bombs is both to form a screen and to threaten danger. By placing the package from his gallery behind the potentially active balls, we equate the two; the envelope screens the message of rejection or acceptance of the artist.

The achievement of an imitation of real textures, or *trompe l'oeil*, usually results in the illusion of a three-dimensional image. This simulation, however, can result in a more abstract, two-dimensional space as in Georges Braque's still life (Figure 218), where the texture of the wood grain is imitated, not real.

Invented Texture

Invented, or decorative, textures do not imitate textures in real life; the artist invents the textural patterns. Invented textures can be nonrepresentational line-and-dot patterns as in the textured shapes of Miguel Condé's ink drawing in Figure 219. They also may be ab-

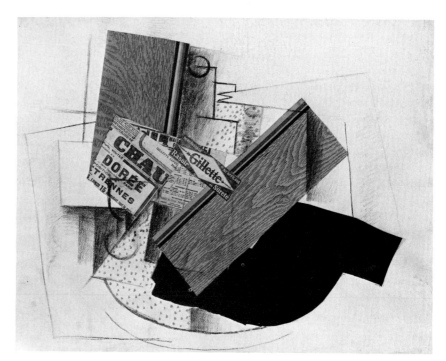

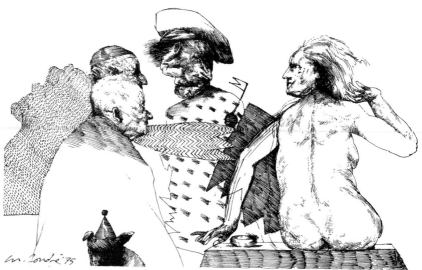

218. Georges Braque. *Still Life on a Table.* 1913. Collage, 18½ × 24¾″ (47 × 62 cm). Private collection.

219. Miguel Condé. *Untitled.* 1975. Pen and ink on 18th century paper, 8 × 11½″ (20 × 29 cm). Courtesy the artist.

stracted, conventionalized textures to symbolize actual textures. Condé, for instance, uses symbolic texture for hair and fabric.

A second example that illustrates the use of invented texture is Jim Nutt's *Thump and Thud* (Figure 220). Here the drawing contains its own frame in the form of a decorative border. Inside that border is a figure whose frontality is reinforced by a textured, vertical shape along the right side and a striped, horizontal shape along the top. Invented textural patterns and outline create closed shapes that result in a severely limited pictorial space, which echoes the flatness of the picture plane. Spatial ambiguity is achieved by the discrepancy

220, left. Jim Nutt. *Thump and Thud.* 1973. Colored pencil, 30 × 27″ (76 × 69 cm). Museum Moderner Kunst, Vienna.

221, right. Neil Welliver. *Brown Trout.* 1975. Etching hand-colored with watercolor, 26½ × 36″ (67 × 91 cm). Courtesy Brooke Alexander, Inc., New York.

of scale between the central figure's hands and head and by the shift in scale in the tiny woman who stands on the ledge of the frame.

Neil Welliver's etching *Brown Trout* (Figure 221) uses conventionalized texture. We have no difficulty interpreting the groupings of parallel lines as rocks and water. The artist has invented textures of lines and dots to symbolize, or refer to, actual textures.

Even more abstract are the textures in Michael Abyi's lively ink drawing on fabric (Figure 222). His decorative line-and-dot patterning is used over the entire surface of the work. In this texture-filled composition, empty space is crowded out. The compact design is made up of repeating shapes and repeating textures that defy logic. The work's complexity is in keeping with its mythic subject, *The Twins Who Killed Their Father Because of His Properties.*

James Rosenquist's work is a concise compendium of texture, a good choice to conclude our discussion of actual, simulated, and invented texture. In his lithograph *Iris Lake* (Figure 223) he combines all three kinds of texture—actual, simulated, and invented. Texture is, in fact, the subject of the work. The image on the left is an example of invented texture; the image in the center simulates crushed paper; and the third image makes use of actual texture in the marks and rubbings. The pictorial space is ambiguous because the illusionistically three-dimensional elements are placed in a flat, white field. Are the shapes on top of the plane or are they holes in its surface? The black vertical lines reinforce this ambiguity.

PROBLEM 6.1
Using Actual Texture
Take your subject from a photograph. In this problem you are to focus on the texture of the drawing medium itself, its inherent qualities. Use mixed media such as chalks, pastels, and/or charcoal in

222, right. Michael Abyi. *The Twins Who Killed Their Father Because of His Properties.* Ink on fabric, 33 × 22″ (84 × 56 cm). Collection Claudia Betti.

223, below. James Rosenquist. *Iris Lake.* 1974. Lithograph, 3′1½″ × 6′2″ (93 × 188 cm). Courtesy Multiples, Inc., New York.

conjunction with a gloss, water-based house paint. Begin with a gestural network of lines using various media; then overlay some sections with paint. Redraw, repaint until you have achieved an interesting surface and a satisfactory composition. Do not develop a focal point; the final product will be a continuous field, a vibrating plane that activates both positive and negative space.

PROBLEM 6.2
Using Simulated Texture

Choose as your subject a textured, two-dimensional surface, such as a weathered piece of wood, a textured piece of wallpaper, a piece of fabric, or a carpet sample (see Figure 258). Photocopy several of these textures, and make studies of both the actual texture and the photocopy in your sketchbook. After making a number of sketches, make a finished drawing in which you incorporate several kinds of simulated texture.

PROBLEM 6.3
Using Invented Pattern

For this drawing you are to invent a mythological creature. Once you have decided on a subject, draw your conceptualized character by using enclosed shapes in both positive and negative spaces. Fill the entire page with enclosed shapes which you define by invented textural pattern and/or outline.

You may change scale of the textural pattern within a shape in order to indicate a spatial progression, as in the shapes that build the froglike creature in Figure 224.

Use pen and ink or black and white acrylic. Try for a disciplined control of the textural patterns.

224. Invented pattern. Student work. Pen and ink, 14 × 14″ (36 × 36 cm).

PROBLEM 6.4
Using Conventionalized or Symbolic Texture

Represent various surfaces in an imaginary scene by means of conventionalized or symbolic texture. You may choose to draw an imaginary landscape, or you might try drawing your room from memory. Aim for a symbolic interpretation of textures.

In *Grove of Cypresses* (Figure 225), Vincent Van Gogh, the master of symbolic texture, used a reed pen and ink to create a drawing made of conventionalized or symbolic texture. The swirling marks build the flamelike forms of the cypresses. Grasses, fields, hills, houses, clouds are all symbolized using line-and-dot patterning. The work is unified by repeating textural patterns. Note the change in value of the brush strokes.

Avoid the predictable in your inventions. Pen and ink or brush and ink is a good medium for conventionalized texture.

TWENTIETH-CENTURY TEXTURES

Additive Materials to Create Texture

We mentioned at the beginning of this chapter the innovations of the Cubists in their introduction of collage and other additive materials to their art (see Figures 10, 218, 306, and 307). We should not underestimate the decisive role this invention played in the development of later art of the century. Philosophically, these additive nonart materials expanded our ideas of what art can be. Additive materials are interesting because they retain a sense of their previous identity while functioning compositionally within the work. (Schnabel's broken crockery, for example, will always be seen on two levels: as autonomous broken dishes on one level, and on a second, formal level, as textural shapes and values within the painting.)

We can divide such additive materials into two classifications: *collage* and *assemblage*. Collage is the addition of any flat material, such as paper or fabric, to the surface of a work. Assemblage is the use of dimensional material attached by any means—glue, nails, wire, or rope, for example.

In the visual arts a major development by the Dadaists was *montage*—the combining of photographs, posters, and a variety of typefaces in startling new juxtapositions. The aim was to jolt the viewer; shock was the motive. These raffish anti-art artists began their campaign in 1918. They attacked the status quo, both in art and in politics. Artistic chaos paralleled political chaos. The Dadaists needed a disjunctive art form to hold up as a mirror to a world out of control. Montage became their primary means.

One of the best known artists to emerge from this movement was Kurt Schwitters. His collages are made up of tickets, newspapers, cigarette wrappers, rubbish from the street (Figure 226). An important element in Dada is randomness of chance as a compositional principle. The informality and looseness of Dada compositions

along with a use of perishable materials had a lasting effect on later art in the century. Schwitters's engagement in everyday life resurfaced in the 1960's with the Pop artists' choice of banal, everyday subject matter. His famous announcement, "I am a painter and I nail my paintings together," could be the motto for late-20th-century art.

Several definitions of terms will be useful in talking about texture. *Papier collé* is a term for pasting paper to the picture plane; *photomontage*, as its name implies, uses only photographs; *collage*, like *montage*, is any flat material put together to create a composition. Works using *papier collé*, collage, montage, and photomontage usually remain flat, although they can be built up in relief.

These techniques are alive and well in contemporary art, and nowhere are they more evident than in Barbara Kruger's work with its pointed exposé of establishment values (Figure 227). Kruger, like Kiefer, uses a visual method of deconstruction in demanding the viewer's reassessment of accepted ideas. A terse statement overlays a photographic image, and at the junction between the two lies a biting admission. Near the puppet's mouth is a line of tiny print that says, "We mouth your words." The message is clear, and the billboard size is not an easy one to ignore. Kruger's work begins with photographs and typography and is then mechanically reproduced; so the resulting image, while resembling a montage, is actually a single, un-

225, left. Vincent van Gogh (Dutch, 1853–1890). *Grove of Cypresses.* 1889. Reed pen and ink over pencil on paper, $24\frac{5}{8} \times 18''$ (62.5 × 46.4 cm). Gift of Robert Allerton, 1927.543. Photograph © 1990, The Art Institute of Chicago. All Rights Reserved.

226, right. Kurt Schwitters. *Merzzeichnung 75 (Merz Drawing 75).* 1920. Collage, gouache, red and black printer's ink, graphite on wood-pulp papers (newsprint, cardboard), and fabric, $5\frac{3}{4}'' \times 3\frac{15}{16}''$ (14.6 × 10 cm). Peggy Guggenheim Collection, Venice. The Solomon R. Guggenheim Foundation, New York.

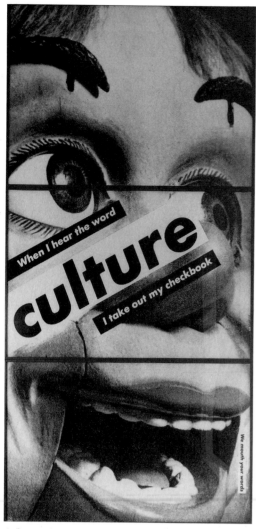

227. Barbara Kruger. *Untitled (When I Hear the Word Culture I Take Out My Checkbook).* 1985. Photograph, 138 × 60″ (3.51 × 1.52 m). Courtesy Mary Boone Gallery, New York.

228. Jacques Villéglé. *Metro Saint-Germain.* 1964. Torn posters, 19 × 13½″ (48.3 × 34.3 cm). Courtesy Zabriskie Gallery, New York.

layered plane. Kruger uses images appropriated from media to underscore her sociopolitical message. *Appropriation* may be used as a means of deconstruction; the appropriated image is given the task of revealing or exposing a hidden or underlying bias.

One final update on collage before we move on to our discussion of assemblage. Jacques de la Villéglé's work is an offshoot of collage (Figure 228). He calls his work *decollage* (unpasting); he pulls down and reveals hidden, layered posters from Parisian walls, executing his art without scissors or paste. This idea had already been suggested as a possibility by Dada artists. Villéglé stresses the impersonal character of his work; he describes himself as an "anonymous lacerator."

Assemblage, called by one critic "home-grown California modern art," was firmly in place in the 1960's. Assemblage has held a continuing attraction, not only for the Pop Artists, but for artists of the Post-Modern period as well.

Jim Dine, who first emerged as a Pop Artist, uses assemblage in his work, frequently attaching art implements and tools to the surface. These implements refer to artmaking; they make a Modernist comment, a self-reference to the nature of art. Everyday objects are infused with personal meaning in Dine's work, especially in his thematic series whose subject is a bathrobe. The bathrobe becomes a stand-in for the artist's self-portrait. In Figure 229 a drawing of the robe is shown in combination with three-dimensional cement objects.

Depending on the dimensional items added to the surface, an assemblage can range from a low relief to a freestanding, three-dimensional composition. It can combine both two- and three-dimensional elements in the same work. In the introductory remarks to this chapter we discussed the object as a special genre in 20th-century art. The object as a work of art had two major influences: Cubist collage and Dada, which opened art to include heretofore nonart objects. Perhaps the artist best known for his objects, for his assemblages, is Joseph Cornell. His intimately scaled, beautifully crafted, poetic works are shadow-box glimpses into a private, intense world. In Figure 230 the dimensionality of the twigs combines with a flat scale-model of a building, enriched by drawn architectural ornament to produce an intricate and delicate "setting for a fairy tale," as its title informs us. Cornell contrasts the actual texture of the twigs with the simulated texture of the architectural embellishment. The discrepancy in scale and texture between the real and drawn gives the work its surreal quality.

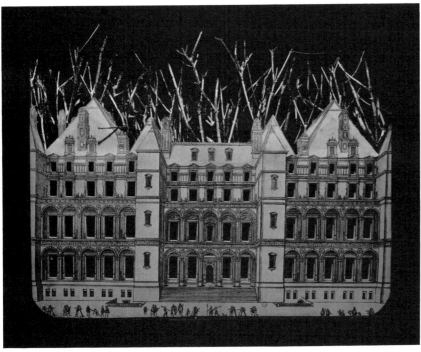

229, above. Jim Dine. *Charcoal Self-Portrait in a Cement Garden.* 1964. Charcoal and oil on canvas with 5 cement objects, 8′11¼″ × 3′9⅝″ × 2′3″ (2.75 × 1.17 × .69 m). Allen Memorial Art Museum, Oberlin College, Oberlin, Ohio. Ruth C. Roush Fund for Contemporary Art, 1965.

230, left. Joseph Cornell. *Setting for a Fairy Tale.* 1942–1946. Box construction 11⅜ × 14½ × 4″ (29 × 37 × 10 cm). Peggy Guggenheim Collection, Venice.

231. Vernon Fisher. *Breaking the Code.* 1981. Mixed media installation at the Modern Art Museum of Fort Worth, Texas. Courtesy Barbara Gladstone Gallery, New York.

A logical development of assemblage is the blurring of categories between two- and three-dimensional art. In earlier times the separation of sculpture, painting, and drawing was readily determined. Today the demarcation is less precise. Installations, such as the one by Vernon Fisher, use both two- and three-dimensional objects, drawing, painting, and photography (Figure 231). In installations artists use an array of textures, both real and pictorial.

In collage, montage, photomontage, assemblage, and installations, bizarre and unlikely combinations press the viewer to interpret, to find meaning in the disparate pieces. The breakdown of conventional categories and predetermined rules for art has helped close the gap between art and life, a steadfast goal of the artists of our era.

PROBLEM 6.5
Using Papier Collé

For this problem, reassemble old drawings to create a new work. For example, you might tear up old figure drawings and rearrange the pieces to make a landscape. Pay attention to the shapes of the torn paper and to the marks drawn on them. Paste the torn paper on a piece of heavy supporting paper and redraw, integrating the *papier collé* into the work.

PROBLEM 6.6
Using Collage

Make a composition with photocopies using an arrangement of real objects directly on the copier. Make several different compositions, altering placements of the objects until you have a good selec-

tion. Choose one of these to develop into a final drawing. Take care in choosing the objects; try for a wide range of textural variety. You may (or may not) draw on the surface, using such media as colored pencils, grease markers, pencil, or ink. Add textural elements, as in Figure 232, where the student has embellished the surface with ribbons, buttons, fabric, and drawing. The result could be an odd amalgamation of seemingly realistically rendered textures in illogical relationships. If you include objects of different scale, the disorientation will be even greater.

PROBLEM 6.7
Using Assemblage

Make an assemblage that will be an homage to art history. Choose a favorite two-dimensional work and transform it into a bas-relief. Interesting spatial effects occur when a piece is changed from two to three dimensions.

In Figure 233 the student has transformed a 19th-century English Pre-Raphaelite painting by Dante Gabriel Rossetti into a free-standing tableau. In this work photocopy is combined with hand tinting to subtly alter the work's original color arrangement.

The contemporary artist Larry Rivers frequently uses assemblage in his art history raids. Look at his mixed media construction for a satirical rendition of Manet's *Olympia* (see Figure 312).

232, left. Collage using real objects. Student Work. Photocopy, tissue paper, plastic, 12 × 9½″ (30 × 24 cm).

233, right. Art history transformation. Student work. Hand-tinted photocopy, 11 × 8½″ × 3½″ (28 × 22 × 9 cm).

234, left. Robert Indiana. *The Great American Dream: Freehold.* 1966. Conté crayon stencil rubbing, 40 × 26″ (102 × 66 cm). Courtesy the artist.

235, right. Robert Rauschenberg. Illustration for Dante's *Inferno: Canto XXI, Circle Eight, Bolgia 5, The Grafter.* 1959–1960. Red and graphite pencil, gouache, cut-and-pasted paper, wash, and transfer, 14⅜ × 11½″ (37 × 29.3 cm). Collection, The Museum of Modern Art, New York. Given anonymously.

Transferred Texture

Related to both actual texture and simulated texture is the transfer of a texture from one surface to another, a technique called *frottage*, developed by the Surrealists in the 1920's. This transfer can be made by taking a rubbing from an actual textured surface or by transferring a texture from a printed surface onto the drawing. Transferred textures cannot clearly be categorized as actual texture or simulated texture because they possess elements of both; they belong to a *crossover* category.

In the rubbing *The Great American Dream: Freehold* (Figure 234) Robert Indiana centralizes a large heraldic image for Americans. In Indiana's work, the rubbing movement diagonally from right to left creates an overall texture that flattens the space. Small areas of lighter value activate the space and break the otherwise insistent textural surface. The image is made static by its central placement and by the enclosed shapes, especially the closed circle. Such complete balance in the positioning of the image permits no movement. The stars above the image are likewise symmetrically placed, as is the rectangular shape of the word *freehold*. Heraldry is a branch of

knowledge that deals with family pedigrees and describes proper armorial insignia. Indiana's rubbing makes a droll comment on democracy by creating a heraldic emblem for Americans.

Transfer from a printed surface is a popular contemporary technique. The image to be transferred is coated with a solvent and then laid face down onto the drawing surface and rubbed with an implement such as a wooden spoon, brush handle, or pencil. The directional marks made by the transfer implement provide additional textural interest in a drawing. Robert Rauschenberg uses this technique in his silkscreens and drawings. In *Canto XXI* (Figure 235), based on Dante's *Inferno*, Rauschenberg combines rubbed transfer with gouache, collage, graphite, red pencil, and wash. The marks made by the implement in transferring the images provide textural unity for the composition. The overall sameness of line direction has the effect of flattening out the images. At the same time the streaked lines build on one another to make an agitated surface, creating a nervous movement throughout the work. Dante's *Inferno* is given a modern interpretation; war, quite literally, is hell. Texture along with image are the carriers of meaning.

Technology has introduced a technique claimed by artists—photocopy. This immediately accessible process depends on the texture inherent in the medium and the texture of the object being photocopied.

PROBLEM 6.8
Using Rubbing

Using a graphite stick, a litho stick, or a china marker, make rubbings of several textured surfaces, combining them into one image or into one composition. By changing pressure on the drawing implement and by controlling the line direction, you can create a range of values. In addition to creating interesting textures, aim for some spatial tension in the work. Line direction and change in value will help establish a sense of space. The resulting space will, of course, be ambiguous since the rubbing technique creates a uniform texture within a shape.

Oriental papers are good for rubbed drawings. They are strong and can withstand the friction without tearing, and they are texturally interesting. Consult the Guide to Materials for a list of papers.

PROBLEM 6.9
Transfer from a Printed Surface

In this project you may use images from magazines or newspapers, or photocopies of images. If you choose photocopies, duplicate several images to be used in one composition. You may wish to copy the same image several times, either enlarging or reducing the scale on the copy machine. Use a machine that produces a good value contrast.

Make a drawing using transferred images. Alcohol can be used for transferring photocopies, turpentine or Nazdar for magazine im-

236. Drawing with photocopy and transfer. Student work. Mixed media, 30 × 42″ (76 × 107 cm).

ages. Lightly brush the solvents on the back side of the image to be transferred, and let it set a minute so that the ink will soften before beginning to rub. Lay the image face down on the picture plane and rub with a wooden spoon, brush handle, or pencil.

After having decided on placement, distribute the transferred images throughout the picture plane; integrate the composition by using gouache, graphite and turpentine, watercolor, or ink wash. You may choose to draw over certain areas in order to unify the work so that the images emerge from and dissolve into the background space. Note the student solution to this problem in Figure 236.

A good quality rag paper is ideal for this problem. Consult the paper list in the Guide to Materials.

SUMMARY:
Spatial Characteristics of Texture

Generally, uniform use of textural pattern and invented texture results in a relatively shallow space. A repeated motif or texture that remains consistent throughout a drawing tends to flatten it.

The use of simulated and invented texture in the same drawing results in arbitrary space, as does a combination of simulated texture and flat shapes. For example, in Romare Bearden's collage *Eastern Barn* (Figure 237), the modeled hands in the center of the picture contradict the spatially flat shapes.

Simulated texture is illusionistically more dimensional than invented texture. If sharpness of textural detail is maintained throughout the drawing, space will be flatter. Diminishing sharpness of textural detail results in a three-dimensional space. Objects in the foreground that have clearer textural definitions than those in the background usually indicate an illusionistic space. In the Audrey Flack painting *Dolores of Córdoba* (Figure 238) there is a sharper focus on the face, and especially on the tears, than on the surrounding headdress. The complicated texture around the face is somewhat blurred. This blurring, by contrast, emphasizes the sharpness of the details in the face.

In summation, simulated texture is generally more three-dimensional than invented texture. Repeated patterns or textural motifs result in a flatter space. Spatial ambiguity can result from a use of simulated and invented texture in the same work.

237, left. Romare Bearden. *Eastern Barn.* 1968. Glue, laquer, oil, and paper on composition board, 4′7½″ × 3′8″ (1.41 × 1.12 m). Whitney Museum of American Art, New York.

238, right. Audrey Flack. *Dolores de Córdoba.* 1971. Oil on canvas, 5′10″ × 4′2″ (1.78 × 1.27 m). Courtesy Louis K. Meisel Gallery, New York.

C O L O R

Color, more than any other element, sparks a direct, immediate response from the viewer. Color evokes associations and memories. Children intuitively seem to understand not only the aesthetic function of color but its symbolic significance as well. Even at the physical level we are affected by color. Certain colors make our heartbeats quicken while other colors are calming. We know that color need not be tied to an imitation of the real world; rather it can be used by artists and nonartists alike both psychologically and symbolically.

Attitudes toward color are culturally revealing. Juan Sánchez, an American-born artist of black and Puerto Rican descent, creates work that reflects his ethnically diverse background (Color Plate 1). His work combines religious, mythical, and cultural symbolism with a strong social consciousness. He uses both *barrio* and Anglo sources for ideas and images. Sánchez describes his efforts as "reconstructions" ("Rican/structions") forging a relationship between his homeland and his Brooklyn neighborhood. His sensuous palette is emotionally charged; we can feel the island's climate in his color choices. The colors from the tropical landscape unify Sánchez's work, and they provide a symbolic underpinning for his visual ideas. He uses large-scale, altarlike formats on which he combines photos, newspaper clippings, and religious artifacts with handwritten texts inscribed over and around the images. The textural surface of the paintings reminds one of urban walls with graffiti and torn posters. Sánchez combines abstract shapes with religious icons and photogra-

phy of real people, fragments from everyday life. Layered, hot colors, actively applied, connect the disparate segments both conceptually and formally.

At certain periods of time people have expressed decided color preferences; for example, in the 1960's Americans generally preferred clear, intense colors associated with advertising and television. In the 1980's Victorian color schemes for houses were making a popular return, a break from the preference for all-white houses that prevailed for many years. Even geography plays a part in color preference; certain colors seem to be right for specific climates, such as pastel colors in California and tropical towns or the rich range of grays in New York City.

COLOR MEDIA

A word about color media and their application is in order before beginning a discussion of the terms and properties of color. Some appropriate color media for the beginning student are oil pastels, colored pencils, colored conté crayons, oil sticks, wax crayons, water-soluble colored felt-tipped pens, colored chalk, colored ink, and watercolor or acrylic for washes.

Experiments with color application should be based on the knowledge and experience you have already gained. Powdered media whether colored or not are applied in the same way. Colored pencils are used just like ordinary pencils. Of course, you have more options with color.

Avoid filling a shape with a single color unless you desire a flat, coloring book effect. Experiment with layering colors, with combining multiple colors to build a rich surface. Pastels can be smudged and layered. Do not neglect to combine media; you can incorporate charcoal, pencil, conté crayon, china markers, and ink with any and all of the colored media.

An interesting use of mixed media can be found in the Arnulf Rainer drawing (Color Plate 2). A traditional religious theme of a deposition from the cross is buried beneath a flurry of heavy gestural marks. The underlying drawing is on a toned or colored paper, which provides a ground that helps unify the work. Green oil pastel describes the draped fabric on the background figures; at other times it breaks out of the confines of the background images and joins with the black scribbles. The red color on the right seems to provide some stability to the frantic movement that envelops the forms. The overlay of the various media creates dense, rich surfaces, especially in the lower left. Spatially, the bright greens and reds advance beyond their background stations to create an ambiguous space. Note how the red changes in intensity from the shoulder to the skirt in the figure on the right.

Because color is such an eye-catching and dominant element, do not forget what you have already learned about the role of shape, value, line, and texture. Color can be used to develop a focal point; it

can be used to lead the eye of the viewer through the picture plane; it can be used to create space. Look at other artists' drawings and incorporate new ideas and techniques into your own repertoire. Develop your own personal response to color.

PROBLEM 7.1
Using Color Media

Choose an old drawing to recycle as a base for this problem. On top of the drawing use a number of colors of oil pastel to build a surface. Try overlapping the colors, drawing directly over the already established image. Try to create an interestingly colored and textured surface. Notice that even though you may have used only five or six colors, your palette seems to be more extensive; this is because of the color mixing, one color modifying another. Take advantage of these color changes.

Use a wet media wash such as turpentine, gesso, or ink in several places to create focal points or to unify the drawing. You might want the underdrawing to reappear in certain places; in this case, redraw the image, incorporating some of the media used in the original background drawing in combination with the color media. Continue to layer images and color until you have achieved a satisfactory effect.

COLOR TERMINOLOGY

Our discussion of color begins with some definitions and terms. Color has three attributes: hue, value, and intensity.

Hue is the name given to a color, such as violet or green.

Value is the lightness or darkness of a color. Pink is a light red, maroon, a dark red. As noted in the chapter on value, a change of values can be achieved by adding white, black, or gray. A color can also be heightened, darkened, or modified by mixing or overlaying two or more hues. Note the modification of the yellow shapes in Richard Diebenkorn's work (Color Plate 3). The smaller yellow rectangle in the center of the painting is the lightest value and most intense color shape in the painting; the yellow shapes to the left have been modified, darkened by thinly layered, transparent washes. Both the overpainting and the underpainting have changed the quality and the value of the yellow. The same is true of the red; a thin sliver of intense red cuts between the blue and blue-green; the red at the bottom of the work is a lighter value than the dark red along the left side. Green underpainting has both dulled and darkened this thin stripe. For Diebenkorn color is a physical and dynamic presence. It is the very subject of his work. The longer you inspect this deceptively simple painting, the more subtle complexities you will find.

Intensity refers to the saturation, strength, or purity of a color. The colors in Wayne Thiebaud's *Candy Ball Machine* (Color Plate 4)

are so intense that they could have been derived from color television. It is as if the blues had been turned up to a high level of brilliance.

The *color wheel* is a circular arrangement of twelve hues (Color Plate 5), although one can imagine an expanded gradation of color. These twelve colors are categorized as primary, secondary, and tertiary. The *primaries* (red, blue, and yellow) cannot be obtained by mixing other hues, but one can produce all the other hues by mixing the primaries. *Secondaries* (green, orange, and violet) are made by mixing their adjacent primaries; for example, yellow mixed with blue makes green. *Tertiaries* are a mixture of primary and secondary hues; yellow-green is the mixture of the primary yellow and the secondary green.

Local color and *optical color* are two terms artists use in describing color. *Local color* is the known or generally recognized hue of an object regardless of the amount or quality of light on it, for example, the red of an apple, the green of a leaf. Elizabeth Butterworth's *Scarlet Macaw* (Color Plate 6) is an illustration of local color. The bird is meticulously observed and rendered according to the rich colorations of its plumage. The local color of an object will be modified by the quality of light falling on it. Bright sunlight, moonlight, or fluorescent illumination can change a color. If, for example, we imagine the macaw under moonlight, the intense red, the local color of the bird, might change to a deep red-violet, and we would call this its *optical*, or perceived, color. The distinction between local and optical color is that one is known (conceptual) and the other is seen (perceptual).

PROBLEM 7.2
Using Local Color

In this problem you are to duplicate as closely as you can the actual, or local, color of an object. In verbal descriptions of the color of an object, it is usually enough to name a single hue, as in "a red apple." But an artist must describe the apple more accurately, using more than one hue.

The subject of this drawing will be, in fact, a red apple. Tape off a segment on the surface of the apple—a rectangle 2 by 3 inches (51 × 8 cm). Using pastels, make a drawing of this selected area, enlarging the section to 18 by 24 inches (46 × 61 cm). Use a buff-colored paper: Manilla paper is a good choice. The drawing will be a continuous-field composition, focusing on color and textural variations.

Examine the portion of the apple to be drawn very carefully, analyzing exactly which colors are there. You may see an underlying coat of green, yellow, maroon, or brown. Tone your paper accordingly and build the surface of your drawing using layers, streaks, dabs, and dots of pastels. The longer you draw and look, the more complex the colored surface will appear. Sustain this drawing over several drawing sessions. If you extend the drawing time to several days, you will find the apple itself has undergone organic changes and will have changed colors as a result. Adjust your drawing accordingly.

COLOR SCHEMES

Color schemes require a special terminology. Although there are other kinds of color schemes, we will discuss only monochromatic, analogous, complementary, and primary color schemes. A *monochromatic color scheme* makes use of only one color with its various values and intensities.

Dorothea Tanning's drawing with its odd juxtaposition of images is monochromatic (Color Plate 7). The media is pastel and charcoal on a beige board. The monochromatic color scheme holds the two disparate images together in a way that would not be possible if a variety of colors were used. The tricycle appears to lie on top of the paper, while the wistful monkey emerges from a deeper space, seemingly behind the awkwardly shaped wheel. The smudged background looks as if it is contracting and expanding because of the change in value around the animal's head.

An *analogous color scheme* is composed of related hues—colors adjacent to one another on the color wheel, as for example, blue, blue-green, green, yellow-green. Analogous color schemes share a color; in the example just given, the shared color is blue. In most instances the shared color will be a primary.

Complementary color schemes are based on one or more sets of complements. Complementary colors are contrasting colors, which lie opposite each other on the color wheel. Blue and orange, red and green, yellow-green and red-violet are complements. Rainer (see Color Plate 2) makes use of the complements red and green; they are high keyed; intensity is further enhanced by the interaction between the two colors. This work uses an unusual color scheme for the subject; the terra-cotta background seems to make the red and green even more pronounced. The two complements not only serve as accents; they play an active part in leading the viewer through the composition. The layering of the media results in rich color passages. We view the work on two levels, as representational and as abstract.

Complementary colors in large areas tend to intensify each other. Small dots or strokes of complementary hues placed adjacently neutralize or cancel each other. The viewer blends these small areas of color optically and views them as a grayed or neutralized tone.

Not only does a color scheme organize a work by directing the eye of the viewer (like attracts like), but a color scheme is also the carrier of meaning in a work. The California artist William T. Wiley uses a primary color scheme in *Your Own Blush and Flood* (Color Plate 8). Not only do we find a primary color scheme and a primary triad (yellow, red, and blue), we find triads abounding in the work. Triangular forms are everywhere: three-pronged, forked limbs, a triangular tabletop; on one of the three central blocks are three symbols, one of them a triangle. There are three cut logs behind the bucket. Are we to surmise, then, that the three-color scheme has symbolic meaning? Much of Wiley's work relies on paradox, on some-

thing being two things at once. Wiley learned from Zen Buddhism that opposites are reconciled when seen as a part of a continuous chain. (Are not the fans and spirals a visual metaphor for this chain? And since the palette has an analogous shape to the fans, can Wiley be giving us a clue as to the important role of art in the continuity of life?) Wiley's work is full of contradiction, complexity, humor, and metaphor. So engaging is it that we don't escape easily; he traps us into attempting to interpret the allegory.

Wiley directs us through his allegorical maze by both shape and color; the reds call our attention from one object to the next, while the complicated blue value patterns unify the jumbled composition. The crystalline colors are in keeping with the fragmented, broken quality of the images. The brittle, jagged edges echo the fragmentation inside the picture plane. Is Wiley saying this is just a part, a fragment, of the greater picture, metaphorically speaking? He presents clues for interpretation grounded in the triangular forms; he offers reconciliation through the triad.

It is interesting to note that Diebenkorn (see Color Plate 3) also uses a primary triad in his work, but to a radically different effect than Wiley. The representational artist and the abstract artist both depend on color as a necessary element in their work.

We have by no means exhausted the number of color schemes available to the artist. The chosen color scheme contributes to the overall mood and meaning in a work. Not only are these color schemes related to aesthetics and to the psychology of color, but they must suit the demands of the artist's own personal vision.

PROBLEM 7.3
Using a Monochromatic Color Scheme

From a magazine or newspaper, choose a black-and-white photograph with at least five distinct values. Enlarge the photograph to a drawing with no dimension smaller than 12 inches. Convert the photograph to a monochromatic drawing, duplicating the original values; for example, you might choose an all-blue or an all-red monochromatic color scheme. Take note of the value variations within a given shape and try to match them in your chosen color.

Some photocopy machines can duplicate images in red, blue, or yellow ink. It might be interesting, after you have completed your drawing, to photocopy the original black-and-white photograph using one of the primary colors; then compare the two versions.

PROBLEM 7.4
Using a Complementary Color Scheme

For this project use as your subject a still life by a window; combine an interior view with an exterior view. You may draw from life, or you may invent the scene. This was a favorite subject of Picasso and Matisse. Before you begin your drawing, go to the library and look at some books on these two artists; be sure to note their use of color and how it contributes to the spatial effect in each work.

Use a complementary color scheme, a color scheme of opposites, with no fewer than three values of each complement. You can mix the opposites to change intensity and use white to change value. You should use color arbitrarily; that is, do not use color to imitate local color and value.

Arrange your composition so that in some areas the complements intensify each other; for example, the view through the window might frame an intense color scheme. In other parts of the drawing, by using dabs of color, try to make the complements neutralize each other. (Carefully examine a reproduction of Georges Seurat's *Sunday Afternoon on the Island of the Grande Jatte* for an understanding of how this works.)

Using adjacent dabs of color complementaries might be an appropriate approach for describing fabric, drapes, or wallpaper in the interior space. Experiment with various intensities and values and their relationships with their opposites.

By changes in value and intensity, you can make a color appear to advance or recede, expand or contract. Can you reverse the expected function of color? For instance, can you make a red shape appear to recede rather than come forward as you would expect? Matisse is a particularly good artist to study in this regard.

WARM AND COOL COLORS

Colors can be classified as warm or cool. Warm colors, such as red, orange, or yellow, tend to be exciting, emphatic, and affirmative. In addition to these psychological effects, optically they seem to advance and expand. We can readily see some of these effects in the Sánchez work (see Color Plate 1). His warm (better said, hot) colors promote an active, excited response in the viewer. Even the greens and blues are warm tones. The work is organized by the broad expanse of the background colors. Try to imagine the effect of this work if the background spaces were white, black, or a cool blue; symbolic and psychological meaning would undergo a radical change.

Cool colors—blue, green, or violet—are psychologically calming, soothing, or depressive, and unemphatic; optically, they appear to recede and contract. These characteristics are relative, however, since intensity and value also affect the spatial action of warm and cool colors. Intensely colored shapes appear larger than duller ones of the same size. Light-valued shapes seem to advance and expand, while dark-valued ones seem to recede and contract. We can observe some of these effects in the Diebenkorn work (see Color Plate 3), in which the composition is divided with the warmest colors on the left, the cooler and grayed colors on the right. Although the central triangle is somewhat intense, it seems to occupy a deeper space than the adjacent yellows and red. The grayed blues on the right have been modified by the addition of orange and white; the paint is more opaque on the outer edges than it is next to the center, where we can detect a transparent application of paint—a faint blue rectangle ap-

pears next to the bright yellow strip. The spatial relationship between the geometric forms is very complex; this complexity is primarily the result of color—warm and cool, intense and dull, dark and light; they each perform a different spatial function.

PROBLEM 7.5
Using Warm and Cool Colors

In this problem you are to use two sources of light, one warm and one cool. Seat the model in front of a window from which natural, cool light enters. On the side of the model opposite the window, place a lamp that casts a warm light. Alternate the light sources; draw using the natural light for three minutes; then close the window shade and draw using the warm artificial light for three minutes. Continue this process until the drawing is completed.

Use colored pencils or pastels and no fewer than three warm colors and three cool colors. There will be areas in the figure where the warm and cool shapes overlap; here you will have a buildup of all six colors. Work quickly, using short strokes, overlapping color where appropriate. Focus on drawing the light as it falls across the form. You are to draw the light, in the negative space and on the figure. Do not isolate the figure; draw both negative and positive forms. Try to imagine the light as a colored film that falls between you and the model. Do not use black for shadows; build all the value changes by mixing the warm and/or cool colors.

Note how the short strokes unify the drawing and limit the space. By concentrating on the quality of light, you will find that you can achieve atmospheric effects.

HOW COLOR FUNCTIONS SPATIALLY

The spatial relationships of the art elements and the ways each element can be used to produce pictorial space is a continuing theme in this text. Color, like shape, value, line, and texture, has the potentiality to create relatively flat space, illusionistically three-dimensional space, or ambiguous space.

When unmodulated, flat shapes of color are used, when colors are confined to a shape, a flatter space results. But when colors are modeled from light to dark, as in the Tanning drawing (see Color Plate 7), a more volumetrically illusionistic space results. Tanning's *Monkey 5* is an interesting combination of different kinds of space. In addition to accurately rendering the features of the animal, the artist uses modeling from light to dark to create a spatial illusion within the circular frame. The application of the colored pastel on either side of the face forms a spatial transition from shallow to a deeper space; the brighter reddish color below the mouth leads our eye up to confront the penetrating gaze; one light stroke of the sanguine-colored pastel completes the movement. The lightest lights and the darkest darks are concentrated in the center of the wheel. Our atten-

tion is riveted to this focal point, while our mind tries to unravel the question of the relationship between the two subjects. Tanning confounds us with her presentation of two very different ways of rendering objects—one mimetic, imitating real life, the other, conceptual.

Colors contribute to a three-dimensional illusion of space not only when they are modeled from light to dark but when brighter colors are used in the foreground and less intense ones in the background. Thiebaud depicts a variety of texture in his *Candy Ball Machine* (see Color Plate 4); the forms are modeled volumetrically with wet and dry media. Those nearest us are more distinct and focused; those farther away are blurred and indistinct, yet the color flattens the drawing. Although Thiebaud uses intense colors, his nuances are of an unexpected nature. Seemingly simple and direct, his work rewards a prolonged inspection. One discovers not only a fine drawing technique, unexpected color combinations, a rich textural surface, but a tongue-in-cheek message which, among other things, concerns colored dots of the most commonplace origin caught in the artist/ magician's crystal ball.

When flat color shapes and modeled color volumes are used in the same composition, an ambiguous space results. Further, when bright colors occur in the background of an otherwise three-dimensional shape, an ambiguous space results. In Michael Heizer's colorful work on paper (Color Plate 9), we see a complicated progression into space. The stacked boxes seem to occupy a logical perspectival space, with their edges forming flat color planes. The space surrounding them is an atmospheric one, somewhat diffused. There seems to be a transparent plane, like a piece of glass, that intervenes between the slabs and the viewer. On this imagined glass wall are scribbles, drips, and notations. The vivid red and yellow marks advance toward the viewer; the blue and turquoise marks occupy a second level, while the gray and black marks appear to be located on yet other levels. The diffused orange, green, and pink airy film made with spray paint looks as if it is suspended and hanging in space; sometimes it seems to come forward; at other times it moves back. Heizer has carried the spatial behavior of color to its limit; in fact, it is the very essence of this complex drawing. Color is both the means and the subject.

When color crosses over shapes, a flattening can take place, making space ambiguous. You can see this effect in Heizer's work in the areas where the blue crosses over the edges of the cubes and melds with shadows and negative space in the background forms. Sprayed color areas, colored marks, and drips all occupy an ambiguous space; they are not confined to a shape. In spite of the abstract nature of this work we sense a spontaneous physical immediacy and presence. A mood, an odd sense of place such as found in some fantastic mind travel is the result of Heizer's unabashed use of color.

SOME EARLY INFLUENCES ON CONTEMPORARY ATTITUDES TOWARD COLOR

Because our current attitudes toward color have been shaped by earlier artists, a quick survey of some innovations in their treatment of color during the past hundred years is in order.

We might begin with what has been called the "revolution of the color patch," the revolutionary way the Impressionists applied color. With Impressionism in the late 19th century, artists began depending on more purely visual sensations. Their concern was the way light in its multiple aspects changes forms, and their approach was scientific in many respects. Recording the stimulation of the optic nerve by light, they began working outdoors directly from nature, using a new palette of brighter pigments and purer colors, applying them in broken patches. Dark shadows were eliminated, local color was ignored, and local values or tones were abstracted to create atmospheric effects.

The Impressionists were innovators in color application, applying it in perceptible strokes unlike the smooth, brushed surface that characterized most earlier works. The outlines of objects were blurred in order to make them merge with their backgrounds. Volumes were diminished in favor of describing the effect of light over a form. These quick, broken strokes, suggesting the flicker of light, resulted in a sameness or uniformity in the overall texture that flattened the image and created a compressed space. Such strokes had the added bonus of allowing the artists to work more directly to keep pace with the changing light. The Impressionists saw that color is relative; when light changes, color changes.

The Post-Impressionists continued their predecessors' investigations into color. They used complementary colors in large areas to intensify each other and in small dabs to neutralize each other. They interpreted shadow as modified color, not simply as black or gray; and they made use of optically blended color. The viewer blends colors visually; a dab of red adjacent to a dab of green will be blended by the eye to appear gray. These complementary hues in small contrasting areas also made for greater luminosity and greatly enlivened the surfaces of the paintings.

Early in the 20th century a group of painters called the *Fauves* (Wild Beasts), who were familiar with the color advances of the Impressionists and Post-Impressionists, renounced the pretense of recreating reality and began a subjective and symbolic investigation of color. They sought a heightened reality more exaggerated than actual appearances. The *Fauves* used flat, pure, unbroken color to further limit traditional perspective, depth, and volume.

Wassily Kandinsky, a contemporary of the *Fauves*, carried the freeing of color a giant step forward into abstraction. In placing emphasis on composition and color, he left representation of objects behind. His goal was to infuse shapes that had no reference to recognizable objects with a symbolic and metaphysical intensity, and he

saw that the most direct means of achieving that goal was through the use of color. His memoirs open with the sentence, "In the beginning was color."

Expressionists throughout this century—the German Expressionists before World War I, the Abstract Expressionists in the 1940's and 1950's, and the Neo-Expressionists in the 1980's—have all used color to underline their own emotional responses. Strong contrasting colors applied in thick slashing strokes give urgency to a charged content.

The Color-Field artists in the 1960's saw that they could communicate essentially through color alone. Reducing their formal means, limiting shape, line, value, and texture, they depended on color to carry the weight of the work both in form and in content. Certainly the Color-Field painters can be said to be dealing with the physiological effects of color noted at the beginning of this chapter. The scale of these artists' works is so large that even our peripheral vision is encompassed. Envisioning the difference between a spot of red on a wall and an entire wall of red will enable you to understand better the concept of enveloping color. We are absorbed by the expanse of color and by the field of color in the painting; experience and vision are one.

The strategy of the Pop Artists in the 1960's and 1970's was to use technology and common objects in a man-made environment as sources of technique and imagery. They used advertising techniques and established a new palette based on color television and advertising layouts. Colors were intensified, often garish.

The Photorealists use film colors to establish their color. Taking their color schemes directly from the photograph, they present the viewer with an alternate means of establishing reality or verification. Image, color, and technique are derived from photography.

In contemporary art, color maintains its decisive role. All the earlier uses of color are exploited—the representative, emotive, psychological, and symbolic impact—for their subjective and objective functions.

The overriding lesson that contemporary artists have learned is that color is relative. Through a lifetime of experimentation Josef Albers investigated the relativity of color. In his theoretical writing and in his work he offered ample proof that color is not absolute but interacts with and is affected by its surroundings. Since colors are always seen in a context, in a relationship with other colors, artists must make use of this knowledge of color relationships.

PROBLEM 7.6
Studying Influences on Contemporary Color Attitudes

Go to the library and find two or three examples of the historical styles that have formed our attitudes toward color (Impressionism, Post-Impressionism, Fauvism, German Expressionism, Abstract

Plate 1. Juan Sánchez. *Bleeding Reality: Así Estamos.* 1988. Mixed media on canvas, 44 × 108½″ (1.12 × 2.76 m). Courtesy Exit Art, New York.

Plate 2. Arnulf Rainer. *Christus.* 1989. Page overdrawn with wax crayon. 14$\frac{3}{16}$ × 11′ (36 × 28 cm). Galerie Thaddaeus Ropac, Salzburg, Austria.

Plate 3, above. Richard Diebenkorn. *Ocean Park #21.* 1969. Oil and charcoal on canvas, 7'9″ × 6'9″ (2.35 × 2.06 m). The Art Museum, Princeton University. On loan from the Schorr Family Collection.

Plate 4, right. Wayne Thiebaud. *Candy Ball Machine.* 1977. Gouache and pastel on paper, 24 × 18″ (61 × 46 cm). Collection John Berggruen, San Francisco.

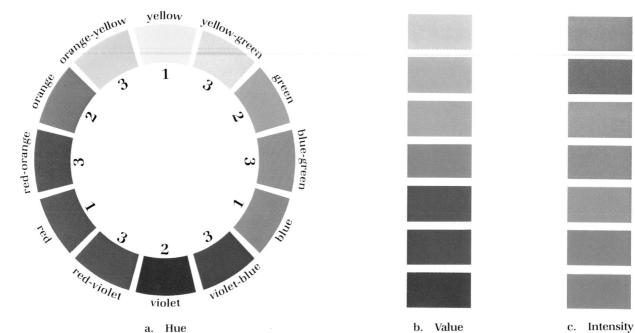

a. Hue b. Value c. Intensity

Plate 5. The major elements of color: hue (as expressed in the color wheel), value, and intensity.

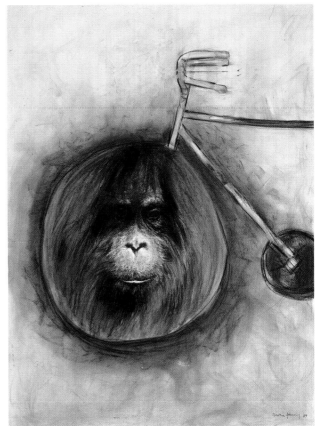

Plate 6, left. Elizabeth Butterworth. *Scarlet Macaw*. 1979. Watercolor, $31\frac{1}{2} \times 21\frac{1}{2}''$ (79 × 54 cm). Collection of Mr. John P. Richardson, New York.

Plate 7, right. Dorothea Tanning. *Message 5*. 1989. Pastel and charcoal on beige board, $52\frac{3}{4} \times 40''$ (1.32 × 1.02 m). Courtesy the artist.

Plate 8. William T. Wiley. *Your Own Blush and Flood*. 1982. Watercolor on paper, 22 × 30″ (55 × 75 cm). Collection Byron and Eileen Cohen, Shawnee Mission, Kansas.

Plate 9. Michael Heizer. 1983. *45°, 90°, 180° Geometric Extraction Study #1*. Silkscreen, watercolor, crayon, ink on paper, 50 × 50″ (125 × 125 cm). Private collection. Courtesy M. Knoedler & Co., Inc., New York.

Expressionism, Color Field, Pop Art, Photorealism, and Neo-Expressionism). Look at one book on Kandinsky and one on Albers.

Pay special attention to color relationships and to color application. Reread this section while looking at the art work from the period. You need not limit your search to drawings because the artist uses color in much the same way whether the work is a painting, a drawing, or a print.

PROBLEM 7.7
Using Symbolic Color

Make a drawing in which you use color symbolically. Invent an imaginary scene or event as your subject. Use color to enhance the subject both visually and symbolically. Consider not only the universal symbolic significance of your chosen palette, but think of personal associations the colors have for you. Try to weld message and color; aim for a formal and conceptual integration of color.

You might look at some work by Paul Gauguin and Vincent Van Gogh, both of whom used color in new and unexpected combinations. Gauguin's *Yellow Christ* is a good example of the use of symbolic color. Van Gogh is well known for his impetuous use of color. His color choices are emotionally based and symbolically powerful.

Use acrylic paint or oil sticks. Try for saturated colors, overlaying colors to create grayed tones. Choose media and technique that allow full expression for the development of your idea.

PROBLEM 7.8
Using Color-Field Composition

On a large format, one that is twice as wide as it is tall, divide the picture plane in half. On one side of your paper make a drawing using a recognizable subject (you may use local color or arbitrary color); on the other side use a continuous field of color. Aim for the same feeling on both sides. On one side you can convey your message by using images and color; on the second side you are limited to color as the carrier of the meaning.

Using a medium of your choice, give careful consideration to the exact color you need, not only to the hue but to its proper value and intensity. You may layer the color in washes, you may build the color in overlapping strokes, or you may use a saturated single color. Try to achieve the effect you want by this continuous field of color. Think of the color in psychological and symbolic terms; determine what you think the physiological effects might be.

Look at some work by the Color-Field painters such as Mark Rothko or Barnett Newman. Make a list of adjectives describing the moods or feelings the works elicit.

SUMMARY:
Spatial Characteristics of Color

In the 20th century we find art works that give the illusion of three-dimensional space, works that are relatively two-dimensional, and works that are spatially ambiguous. Color is one major determinant of spatial illusion.

When flat patterns of hue are used, when colors are confined to a shape, the shapes remain relatively parallel on the surface of the picture plane. On the other hand, when colors are modeled from light to dark, a more volumetric space results; and when bright colors are used in the foreground and less intense values are used in the background, color contributes to a three-dimensional illusion of space.

As a general rule, warm colors come forward and cool colors recede. This rule, however, is relative since the intensity and value of a hue may affect the spatial action of warm and cool colors.

When flat color shapes and modeled color volumes are used in the same composition, an ambiguous space results. When bright colors occur in the background of an otherwise three-dimensional work, the background will seem to come forward, flattening the picture plane to some extent. Also when colors cross over shapes, a flattening takes place, making space ambiguous.

SPATIAL ILLUSION

AND PERSPECTIVE

<div style="text-align: right; font-size: 3em;">8</div>

Chapters 3 through 7 dealt with the spatial relationships of the art elements and the ways each element can be used to produce pictorial depth, the illusion of space. Pictorial space may be relatively flat, illusionistically three-dimensional, or ambiguous, depending on how shape, value, line, texture, and color are used. In some drawings, images seem to jut out toward the viewer; in others the objects seem to recede; forms may appear volumetric or flat. Objects and figures may even seem to occupy a jumbled, fragmented, illogical space.

Space is an essential ingredient in all the visual arts. In architecture we are actually contained by the space of the building; in sculpture we move around the work to see it in its entirety; and in painting and in the graphic arts, where space is pictorial, we are presented with an illusion of space.

Our ideas about space have changed radically in the 20th century as scientific exploration of space has exceeded the most active speculations of the previous century. New knowledge and discoveries in an expanding universe, along with new ideas in physics, such as quantum mechanics and chaos theory, have resulted in an ambiguous notion of space; so it is no surprise that the ways in which artists depict space also have changed.

This is not to say that an artist always predetermines the kind of space used in a work. Space can be intuitive, not accidental. This intuitive response comes not only from a cultural base but from a private, personal one as well. Other considerations, such as subject and intent, also enter into the decision.

185

You, as an artist, must have an understanding of space in order to analyze both your own work and the work of other artists. This understanding gives you wider choices in meaning and technique; knowing which techniques give the effect of two-dimensional, three-dimensional, or ambiguous space keeps you from making unintentional contradictions in your work. Knowledge of how the elements function will help you carry out your intention.

In this chapter we will look at perspective, that convention of representing three-dimensional objects as they appear to recede into space onto a two-dimensional surface. The word *perspective* comes from the Latin, which means "to see through or into." An invention of the Renaissance, perspective developed new areas considered basic to the scientific understanding of objects as seen in nature or as conceived in the imagination. Perspective was the primary device in promoting the fictive space of the Renaissance window of reality that we have mentioned throughout this text. Perspective is both a linear projection and a conceptual abstraction, a convention that artists have used through the centuries.

According to this convention, objects appear larger or smaller in relation to their distance from the viewer. This recession into space can be relayed by the artist according to certain rules. Some knowledge of perspective is invaluable to the artist, but it also has limitations. Perspective should be used as an aid in seeing, not as a formula to be substituted for visual acuity.

EYE LEVEL AND BASE LINE

One important matter that the artist must consider in the treatment of space is the use of eye levels. An *eye level* is an imaginary horizontal line that is parallel to the viewer's eyes. When we look straight ahead, this line coincides with the horizon. If we tilt our heads, if we move our angle of sight to a higher or lower position, this eye-level line will also change on the picture plane, thereby making the horizon line seem higher or lower.

239. Richard Oginz. *When Clients Come to Call.* 1983. Ink on paper, 11 × 30′ (3.35 × 9.14 m). Collection the artist.

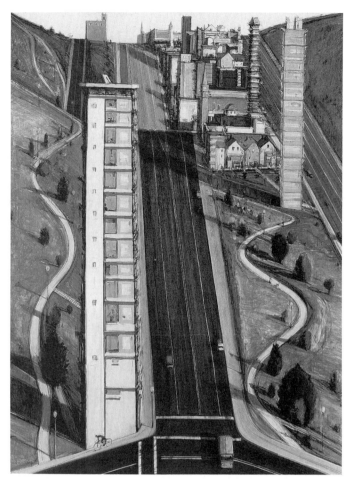

240. Wayne Thiebaud. *Corner Apartments (Down 18th Street).* 1980. Oil and charcoal on canvas, 48 × 35⅞″ (121.8 × 91.2 cm). Hirshhorn Museum and Sculpture Garden, Smithsonian Institution. Museum purchase with funds donated by Edward R. Downe, Jr., 1980.

Two extremes of eye level are the ant's-eye view and the bird's-eye view. (Remember the exaggerated contour exercise in Chapter 5?) The ant's-eye view is obviously one taken from the ground looking up, and the bird's-eye view is exactly the reverse. A look at two examples will clarify the differences.

Richard Oginz uses contour line and perspective to convey the chaos that occurs when "clients come to call"—when visitors disrupt the space of his studio (Figure 239). Connecting diagonal lines unify the drawing as well as call attention to perspectival space. The space of the room and the three-dimensionality of the objects are meticulously translated into a rich interplay of controlled line. The images—the fish, the mechanical arm (a humorous reference to the disembodied artist), the snake—all spill out over the composition in unexpected ways. From our birds'-eye view, we look down onto the tabletops, down into the boxes. You can imagine what a spatial jolt the viewer receives when viewing the actual drawing. It is 11 feet tall and 30 feet long (3 × 9 m), as large as an actual studio.

Wayne Thiebaud uses a modified ant's-eye view in his works based on San Francisco's topography (Figure 240). So developed is his observation and memory that he produces the images without

241, left. Judy Youngblood. *Foreign Correspondants #1.* 1979. Etching with aquatint and drypoint, 11¾ × 14¾″ (30 × 37 cm). Courtesy the artist.

242, right. Judy Youngblood. *Foreign Correspondants #2.* 1979. Etching with aquatint and drypoint, 11¾ × 14¾″ (30 × 37 cm). Courtesy the artist.

visiting a particular site. His work is a refinement of perspective, color, shape, and compositional form. Space is compressed, accenting the vertical. Thiebaud is interested in visual extremism, and certainly San Francisco's extreme contours are ideal subjects for him. It is interesting to note that while he has chosen a subject which demands a perspectival solution—a depiction of three-dimensional space—he is also determined in his work to protect the surface integrity—the autonomy of the picture plane. (We have discussed this Modernist concern through the text.) Color is exaggerated and not descriptive of actual, local color; light is ambiguous; both morning and evening light are used so that, as Thiebaud says, "the day stretched out." The stretched-out space seems to be even further extended by the long freeway that dissects the picture plane. The snake-like movement of the adjoining roads weaves the viewer through the composition.

Both Thiebaud and Oginz employ a highly subjective manipulation of perspective—perspective becomes more than a spatially descriptive tool in their hands.

Another important consideration is *base line*, the imaginary line on which an object sits. Base line and eye level are closely related. If all the objects in a given picture share the same base line, that is, if the base line remains parallel to the picture plane, space will be limited. If objects sit on different base lines, and if these lines penetrate the picture on a diagonal, the resulting space will be deeper.

In Judy Youngblood's suite of etchings *Foreign Correspondants,* horizon lines, eye levels, and base lines play a crucial role. The horizon is placed progressively lower in each print. In Figure 241 bundles of twigs are distributed in a random fashion. In Figure 242 the horizon line is slightly lower; the objects are situated on either side of a double curve leading into a deep space. Here the location of the viewer is somewhat ambiguous; the nearest object seems to be simul-

243, left. Judy Youngblood. *Foreign Correspondants #3.* 1979. Etching with aquatint and drypoint, 11¾ × 14¾″ (30 × 37 cm). Courtesy the artist.

244, right. Judy Youngblood. *Foreign Correspondants #4.* 1979. Etching with aquatint and drypoint, 11¾ × 14¾″ (30 × 37 cm). Courtesy the artist.

taneously seen from above and below. This figure of wrapped hair intrudes on the viewer's space; it is cut off by the lower left corner.

In Figure 243 the horizon line has been lowered considerably, and the stuffed sacks are less ominously placed; space is somewhat limited. In Figure 244 the bags have sprouted legs. (Twigs from Figure 241 seem to have combined with bags from Figure 243 to produce striding anthropomorphic figures.) These figures occupy different base lines on a low horizon. The figures seem to be standing on the rim of the horizon. Cast shadows connect the objects in a series of diagonal lines that penetrate the picture plane.

The images in the four prints are made from objects that are intimately associated with both the artist and her environment. Tableaux are arranged from which drawings and occasionally photographs are made. Spatial manipulation—variations in eye level and base lines—is of utmost importance in Youngblood's work.

Keep in mind that eye level is only one determinant of pictorial space. The space an artist uses is relative; it is not possible to determine the spatial quality of a work by eye level alone. In fact, the same eye level can result in a shallow or deep space depending on other determinants in the work, such as scale, proportion, texture, value, and color.

PROBLEM 8.1
Using Eye Level and Base Lines

In your sketchbook invent some organic, bonelike forms (see Figure 353 in the Sketchbook Practical Guide). Try to imagine what they would look like from various angles as they turn into space. Concentrate on making them volumetric. Imagine a single light source; employ cast shadows to enhance the forms' three-dimensionality. Using several of the volumes that you have invented, do a series

of drawings in which you employ different horizon lines. In the first, arrange the forms on a low horizon line. Take note of their base lines. Remember that if all the forms share the same base line, that is, if they are lined up along a single line parallel to the picture plane, space will be limited. Diagonals penetrating the picture plane will result in a more three-dimensional spatial illusion.

In a second drawing raise the horizon line; locate it somewhere in the middle third of the picture plane. Be aware of manipulating the viewer's stance. Is the viewer seeing the forms from above or from below? Again, use a light source outside the picture plane to achieve the effect you desire.

In the remaining drawings of the series, experiment with placements of horizon lines.

AERIAL PERSPECTIVE

Depicting atmospheric conditions can convey a sense of depth. *Aerial perspective* is one means by which the artist creates spatial illusion. In aerial perspective objects in the foreground are larger and their details are sharp, while those in the background are diminished and

245. Aerial perspective. Student work. Watercolor, 20 × 14″ (50.8 × 35.6 cm).

less distinct. As the objects recede into space their color and value become less intense and their textures less defined. Note these effects in the *Foreign Correspondants* suite (see Figures 241–244) earlier in this chapter.

PROBLEM 8.2
Using Aerial Perspective

In a drawing depict objects as if they were in a landscape; that is, distribute the forms so as to achieve a progression of space, foreground, middle ground, and background. Employ overlapping forms, diminution of size as the forms recede, blurring in focus from front to back, and change in texture from foreground to background as devices by which you can control space and create a sense of atmosphere.

In the student work (Figure 245) objects are exaggeratedly large and more precisely indicated than those in the background. Forms are diffused and smaller in the most distant space. Diagonals that penetrate the picture plane reinforce the sense of space.

Ink and wash or watercolor is an appropriate medium to use to achieve a blurred focus.

LINEAR PERSPECTIVE

Perspective assumes a fixed point of view, so it is important that you remain relatively stationary in order to make a consistent drawing.

In order to use perspective it is necessary first to establish a horizon line. Imagine a pane of glass directly in front of you. This glass is perpendicular to your sight line. If you look up, the horizon line is below the direction of your sight; if you look down, the horizon line is above your sight line. The pane of glass always is perpendicular to your line of vision.

This pane of glass represents the picture plane; you are transferring the visual information seen through this imagined glass onto your drawing surface.

Your viewing position is of utmost importance in perspective. Two relationships are crucial: one, your distance from the subject being drawn, and two, your angle in relationship to the subject. Are you directly in the middle front and parallel to the subject, or are you at an angle to it?

The horizon line should always be located even if it falls outside the picture plane. Its position will describe the viewer's position—whether the viewer is looking up, down, or straight ahead.

Perspective hinges on the fact that lines that in reality are parallel and moving away from us appear to meet at some point on the horizon. That meeting place is called the *vanishing point*, or the point of convergence. Parallel lines of objects above the horizon line will converge downward; those of objects below the horizon will converge

upward. Lines perpendicular and parallel to the picture plane do not converge unless the viewer is looking up or down, tilting the picture plane.

Once the horizon line has been determined, finding the vanishing point is relatively easy. Simply point with your finger, tracing the direction of the receding lines until you reach the horizon line. The vanishing point is located at the juncture of the traced line and the horizon line. True *one-point perspective* will have a single vanishing point in the middle of the picture plane. One-point perspective is useful chiefly in situations in which subjects are parallel or perpendicular to the picture plane.

If you are standing in front of a building parallel to the picture plane and you move to the right or left so that the building is seen at an angle, you will have changed to a *two-point perspective*. There are now two sets of parallel lines, each having a different vanishing point. There may be multiple vanishing points in two-point perspective; any number of objects set at an angle to the picture plane can be drawn, and each object or set of parallel lines will establish its own vanishing point. All planes which are parallel share the same vanishing point.

Objects in *three-point perspective* have no side perpendicular to the picture plane, so there will be three sets of receding parallel lines, which will converge to three vanishing points, two sets on a horizon line and one set on a vertical line.

PROBLEM 8.3
Locating Vanishing Points
Cut six strips of paper $\frac{1}{4}$ by 11 inches (.6 by 28 cm). Use them to determine where the vanishing points fall on the horizon. Locate vanishing points and horizons in each illustration in this chapter by laying the strips along the converging lines. Note that horizon and convergence points frequently fall outside the picture plane. Note whether or not the artist has taken liberties with a strict perspective in each drawing.

One-Point Perspective

A humorous introduction to the discussion of one-point perspective is the sketch by David Macaulay entitled *Locating the Vanishing Point* (Fig. 246), taken from his book *Great Moments in Architecture*. It certainly was a great moment in art when Renaissance artists discovered this new means of describing the visual world. One-point perspective is the device in which parallel lines (lines parallel in actuality) located diagonally to the picture plane converge at a single point on the horizon (Fig. 247). This convergence point is called the vanishing point. The humor in Macaulay's drawing stems from the fact that the railroad tracks converge before they reach the horizon. This contradiction sets up a complicated response in the viewer who tries to explain (both logically and visually) this paradox.

246, left. David Macaulay. Final preliminary sketch for Plate XV, *Locating the Vanishing Point* (Macaulay's intentionally misplaced horizon line), from *Great Moments in Architecture* by David Macaulay. 1978. Ink and feltmarker.

247, below. Diagram—One-point perspective superimposed on David Macaulay's final preliminary sketch for Plate XV, *Locating the Vanishing Point* (Macaulay's intentionally misplaced horizon line).

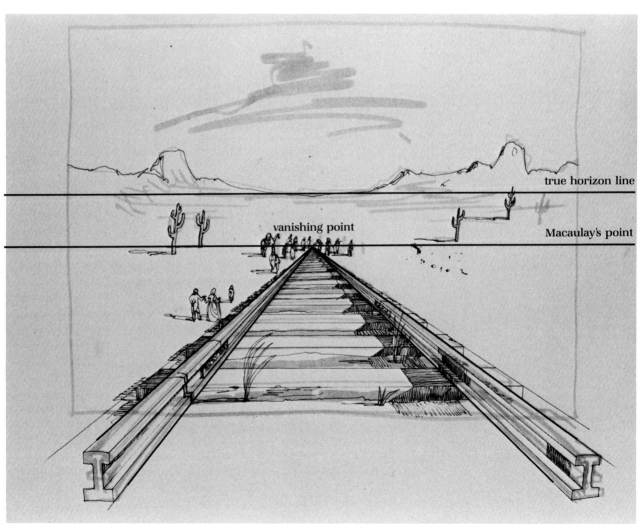

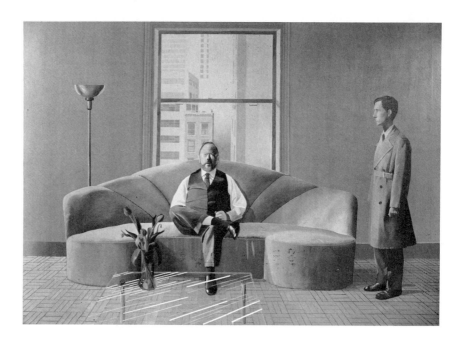

248. David Hockney. *Henry Geldzahler and Christopher Scott.* 1969. Acrylic on canvas, 7 × 10′ (2.13 × 3.05 m). Abrams Family Collection.

In addition to a point of convergence, other devices—overlapping, reduction in the size of objects as they recede, and blurring of detail in the distance—contribute to the sense of spatial recession.

An example of use of one-point perspective with a fixed, straight-on eye level is the painting *Henry Geldzahler and Christopher Scott* (Figure 248) by David Hockney. The space is relatively shallow. The lines on the floor, the angle of the couch, the sides of the table all converge to a single point, the head of the seated man. In contrast to this one-point convergence is a series of parallel lines on the glass table pointing to the standing figure. The interior space is limited, and even though there is an outside window behind the central figure, our eyes are stopped abruptly by the flat wall and by the rigidly confining framework of the window. Space seems to exist on a limited number of planes. The psychological effect of Hockney's painting is slightly disturbing, and it is the artist's treatment of space that contributes to the uneasiness the viewer experiences.

PROBLEM 8.4
Using One-Point Perspective

In this problem and those following, it is important to position yourself so that your angle of vision encompasses both the height and width of your subject.

Station yourself directly in the center of a house, a building, or a room; your angle of vision will be the center of the drawing. If you place the picture plane too close to your line of vision, the objects in the foreground will be so large that they will crowd out the objects in

the distance. First, lightly establish the horizon line, even if it is off the paper. Establish the height of the verticals nearest you. Draw them, and then trace the parallel lines to their vanishing point on the horizon line.

Use contour line. Create a center of interest in the center of the drawing. The depth of space is flexible; you may either create an illusionistically deep space or one that is relatively flat. Remember to maintain a fixed point of view. It may be helpful to close one eye to rid yourself of the problem of binocular vision in tracing vanishing points.

Two-Point Perspective

A picture that uses two-point perspective has two vanishing points on the horizon, rather than the single point of convergence in one-point perspective. Two-point perspective comes into use when objects are oblique to the picture plane, that is, when they are turned at an angle to the picture plane. This is clear when we look at Edward Ruscha's *Double Standard* (Figure 249). The verticals all remain parallel to the vertical edges of the picture plane, but the two sides of the service station lead to two vanishing points, one to the right and the second to the left (Figure 250). The vanishing point on the right is at the exact lower right corner; the one on the left falls outside the picture plane. The horizon line coincides exactly with the bottom edge of the picture plane. (For two-point perspective, any number of objects may be oblique to the picture plane, and each object will establish its own set of vanishing points on the horizon line.) Conceptually, the form is well suited to the meaning in Ruscha's work. What better way to present a double standard than an X shape! Further, there is a play on words: "double standard" is equated with "moral dilemma," and certainly Ruscha indicates we have had a standard response to the question. The looming form of the building takes on mythic proportions as has our profligate use of nature (oil). The base line is at the exact bottom edge of the print. The scale of the building and the extreme upward view emphasize the ant's-eye view and diminish the scale of the implied viewer.

Thus, you can see that perspective can be much more than a convention used to represent space; it can also play a dynamic role as a conveyor of meaning.

PROBLEM 8.5
Using Two-Point Perspective
Choosing the same subject matter as in the preceding problem, change your position either to the right or to the left, so that you will be at an angle to the subject. (Remember that in two-point perspective, the subject must be seen obliquely.) Before using perspective in this problem, execute a quick free-hand sketch, depending on your perceptual ability. Then make a drawing in which you use one-point perspective. Compare the two drawings for accuracy and for expressive content.

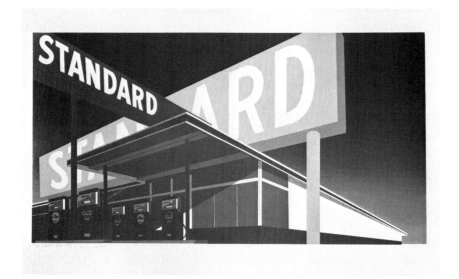

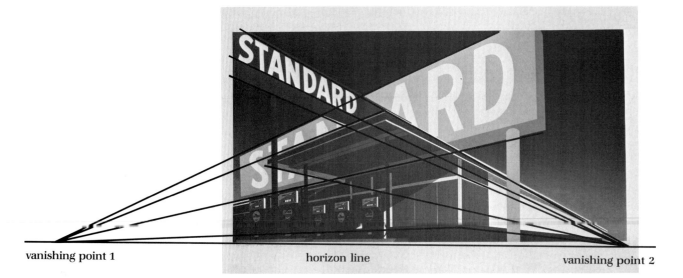

vanishing point 1 horizon line vanishing point 2

249, above, top. Edward Ruscha. *Double Standard (Collaboration with Mason Williams).* 1969. Color silkscreen printed on mold-made paper, 25¾ × 40⅛″ (65 × 102 cm). Edition of 40. © Edward Ruscha/ VAGA New York 1991.

250, above, bottom. Diagram—Two-point perspective superimposed on Edward Ruscha's *Double Standard.*

Now draw the same view using two-point perspective. Again register the horizon line by checking your angle of vision. Estimate the height of the vertical nearest you, and draw it. This first step is crucial; it establishes the scale of the drawing, and all proportions stem from this measurement. Next trace the vanishing points. Remember that you may have several sets of vanishing points (all facing on one horizon line) if you are drawing a number of objects that are set at an angle to the picture plane.

A preliminary aid to drawing in perspective is to use a china marker on a piece of clear plexiglas. The grease marks can be wiped clean after your study is finished.

Hold the glass at a fixed distance from your eyes; close one eye and trace the scene, concentrating on the objects in perspective. Es-

tablish the horizon line and lightly extend the diagonals to their vanishing points on the horizon. Place the clear glass on a piece of white paper and compare your drawing with the traced one. This device will help clarify the angles and points of convergence. Using a transparent picture plane will help you solve some problems in seeing. Do not, however, use this as a crutch to prevent you from developing your own visual acuity.

Three-Point Perspective

In addition to lines receding to two points on the horizon, if you are looking up (at a building, for example), parallel lines that are perpendicular to the ground appear to converge to a third, a vertical, vanishing point. In Hugh Ferriss's dramatic study for a skyscraper (Figure 251), we can easily trace this third, vertical vanishing point. Each tower has its set of stacked parallel, horizontal lines receding down-

251, left. Hugh Ferriss (United States, 1889–1962). *Study for the Maximum Mass Permitted by the 1916 New York Zoning Law, Stage 4.* c. 1925. Carbon pencil, brush and black ink, stumped and varnished on illustration board, $26\frac{3}{16} \times 20''$ (66.5 × 50.8 cm). Gift of Mrs. Hugh Ferriss, 1969-137-4. Courtesy of the Cooper-Hewitt Museum, Smithsonian Instition/Art Resource, New York.

252, right. Diagram—Three-point perspective superimposed on Hugh Ferriss' *Study for the Maximum Mass Permitted by the 1916 New York Zoning Law, Stage 4.*

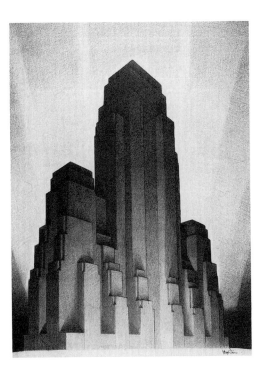

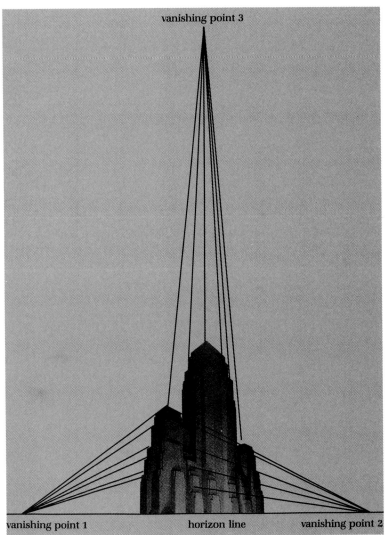

ward to two points on the horizon line, while the vertical lines of each tower converge at a single point above the central tower (Figure 252). The speed with which the lines converge produces a sense of vertigo on the part of the viewer, not unlike the effect the tourist experiences in New York City looking upward at the vertical architectural thrusts. Ferriss counters this pyramidal effect with rays of beacon lights, which converge downward. The cleanly modeled forms change in value, from light at the base to a flat, dense black at the top, further emphasizing the building's verticality.

PROBLEM 8.6
Using Three-Point Perspective

Assume an ant's-eye view and arrange several objects on a ladder. Position yourself at an angle to the ladder so that your view is looking upward. Again, trace with your finger the vanishing points

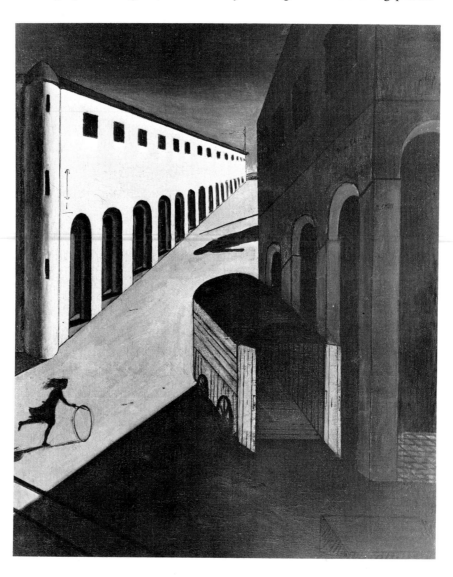

253. Giorgio de Chirico. *The Mystery and Melancholy of a Street.* 1914. Oil on canvas, $34\frac{3}{8} \times 28\frac{1}{2}''$ (87 × 72 cm). Private collection.

that will fall on the horizon line, and then trace a third vanishing point, the vertical one. Remember to keep in mind all three vanishing points even though they may fall outside the picture plane. The forms will be larger at the bottom of the ladder (and at the bottom of the picture plane). When you reach midpoint on your paper, check the scale and draw in the remainder of the ladder and objects. Employ some aerial perspective to further enhance the feeling of space.

MULTIPLE PERSPECTIVE

The extremely disorienting effect that can be achieved by changing eye levels and perspectives in the same painting is illustrated by Giorgio de Chirico's eerily disturbing *Mystery and Melancholy of a Street* (Figure 253). In addition to the unreal lighting, sharp value contrasts, and extreme scale shifts, which contribute to the surreal, otherwordly atmosphere, the most jarring effect is produced by de Chirico's forcing the viewer to change eye levels from one part of the painting to the other. One eye level is used for the cart, another for the building in the foreground, another for the building on the left, and yet another for its openings. (The top windows and the top of the arched arcade should vanish to the same point as the other parallel lines in the building, but they do not.) In the diagram in Figure 254, you see four sets of vanishing points, which do not fall on the horizon line. The diagonals converge at dizzying rates within the picture plane. A troubling strangeness upsets what could be a classical objectivity.

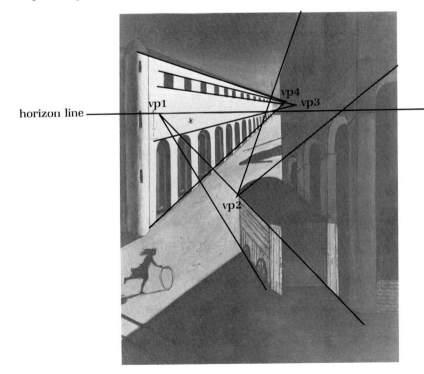

254. Diagram—multiple perspective superimposed on Giorgio de Chirico's *The Mystery and Melancholy of a Street.*

255. Using multiple perspective. Student work. 18 × 24″ (46 × 61 cm).

PROBLEM 8.7
Using Multiple Perspective
Make a drawing in which you use changing, or multiple, eye levels within the same drawing. The resulting space will be ambiguous. You might draw the interior of a room, using one eye level and perspective for a view through the window, another for a tabletop, and still another for objects on the table.

Or you might choose to draw figures in a landscape, as in the student drawing (Figure 255), in which the large, fallen? dead? reclining? man occupies the central space. He is out of scale with the building and roadway, which vanish on an extreme diagonal into space. A seated figure occupies yet another space, while the cube on the left is seen from a higher eye level. Rockets along the bottom edge and lower right seem to refer to an aerial space. The effect of these multiple perspectives is extremely disorienting. The space is highly ambiguous. Extremes of perspectival space are offset in the student work by the uniform, cross-hatched pattern that tends to flatten the figures, the objects, and the space they occupy.

STACKED PERSPECTIVE

An ancient Egyptian mural (Figure 256) and a 20th-century comic-strip-style painting by Öyvind Fahlström (Figure 257) illustrate how parallel base lines create space that is predominately two-dimensional. These parallel base lines within the same picture plane give the effect of stacked panels or frames and encourage the viewer to

256, above. Wall painting from Tomb 261, Thebes.
c. 1500 B.C. 29½ × 41¼″ (75 × 105 cm).

257, right. Oyvind Fahlström. *Performing Krazy Kat
III*. 1965. Variable painting, tempera on canvas and
metal with movable magnetic elements, 4′6½″ × 3′1½″
(1.38 × .93 m). Collection Robert Rauschenberg,
New York.

read the page from top to bottom or from bottom to top in a sequential order. The parallel base lines call attention to the two-dimensionality of the picture plane.

Both works use a number of common devices to maintain a relatively shallow space. Modeling is limited; value remains flat within a given shape. Repeated shapes organize the two compositions. There is a limited use of diagonals; shapes remain parallel to the picture plane on a horizontal/vertical axis. Outlines and invented textures in both works are made up of lines and dots.

The emphasis in the Egyptian painting is on positive shapes, which fill the grid but create little depth. The size and placement of figures are arbitrary; they fit a religious and social hierarchy rather than a visual reality. The Egyptian panel also uses a twisted perspective to show the salient features of profile and front torso; the head is in profile, the eyes are front view. It is impossible actually to assume the stance of the standing figures, especially that of the small figure in the top panel with head turned completely around.

Size and placement of images in the Fahlström piece are also arbitrarily determined. The contemporary work makes more use of negative space, indicated by horizon lines that vary slightly from frame to frame. There are also pronounced shifts in eye level.

In Figure 240 we discussed Thiebaud's use of an ant's-eye view. Due to the extreme compression of space from bottom to top of the picture plane, we have a sense of stacked perspective. While this work is not so apparently conceptualized as the other work we discussed, it could easily be classified as stacked perspective. In this work the viewer "enters" the painting from the bottom and is directed upward immediately through the black freeway shape. In the other works we discussed, the reading is from left to right (an encoded Western bias), and from top to bottom.

PROBLEM 8.8
Using Stacked Perspective
Set up a still life made up of several common objects. Place some of the objects on a table in front of a window; arrange the remainder on a windowsill. Use multiple parallel base lines. Draw two or three objects on each base line. Make use of repeated shapes, repeating values, invented texture, and outlining to create a relatively shallow space. Some of the objects may be parallel to the picture plane, others set at an angle to it. Scale and proportion may or may not change from panel to panel. Macaulay's *Fragments from the World of Architecture* (Figure 258) could be a suitable solution to this problem. For subject matter he has chosen common building materials—acoustical tiles, formica, fake brick, Styrofoam, and astro turf—all "archaeological finds" from the 20th century. They are stacked on various base lines in a two-point perspective drawing. Texture is meticulously handled. The volumetric depiction of the objects is in contrast with their strictly limited space.

258. David Macaulay. *Fragments from the World of Architecture,* from *Great Moments in Architecture* by David Macaulay. 1978.

FORESHORTENING

Perspective is concerned with representing the change in size of objects as they recede in space. *Foreshortening* is the representation of an object that has been extended forward in space by contracting its forms. Foreshortening produces an illusion of the object's projecting forward into space. The two techniques are related, but they are not the same thing. Foreshortening deals with overlapping. Beginning with the form nearest the viewer, shapes are compiled from large to small, one overlapping the next, in a succession of steps. In George Rohner's 20th-century version of Andrea Mantegna's 15th-century Christ (Figure 259), we are presented with an example of extreme foreshortening. The forms are compiled one behind the other from foot to head. The leg on the left is more severely foreshortened than the one on the right presented in a side view. The leg on the left is compressed, each unit maintaining its own discrete shape; there is no flowing of one form into the other as we see in the other leg.

Foreshortening does not apply to the figure exclusively; any form that you see head-on can be foreshortened. In foreshortening, spatial relationships are compressed, rather than extended. Foreshortening heightens or exaggerates the feeling of spatial projection in a form, its rapid movement into space.

259. George Rohner. *Drowned Man.* 1939. Oil on canvas, $23\frac{3}{4} \times 31\frac{5}{8}''$ (60 × 80 cm). Courtesy Galerie Framond, Paris.

PROBLEM 8.9
Using Foreshortening

Observing a model, combine four or five views of arms or legs in a single drawing. In at least one view employ foreshortening; that is, begin with the form nearest you, enclose that form, then proceed to the adjacent form, enclosing it. Be careful to draw what you see, not what you know or imagine the form to be. For example, in drawing the leg, break down the parts that compose the form: foot, ankle, calf, knee, thigh, hip connection. This is unlike a profile drawing where you are presented with a side view and each form flows into the next. Foreshortening describes the form's projection into space. In foreshortening a feeling of distance is achieved by a succession of enclosed, overlapping forms. Make careful sightings when making horizontal and vertical measures.

SUMMARY:
Spatial Illusion

The type of space an artist uses is relative; it is seldom possible to classify a work as strictly two- or three-dimensional. As a drawing student you may be required to create a flat or an illusionistic or ambiguous space in given problem, but as an artist your treatment of space is a matter of personal choice. Mastery of the spatial relationships of the elements will give you freedom in that choice. Your treatment of space should be compatible with the ideas, subject, and feeling in your work. Along with shape, value, line, texture, and color, proficiency with spatial manipulation can help you make an effective personal artistic statement.

Part 3

A CONTEMPORARY VIEW

THE PICTURE

PLANE

9

New ideas and concepts in art demand a new way of speaking about art. Art changes along with society, and language reflects such change. More traditional art vocabulary is still in use, but artists, critics, and teachers have found new terms to discuss today's compositional concerns. This chapter will introduce some of these new concepts.

In recent years artists have been subverting and otherwise transforming the conventions and aesthetics of earlier times, for example, the substitution of randomness for geometric order. This is not to say that one must not be familiar with former principles of compositional organization, but it is imperative to realize that these principles of design are not locked into place. They may be turned topsy-turvy; they may even be negated.

We confront crowded, disjunctive environments in the real world, so it is not surprising to find this kind of disorder in art as well. Art today encompasses the full gamut of personal expression; we find straightforward work alongside involuted work, the political alongside the comical, direct art statements alongside oblique ones. In other words, art, like life itself, is multidimensional in its pursuit of significance. And in art the means to this diversity go beyond the conventional compositional rules.

CONTEMPORARY APPROACHES TO THE PICTURE PLANE

Part 2 dealt with the way the art elements can be used to create spatial illusion and with some of the ways pictorial space can be controlled through eye level and perspective. As you have seen, treatment of space is a major concern of the artist. This chapter focuses on another contemporary concern, the picture plane and how to handle the problems it presents. Artists have always been aware of the demands of the picture plane—its size, shape, flatness, edges, and square corners. However, many innovations in form in 20th-century art have specifically and explicitly centered around the demands and limitations of the actual physical support or surface on which an artist works.

The picture plane makes certain formal demands on the artist; certain compositional concerns must be dealt with in working on a flat, two-dimensional surface. *Form,* the interrelationship of all the elements, is the way artists say what they mean. In art, form and meaning are inseparable; form is the carrier of the meaning. It is the design or structure of the work, the mode in which the work exists. It is an order created by the artist. In this chapter we will look at some of the specific ways artists handle the picture plane and discuss the ways the picture plane have affected the form of contemporary art.

260. Elizabeth Murray. *Art Part.* 1981. Oil on twenty-two canvases, 9'7" × 10'4" (2.92 × 3.15 m). Private collection. Courtesy Paula Cooper Gallery, New York.

261. Yvonne Jacquette. *Airplane Window.* 1973. Watercolor, 12⅛ × 9″ (53.6 × 22.9 cm). Collection of Mr. and Mrs. John F. Walsh, Jr., New York. Courtesy Brooke Alexander, New York.

Dominance of the Edge

Perhaps the most obvious challenge to the rigidity of the perimeters of the traditional picture plane has been the breakup of its regular shape. Artists of the 1960's led the way for new forms and expressive means; the shaped canvas was one such innovation. Frank Stella gained wide recognition for his relief constructions. His early work was related to Minimalism; he employed symmetry and repetition of line. Over the years Stella has pushed his work increasingly toward a more projective three-dimensionality (see Figure 84). His work has moved from logical, serialized investigation of flatness to a flamboyant, dramatic, expressionistic involvement, that he himself proclaims has affinities with Baroque art.

Another artist known for shattering the traditional rectangular format is Elizabeth Murray. She says she wants her work to look as if it had been "thrown against the wall and stuck there." In Figure 260 the white plane of the background wall plays an important part in the composition; the white negative spaces or intervals become shapes within the composition.

Another example will also demonstrate the importance of the edge of the picture plane; in the watercolor (Figure 261), Yvonne Jacquette uses the airplane window as a border for the view outside the window. This window serves a triple function: It frames another

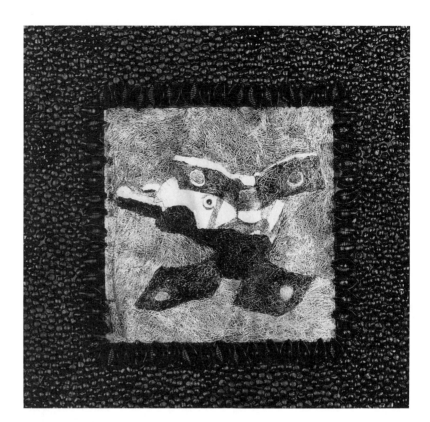

262. Sandy Gault. *Torture XXVIIe: Something for Piyapong.* 1989. Acrylic on cast paper, pasta and lentils on wood, 13 × 13″ (33 × 33 cm). Collection of Lucy Cameron, Stanberry, Missouri.

image, it reiterates the size and shape of the picture plane, and it is a contemporary window into a contemporary space. Here the traditional Renaissance use of the picture plane as a "window into space" has been given a radically new 20th-century look. In this instance the two images, window and outside view, serve a contradictory function. The window border has a beginning and an end—we know where it stops and where it starts—whereas the image outside the window depicts a continuous space, quite literally a limitless one. This highly complicated and sophisticated statement is delivered in a rather simple and straightforward way; both form and image are carriers of a complex message. Jacquette has created a visual/verbal pun in the play on the word "plane" with its double meaning: picture plane and airplane.

A final example will illustrate the emphasis an artist can place on the edge; Sandy Gault's drawing (Figure 262) contains its own frame in the form of a decorative border. The frame is an integral part of the work; it is highly textured and resembles three-dimensional, tightly drawn squiggles. What a surprise to discover it is made of enameled macaroni shells! The centralized image is a can opener, treated like some cherished relic framed in an elaborate, heavy frame. Both subject matter and framing material are unexpected. We share in the artist's joke. Gault chooses unobtrusive, banal subject matter that has nonart associations in order to focus on the marks themselves.

PROBLEM 9.1
Shaped Picture Planes

Go to the library and look at some catalogues of art shows and some books that deal with contemporary art. Focus on those contemporary artists who use nontraditional shaped formats in their work. Look at the work done in the 1960's when this movement was in its early stages of development. We have already mentioned Frank Stella; other artists of the same time are Tom Wesselmann (who cut the picture plane to conform to the shape of the actual object being painted, such as a hand holding a cigarette), Ellsworth Kelly, Kenneth Noland, and Richard Smith (whom we discussed in Chapter 6). Note the evolution of the motif or image in Stella's work from the 1960's to the present.

Elizabeth Murray is only one of the many current artists working with shaped picture planes. Neil Jenney is associated with dominant, sometimes irregularly shaped frames that alter the look of the traditional format. Robert Morris's work makes use of eccentrically shaped frames that are an integral part of his work. Miriam Schapiro uses fan- and kimono-shaped canvases, appropriate to her work as a Pattern-and-Decoration Artist.

The shaped canvas is not only about edge but concerns itself with establishing the plane as an object, giving it a physicality that is different from the dematerialization sought after in illusionistic work.

In your visual research pay close attention to the motif or image and how it relates to the shape of the support. You will discover a broad range of subject matter being used on these structures, from nonobjective to recognizable. Try to determine how subject, content, and support are welded in each work.

This project will not only acquaint you with the important issue of the dominance of the picture plane but also offer you a wider spectrum of work (and in color) than we are able to present in this text.

PROBLEM 9.2
Confirming the Flatness of the Picture Plane

Make two drawings that assert the limits and flatness of the picture plane. You might choose a common, everyday object as subject for the first drawing. Present the object frontally and enclose it with a patterned border. Use a conceptual approach. Combine solid value shapes, outlining, or invented texture within confined shapes, along with reverse perspective to emphasize the flatness of the picture plane. Jim Nutt is a good artist to study before beginning your drawing (see Figure 220 in Chapter 6). Another artist who uses flat shapes but whose subject is taken from real life is Alex Katz (see Figure 275).

In the second drawing, using a subject of your choice, concentrate on a more realistic depiction. Again, use a border to call attention to the flatness of the picture plane even though you have created a spatial illusion within the frame. The photocopy composition in Figure 263 presents the continuous surface of a ballroom floor with

263. Color photocopy drawing. Student work. Mixed media, 18 × 24″ (46 × 61 cm).

moving images of women's feet. The plane of the floor repeats the flatness of the picture plane, although the dancing feet deny a two-dimensional space. An abrupt value change in the border also calls attention to the flatness of the picture plane. This opposition between flat and illusionistic space relays a contemporary concern.

Continuous-Field Compositions

One innovation contemporary artists have made in dealing with the edge of the picture plane is to negate its limitations by making a continuous-field composition; that is, if we imagined the picture plane to be extended in any direction, the image would also extend, unchanged—the field, or picture plane, would continue as it is. For example, if we imagine Vija Celmins's graphite drawing of the sea (Figure 264) to encompass a larger view, it would still have the same continuous image over its surface; there would still be a continuous field of water. Celmins uses a recognizable subject and treats it illusionistically, but this continuous-field effect can be achieved with nonobjective forms as well. Jackson Pollock's work (Figure 265) is less a composition than a process; the action of the artist while painting has been documented. Movement and time have been incorporated to result in a richly energized surface; the limits of the final piece seem somewhat arbitrarily chosen. (Note that the paint drips go off the paper on all four sides.) Again, we can imagine the field to be continuous.

If a recognizable subject is used, as in Stuart Caswell's *Chain Link Disaster* (Figure 266), it must be one the viewer can imagine continues beyond the limits of the picture plane. In comparing the two works by Caswell and Pollock, it is as if Pollock's drips have metamorphosed into the tangled wire of Caswell's drawing. Both

264. Vija Celmins. *Untitled (Big Sea #1).* 1969. Graphite on paper, $34\frac{3}{8} \times 45\frac{1}{2}''$ (87 × 116 cm). Collection Chermayeff and Geismar Associates, New York. Courtesy David McKee Gallery, New York.

265. Jackson Pollock. *Composition.* 1948. Casein on paper mounted on masonite, $22\frac{1}{4} \times 30\frac{1}{2}''$ (57 × 77 cm). Courtesy of New Orleans Museum of Art, Bequest of Victor K. Kiam.

266. Stuart Caswell. *Chain Link Disaster.* 1972. Pencil on paper, 22 × 28″ (56 × 71 cm). Minnesota Museum of Art, St. Paul.

267. Jean Dubuffet. *Storm on the Steeple.* June 1952. Pen and ink, $18\frac{3}{4} \times 23\frac{3}{4}''$ (48 × 60 cm). Location unknown.

works are tense with implied motion; the lines are stretched across the surface. And in both works overlapping darks and lights bind the forms to each other in a complexly layered surface.

Jean Dubuffet's pen-and-ink drawing (Figure 267) seems to be a third variation on the same theme. Here the repeated shapes and overall patterning create a texture that seems to continue beyond the confines of the picture plane. In both the Caswell and the Dubuffet there is no single focal point, no one area that has priority over another, no center of interest. Both works illustrate the denial of the limits of the picture plane.

PROBLEM 9.3
Continuous-Field Compositions

Make two drawings that deny the limits of the picture plane, one using a recognizable, illusionistic image and the second using nonobjective imagery. Create an overall textured surface so that no segment of the drawing has precedence over another. There should be no dominant center of interest. Try to create the illusion that the image extends beyond the confines of the picture plane. In the student drawing (Figure 268), shapes resembling flagstones serve as the motif. The use of line, value, and texture is consistent throughout the drawing. The shapes fill the picture plane with no priority of focus. We can easily imagine that the image extends beyond the edges of the paper.

268, above. Continuous field composition.
Student work. Colored pencil, 9 × 12″
(23 × 30 cm).

269, right. Claes Oldenburg. *Floating Three-Way
Plug.* 1976. Etching and aquatint, 42 × 32¼″
(107 × 82 cm). Published by Multiples Inc., New
York.

Arrangement of Images on the Picture Plane

The importance of the relationship between positive and negative
space has been emphasized throughout the book. In dealing with the
demands of the picture plane, this relationship is again crucial. Posi-
tioning of positive and negative shapes is of utmost importance. By
placement the artist may assert or deny the limitations of the picture
plane.

Placement of an image calls attention to the shape and size of
the plane on which it is placed. (Too small a shape can be dwarfed by
a vast amount of negative space, and too large a shape can seem
crowded on a small picture plane.)

Center, top, bottom, and sides are of equal importance until the
image is placed; then priority is given to a specific area. Centralizing
an image results in maximum balance and symmetry, and if that
centralized image is stated frontally, the horizontal and vertical for-
mat of the picture plane will be further reinforced.

In his print (Figure 269) Claes Oldenburg centralizes a three-
way plug. The image is made static by its placement; the stasis is
further enhanced by the use of the enclosed shapes, especially the
closed circles. Such complete balance in the positioning of the image
permits no movement. Oldenburg, in typical, whimsical contradic-

270, left. Susan Hauptman. *Line Drawing #46*. 1970. Pen and ink on masonite, 14 × 10½″ (36 × 27 cm). Minnesota Museum of Art, St. Paul.

271, right. Robert Lostutter. *Emerald Bird on Sunset*. 1985. Watercolor on paper, 8 × 9¾″ (20.3 × 24.8 cm). Courtesy Dart Gallery Inc., Chicago, Illinois.

tion, makes the plug seem to levitate or float by bisecting the shape with a line. So now we interpret the image as suspended between sky and water, as being submerged midway between air and water. Several hints are dropped for this reading of the image—the triangular ship sail and the cursive writing in the water, "floating plug in sunset." Scribbles radiate from the sun in the upper half. These marks activate an otherwise static space.

In some contemporary work the center is left empty. A void seems to crowd the images to the edge. This is especially true in Susan Hauptman's drawing (Figure 270), which can be read on two levels—either as a tangled web of threads or as an abstract, tangled mass of line. The placement calls attention to the bottom and side of the paper and tests our sense of gravity. Does the thread fall to the bottom, or is it being pulled forcibly by the bottom mass?

In Robert Lostutter's *Emerald Bird at Sunset* (Figure 271), the picture plane is divided diagonally, an unusual compositional device. Spatially, the work is confounding. The bird-man is statically placed in the upper left corner, his beak-nose paralleling the divided plane. The area below him depicts a deep space of clouds and sky, while the empty, white triangle seems conceptually charged. We can begin to decipher Lostutter's work in reading his poetry, in which images of

"an imperfect edge," flight, paradise, and seasonal references to wintertime appear. In this work the function of the divided plane is to convey the meaning of the work.

Don Scaggs encases his diary drawing in a vinyl packet (Figure 272). An interesting interchange between positive and negative shapes takes place in the center white space. At times this space appears to be an empty, negative space; at other times it seems to be a torso. The shapes along the edge press inward on the torso. We do not see the torso shape in its entirety; there is an implication that this form has been cut off, that the image continues beyond the confines of the border.

Another technique for asserting the picture plane is to crowd the picture surface with a great number of images. This device eliminates a priority of focus. Seemingly unrelated images of contradictory size, proportion, and orientation announce that the picture plane is not a place for a logical illusion of reality; rather, it is a plane that can be arranged any way the artist chooses, as in the print by Dennis Corrigan (Figure 273). Images are juxtaposed in odd ways in *Queen Victoria Troubled by Flies*, where the incongruity of the subject matter is underscored by the large scale of the flies and the seemingly inexplicable image the queen is holding. Or does the figure recede into her bosom? Could the clownlike figure be a metaphor for the monarchy,

272, left. Don Scaggs. *Diary 17/18: Dad's Chuckles.* 1975. Mixed media on paper, encased in vinyl envelope, 46 × 30″ (117 × 76 cm). Courtesy the artist.

273, right. Dennis Corrigan. *Queen Victoria Troubled by Flies.* 1972. Cronaflex, 13 × 10½″ (33 × 27 cm). Courtesy Associated American Artists, New York.

"the puppet of the state"? The transformation of the queen's headdress into an insect form further confuses our interpretation.

Some artists seem to disregard accepted norms of taste and form and intentionally to break all rules. Such an artist is Öyvind Fahlström (Figure 274). Viewing his *Notes "150 Persons,"* we are exhausted by the number of images, their scale and placement, and the difficulty of sorting out words and images. The artist gives no help in what we are to look at first. Positive shapes crowd out negative space. Some semblance of order is introduced by the square segments, which read from left to right, but these give way to a burst of images that, for the most part, are unidentifiable. The result is a highly complicated, textured surface in which images are cut off at top, bottom, and sides. Fahlström asserts the picture plane as a plane to deposit images, but he denies it as a limiting factor in the drawing.

Frequently artists use a single positive image to crowd out the negative space, as does Alex Katz in his lithograph to Frank O'Hara (Figure 275), which presents a point-blank stare of a youthful, empty face. The figure is cropped on all four sides by the edges of the picture plane. Katz denies the limits of the paper in this close-up, blown-up view. We are forced to come to terms with the unblinking eyes in the empty, negative shape of the face. While Katz's figures are extreme

274, left. Oyvind Fahlström (American, 1928–1976). *Notes (150 Persons).* 1963. Tempera and black ink, $18\frac{5}{8} \times 23\frac{3}{4}''$ (47.3 × 60 cm). Gift of Mr. and Mrs. Edwin A. Bergman, 1983.865. Photograph © 1991 The Art Institute of Chicago. All Rights Reserved.

275, right. Alex Katz. *Homage to Frank O'Hara: William Dumas.* 1972. Lithograph, $33\frac{1}{4} \times 25\frac{1}{2}''$ (84 × 65 cm). Edition of 90. Courtesy Brooke Alexander Editions, New York.

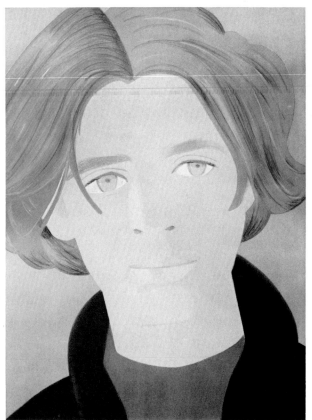

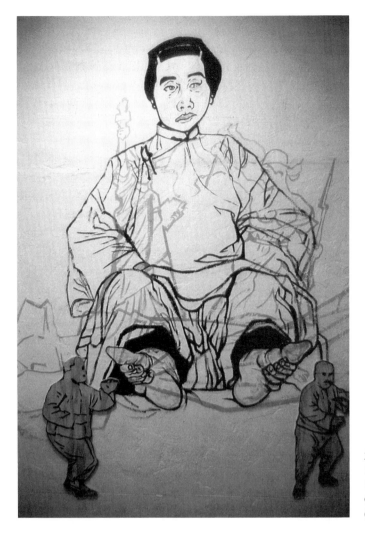

276. Hung Liu. *Trauma* (detail). 1989. Mixed media installation at Sushi Gallery, San Diego, California. Dctail approx. 80 × 64″ (2.03 × 1.63 m). Courtesy the artist.

simplifications of the human form, they are, nonetheless, real portraits. Katz's paintings are at once a picture of a class and of a single individual.

A compositional approach that has found favor with a number of contemporary artists is the use of overlayed or superimposed images. Hung Liu layers distinct but symbolically related images in her installation entitled *Trauma* (Figure 276). Liu, a native Chinese artist, makes work that is politically charged. In one wall of the installation she superimposes a drawing of a traditional Chinese woman, her feet bound, with images of the Statue of Liberty and the Goddess of Liberty (the figure of *Liberty Leading the People* created by the 19th-century painter Eugène Delacroix). The two liberty symbols were used by the Beijing students in their uprising in 1989 in Tiananmen Square. The three juxtaposed figures are in uneasy balance; they are a metaphor for a culture that is tradition bound and in the throes of trauma; hence the title of the work. In Liu's work the rigidly balanced, centralized figure dominates the wall. By hierarchical scale

and placement Liu helps us realize that tradition is not easy to unseat. In Post-Modernist work, such as Liu's, formalist concerns are in the service of content. How different the meaning would be if the three images—the Chinese woman, the Statue of Liberty, and the French Liberty—were separate and of equal size. It is the cultural context that provides the means of interpreting the work.

PROBLEM 9.4
Placing Images on the Picture Plane

Make two drawings in which placement is the prime concern. In the first drawing use a nonobjective centralized image. Present the image frontally. In the student drawing in Figure 277, space is limited; there are no diagonals; the composition utilizes several simple geometric motifs. The static composition is activated by small circles, crosses, and triangles, which pulsate within the grid. The media are freshly handled; the finished drawing resembles a primitive weaving. It has a direct, energetic appeal.

In the second drawing emphasize the edges or corners of the picture plane. Position the image so that corners or sides are activated. You may use either an abstract image or a recognizable one. For different solutions to this problem see Figures 106, 270, and 271.

277. Centralized image. Student work. Pastel and turpentine, 30 × 22″ (76 × 56 cm).

PROBLEM 9.5
Crowding the Picture Plane

Make a composition in which you crowd the surface with a great number of images. They can be totally unrelated—some recognizable images mixed with abstract or nonobjective shapes. You might use your sketchbook for this exercise. Over a period of a week make a collection of drawings, all on the same page. You might include some writing, notes to yourself, scraps of information, quotations that appeal to you. Avoid a symmetrical or balanced distribution of images, especially in the beginning. Overlap some of the images. Turn your paper so that the orientation is flexible. Try not to think in terms of bottom, top, sides.

After you have crowded the picture plane with an array of images, impose some minimal order by use of value or by connecting lines and shapes. Avoid the development of a focal point. Your final drawing could somewhat resemble a continuous-field composition.

PROBLEM 9.6
Filling the Picture Plane

In this problem you are to use a single image that completely fills the picture plane. You may enlarge a detail of a form, or you may crowd out the negative space by filling the picture plane with the image. Confront the viewer with a composition that is cropped top, bottom, and sides by the edges of the paper.

DIVISION OF THE PICTURE PLANE

Another formal means contemporary artists have used to meet the demands of the picture plane is the grid, which divides the picture plane into units or segments. In addition to reiterating the flatness of the picture plane, its horizontal and vertical shape, the units introduce the element of sequence, which in turn brings up the idea of time. More traditional art is viewed synchronically; that is, the composition is seen all at once in its entirety. Grid compositions, on the other hand, are viewed both synchronically and linearly. We, of course, see the entire work at a first glance, but when we take a more sustained look, the composition demands to be read sequentially, segment by segment.

Pat Steir's drawn-on canvas (Figure 278) has been gridded by intersecting lines in the upper two-thirds and by horizontal lines in the lower third. The grid alternately advances and recedes in different segments of the painting. Pronounced rectangular shapes are distributed throughout the composition, again calling attention to the horizontal/vertical axis. The irregular line that divides the two major segments can be read either as the horizon or as a fluctuating graph line. The loosely stated marks and drips cancel out the otherwise

278. Pat Steir. *Three Green Days.* 1972. Oil, crayon, pencil, and ink on canvas, 6 × 9″ (1.83 × 2.74 m). Collection Mrs. Anthony J. A. Bryan.

rigid format. Certainly, the idea of sequence and of time is reinforced by the title *Three Green Days.* Our reading of the work is both synchronic and sequential.

Rob Erdle uses an implied and irregular grid in his watercolor *Tetuan* (Figure 279). The units vary in size and shape; each segment is slightly tilted, slightly off square. These irregular segments and their interior shapes overlap adjacent units, creating a complicated interplay. This unpredictable type of grid, while affirming the picture plane on one hand, seems also to defy its flatness. We feel that if each unit in Erdle's work were cut out and reassembled in a strictly horizontal and vertical format, the newly constructed plane would be larger than the original one.

The grid can be stated in a sequential pattern to suggest a stopped-frame, or cinematic, structure. While grids can be read in a number of ways—horizontally, diagonally, or vertically—in cinematic structure each frame logically follows the other. There is a definite sense of time lapse and movement.

These stopped-frame compositions use a regular geometric frame (like the segment of a piece of film) as in Steir's flower painting (Figure 280). This three-part composition is conditioned by modern technology, by close-up photography. The viewer is forced to adjust to the rapid change in scale from the first, rather distantly conceived object to the disproportionately large scale of the same flower in the third section. The traditional boundaries between realism and abstraction are also called into question in this single painting. The final segment seems more closely related to the Pollock in Figure 265 than to the painting of the small vase on the left. This relation is especially apparent when you realize that each segment in the Steir painting measures 5 feet (1.53 m) square.

279, left. Rob Erdle. *Tetuan.* 1976. Watercolor and graphite, 3′ × 4′4″ (.91 × 1.32 m). Private collection.

280, below. Pat Steir. *Chrysanthemum.* 1981. Oil on canvas, 3 panels, each 5 × 5′ (1.52 × 1.52 m). Collection Gloria and Leonard Luria.

Jody Mussoff uses a segmented picture plane, related to a stop-frame composition—gridded at the top, with one large segment at the bottom—for her drawing *Atlas* (Figure 281). Mussoff uses the theme of passage, states of growth and change, in her work. Conceptually, then, the divided picture plane is appropriate for the content. Close-ups of the girl's face seen from different angles fill the four top units. The eyes are intently focused in each segment, while the figure of the kneeling girl is tentative in her pose and in her glance. We cannot help but think of gravity and weight with the name *Atlas;* it leads us to question what this young female Atlas is supporting. We assume that vision is another major theme—the eyes are certainly the dominant feature of the top planes. We can reasonably assume that the subject of this powerful work deals with the role of the artist, with growth, vision, support, performance, vulnerability. While the

281. Jody Mussoff. *Atlas.* 1986. Colored pencil on paper, 48½ × 60″ (123.2 × 152.4 cm). Collection of Mr. and Mrs. Irving Tofsky.

subject may deal with vulnerability and the pose may portray a tentative position, Mussoff's line quality is strong and assured; it builds a powerful structure on which to hang a world of meaning.

In cinematic grids, visual reinforcement of the picture plane comes from the contained images. Conceptual denial is suggested by the idea of continuation, by the idea that with a longer lapse of time come more stopped-frame images.

While most stopped-frame compositions use a regular geometric division, a linear, sequential arrangement can be achieved by omitting the lines that divide the units. A long, narrow format is ideal for work that requires a sequential, linear reading such as Francesco Clemente's drawing *Non Morte di Eraclito* (Figure 282). Time is central to the unraveling of Clemente's work; movement and dislocation are repeating themes. His work is more symbolic than narrative; he invents himself; he stars in his own dramas, meditations on the body and on desire. By placing the drawing at floor level, Clemente, in his two-dimensional manifestation, seems to engage us in a silent conversation as we stroll along with him throughout the length of the extended picture plane.

Recent artists seem to have abandoned the formal, rigid, grid format in favor of a picture plane divided into two or three segments— a *diptych* is a work in two parts; a *triptych* is a work in three parts. In these contemporary works, the images in each unit are discontinuous; that is, they seem not to belong to each other. The viewer is forced to try to relate the seemingly unrelated sections. This format is widely used by Post-Modernist artists; it fills a conceptual need.

282. Francesco Clemente. *Non Morte di Eraclito*. 1980. Charcoal and pastel on paper mounted on canvas, 79 × 335″ (201 × 850 cm). Courtesy Galerie Bruno Bischofberger, Zurich.

283. David Salle. *Zeitgeist Painting #4*. 1982. Acrylic and oil on canvas, 156 × 117″ (396 × 297 cm). Saatchi Collection, London.

Throughout the text we have mentioned such strategies as deconstruction, appropriation of images from pre-existing sources, exposés of accepted norms. At the root of all these concerns is the problem of context. Meaning or interpretation must have a context in which to develop. The divided picture plane is a conceptually loaded formal device to aid the artist in establishing context—even discontinuity between images—that has the underlying purpose of expanding or questioning our cultural and personal attitudes.

In David Salle's work we are forced to examine appearances carefully (Figure 283). He presents the viewer with layers of meaning. Formally, he uses superimposed images along with a divided picture

284, left. Rick Floyd. *The Whole Battle of Splinters.* 1990. Charcoal and acrylic on paper, 20 × 22¼″ (50.8 × 56.5 cm). Courtesy the artist.

285, above. Robert Longo. *Men Trapped in Ice* (triptych). 1979. Charcoal and graphite on board, each panel 60 × 40″ (152.4 × 101.6 cm). Saatchi Collection, London.

plane to dramatize his psychological subject matter. Like de Kooning (see Figure 207), Salle's theme is women, the images of which are taken from the media. He uses dissociated images, unrelated styles within the same work, titles that only add another confusing layer. All contribute to a sense of disjointedness; he forces viewers to create their own connections between the disparate parts.

In Rick Floyd's work (Figure 284) the divided picture plane is much less rigid; the division seems to be conceptually related to the figures in the upper segment. These conceptualized, invented, somewhat menacing shapes with their skeletal forms seem either to be rising out of or sinking into the black, murky, watery shape below.

Robert Longo, an artist who focuses on the theme of tension in urban life, uses a multiple format, a triptych, in many of his works. His series of *Men in the Cities* are life-sized drawings of young professionals "frozen" in ambiguous poses (Figure 285). They seem to be victims of unseen forces, pushing, pulling, distorting them. Longo isolates the figures in an empty void—a formal means to a conceptual end—and he further distances the figures from one another by framing each unit separately, although he intends the three pieces to be viewed as a unit. Longo takes his subject matter from mass media-derived symbols of power and of "the good life," a theme of another of his series whose intent it is to expose media-propagated symbols.

Loosely related to the divided picture plane is the composition with an inset. In older, more traditional work, the artist always felt free to draw a detail or to rearrange the composition in some area of the drawing. In contemporary work, this latitude has been claimed as

286. Leonel Góngora. *Transformation of Samson and Delilah into Judith and Holofernes.* 1970. Lithograph, 29½ × 22″ (75 × 56 cm). Courtesy the artist and Udinotti Gallery, San Francisco.

a favored compositional device. An inset creates an opposition between itself and the primary subject and sets up a feeling of discontinuity between the two images. In Leonel Góngora's lithograph (Figure 286), the artist has used several insets; in fact, all three figures plus the dark rectangle at the top of the page are set off by encircling marks. The centralized, transformed head of Samson dominates the loose composition. Góngora's beheading of Holofernes (by the encasement of the head in a white frame) parallels the actual decapitation by Judith. Góngora draws an analogy between the two biblical tales, the shearing of Samson's hair by Delilah and the beheading of Holofernes by Judith. In his palimpsestlike, layered drawing, Góngora pays tribute to a favorite Renaissance art theme, Judith's victory over Holofernes.

PROBLEM 9.7
Composing with a Grid

Make three drawings in which you use a grid. In the first drawing, establish a grid with each unit the same size (Figure 287). In the second drawing, lightly establish the grid; then use value, texture, and/or line to negate the regular divisions. Try to achieve an overall effect as opposed to a sequential reading of the drawing. In

287. Grid of equal size units. Student work. Felt-tip pen, 16 × 20″ (40.6 × 50.8 cm).

the third drawing, use a grid of irregular units. You might use a concentric grid, or a grid in only one area, as in the Mussoff drawing (see Figure 281), or you might simply imply a grid structure.

PROBLEM 9.8
Dividing the Picture Plane

Using a picture plane that is exactly twice as wide as it is high, divide the format into two equal segments. Make a drawing with an image in one half totally unrelated to the image in the other

288, left. Divided picture plane–visual cliché. Student work. Chalk and pencil, 36 × 24″ (91 × 61 cm).

289, right. Inset. Student work. Oil stick, 12 × 14″ (30 × 36 cm).

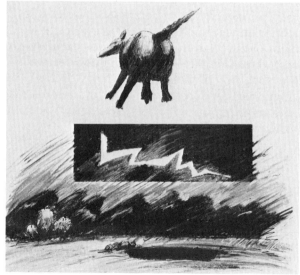

half. This is not as easy to do as it sounds, since we attempt to relate any two images seen simultaneously. For the first image you might choose a visual cliché, an image that is well known to everyone in American culture, such as the Statue of Liberty. Try to pair with the first image another subject that is totally unrelated by form, media, technique, scale, or meaning. The result should be a very disjunctive composition, one that is unsettling to the viewer. See Figure 288 for one solution to this problem.

PROBLEM 9.9
Using Inset Images
Make a drawing that employs an inset. The inserted image may or may not be related to the larger drawing (Figure 289). Again, you might change subject, style, media, or scale in the inset.

PROBLEM 9.10
Using Linear Sequence
In this problem you are to repeat an image in a linear or cinematic sequence. The drawing may progress from left to right across the page or move in a vertical direction from top to bottom. Keep in mind the idea of a time lapse. This may be achieved by having the image undergo slight changes from frame to frame. Try to create a sense of expectation as you progress along the picture plane.

Another option for subject is a narrative sequence; for example, you might take an imaginary character through a catastrophic day.

SUMMARY:
Personal Solutions/Different Kinds of Order

You have looked at and discussed a number of ways contemporary artists have dealt with the demands of the picture plane. The list is by no means comprehensive, for each time artists are confronted with the clean, unblemished surface of the picture plane, new problems arise. Out of the artist's personal and subjective experience come the solutions to these problems. For many artists the response to the demands of the picture plane is on a highly conscious level; in others the response is more intuitive.

In your own work, whatever approach you take, the solutions or resolutions should not be turned into formulas, for there are no pat answers to any problem in art. Involvement in your own work and familiarity with the concerns and styles of other artists will help you solve your own problems in a personal and exciting way.

THEMATIC

DEVELOPMENT

<div style="text-align: right;">

10

</div>

This chapter on thematic development continues investigating contemporary issues in art and emphasizes artists' conceptual and highly personal involvement in their work by taking a look at the process of producing that work—the welding of idea, content or meaning, image, and form. A study of thematic development will show you the variety of ways artists use particular concepts so that you can better understand your own individual options.

Thematic drawings are a sustained series of drawings that have an image or idea in common. Artists have always worked in thematically related series, but a contemporary concern with process has made thematic development especially evident today. Galleries and museums not only display works in series dealing with a single theme but also show working drawings leading to more finished pieces. Since the trend toward thematically related works is particularly current, this chapter focuses on the ways a body of related work can be developed.

There are a number of reasons to develop a series of drawings based on a single theme. The most basic reason is that art involves the mind as well as a coordination between eyes and hand. Art sometimes begins with an exercise in thinking and moves to an exercise in doing. Just as frequently, the order is reversed, but the processes of thinking, observing, and executing a work are always in tandem. The emphasis in thematic series—and the emphasis throughout the problems in this chapter—is on process rather than product.

Any drawing problem has many possible solutions. Thematic drawings, since they are an open-ended body of work, provide a way to express more ideas or variations on an idea than it is possible to address in a single drawing. Nothing can better illustrate the number of possible compositional and stylistic variations on a given subject than a set of connected drawings. Since you will be using only one subject or idea throughout the series, you are free to attend more fully to matters of content and composition.

A thematic series allows you to go into your own work more deeply, with more involvement and greater concentration. Further, you work more independently, setting your own pace.

Finally, the process of working on a series develops a commitment to your ideas and thereby a professional approach. And, like a professional, you will begin more and more to notice the thematic patterns in other artists' work.

A first step toward developing thematic drawings is to look at the way other artists have handled a theme in their works. This chapter discusses three general categories: *individual themes*, chosen by individual artists; *group themes*, developed within a movement or style, such as Cubism or Impressionism; and *shared themes*, the same images or subjects used by different artists over a period of time.

INDIVIDUAL THEMES

An example of individual thematic development can readily be seen in the works of Jasper Johns (Figures 290, 291, 292). Johns has used the cross-hatch pattern since the early 1970's. The motif has been interpreted on a number of levels: 1) as abstractions, 2) as subtle compositional structures, 3) as symbolic of something camouflaged or hidden, 4) as a reference to traditional pictorial elements, 5) as a pictorial device appropriate for concerns with process and systems, 6) as an analogy for a covering such as the stretched canvas, and 7) as a motif for the artist's personal signature. In Johns's work in the early 1970's he used this motif in a nonobjective mode on panels of equal size, using different media on each subsection. In these works each subsection of cross-hatch complied with a preset system; variations in color and scale contributed to a change in mood.

In the three examples shown here, the cross-hatch motif has undergone a transformation. The apparently abstract patterning is more dimensional; its source is a detail of the demon of the plague in Matthais Grünewald's early 16th-century painting, which Johns has abstracted and reversed, or turned upside down. This citation has been the subject of much critical investigation. Without clues to help locate the hidden image, the average viewer could not detect the disguised reference, but this strategy lies at the very heart of Johns's work; doubleness of meaning and of appearance are prime concerns.

In the latest phase of his career, Johns uses more recognizable imagery. In addition to the cross-hatch motif, other recurring images are the clothes hamper, the faucet, the skull, the double flags (one

290. Jasper Johns. *Untitled*. 1983. Ink on plastic, 24¾ × 36¼″ (63 × 92.1 cm). Collection, The Museum of Modern Art, New York. Gift of The Lauder Foundation. © Jasper Johns/VAGA New York 1991.

with forty-eight stars; the other with fifty—again, the question of doubleness), a vase, and a rather clumsily drawn head of a woman with a feather curling out of her hat. Johns has established a theme by using the same images and the same format (the diptych) throughout the 1980's. These images and format are the language Johns uses in his visual speculations on art, and they are the means he uses to tell us that things are not what they appear to be. The idea of multiple appearances and of art as the ground of his work has its visual equivalency in the divided picture plane. (In each of the three drawings, the Grünewald cross-hatch always appears on the left; it is the continuing ground of the entire cycle of work.) Not only is the picture plane divided into two major sections, each section is further subdivided into planes within planes. Johns has had a continuing interest in pictorial space from his early work to the present; segmentation is one manifestation of that involvement. He is interested in the part as opposed to the whole. The right picture plane functions as a wall on which two-dimensional objects are attached (note nails and shadows), while the objects that refer to dimensional shapes in the real world, basket, faucet and vase, are singularly flat.

Two images are especially worthy of note; they are both picture puzzles, paradoxes. The white vase can alternately be seen as a vase or as two facing profiles, male and female (again, doubleness of identity; the one on the left is Johns's profile). The drawn figure of the woman on the right is another composite, a borrowed 1915 cartoon, originally titled *My Wife and My Mother-in-Law*; she is either a young woman with her features turned away from the viewer, or she is an old crone depicted in profile view with a huge nose, her head lowered into her fur collar. Johns tests our perceptual quickness and requires us to form relationships and distinctions between the parts. Refer-

291. Jasper Johns. *Untitled*. 1983–1984. Ink on plastic, $26\frac{1}{8} \times 34\frac{1}{2}''$ (66 × 87.5 cm). Collection of the artist. © Jasper Johns/VAGA New York 1991.

292. Jasper Johns. *Untitled*. 1986. Watercolor and pencil on paper, $24\frac{5}{8} \times 35\frac{1}{2}''$ (62.5 × 90 cm). © Jasper Johns/VAGA New York 1990.

ences to mortality reverberate through these works—the skull, the two ages of woman, the Grünewald citation. And mood changes from drawing to drawing—from an atmosphere heavy and stormy to a lighter one with a summery feeling. These contrasts are crucial to Johns's concerns, to his continuing thematic dialogue on art and mortality. His 1986–1987 series of paintings, prints, and drawings is entitled *Seasons*, that traditional metaphor for growth, change, death, and renewal.

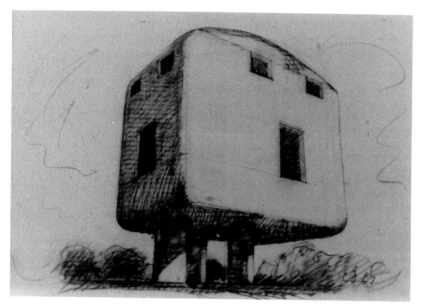

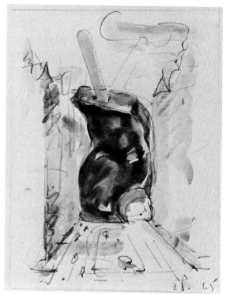

293, left. Claes Oldenburg. *Building in the Form of an English Extension Plug.* 1967. Pencil, 22 × 30″ (56 × 76 cm). Collection James Fleck, Toronto.

294, right. Claes Oldenburg. *Proposed Colossal Monument for Park Avenue: Good Humor Bar.* 1965. Wash and crayon, 23½ × 17½″ (60 × 44 cm). Collection Carroll Janis, New York.

We have discussed Johns's work at length, not only because it is so rich and full of meaning, but because it shows how an artist's theme and variation can extend over a lifetime of work. In Johns's art, we find a consistency of images or motif and a continuing involvement in formal concerns, especially that of pictorial space. His work has become much more personal in the latest phase of his career, in which he uses more figurative references and recognizable images. Throughout his work he has maintained an intense investigation into the ways in which pictorial space reflects and represents real space.

On a lighter note, Claes Oldenburg's proposed monument drawings are thematic on a number of levels: They deal with imagined installations of familiar objects on an actual geographic site; they combine, as Oldenburg says, "two kinds of scale—the landscape and the object—in a single space (a sheet of paper);" they make use of shape analogy; and they deal with transformation of a very witty nature. In *Building in the Form of an English Extension Plug* (Figure 293), the plug shape is rather architectural; it is easy to see how it might be enlarged to make a modern-looking building. Oldenburg explains the appropriateness of using this design for a church in that the three openings suggest a cross and in that both plug and chapel can be identified with power, one electrical and the other religious. We see two analogies—one by shape, the second by concept.

Oldenburg's emphasis is not on a polished, finished drawing, but rather on an idea, a concept. His drawing style is energetic; sometimes he uses simple indications with just enough information to convey the idea, as in the Good Humor Bar monument (Figure 294). He has used a shorthand approach, but the viewer has no difficulty translating the squiggles into buildings, streets, traffic, and sky.

A final example of individual thematic development is Tom Sale's *Self-Study Primer* (Figure 295). Formally, this series is unified by media, technique, and image. Each segment is drawn on a blackboard, separately framed; each unit employs a limited number of images juxtaposed with a title that gives some clue as to how to interpret the drawing. In one drawing a fishing lure with an eye-hook is combined with a centralized image of teeth; the single word written in a style akin to that in a handwriting manual reads "Pacify." The second panel in the triptych has a rocket, a fingertip bone, a pencil, and the words *Distal Phalanx*. How are we to interpret such disparate images? Are they connected? What if anything, do they have in common? Artists frequently develop a personal iconography, as in Johns's work, that may be difficult to comprehend. The effort to discover, to unravel their meaning is a vital part of the art experience. Subtle connections emerge, testing our interpretative and deductive reasoning. We can approach this triptych as if it were a game. Our first major clue in unraveling the meaning comes from the title, *Self-Study Primer*; we can assume that these drawings are lessons, a symbolic self-portrait. Two of the boards contain images that refer to seeing: the eye-hook on the fishing lure (two visual/verbal puns). In the third drawing, a face is made of objects: rocket-eyes, bone-nose, pencil-mouth. What are the connotations of the objects? They seem to have double functions; in the fishing lure, there is a hook; the eye can be snagged. The rocket and pencil function as arrows, directing the viewer's line of vision; they, along with the teeth, are sharp; they could be a danger. The word *Pacify* defuses the danger; one of the functions of art is to blunt the hooks of existence. The shoulder blade is also a visual/verbal pun (shoulder blade/knife blade). It appears with the words *Boy Enemies*, reminding us of the games even big boys play with knives and rockets. The *distal phalanx* is the name of the first joint in the finger—also a pointer, a means of directing atten-

295. Tom Sale. *Self-Study Primer.* 1990. Oil pastel on chalkboard with wood, each segment 18 × 24″ (46 × 61 cm), overall 24 × 54″ (61 × 137 cm). Collection of the artist.

tion. Pointers direct you where to look, lures intrigue, eye-hooks grab or capture, rockets destroy, pencils create, teeth bite lures, and so on. We see the makings of a story in these seemingly incongruent images and words. Contradictions and oppositions seem to be contained within a single image; images and words play interchanging analogy games. We see how an artist can look at objects outside of art and reassemble them to make new meanings. Images fade in and out like half-remembered ideas. The erased images, Sale says, indicate that there are layers of images, built from back to front; others are ready to appear to create new sets of oppositions, contradictions, metaphors for making and looking at art, and, as the artist says, for creating the self. The artist, like his art, is in the process of becoming.

Our discussion of individual thematic work has been quite involved. We are dealing with matters of content in order to introduce you to only a few of many options that are available when you embark on a project of theme and variation. Media, subject, images or motifs, formal decisions, technique, and style—all have a role in thematic development. Let us now look at some suggestions for beginning a thematic series.

PROBLEM 10.1
A Series of Opposites

Chapter 9 discussed the divided picture plane and how contemporary artists frequently create a feeling of disjunction by placing together two highly dissimilar objects. In this series you are to choose one object that will appear in each drawing. With that constant object juxtapose another object that will either amplify or cancel the first object's meaning or function.

296. Gael Crimmins. *Spout* (after Piero della Francesca, *Duke of Urbino*). 1983. Oil on paper, 22 × 22½″ (56 × 57 cm). Private collection, Los Angeles.

In Gael Crimmins's *Spout* (Figure 296), she combines Piero della Francesca's 15th-century portrait of the Duke of Urbino with a small milk carton that is in some strange way analogous to the Duke's profile. By this surprising pairing we can read multiple meanings into the work: the debt of modern artists to Renaissance art, the dominance of man over nature, the richness of the old compared with the depleted, ordinary, contemporary carton.

In your drawings give real consideration to both the visual and conceptual effects of the opposites. Do they repel or attract?

PROBLEM 10.2
Transformation

Another way of developing a private theme is to have an object transform into another one. The two subjects need to be visually analogous to be transformed. In the student chair series in Figures 297 to 299, the torso merges with the chair, uniting and changing both figure and chair. The student has given the chair human characteristics; it has been anthropomorphized. You should begin with analytical drawings of both objects before you begin the metamorphosis.

297. Transformation. Student work. Pastel, 21 × 23″ (53 × 58 cm).

PROBLEM 10.3
Transformation/Using Computer Generated Images

This problem is, of course, optional. Because many art programs have computers available to their students, we are including a problem dealing with this contemporary medium.

The process of drawing with a computer is closely related to design. The distinction that we make between drawing and design is that in design there is a stated problem to solve and goals to be met. In this drawing you are to respond to what you see on the computer screen, allowing the image to govern what happens next: Do not let preconceptions interfere with the process.

298, left. Transformation. Student work. Pastel, 21 × 23″ (53 × 58 cm).

299, right. Transformation. Student work. Pastel, 21 × 23″ (53 × 58 cm).

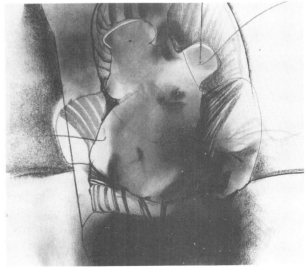

300. Danielle Fagan. *Fish Book.* 1990. Computer-generated book, $8\frac{1}{2} \times 11''$ (21.6 × 28 cm). Collection of the Artist.

Use a program that allows input from a video camera to capture the image; alter it, converting the image to lines, dots, or value shapes. Scanners are used for image input. You might find some interesting black-and-white images in a science textbook or in a book of illustrations. You can use some grid images that come with the programs. Stretch, distort, enlarge, and/or crop on the computer. (You might include some words in your drawing. Various typefaces also come with computer programs. These, too, can be manipulated, altered, enlarged, etc.)

Print your computer-generated drawing on a laser printer, and then photocopy it—either enlarging or reducing the image to produce an appropriate scale.

Figure 300 shows pages from a book that was produced entirely on a computer. Danielle Fagan used only one image of a fish which she manipulated—stretching, compressing, enlarging, deleting, compiling, combining with some found texts all referring to fish. A grid has been altered to become a net, which is printed in red ink on clear acetate and is dispersed throughout the book, as if to catch the fish on the pages underneath. Blue paper is used for some of the pages, as an obvious reference to water.

The artist says the fish is a metaphor for the artist, who might "fall prey to fishermen or be trapped in the outer isles." She recommends a metaphorical summer as the time to go fishing, fishing for new ideas, images, questions, and answers.

One final comment before we move on to our next project: Computers can be good tools for artists, especially beginners, because they allow students to use and create more sophisticated images at an early stage in their work. Frequently, beginning students want to produce more elaborate work than their hand skills permit. Using the computer will allow you to produce many variations quickly. You do not have to imagine what it would look like if, for example, you made it bigger, made it blue, moved it to the left, doubled it, or turned it

sideways. The computer can turn your "what ifs" into concrete images. Computers are experimental tools; they can be freeing; they do not produce work that is "precious"; images can be discarded and retrieved easily. They do have a "sneaky" aesthetic and process all their own; it is important not to buy into it completely. In the hands of an artist with an established knowledge of art, they can be helpful aids, and the resulting drawings can be very creative. It will be very exciting to see what happens, the changes that occur, when young artists who have had this advantage mature.

PROBLEM 10.4
Visual Narration

A further suggestion for developing a series of drawings is to think of a visual narration. You might establish a language of privately developed symbols, as in Johns's and Sale's work.

In Figures 301, 302, and 303, the rooster is the repeating image. In the first drawing of the series, the student carefully observed and rendered the rooster's head, drawing from life. Behind the rooster is a

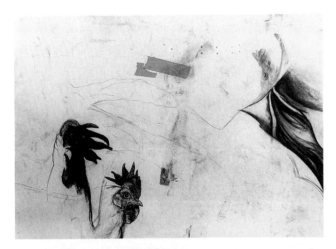

301, left. Visual narration. Student work. Charcoal, carbon pencil, and brown paper tape, 36 × 48″ (91.4 × 121.9 cm).

302, below left. Visual narration. Student work. Charcoal and carbon pencil, 36 × 48″ (91.4 × 121.9 cm).

303, below right. Visual narration. Student work. Charcoal and carbon pencil, 36 × 48″ (91.4 × 121.9 cm).

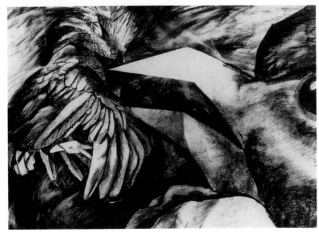

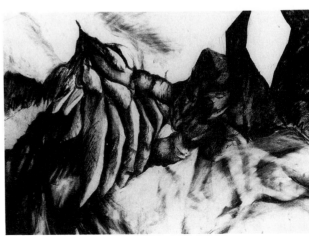

menacing shape, a shadow, a transformation. Even in this initial drawing, a direction is set. The marks on the paper indicate the artist is feeling his way through some formative ideas. The white space of the paper is activated by the tension between the three images; on the right side of the picture plane is a detail of a feather, enormously blown up. There is already in the early stages of the series an abstraction of the bird. This abstraction increases as the series progresses (Figures 302 and 303). The thematic series never loses contact with its subject, although in many of the drawings a claw, or a beak, or an eye are the only recognizable parts of the rooster. Jagged shapes, distortion, the idea of conflict, even of terror, produce a dramatic story.

PROBLEM 10.5
Developing a Motif

For this series you are to choose a single motif, a recurring thematic element, a repeated figure or design, that will be the dominant image in each drawing. Use nonobjective imagery rather than recognizable objects or figures. (The repeating motif in Johns's work was the cross-hatch shape.)

Using this single motif, develop it through variations of the form. Change the scale of the motif; vary its placement; think in terms of its compositional and spatial arrangement. Figures 304 and 305 make use of two basic ideas: the decorative pattern that contracts

304, left. Development of a motif. Student work. Graphite, 30 × 26″ (76.2 × 66 cm).

305, right. Development of a motif. Student work. Graphite, 32 × 28″ (81.3 × 71.1 cm).

and expands, and a surface that resembles a billowing piece of paper. In both drawings the images seem to press forward, out of the picture plane, sometimes folding back on themselves. The decorative pulsating pattern appears to be stretching and shrinking due to some internal tension.

These student drawings are worked in graphite on rag paper. You should use the same medium and the same paper throughout the project. The images might change gradually from drawing to drawing, so that a considerable difference is visible between the first and last drawing in the series, but only slight change when the drawings are seen in true sequential order.

PROBLEM 10.6
Formal Development
In this set of thematic drawings you are to choose abstract shapes, using the same media and technique in each of the drawings. Drawings dealing with form need not lack in expressive content. Formal development does not rule out a subjective approach. (See Figures 168 and 169 on page 116.)

You might use mixed media for this project, focusing on the inherent characteristics of each medium as a major thrust of the series. Review the placement of images discussed in Chapter 9 for ideas on formal development.

GROUP THEMES

Members of the same schools and movements of art share common philosophical, formal, stylistic, and subject interests. Their common interests result in group themes. Georges Braque and Pablo Picasso, both Cubists, illustrate the similarity of shared concerns most readily (Figures 306, 307). Their use of ambiguous space through multiple, overlapping, simultaneous views of a single object, along with a combination of flat and textured shapes, is an identifying stylistic trademark. Collage elements—newspapers, wallpaper, and playing cards—as well as images of guitars, wine bottles, and tables appear in the works of many Cubists.

Pop artists have a preference for commonplace subjects. As the name suggests, these artists deal with popular images, taken from mass media, which are familiar to almost everyone in American culture. Not only do they choose commercial subjects such as the Coca-Cola bottle (Figures 308, 309), but they also use techniques of advertising design such as the repeated or jumbled image. The effect of the seemingly endless rows of bottles in Andy Warhol's painting is to emphasize the conformity and sameness of a commercially oriented world. For the Pop Artists both subject and technique make a comment on American life and culture.

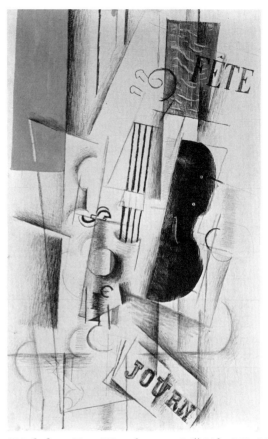

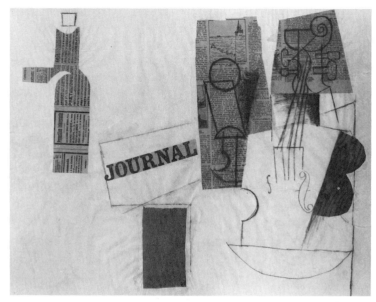

306, left. Georges Braque. *Musical Forms*. 1913. Oil, pencil, and charcoal on canvas, $36\frac{1}{4} \times 23\frac{1}{2}''$ (92 × 60 cm). Louise and Walter Arensberg Collection, Philadelphia Museum of Art.

307, above. Pablo Picasso. *Bottle, Glass and Violin*. 1912–1913. Paper collage and charcoal, $18\frac{1}{2} \times 24\frac{3}{8}''$ (47 × 62 cm). Moderna Museet, Stockholm.

308, below. Tom Wesselmann. *Still Life #50*. 1965. Assemblage on wood; diameter $39\frac{1}{2}''$ (100 cm), depth 4″ (10 cm). Courtesy Sidney Janis Gallery, New York. © Tom Wesselmann/VAGA New York 1990.

309, right. Andy Warhol. *Green Coca-Cola Bottles*. 1962. Oil on canvas, 6′10″ × 4′9″ (2.08 × 1.45 m). Collection of Whitney Museum of American Art. Purchase, with funds from the Friends of the Whitney Museum of American Art. 68.25

PROBLEM 10.7
Style/Visual Research Project

Go to the library; look through several 20th-century art surveys. Choose three 20th-century styles. Find the commonalities in the work of at least three artists within each style. Pay attention to preferred medium, to shared imagery, and especially to style. (Style is the way something is done, as distinguished from its substance or content, the distinctive features of a particular school or era.) What are the distinctive characteristics of the periods you have chosen? Analyze the works according to how the elements of line, shape, value, texture, and color are used. What is the resulting space?

Some suggestions are: Analytical Cubism, Synthetic Cubism, Fauvism, German Expressionism, Surrealism, Constructivism, Abstract Expressionism, Pop Art, Minimal Art, Photorealism.

Paul Giovanopoulous provides us with a good art-history exam in his apple conversion (Figure 310). How many artists or styles can you identify? We have discussed several of the artists whose works are parodied by Giovanopoulos. In your research on the shaped picture plane, you no doubt looked at Frank Stella's *Protractor Series,* but did it occur to you they were analogous to an apple?

310. Paul Giavanopoulos. *Apple-Léger.* 1985. Mixed media on canvas, 60 × 40″ (152.4 × 101.6 cm). Courtesy Louis K. Meisel Gallery, New York.

SHARED THEMES

Examples of the third category, shared themes, come from art history. No clearer example of this rich source of imagery can be found than in the Giovanopoulous grid. Artists frequently go to the works of their predecessors for subject sources. Our discussion of Jasper Johns's citation of the 16th-century artist, Matthais Grünewald, is only one of many we have pointed to in this text.

Many artists use "quotations" from other artists. Appropriation is a widespread strategy in contemporary art—appropriated images not only from art but from mass media sources as well. Appropriated images were calculated to arouse associations with style as well as with subject matter. These quotations pose questions concerning our pictorial language. Josef Levi's major theme is the combination of

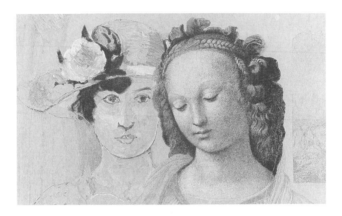

311. Joseph Levi. *Still Life with Matisse & Leonardo*. 1984. Acrylic and graphite on canvas, 38½ × 62½″ (97.8 × 158.8 cm). Courtesy O. K. Harris Works of Art, New York.

312. Larry Rivers. *I Like Olympia in Black Face*. 1970. Mixed media construction, 5′11″ × 6′3⅝″ × 3′3″ (1.82 × 1.94 × 1 m). Musée National d'Art Moderne, Centre Georges Pompidou, Paris.

313. Edouard Manet. *Olympia*. 1863. Oil on canvas, 4'3¼" × 6'2¾" (1.3 × 1.9 m). Louvre, Paris.

314. Mel Ramos. *Manet's Olympia*. 1973. Oil on canvas, 4' × 5'10" (1.22 × 1.78 m). Courtesy Louis K. Meisel Gallery, New York.

two figures from separate art historical periods. In Figure 311 we see two heads, one appropriated from Henri Matisse, the second from Leonardo da Vinci. This new context certainly alters our preconceptions about both artists' work; a new meaning is produced in seeing the images in the same picture plane. New meanings derive from style, from subject matter, from cultural attitudes of two very different periods.

Larry Rivers and Mel Ramos are only two among many who have taken subjects from earlier art and given them new meaning. In *I Like Olympia in Black Face* (Figure 312), Rivers transforms Edouard Manet's famous 19th-century painting (Figure 313) into a mixed-

media construction. The cartoon quality of the figures, the absurdity of the construction, and the general kitsch approach to a revered painting from history do not undercut the strong human comment on class and servitude that Rivers is making. One additional in-joke refers to the fact that Manet was criticized sharply for the flattened spatial effect of his painting. The extreme lights and darks, along with limited modeling across the reclining figure, resulted in a very limited space—especially for the art of the time. It is Manet's spatial innovations that had such a strong influence on later art; Rivers's raid has more than a double meaning in its conversion of Manet's flattened pictorial space to a literal three-dimensional object.

Ramos's satirical handling of the same painting transposes Manet's courtesan into a 1970's centerfold (Figure 314). Different techniques, styles, and materials have worked jolting transformations.

Shared themes also include the very personal subject of the artist's own studio. A studio is the artist's contained world; it is a private and personal space. We saw in Oginz's large studio drawing "what happens when clients come to call" (see Figure 239 in Chapter 8). Work using this subject therefore has an autobiographical overtone. This is decidedly true of Gregory Gillespie's painting (Figure 315). Gillespie looks out at the viewer as if to a mirror. The figure in the center is painted in a realistic style, convincingly and carefully rendered. The painting within the painting is distorted, expressionistic, unlike the other objects in the studio. Traditional still-life material is

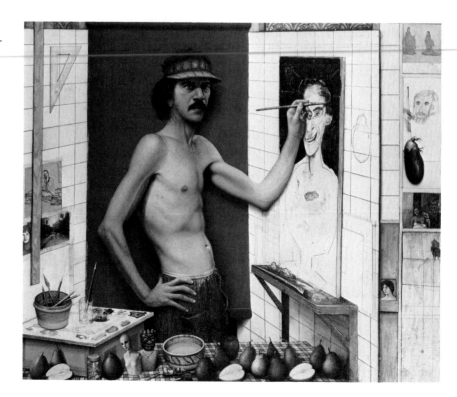

315. Gregory Gillespie. *Myself Painting a Self-Portrait.* 1980–1981. Mixed media on wood, 4'10⅛" × 5'8¾" (1.47 × 1.75 m). Hirshhorn Museum and Sculpture Garden, Smithsonian Institution, Washington, D.C.

NOTHING CONFORMS TO X SPECK STATION'S... FANCY REAM ARCHS AND A LX FILTER. PEACE ORIKE WAITING FOR THE MODEL. SHADOW LUCK ASEA2 SLITHER THROUGH

316. William T. Wiley. *Nothing Conforms*. 1978. Watercolor on paper, 29½ × 22½″ (74.93 × 57.15 cm). Collection of the Whitney Museum of American Art. Purchase, with funds from the Neysa McMain Purchase Award. 79.25

lined up along the lower edge of the painting; small thumbnail sketches are attached to the walls on either side. Gillespie calls our attention to the dual bases of art, the conceptual, abstracting base and the perceptual one. He points out multiple levels of reality in this single painting.

William T. Wiley's *Nothing Conforms* (Figure 316) shows us the kind of metamorphosis that takes place in an artist's studio. Wiley himself is absent, but we are privy to a look into a cluttered, chaotic, crumbling room, filled with symbols of time and change—candle, skeleton, worn shoe. A looped infinity symbol hangs on the wall on the right; a mirrored wall is on the left, reflecting the double spiral and a triangle, symbols of eternity. This cluttered interior is the subject of the neat, highly ordered composition tacked on the wall, and in that painting within a painting is yet another painting, this one blank. Wiley has an amazing stock of images, all invested with symbolic significance and housed in humorous visual and verbal settings.

Some shared themes appeal to a wide public. Their general human concerns have a universal attraction. The traditional mother-and-child subject can be found throughout the history of art, in all cultures, at all times. We have only to think of the variety of Christmas cards that come from many sources to be reminded of how widely this theme has been used by artists. Usually in these works a balanced, insulated, protected world is depicted. How sharp in contrast in both feeling and content is Alice Neel's *Carmen and Baby.* (Figure 317)!

Neel's interest in women's experiences and motherhood furnished her with a continuing theme. The unconventional view of a mother with her ill infant is a moving portrait. Neel's view is above eye level, so that the mother's loving face looms as the focal point of the composition. The child's strange posture with its frail, bent legs is echoed in the mother's enfolding hand. Neel makes a psychologically gripping statement in this work.

We end our discussion on shared themes with a work that sums up this topic: Frank Gardner's gridded image (Figure 318) has as its base a traditional mother-and-child subject. The artist has converted the image to a 20th-century version by seemingly digitalizing the composition. What a surprise to discover that the work is, in fact, making use of a traditional technique—fabric squares, put together

317. Alice Neel. *Carmen and Baby.* 1972. Oil on canvas, 40 × 30″ (102 × 76 cm). Private collection.

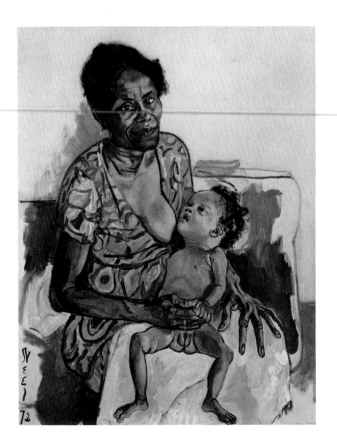

318. Frank Gardner. *Mother and Child*. 1987. Fabric on canvas, 76 × 64″ (1.93 × 1.63 m). Courtesy O. K. Harris Works of Art, New York.

like a quilt! The resulting work is a clever compilation of the old and the new, of the recognizable and the abstract, of tradition and innovation.

PROBLEM 10.8
Art History Series

Choose as your subject a work from art history. Make a series of drawings with the work as a point of departure. You can approach your theme through any of the methods discussed in this chapter. The original work can be altered and transformed stylistically. You can make changes in the form, or you can use a contemporary compositional format taken from Chapter 9.

In your drawings you can change the meaning of your chosen reference by transforming it from its context into a scientific, secular, or religious context. The use of grids or other 20th-century devices, such as collage or photomontage, can give your subject a contemporary look.

You might crop the original image and blow up a detail of the work. In any case, keep the source of your subject apparent to the viewer. The resulting series is to be a homage to your chosen artist.

SUMMARY:
Development of a Theme

An artist's style is related to imagery. Sometimes an artist works with an idea in different media and in different styles, yet the theme is constant. In other artist's work the theme is the result of a stylistic consistency, and the imagery is changed from piece to piece. Whatever approach you take, let your own personal expression govern your choices.

Here is a list of some variables that will help you in structuring your thematic series:

1. subject matter, imagery, or motif
2. media or material
3. technique
4. style
5. compositional concerns, such as placement on the picture plane
6. use of space (determined by how you use line, shape, color, texture, and value)
7. scale

It is necessary to find a theme that is important to you. Each drawing in your series should suggest new ideas for succeeding drawings. An artist must observe, distinguish, and relate; these three steps are essential in developing thematic work. After having completed several of these problems, you will think of ways of developing your own personal approach.

A LOOK AT

ART TODAY

<p style="margin-left:1em">11</p>

This final chapter is an overview of the art of our time, a crucial period not only for art, but for human culture generally. We live in a world full of disturbing conditions: environmental concerns, threat of nuclear disaster, shifts in international political power, problems of urban existence, the increasing separation between classes, problems of prejudice and disenfranchisement of ethnic groups, along with gender-related concerns. In a world of changing political and economic stability, it is no surprise that artists respond to the anxiety of the contemporary world by employing images and strategies whose associations, references, and meanings are also in flux.

Throughout the text we have concentrated on developments in contemporary art; in this chapter we will look at some of the major directions art has taken toward the end of the century. It would take a full volume to review the art even of the past ten years; it is our intent to look at some major trends and to discuss a few out of a multitude of artists.

WHY LOOK AT CONTEMPORARY ART?

Familiarity with today's art will enable you to relate your work to your own experiences and to the times in which you live. An acquaintance with current issues will increase your knowledge of art

and provide a reservoir of techniques and points of view which will strengthen your own work.

Keep in mind while studying this chapter some ways in which meaning in an art work is modified and conditioned: first, by the artist's intent, second, by the viewer's relationship to the art, and third, by the cultural context or setting of the work.

DEFINITIONS OF MODERNISM AND POST-MODERNISM

The last quarter of the 20th century has been labeled Post-Modern. Let us briefly examine the differences between Modernism and Post-Modernism.

Twentieth-century art has been a march toward abstraction and reduction under the major direction of Modernism. Modernism has been characterized by dialectical shifts in style. Analytical Cubism, Fauvism, Futurism, Constructivism, Purism, Abstract Expressionism, and Minimalism are only a few in a line of "isms" progressing through the century. Each "ism" responded to a different philosophical theory of what art is. Modernism has been seen as a set of codified values about art and artmaking whose role is to investigate the essential nature of visual art. It deals with the processes by which art is made and with the nature of pictorial space. It stresses the primacy of form; it promotes truth to the intrinsic properties of the material from which it was made; and it asserts that art is a way of thinking and seeing that is opposed to the natural appearance of objects in the real world.

In Modernism, definitions held schools together—color for the Fauves, space for the Cubists, gestural vocabulary for the Abstract Expressionists. The definitions were exclusive. Modernism is involved in how an object is made, how it is perceived, and what defines art. It focuses on the formal properties of art.

In contrast, formalist issues in Post-Modern art take a secondary role to other concerns, such as why an art object is made, how it is experienced, and what the object means beyond its formal composition. Post-Modernism focuses on the relationship between representation and content. In Post-Modernism categories are never clearly drawn; a multitude of purposes and categories exist side by side.

The two basic approaches, Modernism and Post-Modernism, are clearly evident in two periods of work by the same artist, Robert Morris (Figures 319 and 320). A leading proponent in the two movements of Minimalism and Earthworks in the 60's and 70's, Morris was involved in material, seriality, and process—all formal concerns. In contrast, his recent work uses apocalyptic images dealing with the aftermath of nuclear destruction. A heavy Baroque-like, freestanding frame encases a garishly colored canvas, with paint applied in slashing, violent strokes. The frame combines bas-relief images of skulls and dismembered body parts. Called a "mini-theater of fear and fas-

319. Robert Morris. *Battered Cubes.* 1965–1988. Painted steel, 36 × 36 × 36″ (91.4 × 91.4 × 91.4 cm) each. Courtesy Leo Castelli Gallery.

320. Robert Morris. *Enterprise (Burning Planet Series).* 1984. Oil on canvas and painted cast hydrocal, 141 × 148 × 60″ (358 × 376 × 152 cm). Courtesy Leo Castelli Gallery.

cination," Morris's new work presents a horrific drama. It was inevitable that an investigation into subject matter would follow the "exhaustion of modernists forms," to quote the Minimalist-now-Post-Modernist artist, Morris.

PRECURSORS OF POST-MODERNISM

Let us now look at some styles within Modernism that led to the development of Post-Modernism.

Pop Art

In the 1960's the philosophical foundations of Modernism began to be undermined by Pop Artists with their debunking of the sanctity of art and the role of the "art hero" and the introduction of mundane sub-

ject matter. (Think of Andy Warhol's now well-known Brillo boxes. Warhol's equation of art with mass-produced commodities emphasized how commercialized art had become just another commodity in a world full of commodities. Warhol's subject matter and method of working—having others execute his ideas—challenged the long-honored idea of originality.)

Minimalism/Conceptual Art/Earth Art

Modernism, or Formalism as it came to be called, reached its apex in Minimalism, which investigated such issues as sensory perception and process, the process of thought itself and its operation in how we perceive and order the world.

Form underwent a radical reduction in Minimalism (sometimes referred to as Reductivism), which in turn bred two further movements in the late 60's and early 70's: Conceptual Art and Earthworks, or Environmental Art. The latter involved work on a monumental scale using the earth itself as the medium (see Figure 6). Conceptual artists pushed Reductivist ideas to their extreme; these artists advocated the primacy of idea over form, finally eliminating the object altogether and driving a deep wedge in Formalist strongholds. Since idea is the essence in Conceptual Art, painting and sculpture were replaced by the unpossessable workings in the artist's mind. Art's long-standing complicity with commercialism, they believed, would be overcome by this strategy. Conceptualism did help liberate artists from critical and institutional restraints.

Photorealism

The Photorealists opened the door wide to representational imagery in the 1970's (see Figures 81 and 238). While their approach to subject matter is detached and removed, imitating the way the camera sees, here the issue of major importance is that Photorealism dealt with a *mode* of representation—the manner in which the subject is represented, the way the camera sees. As you will learn later in this discussion, modes of representation lie at the very heart of Post-Modernist work.

EARLY DEVELOPMENT OF POST-MODERNISM

The critic Leo Steinberg used the term *Post-Modern* as far back as 1968 in reference to Robert Rauschenberg's work (see Figure 235). In the early 50's, Jasper Johns and Robert Rauschenberg began incorporating three-dimensional objects, words, collage, and photographs from mass media sources into their works. Steinberg labeled their approach a "shake-up which contaminates all purified categories."

Some artists, such as Rauschenberg and Jasper Johns, felt that Modernism's immersion in abstraction and reduction was in conflict

321, left. Philip Guston. *Dial.* 1956. Oil on Canvas, 72 × 76″ (183 × 193 cm). Collection of Whitney Museum of American Art. Purchase.

322, right. Philip Guston. *The Studio.* 1969. Oil on canvas, 48 × 42″ (123 × 107 cm). Private collection, New York. Courtesy David McKee Gallery, New York.

with efforts to incorporate life and art, to bridge the gap between the two. People, their emotions, landscapes, and still lifes were excluded as subjects from Modernist art, and in the late 70's and 80's representations of human experiences returned to take center stage in the drama of art. Philip Guston was one of the first artists of major importance in redefining painting. His reputation was firmly established as an Abstract Expressionist; his early work dealt with the formal issues of color and atmospheric space (Figure 321). Then, in the late 60's and early 70's, his painting underwent a radical change. He began making self-portraits featuring clumsily drawn, hooded klansmen with enormous hands and feet who were usually smoking, drinking, painting, or sleeping (Figure 322). Guston claimed that a painting is made in the mind, that it might be made of "things, thoughts, a memory, sensations which can have *nothing* to do directly with painting inself." The work of Guston, along with that of other artists such as Robert Morris and a group called the New Imagists, were the pioneers of Post-Modernism in their exploration of new subject matter and their rejection of Modernist tenets. (We have included a number of them in this text: Jonathan Borofsky, Neil Jenney, Jim Nutt, Roy DeForrest.)

Influences of Feminist Art on Post-Modernism

One of the important influences forging change in contemporary art has been the women's movement. Feminist art is devoted to the idea of art as a direct experience of reality. Its goals are "raising con-

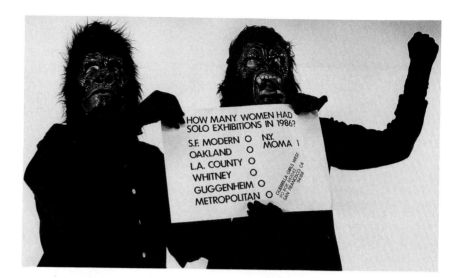

323. Guerrilla Girls West monitor exhibitions by women artists by major museums.

324. Miriam Schapiro. *Collaboration Series: Mary Cassatt and Me.* 1974. Acrylic and fabric on paper, 30 × 20″ (76.2 × 50.8 cm). Collection Dorothy Seiberling, New York City. Courtesy Bernice Steinbaum Gallery, New York City.

sciousness, inviting dialogue, and transforming culture." Women have demanded new criteria for judging art. They challenge the limitation of a singular, dominant, "right" view of experience. The Guerrilla Girls are a group involved in exposing the "remedial category" to which women artists have been relegated (Figure 323). This anonymous group uses creative means to combat sexism in the art world—fighting not only artistic discrimination but other gender and racial problems as well.

Out of women's work of the 70's came new strategies; women were leaders in the evolving art forms of performance, video, and artists' books (see Figure 210). A newly accepted female-centered vantage point opened art to new content, new techniques, and new materials. Autobiographical issues, particularly those related to women's sensibilities, have now been legitimized as vital subjects for art.

Miriam Schapiro and Judy Chicago were co-directors of the influential Feminist Art Program in Los Angeles, a program that promoted and sponsored art works and performances by women. In her own work Schapiro draws both her imagery and materials from women's crafts—art which she calls "femmages" (Figure 324). Her work summarizes the influences the women's movement has had on art in its use of personal iconography overlaid with political implications.

European Influence: The Development of Neo-Expressionism

A seminal figure in the erosion of strict categories of art was the German artist Joseph Beuys. He embraced Performance Art (called the most characteristic art of the 1970's) as a means of rehumanizing not only art but life. Performance Art encompasses language, physical activity, projected slides, three-dimensional objects—theater unbound by rules or traditions. Beuys's wartime experience (in World War II he had been shot down in the Crimea, and nomadic tribesmen had saved his life by wrapping him in grease and felt) provided impetus and techniques for his ritualized performances, the goal of which was transformation and healing (Figure 325).

Beuys had a tremendous influence on the developing new artists in Germany; in his teachings and in his art he revived myth as a powerful theme. German artists followed Beuys's lead in his humanizing efforts and in the revival of historical themes as redemptive necessities. Italian art paralleled these efforts.

German and Italian artists, the Neo-Expressionists as they were called, spearheaded a new movement in Europe and claimed international attention on two counts: their forceful use of paint and the return to the convention of representation. Enormous, heroic-scale, apocalyptic subject matter, bold, gestural brush work, vigorous, color-laden, energized works announced the arrival of something very different from the prevailing art, and continental artists were in the vanguard.

Anselm Kiefer, Georg Baselitz, Mario Merz, A. R. Penck, Francesco Clemente, Enzo Cucchi, and Helmut Middendorf are names you

may be familiar with—we have discussed several of their works elsewhere in the text. And you are familiar with their American counterparts, Julian Schnabel, David Salle, Robert Longo, among others. Anselm Kiefer has been called the quintessential Post-Modernist in his broad-ranging, wide-foraging use of appropriated images, in his conceptually loaded, nonart materials, and in his demanding agenda to reassess history and culture (see Figure 208).

The Neo-Expressionists revitalized painting and embraced images, subjects, and styles which had been banned by the Modernist code. By the late 70's and early 80's Post-Modernism took center stage in its search for a radical new content and in its renunciation of Modernism.

POST-MODERNISM: NEW SUBJECT MATTER, NEW STRATEGIES

The relationship between representation and content are in the forefront of Post-Modernist work. Figuration was reintroduced as a vehicle for conveying meaning, for making social and political commentary, as a vital way to invoke associations and make references to popular culture, history, and art itself. Post-Modernism is character-

325. Joseph Beuys. *Eurasia* from *Siberian Symphony*. 1966. Performance.

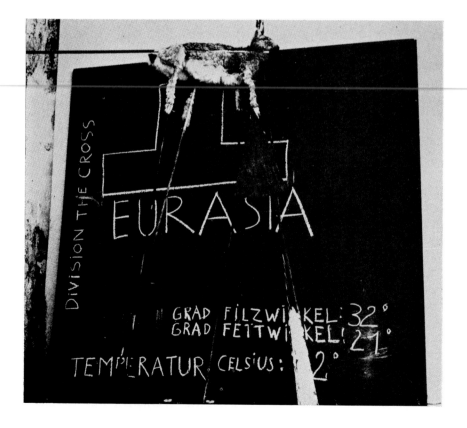

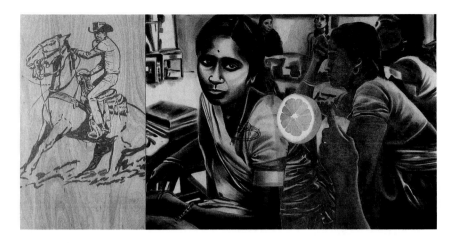

326. David Salle. *Barking Salts*. 1985. Acrylic on wood, 78 × 156¼″ (198 × 397 cm). Collection Stefan Edlis, Chicago. Courtesy Gagosian Gallery, New York.

ized by a reassessment of modern traditions of art and the role of art in society. Post-Modern artists see art as a means of interpreting non-art experiences, borrowing freely from the past and using art and nonart sources, popular imagery, and cultural artifacts.

Modernism had discredited certain themes as inappropriate for art, such as the role of the artist as social critic, literary themes, the relationship between art and language, image and concept, issues of political, social and cultural relevance, moral issues, the question of class and gender structure, the role of myth in a culture, and other psychological and philosophical investigations. In contrast, current artists have reclaimed these vital subjects in their art; they have shifted from a concern with style to a concern with issues, meaning, content, and context—with *how* we know what we know.

Content or meaning, then, has become the focus of current art. Robert Longo (see Figure 285) speaks for a number of contemporary artists when he says that he is "totally obsessed with the idea of human value. I feel like I'm contributing to my culture, posing certain questions about living and the pressures of living today."

Appropriation and Recontextualization

The art of the 80's has been characterized as being art about pictures, with appropriation as the prevailing mode. Artists appropriate or "quote" pictures and styles from myriad sources. Art images are taken from the media—from television, newspapers, magazines; from films, posters, advertising, cartoons, illustrations; and from other works of art.

Artists remove images from their original context and recontextualize them. By this strategy the image sheds some of its original meaning and acquires new ones. Remember the Larry Rivers recontextualization of Manet's *Olympia?* (see Figure 312). David Salle is the artist who most readily comes to mind as an example of this Post-Modern approach (Figure 326). His inventory of images comes from many sources. The picture plane is divided; images are overlaid,

separated from their original context, combined in odd juxtapositions. Divorced from their original sources, their modes of representation are more pronounced. Salle combines the black-and-white realism of a magazine photograph with color overlays—these alongside an image taken from a pulp magazine on wood with the grain dominating the panel. The images are too disjunctive for us to make a narrative interpretation; they are isolated and exaggerated. Interpretation of Salle's work demands a recognition of the signs of meaning codified by the mass media by which we have all been conditioned. What is represented are not only second-hand images but the mode or manner of representation itself. In Salle's art, like in many other contemporary works, cultural biases and pictorial conventions are exposed as forces that control us.

The artist who has gone to the greatest lengths in appropriation is Sherrie Levine—in her photographs of photographs of other artists' work or her copies of art book reproductions. In this "original" format she questions the Modernist value of originality, along with its selective and exclusionary stance.

Myth and Allegory

Representation is not simply an imitation of objects; rather, it is a symbolic system that changes along with culture. Our representational tradition controls our perception of real life; it literally changes the way we perceive. Pictures or images can be signs, symbols, or archetypes; they are the means by which we create visual metaphors. Myth and allegory are important themes in much con-

327. Mario Merz. *Unreal City, Nineteen Hundred Eighty Nine (Citta Irreale, Millenovecentottantanove).* 1989. Glass, mirrors, metal pipes, twigs, rubber, clay, clamps, 16'4⅞" × 32'8" (500 × 996 cm). Solomon R. Guggenheim Museum, New York. Gift of the Artist, 1989.

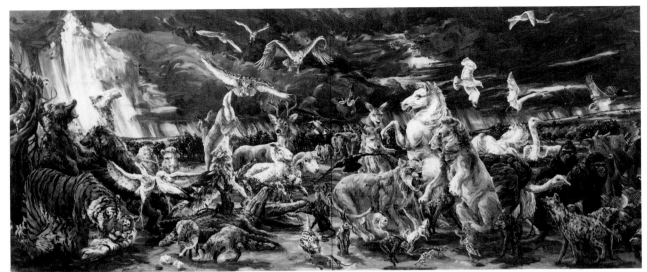

328. Melissa Miller. *The Ark*. 1986. Oil on linen, two panels 67 × 84″ (170 × 213 cm). Collection of the Modern Art Museum of Fort Worth, Museum Purchase, The Benjamin J. Tillar Memorial Trust.

temporary art. Elsewhere in the text we have discussed the work of a number of artists involved in the relationship of myth and the individual, and with myth and society. Borofsky's work deals with dreamlike experiences (see Figures 183 and 350); Schnabel reworks traditional, classical mythic themes (see Figure 209); Clemente is interested in the coexistence of alternative realms of experience (see Figure 282); and Kiefer is concerned with cultural myths and how they direct history (see Figure 208).

Mario Merz is interested in that state between the animal and human world animated by primal forces, a world beyond the physical world with its social/cultural problems. Merz is particularly interested in the generative principles of the universe (Figure 327).

Many female artists are deeply involved in myth and allegory as subjects. In their search for a new, liberated identity, myth is a shared theme. Ellen Lanyon (see Figure 211) and Melissa Miller (Figure 328) juxtapose known images into imagined realms. They, like other contemporary artists, are examining the efficacy of imagery and expressive content, expanding our notions of the unknown and the illogical. Like many current artists, Miller uses animal imagery in her allegorical scenes. How unlike the "Peacable Kingdom" images of the ark in traditional paintings of this subject! A turbulent, dark vision underlies this active painting.

Archetypal, symbolic images present us with a natural energy, and they reveal to us our more base nature, which, Kiefer suggests, we must imaginatively overcome in order to be reconciled with each other and with the earth.

Images of the earth, garden, landscapes, animals, "the earth goddess," masks, snakes, along with natural forms and materials fill the work of a great number of women artists (see Figure 128). Not only are they interested in changing old attitudes toward women, they are involved in trying to change destructive attitudes toward the environment, in creating new restorative myths for the earth.

329, above left. Andy Warhol. *Myths*. 1981. Acrylic and silkscreen enamel on canvas, 254 × 254″ (100 × 100 cm). © 1981 Estate and Foundation of Andy Warhol, courtesy ARS/Ronald Feldman Fine Arts, New York.

330, above right. Sigmar Polké. *Untitled*. 1988. Laquer and distemper on fabric, 118 × 87¾″ (300 × 223 cm). Courtesy Michael Werner Gallery, New York.

Humor and Irony

No artist has been more involved in the enterprise of showing us how popular culture and its modes of communication direct art's meaning than Andy Warhol—albeit with a light- and cold-hearted edge. Images from popular culture form the vocabulary of Warhol's *Myths* (Figure 329). His pop icons are a tongue-in-cheek way of pointing to the role cultural symbols have in creating our reality. He even includes his disappearing profile "casting a long shadow" in the rows of mythic characters. Could he be commenting on his continuing influence in art? What an indictment of our society these shallow heroes make! Humor and irony play a major role in Post-Modernism. An ironic approach is fitting for a project whose role it is to disclose and criticize. Irony allows an ambivalent stance: Criticism and humor are inextricably bound.

In a tangential vein is the work of the German artist Sigmar Polké (Figure 330). Although on the surface his work is humorous, on a more serious level, it deals with modes of representation, the interplay between various modes of abstraction. Polké is a trickster—in some recent work he uses light-sensitive pigments, "time-released colors," whose unpredictable future appearance cannot be known.

Popular or Commercial Tactics

In Post-Modernist art the boundaries between art and commerce are frequently blurred. Jenny Holzer's Spectacolor signs were beamed above Times Square as a part of a project bringing art into public

331. Jenny Holzer. "Selection from *Truisms*." 1982. Spectacolor board, Times Square, New York. Sponsored by the Public Art Fund. Courtesy Barbara Gladstone Gallery.

places (Figure 331). Her method of delivery is exactly the same as advertising techniques, but here the comparison ends. Holzer's "Selections from *Truisms*" call attention to commercial platitudes. "Your Oldest Fears Are the Worst Ones" and "Order is Man's Vocation for Chaos is Hell" are like no messages you will ever read on an ordinary billboard. It is interesting to note that in the art of Holzer and Joseph Kosuth (some of whose work is also on billboards), words replace images—they are the images. Kosuth says that "artists work with meaning (not form) . . . by canceling, redirecting or re-organizing the forms of meaning that have gone before." Their work, along with that of Barbara Kruger (see Figure 227), has a political slant in addition to its appropriation and exposure of popular commercial techniques. Artists, advertisers, and politicians are interested in influencing public opinion.

Social and Political Themes

We have already noted women's challenges to the traditional insularity of art, especially of art history. Not only women, but artists in general, urge us to look again at human values and to regard art from a broadened stance, to discover that art is more than simply an aes-

332, above left. Sue Coe. *Wheel of Fortune . . . Today's Pig Is Tomorrow's Bacon*. 1989. Mixed media, 58⅜ × 55⅝″ (148 × 141 cm). Courtesy Galerie St. Etienne, New York. © 1989 Sue Coe.

333, above right. Nancy Spero. *Thou Shalt Not Kill*. 1987. Letterpress and lithograph, 18 × 23¾″ (45.7 × 60.3 cm). Courtesy Josh Baer Gallery, New York.

334, right. Leon Golub. *White Squad II*. 1982. Acrylic on canvas, 10′ × 15′6″ (3.05 × 4.75 m). Courtesy Josh Baer Gallery, New York.

thetic discipline. Modernism has been accused of a divisive elitism: art for the few. Much of today's art, however, is bound up with social interaction that has a united goal; it represents an attempt to expose an indifferent culture and to replace it with a more human one. Not since the 1930's has there been such an involvement by artists in social and political issues.

Literary content was disallowed within the confines of Modernism, but in the 80's and 90's we are seeing a resurgence of a repoliticized art. In social and political work, the demands of communication bypass the need for a critic/interpreter; the goal is to convey and communicate ideas as directly as possible. This is certainly the case in the work of the three artists shown here (Figures 332, 333, and 334). The work of Sue Coe, an English artist, has its precedence in English satire and its stylistic roots in Dadaism, especially in the works of George Grosz (see Figure 175). Her theme in the series *Porkopolis/Animals & Industry* is the industrialization of death. In strong graphic images we are presented with a blistering indictment of our increasingly coarsened human sensibilities. Coe proclaims, "We are the pigs." She conducts extensive research, presenting written historical documentation collaged onto the drawings, invoking a tremendous pathos in her allegory or parable. Coe is best known for her disturbing and relentless protest against South African and American racism.

Political content is at the heart of Nancy Spero's and Leon Golub's work, which exposes injustices and abuses of power. For these artists the issues clearly outstrip aesthetic theories in importance. Golub's large-format paintings make overt references to contemporary political events. Mercenaries, interrogations, riots, victims, violators, combatants are depicted in a claustrophobic space, walled in, all coldly engaged in their everyday activities. Golub's scraped paint and thin, raw, worked surfaces are carriers of meaning, a brutalized surface for a brutalized subject. In Spero's and Golub's work the violence mirrors the nightly news reports.

New Ethnicity

Pictures have power over us; they make us desire—desire to know, to have, to be, to control, to own, to become. They attempt to tell us what the good life is, what our values are, what kind of persons our society values. Art that uses these pictures and styles makes us confront and reassess our preconceptions about ourselves and the world; it makes us look at our assumptions and attitudes toward others. The concept of "the other" is crucial to a reading of Deconstruction, a prevalent critical mode of the 80's. ("The other" involves the idea of difference, that if persons are not like me, white, male, American, they are of less value.) Both conditions in the real world and in the art world have been such that a large number of ethnic artists are now being shown; they were previously ignored by critics, art publications, galleries, and museums. Art is richer by hearing the voices of these heretofore marginalized, "silent" artists. (Look at Color Plate 1, at the work of Juan Sánchez, an investigation in cultural identity.)

A large number of artists work in collaboration with a group of artists or in tandem with another artist. Gilbert and George, Komar and Melamid are two such teams. Generally, these group artists shed their individual creative identity and merge talents and ideas. One group of activist artists, composed of Mexicans and Chicanos, have organized the Border Art Workshop/Taller de Arte Fronterizo (BAW/

335. David Avalos. *Border Fence as Möebius Strip*. 1987. Mixed media installation at Centro Cultural de la Raza, 6′ × 15′6″ × 11′ (1.83 × 4.72 × 3.35 m).

336. Koamar & Melamid. *Winter at Bayonne*. 1988. Oil on canvas with brass leaf, cardboard, and two paper cutouts, 25 × 86″ (63.5 × 218.4 cm). Courtesy Ronald Feldman Fine Arts, New York.

TAF). They are involved in performances, installations, and events which expose the political, social, and economic conditions of the border region between Mexico and the United States. They are interested in the clash between history and ideology, in the debate between individual and cultural positions. Figure 335 shows an installation view of David Avalos's *Border Fence as Möebius Strip*. Like the Möebius strip, the border turns back on itself; there is no end and no beginning. What an apt visual metaphor for a no-way-out situation!

The Russian team of Komar and Melamid, who now live in the United States, present a pastiche of Modernist and official Soviet, state-sponsored styles in their art. Their work makes us look at now-

dated styles for new meanings. They combine American subjects with appropriated styles in some works that resemble the Social Realism of the 1930's. In the four-paneled *Winter at Bayonne* (Figure 336), the subject is a New Jersey brass foundry where the artists spent six months working on location. They combine the paintings and drawings with documentary photographs and objects taken from the site. These artists disregard the Modernist prohibition of such styles considered beyond the bounds of good taste.

Semiotics: Words and Images/Narrative Content

It is important to keep in mind that Post-Modernism is more an attitude than a style. Frank Stella said of Modern Art, "What you see is what you see." This is not the case in Post-Modern Art, where what you see is what is implied. What is not present is as important as what is present. The Post-Modern artist is primarily concerned with content, with "signification," a sign or evidence of something beyond the image manifested, something in the world of ideas. *Semiotics* is a program whose goal it is to identify the conventions and strategies by which signifying practices, such as art and literature, produce their effects of meaning. No sign or image is ever pure; traces of other meanings are over- and underlaid in the viewer's mind. Semiotics focuses on communication and on how our values are encoded in our culture. The connections between language and art compound the problem of interpretation.

Vernon Fisher's complex installations, using drawing, photography, three-dimensional objects, and narrative texts, explore the role of signs and narrative structure and their relationship to semiotic investigation (Figures 337 and 338). The words and images in Fisher's work mutually question each other and subvert meanings. His work is metaphoric, suggesting multiple interpretations. The images cannot be read sequentially; associative meanings fill the gaps between two types of cognition: reading and seeing, words and pictures. Both approaches are culturally encoded. *Movements Among the Dead* deals

337, 338. Vernon Fisher. Installation views—south (left) and east (right) walls—of the exhibition *Projects: Vernon Fisher*. January 20, 1990, through March 6, 1990. The Museum of Modern Art, New York. Photograph courtesy the Museum of Modern Art, New York.

339. Eric Fischl. *Birthday Party.* 1980. Oil on glassine, 69 × 76" (175 × 193 cm). Collection of the artist. Courtesy Mary Boone Gallery, New York.

with the blurred lines between reality and illusion. The text is a narrative relating a story about the Russian physiologist Pavlov and his well-known experiments on conditioned reflexes using dogs. Pavlov's dog has been conditioned to salivate at the sound of a bell (which previously announced the arrival of food). In Fisher's narrative the dog turns on his master. Fisher calls into question our human nature. In one section of the installation an appropriated photographic image of explorers in a strange environment suggests our search for hidden, undisclosed meanings. A parabolic mirror reflects and transforms an image on the adjacent wall, converting the white oval into a circle and restoring the black-and-white image into a Dalmatian. The "Pluto" quotation in the upper left has multiple associations—as a planet, as the cartoon character, as a classical mythic figure. Each viewer comes away with a different interpretation, conditioned by personal experience; much of what one sees in Fisher's work is what is implied. What is not there is as important as what is there.

The narrative impulse shows us our process of thought, how we perceive, and how we order the world, how we in turn are controlled and ordered by images. Eric Fischl is another of the artists involved in narrative content. Family portraits are a traditional genre, but how different is Fischl's variation on this theme! In Figure 339, Fischl presents us with the crisis of growing up in a hedonistic, surburban setting; the work is a psychological drama of anxiety and trauma.

The point of view is from that of an adolescent; there are autobiography reverberates throughout Fischl's work. His work has been called "exorcistic"—he presents a situation from his past to rid himself of it, to control it, to exorcise it. The artist employs a multipartite picture plane, with figures on separate sheets of transluscent glassine paper (implying separation and changing relationships?); the fragile, brittle quality of the glassine relays a sense of vulnerability. Defiance in a situation in which everything is in the process of slipping out of control is the basis of the work; we need no words to read the story in Fischl's art.

Landscape: Illusion and Abstraction

We all have increasing concerns about the environment, and some art works reinforce our anxiety. The landscape is presented to us by some Post-Modern artists in its very act of disappearance. Today's landscapes are melancholic, frequently elegaic; loss rather than presence is most significant.

Peter Fleps appropriates images and styles in his new/old landscapes. He borrows landscape images from post cards and inlays the small scale paintings into boxes that resemble sculpture stands (Figure 340). The landscape painting and the box are disjunctive. The natural images are in strong contrast with the commercially structured box.

Don Suggs paints landscapes with a difference. He, like other contemporary landscape painters, does not paint from nature. He

340. Peter Fleps. *North*. 1985. Oil on cinderblock, aluminum, and plywood, 36 × 22 × 11" (91.4 × 55.8 × 27.9 cm). Courtesy the artist.

341. Don Suggs. *Proprietary View (Mount Shasta).* 1985. Oil on panel, $21\frac{3}{4} \times 39\frac{3}{4}''$ (55.2 × 100.9 cm). Courtesy L. A. Louvre Gallery, Venice, California.

appropriates his images from photographs in books. These second-hand images (like postcards) stand between us and the real experience of nature in the same way as Suggs's bars intervene between the viewer and the painted image (Figure 341). The title *Proprietary View (Mount Shasta)* has a double edge: How can one "own" the earth except through images, which are feeble substitutions and reflections of the real thing? Our experience of landscape has been reduced to copies of copies. It is impossible not to see both images merged in Suggs's work. Both identities, illusion and abstraction, assert themselves. Suggs forces us to pay heed to the landscape by rearranging the visual and emotional focus of the work.

Neil Jenney, unlike Fleps and Suggs, addresses specific environmental problems in his work. He produces a ravaged slice of landscape in massive black frames (see Figure 107). The frames seem to be a metaphor for the closing in and shutting off of the natural world. The words on the frames in his work of the 80's confront us more explicitly with the threat to the environment in their stark announcements, "Acid Rain," "Meltdown Morning," "Saw and Sawed."

How unlike the idyllic landscapes of the previous century with their sublime, heroic, romantic views of the wilderness! We had a physical sense of being able to enter into those illusions. The attitudes that formed those 19th-century paintings have disappeared as surely as the wilderness itself is disappearing. In the new landscapes barriers, blocks, frames prohibit even our visual contact with nature.

Abstraction

The strategy of appropriation extends to the discovery of subject matter in abstract painting. Terry Winters's organic abstractions have their origin in textbooks, not as a literal source but as a point of departure. His recent visual investigations involve how DNA strands are constructed or the structure of vascular systems. Drawing plays a major role in Terry Winters's exploration of form. His work deals with generative energy, primeval origins, primal forces, and stages of growth (Figure 342). The connections in Winters's work between the personal and the universal, between scientific research and the metaphorical, place him strongly in the Post-Modernist camp. A number of artists are involved in organic abstraction: Suzanne Anker, Willy Heeks, and Rodney Ripps, for example. They employ a painterly and highly unmechanistic approach to a subject matter grounded in science.

We have already referred to Sigmar Polké's investigation into the various modes of abstraction and the interplay between them. Jed Garet's abstract shapes are quotations from a broad range of abstract artists and styles from Arp to Polké (Figure 343). In *Pagoda* the odd, flat shape entering the picture plane from the right can be interpreted on two levels—it is suggestive of some flayed, erratically shaped animal. It can be seen as a silhouette of some distorted horned animal; or it can be seen as a pure formal device, a two-dimensional shape precariously poised in an ambiguous space. Garet's work seems to invite metaphorical interpretation, even though his forms are abstract. A strange movement is suggested by the swipes of paint that seem to lead us through an odd spatial field of bars and "sticks."

342, left. Terry Winters. *"b"*. 1987. Graphite and gouache on paper, $11\frac{1}{2} \times 15\frac{1}{8}''$ (29.2 × 38.4 cm). Courtesy Sonnabend Gallery, New York.

343, right. Jedd Garet. *Pagoda*. 1988. Acrylic on canvas, 95 × 70″ (241.3 × 177.8 cm). Courtesy Robert Miller Gallery, New York.

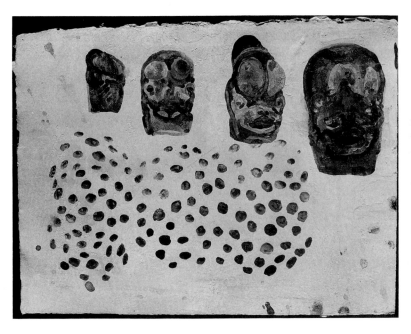

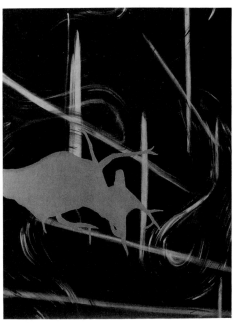

At the heart of Post-Modern art is the impulse that all art—including the figurative and the representational—is abstract. All images, the Post-Modernists have discovered, are at least one remove (and frequently many more) from reality, from direct experience. (An example: an offset print of a photograph of a mountain published in a book used as a subject for a painting over which have been imposed abstract stripes.)

CONCLUSION

We have seen that the common purposes which used to bind schools together are no longer operative in Post-Modern art. It is difficult to understand today's art with its many subjects, strategies, attitudes, and approaches, but a commitment to making and looking at art is one of the most rewarding activities in which we can involve ourselves.

Literacy is the ability to decode words: Visual literacy is the ability to decode images—the capacity to discover in them meaning and knowledge about ourselves and about our world. What a humanistic enterprise art is!

Let us conclude with a work by the Conceptual artist John Baldessari (Figure 344). In this work, movie stills from old films are framed and hung askew on the wall. The images are of catastrophic events, of a world in disarray. The final frame tells the story:

> There's a story about Thelonius Monk going around his apartment tilting all the pictures hanging on the wall. It was his idea of teaching his wife a different kind of order. When she saw the pictures askew on the wall, she would straighten them. And when Monk saw them straightened, he would tilt them. Until one day his wife left them hanging on the wall tilted.

Perhaps the moral to this story is that art offers us "a different kind of order." All perspectives are valuable!

344. John Baldessari. *A Different Kind of Order (The Thelonius Monk Story)*. 1972–1973. Five gelatin silver photographs and one typewritten sheet, individually framed; each image: $6\frac{9}{16} \times 9\frac{13}{16}''$ (16.7 × 24.9 cm); each frame: $11\frac{5}{8} \times 14\frac{11}{16}''$ (29.5 × 37.3 cm). The Museum of Fine Arts, Houston; Purchase with partial funding provided by the National Endowment for the Arts.

Part 4

PRACTICAL

GUIDES

Guide A

MATERIALS

The relationships among form, content, subject matter, materials, and techniques are the very basis for art, so it is essential that the beginning student develop a sensitivity to materials—to their possibilities and limitations. The problems in this text call for an array of drawing materials, some traditional, some nontraditional. The supplies discussed in this chapter are all that are needed to complete the problems in the book.

> *Warning:* Since many materials used in the manufacture of art supplies are toxic, you should carefully read the labels and follow directions. Always work in a well-ventilated room.

PAPER

To list all the papers available to an artist would be impossible; the variety is endless. The importance of the surface on which you draw should not be minimized. The paper you choose, of course, affects the drawing.

Since the problems in the book require the use of a large amount of paper, and since the emphasis is on process rather than product, expensive papers are not recommended for the beginning student. Papers are limited to three or four types, all of them serviceable and inexpensive. Experimentation with papers, however, is encouraged— you may wish to treat yourself to better-quality paper occasionally.

Newsprint and *bond paper* are readily available, inexpensive, and practical. Both come in bulk form—in pads of 100 sheets. Newsprint comes either rough or smooth; the rough is more useful. Buying paper in bulk is much more economical than purchasing single sheets. Bond paper, a smooth, middle-weight paper, is satisfactory for most media. Newsprint is good for warm-up exercises. Charcoal and other dry media can be used on newsprint; it is, however, too absorbent for wet media.

Ideally, *charcoal paper* is recommended for charcoal drawing, since the paper has a tooth, a raised texture, that collects and holds the powdery medium. Charcoal paper is more expensive than bond paper and is recommended only for a few problems, those in which extensive rubbing or tonal blending is emphasized.

A few sheets of black *construction paper* are a good investment. Using white media on black paper makes you more aware of line quality and of the reversal of values. A few pieces of toned charcoal paper would likewise furnish variety. Only the neutral tones of gray or tan are recommended.

All paper should be at least 18 by 24 inches (46 × 61 cm). If you draw on a smaller format, you can cut the paper to size.

An inexpensive way to buy paper is to purchase it in rolls. End rolls of newsprint can be bought from newspaper offices at a discount. Photographic backdrop paper is another inexpensive rolled paper. It comes in 36-foot (10.98 m) lengths and 10-foot (3.05 m) widths. The paper must be cut to size, but the savings may be worth the inconvenience. The advantage to buying rolls of paper is that you can make oversize drawings at minimal cost. Brown wrapping paper also comes in rolls and is a suitable surface, especially for gesture drawings.

Another inexpensive source of paper is scrap paper from printing companies. The quality of the paper varies as does the size and color, but it would be worthwhile to visit a local printing firm and see what is available.

Shopping for drawing papers can be a real treat. You need to examine the paper for its color, texture, thickness, and surface quality—whether it is grainy or smooth. In addition to these characteristics you need to know how stable the paper will be. Paper is, of course, affected by the materials from which it is made, by temperature, and by humidity. Paper that has a high acid or a high alkaline content is less stable than a paper made from unbleached rag or cotton; such papers are not lightfast, for example. The selected papers listed below are more expensive than the newsprint, bond, and charcoal paper that is recommended for most of the exercises in this text. Remember to select a paper that seems to you to be right for a given project. Becoming acquainted with various papers and learning their inherent qualities is one of the joys of drawing.

Selected Papers for Drawing (high rag content)

All papers below (except Index) are appropriate for any art media, including wash. Index is a slicker paper and is good for pen-and-ink

drawing. Rives BFK and Italia are especially good for transfer drawings.

Arches	22 × 30″; 25 × 40″	(56 × 76; 64 × 102 cm)
Copperplate Deluxe	30 × 42″	(76 × 107 cm)
Fabriano Book	19 × 26″	(49 × 66 cm)
Fabriano Cover	20 × 26″; 26 × 40″	(51 × 66; 66 × 102 cm)
German Etching	$31\frac{1}{2} × 42\frac{1}{2}″$	(80 × 105 cm)
Index	26 × 40″	(66 × 102 cm)
Italia	20 × 28″; 28 × 40″	(51 × 71; 71 × 102 cm)
Murillo	27 × 39″	(69 × 100 cm)
Rives BFK	$22\frac{1}{2} × 30″$; $29\frac{1}{3} × 41\frac{1}{3}″$	(57 × 76; 74 × 105 cm)
Strathmore Artists	Various sizes	
Manila Paper	Various sizes	

Some Suggested Oriental Papers (plant fiber content)

Hosho	16 × 22″	(41 × 56 cm)
Kochi	20 × 26″	(51 × 66 cm)
Moriki 1009	25 × 36″	(64 × 92 cm)
Mulberry	24 × 33″	(61 × 84 cm)
Okawara	3 × 6′	(.92 × 1.83 m)
Suzuki	3 × 6′	(.92 × 1.83 m)

The sketchbook pad is discussed in the Practical Guide to Keeping a Sketchbook. Size is optional. You should choose a size that feels comfortable to you, one that is easily portable, no larger than 11 by 14 inches (28 × 36 cm).

CHARCOAL, CRAYONS, AND CHALKS

Charcoal is produced in three forms: vine charcoal, compressed charcoal, and charcoal pencil.

Vine charcoal, as its name indicates, is made from processed vine. It is the least permanent of the three forms. It is recommended for use in quick gestures since you can remove the marks with a chamois skin and reuse the paper. The highly correctable quality of vine charcoal makes it a good choice for use early in the drawing, when you are establishing the organizational pattern. If vine charcoal is used on charcoal paper for a longer, more permanent drawing, it must be carefully sprayed several times with fixative.

Compressed charcoal comes in stick form and a block shape. With compressed charcoal you can achieve a full value range rather easily. You can draw with both the broad side and the edge, easily creating both mass and line.

Charcoal pencil is a wooden pencil with a charcoal point. It can be sharpened and will produce a much finer, more incisive line than compressed charcoal.

Charcoal is easily smudged; it can be erased, blurred, or smeared with a chamois skin or kneaded eraser. All charcoal comes

in soft, medium, and hard grades. Soft charcoal is recommended for the problems in this book.

Conté crayons, too, can produce both line and tone. They come in soft, medium, and hard grades. Experiment to see which you prefer. Conté comes in both stick and pencil form. It has a clay base and is made of compressed pigments. Conté is available in white, black, sanguine, and sepia.

Water or turpentine will dissolve charcoal or conté if a wash effect is desired.

Colored chalks, or *pastels,* can be used to layer colors. These are manufactured either with or without an oil base.

Another medium in stick and pencil form is the *lithographic crayon* or *lithographic pencil.* Lithographic crayons have a grease base and are soluble in turpentine. They, too, can be smudged, smeared, and blurred and are an effective tool for establishing both line and tone. The line produced by a lithographic crayon or pencil is grainy; lithographic prints are readily identified by the grainy quality of the marks. (Lithographic crayons and pencils are specially made for drawing on lithographic stone, a type of limestone.) Lithographic crayons are produced in varying degrees of softness. Again, you should experiment to find the degree of softness or hardness you prefer.

China markers, like lithographic pencils, have a grease base and are readily smudged. Their advantage is that they are manufactured in a wide variety of colors.

Colored oil sticks are an inexpensive color medium that can be dissolved in turpentine to create wash effects.

PENCILS AND GRAPHITE STICKS

Pencils and *graphite sticks* come in varying degrees of hardness, from 9H, the hardest, to 7B, the softest. The harder the pencil, the lighter the line; conversely, the softer the pencil, the darker the tone. 2B, 4B, and 6B pencils and a soft graphite stick are recommended. Graphite sticks produce tonal quality easily and are a time-saver for establishing broad areas of value. Pencil and graphite marks can be smudged, smeared, erased, or dissolved by a turpentine wash.

Colored pencils come in a wide range of colors, and water-soluble pencils can be combined with water for wash effects.

ERASERS

Erasers are not suggested as a correctional tool, but erasure can contribute to a drawing. There are four basic types of erasers. The *kneaded eraser* is pliable and can be kneaded like clay into a point or shape; it is self-cleaning when it has been kneaded. *Gum erasers* are soft and do not damage the paper. A *pink rubber pencil eraser* is recom-

mended for use with graphite pencils or sticks; it is more abrasive than the gum eraser. A *white plastic eraser* is less abrasive than the pink eraser and works well with graphite.

While a *chamois skin* is not technically an eraser, it is included here because it can be used to erase marks made by vine charcoal. It also can be used on charcoal and conté to lighten values or to blend tones. As its name indicates, it is made of leather. The chamois skin can be cleaned by washing it in warm, soapy water.

INKS AND PENS

Any good drawing ink is suitable for the problems in this book. Perhaps the most widely known is black *India ink*. It is waterproof and is used in wash drawings to build layers of value. Both black and sepia ink are recommended.

Pen points come in a wide range of sizes and shapes. Again, experimentation is the only way to find the ones which best suit you. A crow-quill pen, a very delicate pen that makes a fine line, is recommended.

Felt-tip markers come with either felt or nylon tips. They are produced with both waterproof and water-soluble ink. Water-soluble ink is recommended, since the addition of water will create tone. Invest in both broad and fine tips. Discarded markers can be dipped in ink, so you can purchase different-sized tips and collect an array of sizes.

PAINT AND BRUSHES

A water-soluble *acrylic paint* is useful. You should buy tubes of white and black. You might wish to supplement these two tubes with an accent color and with some earth colors—for example, burnt umber, raw umber, or yellow ochre.

Brushes are important drawing tools. For the problems in this book you need a 1-inch (2.5 cm) and a 2-inch (5 cm) varnish brush, which you can purchase at the dime store; a number 8 nylon-bristle brush with a flat end; and a number 6 Japanese bamboo brush, an inexpensive reed-handled brush.

OTHER MATERIALS

A small can or jar of *turpentine* should be kept in your supply box. Turpentine is a solvent that can be used with a number of media—charcoal, graphite, conté, and grease crayons. Other solvents are alcohol, for photo copy transfers, and gasoline or Nazdar, for transfer of magazine images.

Rubber cement and *white glue* are useful, especially when working on collage. Rubber cement is practical, since it does not set immediately and you can shift your collage pieces without damage to the paper. However, rubber cement discolors with age. White glue dries transparent, it is long lasting, and it does not discolor.

Sponges are convenient. They can be used to dampen paper, apply washes, and create interesting texture. They are also useful for cleaning up your work area.

Workable fixative protects against smearing and helps prevent powdery media from dusting off. Fixative comes in a spray can. It deposits uniform mist on the paper surface, and a light coating is sufficient. The term *workable* means that drawing can continue without interference from the hard surface left by some fixatives.

The purchase of a *drawing board* is strongly recommended. It should be made from Masonite and be large enough to accommodate the size of your paper. You can clip the drawing paper onto the board with large metal clips. The board will furnish a stable surface; it will keep paper unwrinkled and prevent it from falling off the easel.

Masking tape, gummed paper tape, a mat knife and blades, single-edge razor blades, scissors, a small piece of sandpaper (for keeping your pencil point sharp), and a metal container for water also should be kept in your supply box.

NONART IMPLEMENTS

Throughout the text experimentation with different tools and media has been recommended. This is not experimentation just for experimentation's sake. A new tool does not necessarily result in a good drawing. Frequently a new tool will help you break old habits; it will force you to use your hands differently or to approach the drawing from a different way than you might have with more predictable and familiar drawing media. Sticks, vegetables (potatoes or carrots, for example), pieces of Styrofoam, a piece of crushed paper, pipe cleaners, and cotton-tipped sticks are implements that can be found easily and used to good effect.

Keep your supply box well stocked. Add to it newly found materials and drawing tools. Keep alert to the assets and liabilities of the materials you use. Experiment and enjoy the development of your understanding of materials.

> Remember to read all warning labels on all products and to work in a well-ventilated room!

Guide B

P R E S E N T A T I O N

The selection of drawings to represent your work is an important undertaking. Your portfolio should show a range of techniques and abilities. The four most important criteria to keep in mind are accuracy of observation, an understanding of the formal elements of drawing, media variety and exploration, and expressive content.

After you have chosen the pieces that best incorporate these considerations, your next concern is how to present them. The presentation must be portable and keep the works clean and whole, free from tears and bends. Since framing stands in the way of portability, that option will not be discussed.

Some possible ways of presenting your work are backing and covering with acetate, stitching in clear plastic envelopes, laminating, dry mounting, and matting. Each method of presentation has advantages.

ACETATE

A widely used way of presenting work is to apply a firm backing to the drawing and then cover both drawing and backing with a layer of acetate, a clear thin plastic that holds the drawing and backing together. More importantly, the covering provides protection against scuffing, tearing, and soiling. (Matted drawings can also be covered with acetate.) Backing is a good option if a work is too large for matting or if the composition goes all the way to the edge and you cannot afford to lose any of the drawing behind a mat.

Another option is to attach the drawing with gummed linen tape to a larger piece of paper and cover it with acetate. The drawing then

has a border of paper around it and can retain its edges. The drawing lies on top; it is loose, not pinned back by a mat. The size of the backing paper is an important consideration. The drawing might need a border of an inch (2.5 cm); it might need one several inches wide. Experiment with border sizes before cutting the backing paper and attaching it to the drawing.

Paper comes in more varieties and neutral colors than does mat board. The choice of paper is important. The drawing and the paper it is done on should be compatible with the texture, weight, value, and color of the backing paper. Backing paper should not dominate the drawing.

A disadvantage to acetate as a protective cover is its shiny surface. This interferes with the texture of the drawing and with subtleties within the drawing.

PLASTIC ENVELOPES

If flexibility or the idea of looseness is important to the drawing, there is another simple means of presentation: stitching the drawing in an envelope of clear plastic. For a drawing of irregular shape—for example, one that does not have square corners—a plastic envelope might be an appropriate choice. A plastic casing would allow a drawing done on fabric to retain its looseness and support the idea of flexibility.

A disadvantage to clear plastic is its watery appearance and highly reflective surface, which distorts the drawing. The greatest advantage to this method of presentation is that large drawings can be rolled, shipped, and stored easily.

LAMINATION

Lamination is midway in stiffness between drawing paper and a loosely stitched plastic envelope. You are familiar with laminated drivers' licenses and credit cards.

Laminating must be done commercially. It is inexpensive, but cost should not be the most important consideration. The means of presentation must be suited to the concept in the drawing. Laminating is a highly limiting way of presenting work—once sealed, the drawing cannot be reworked in any way.

DRY MOUNTING

If the likelihood of soiling and scuffing is minimal, you might want to *dry mount* the drawing. You do this in exactly the same way as you dry mount a photograph, sealing the drawing to a rigid backing and

leaving the surface uncovered. Dry-mount tissue is placed between drawing and backing. Heat is then applied by means of an electric dry-mount press, or if done at home, by a warm iron. Dry-mount tissue comes in a variety of sizes; rolled tissue can be found for large drawings. This tissue must be the same size as the drawing. Wrinkling can occur, and since a drawing sealed to backing is not easily removed, extreme care should be taken in the process. Carefully read and follow the instructions on the dry-mount tissue package before you start.

Since dry mounting is done with heat, it is important that the media used in the drawing do not run or melt when they come in contact with heat. Greasy media such as china markers, lithographic sticks, or wax crayons should not be put under the dry press for mounting.

MATTING

Matting is the most popular and traditional choice for presentation. The mat separates the drawing from the wall on which it is hung and provides an interval of rest before the eye reaches the drawing. Secondly, a mat gives the drawing room to "breathe." Like a rest in music, it offers a stop between the drawing and the environment; it allows for uncluttered viewing of the drawing.

For this reason mats should not call attention to themselves or they will detract from the drawing. A colored mat screams for attention and diminishes a drawing's impact. White or off-white mats are recommended at this stage, especially since most of the problems in this book do not use color. An additional argument for white mats is that art is usually displayed on white or neutrally colored walls, and the mat furnishes a gradual transition from the wall to the drawing.

Materials for Matting

The materials needed for matting are:

- a mat knife with a sharp blade
- all-rag mounting board
- gummed linen tape
- a 36-inch-long (92-cm-long) metal straightedge
- a pencil
- a gum or vinyl eraser
- a heavy piece of cardboard for cutting surface

Change or sharpen the blade in your knife often. A ragged edge is often the result of a dull blade. A continuous stroke will produce the cleanest edge. Mat blades should not be used for cutting more than one mat before being discarded. The expense of a blade is minimal in comparison with the cost of mat board, so be generous in your use of new, sharp blades.

Do not use illustration board or other kinds of board for your mat. Cheaper varieties of backing materials, being made from wood-pulp, contain acid; they will harm a drawing by staining the fibers of the paper and making them brittle. Use white or off-white, all-rag mat board, sometimes called museum board, unless special circumstances dictate otherwise. A heavyweight, hot-pressed watercolor paper can be used as a substitute for rag board.

Masking tape, clear tape, gummed tape, and rubber cement will likewise discolor the paper and should be avoided. They will lose their adhesive quality within a year or so. Use gummed linen tape because it is acid free.

Instructions for Matting

Use the following procedure for matting. Work on a clean surface. Wash your hands before you begin.

1. Carefully measure the drawing to be matted. The edges of the mat's opening will overlap the drawing by $\frac{3}{8}$ inch (1 cm) on all sides.
2. For an 18- by 24-inch (46 × 61 cm) drawing, the mat should have a 4-inch (10 cm) width on top and sides and a 5-inch (13 cm) width at the bottom. Note that the bottom border is slightly wider—up to 20 percent—than the top and sides.
3. On the front surface of the mat board, mark lightly with a pencil the opening to be cut. You can erase later.
4. Place a straightedge on the mat just inside the penciled line toward the opening and cut. Hold down both ends of the straightedge. You may have to use your knee. Better still, enlist a friend's help. If the blade slips, the error will be on the part that is to be discarded and can, therefore, be corrected. Cut the entire line in one continuous movement. Do not start and stop. Make several strokes; do not try to cut through completely on your first stroke (Figure 345).
5. Cut a rigid backing $\frac{1}{8}$ inch (.3 cm) smaller on all sides than the mat.
6. Lay the mat face down and align the backing so that the two tops are adjoining. Cut four or five short pieces of linen tape, and at the top, hinge the backing to the mat (Figures 346, 347).
7. Minor ragged edges of the mat can be corrected with fine sandpaper rubbed lightly along the edge of the cut surface.
8. Erase the pencil line and other smudges on the mat with a gum or vinyl eraser.
9. Hinge the drawing to the backing *at the top only*. This allows the paper to stretch and contract with changes in humidity (Figure 348).
10. You may cover the matted drawing with acetate, which will protect both the drawing and mat. Place the backed, matted drawing face down on a sheet of acetate 2 inches (5 cm) wider on all sides than the mat. Cut 2-inch (5 cm) squares from each corner of the acetate (Figure 349). Fold the acetate over, pulling lightly and evenly on all sides. Attach the acetate to the backing with tape.

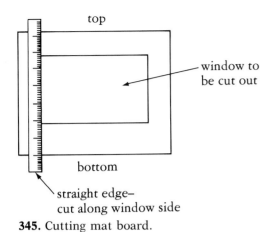

top

window to
be cut out

bottom

straight edge–
cut along window side

345. Cutting mat board.

mat–
face down

tape

top of mat

tape

backing

346. Hinging the mat.

additional
tape

fold

347. Hinging the mat.

bottom of
mat

top of mat

drawing

hinged at top <u>only</u>

348. Hinging drawing at the top.

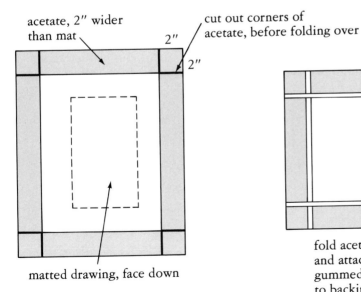

acetate, 2″ wider
than mat

2″

cut out corners of
acetate, before folding over

2″

matted drawing, face down

349. Cutting acetate.

fold acetate over
and attach with
gummed tape
to backing

SUMMARY:
Selecting a Method of Presentation

In making your decision about the most suitable presentation, you should first try to visualize the piece in a variety of ways. If you are attentive, the work itself will probably suggest an appropriate presentation. Matting is generally the safest. Stitching in plastic and lamination should be reserved for only those pieces that absolutely demand that type of presentation. Whatever your choice, remember that compatibility between drawing and method of presentation is essential.

If the manner of presentation is not clear to you, experiment with the piece. Place it in a discarded mat, or use some L-frames to crop the composition exactly right. Assess the drawing without a mat. Lay it on a larger piece of paper. Does the drawing go to the edge? Can you afford to lose half an inch (1 cm) on the borders? Is the idea of looseness or flexibility important to the drawing? Would a reflective covering detract from or enhance the drawing? What kind of surface and media are used in the drawing? What kind of backing would best complement the piece? What size mat or paper backing is the most appropriate? Does a cool white, a warm white, an off-white, a neutral, or a gray look best with the drawing? Does the size of the drawing present a problem?

The care and storage of individual drawings is another professional concern. Minimal good care is simple. You should spray-fix your drawings as soon as they are finished. Remove any smudges and store the drawings in a flat, rigid container slightly larger than the largest drawing. This ensures that the drawings will not become dog-eared, soiled, bent, or smudged. You should place a clean piece of paper between drawings so that the medium from one does not transfer onto the white of another.

Your attitude toward your work influences others' attitudes. A bad drawing can be improved by good presentation, while a good drawing can be destroyed by poor presentation. Each drawing does not have to be regarded as a precious monument, but proper care and handling of your work is a good habit.

Guide C

KEEPING A SKETCHBOOK

Paul Klee has said that the way we perceive form is the way we perceive the world, and nowhere is this more strikingly visible than in a well-kept sketchbook. The sketchbook takes art out of the studio and brings it into daily life. By means of the sketchbook, actual experience is reintroduced into the making of art. This is a vital cycle, infusing your work with direct experience and at the same time continuing the acute observation that you have been using in the studio.

You are no doubt already aware of the indispensable role of the sketchbook in helping you solve formal problems encountered in the classroom. Keeping a sketchbook is an important extension of classroom activity.

The first consideration in choosing a sketchbook is that it be portable, a comfortable size to carry. Any materials are appropriate for a sketchbook, but crayons, water-soluble felt-tip markers, and pencils are some convenient media.

A sketchbook is an ideal place to juggle form, ideas, and materials. You can experiment freely with any or all of these aspects of art and have the record of your investigations for quick reference.

Any of the problems in the chapters on art elements is an appropriate stepping-off place for sketchbook development. You should try for continuity; force yourself to develop one idea through ten or fifteen pages. You might choose an article of clothing as the subject of a number of sketchbook drawings. Imagine the article of clothing as if it were hung, crumpled, starched, and hidden. Each drawing will suggest new forms, new media.

You should use your sketchbook daily. Though this may seem artificial and awkward in the beginning, you will soon develop a reliance on the sketchbook that will prove profitable.

Using your sketchbook for recording your dreams, both visually and verbally, will bring important insights. Jonathan Borofsky is an artist who often uses dream images (Figure 350).

The sketchbook is a practical place for self-instruction. It is a good testing ground for ideas and formal design options as well as for media experimentation. Quick collages focus one's conceptual and compositional thinking. Sketchbook drawings are not meant to be final statements. They are directional signals that point to a new problem or suggest a new solution to an old problem.

It would be impossible for artists to carry out all their ideas. The sketchbook offers a place to record both visual and verbal ideas for selection and extended development later. Claes Oldenburg's concern with verbal and visual analogies is apparent in his sketchbook *Notes in Hand*. In his drawing *Ketchup + Coke Too?* (Figure 351) from this notebook, Oldenburg equated ketchup, french fries, and Coke with the Pisa group—cathedral, tower, and baptistry. The equation is a verbal one noted along the sides of the drawing. Oldenburg makes suggestions for materials to be used if he ever decides to make this grouping into a sculpture. He uses a time-saving device of drawing over a photograph.

Sketchbook drawings are, in the long run, time-savers. Quickly conceived ideas are often the most valid ones. Having a place to jot down notations is important. Robert Smithson's *Spiral Jetty* (Figure 352) is an example of a rapidly stated idea. His verbal notes are mini-

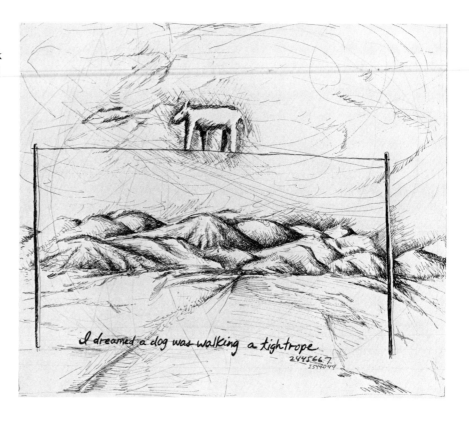

350. Jonathan Borofsky. *I Dreamed a Dog Was Walking a Tightrope at 2,445,667 and 2, 544, 044.* 1978. Ink and pencil on paper, 12 × 13″ (30 × 33 cm). Private Collection, New York. Courtesy Paula Cooper Gallery, New York.

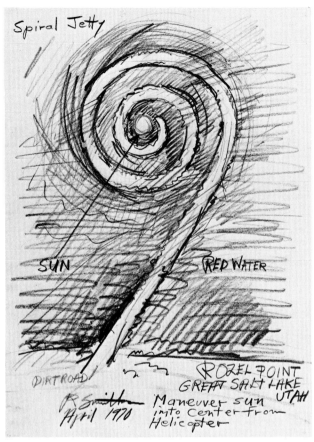

mal; the drawing style is hasty. This is one of the preliminary sketches for a complex Earthwork Smithson constructed on the Great Salt Lake in Utah. A more finished drawing made after his ideas had become more firmly established can be seen in Figure 25 encountered earlier.

The sketchbook could function as both a verbal and visual journal. It is a place to record critical and personal comments on what you have read, seen, and experienced. The sketchbook serves as a repository, a memory bank for information and feelings that might escape if you do not jot them down. Keeping a written journal is a particularly important aspect of a sketchbook. Frequently a fleeting thought—either yours or someone else's—can trigger new responses when it is seen from a later vantage point.

While your approach in keeping a sketchbook is serious, playful improvisation should not be minimized. Picasso is well known for his visual improvisations. He was rigorous in keeping sketchbooks—volumes of them. Figure 353 shows twenty-two playful variations on bonelike forms. The main thing to remember about your sketchbook is that you are keeping it for yourself, not an instructor, even though you have been given assignments in it. You are the only one who

353. Pablo Picasso. *An Anatomy.*
1933. Pencil on paper. Musée
Picasso, Paris.

benefits from a well-kept sketchbook. Looking back through a sketchbook can give you direction when you are stuck and provide a constant source of ideas for new work. When you use an idea from your sketchbook, you have the advantage of choosing an idea that has continuity to it—you have already done some thinking about that idea. A new viewpoint adds another dimension. Both *process* and *progress* are the rewards of dedication to keeping a sketchbook.

The important thing to remember about a sketchbook is that you are keeping it for yourself, not your instructor. You are the one who benefits from it.

Your sketchbook should be easily portable (10 × 12″ or 11 × 14″). Use it daily; take it with you everywhere. It is important that you draw every day—365 days a year. It does not matter what you draw—draw anything and everything. The sketchbook is an outlet for your creativity. Experiment freely; your sensitivity and creativity will become keener with every page.

Some suggestions for sketchbook drawings:

1. Experiment with form and variations.
2. Note quick visual and verbal ideas.
3. Experiment with different techniques, tools, or mediums.
4. Develop an object or an idea through several pages of sketches.
5. Experiment with different compositions; place objects and shapes in different juxtapositions.
6. Record objects through sustained observation.
7. Investigate. Make preparatory drawings.
8. Use your sketchbook as a diary or journal, recording your interests and activities.
9. Make comments on artwork (your own or others').
10. Attach clippings that interest you.
11. Draw from memory.
12. Draw your feelings.

13. Draw from nature.

14. Record your dreams, both visually and verbally.

15. Experiment with new and playful imagery.

SUMMARY:
The Advantages of a Sketchbook

Over the years your sketchbooks will form a valuable repository. Through these records you can trace your growth as an artist. You may see that you have a preference for certain ideas and relationships. The sketchbook will jolt your memory, reminding you of visual and verbal information you might otherwise have forgotten.

Remember the ground rules. Choose a sketchbook for its portability. Use it daily; set yourself a minimum number of fifteen pages a week. For each theme, develop no fewer than ten variations. Above all, remember that the sketchbook is a personal source, a chance to experiment. It is yours, and yours alone.

Guide D

BREAKING

ARTISTIC BLOCKS

Generally, there are two times when artists are susceptible to artistic blocks: in an individual piece when they feel something is wrong and do not know what to do about it, and when they cannot begin to work at all. These are problems that all artists, even the most experienced, must face. They are common problems that you should move quickly to correct.

CORRECTING THE PROBLEM DRAWING

What can you do with a drawing you cannot seem to complete? The initial step in the corrective process is to separate yourself, physically and mentally, from the drawing in order to look at it objectively. You, the artist/maker, become the critic/viewer. This transformation is essential in assessing your work. The original act of drawing was probably on the intuitive level; now you begin the process of critical analysis. You are going to learn to bring into consciousness what has been intuitively stated.

Turn away from your work for a few minutes. Occupy your mind with some simple task such as straightening equipment or sharpening pencils. Then pin the drawing on the wall, upside down or sideways. Have a mirror handy to view the drawing. The mirror's reversal of the image and the new perspective of placement will give you a new orientation so that you can see the drawing with fresh eyes. This fresh viewpoint allows you to be more aware of the drawing's formal qualities, regardless of the subject you have chosen.

When you can see how line, value, shape, volume, texture, and color are used, you are not so tied to the subject matter. Frequently

the problem area will jump out at you. The drawing itself tells you what it needs. Be sensitive to the communication that now exists between you and your work. Before, *you* were in command of the drawing; now *it* is directing you to look at it in a new way. At this stage you are not required to pass judgment on the drawing. You simply need to ask yourself some nonjudgmental questions about the piece. The time for critical judgments comes later. What you need to discover now is strictly some *information* about the drawing.

Here are some beginning questions dealing with form to ask yourself.

1. What is the subject being drawn?
2. Which media are used and on what surface?
3. How is the composition related to the page? Is it a small drawing on a large page? A large drawing on a small page? Is there a lot of negative space? Does the image fill the page? What kind of space is being used in the drawing?
4. What kinds of shapes predominate? Amoeboid? Geometric? Do the shapes exist all in the positive space, all in the negative space, or in both? Are they large or small? Are they the same size? Are there repeated shapes? How have shapes been made? By line? By value? By a combination of these two? Where is the greatest weight in the drawing? Are there volumes in the drawing? Do the shapes define planes or the sides of a form? Are the shapes flat or volumetric?
5. Can you divide value into three groups: lightest light, darkest dark, and mid-gray? How are these values distributed throughout the drawing? Is value used in the positive space only? In the negative space only? In both? Do the values cross over objects or shapes, or are they contained within the object or shape? Is value used to indicate a single light source or multiple light sources? Does value define planes? Does it define space? Does it define mass or weight? Is it used ambiguously?
6. What is the organizational line? Is it a curve, a diagonal, a horizontal, or a vertical? What type of line is used—contour, scribble, calligraphic? Where is line concentrated? Does it create mass? Does it create value? Does it define edges? Does it restate the shape of a value? Again, note the distribution of different types of line in the drawing; ignore the other elements.
7. Is invented, simulated, or actual texture used in the drawing? Are there repeated textures, or only one kind? Is the texture created by the tool the same throughout the drawing? Have you used more than one medium? If so, does each medium remain separate from the other media? Are they integrated?

This list of questions looks long and intimidating at first glance, but you can learn quickly to make these assessments—make them almost automatically, in fact. Of course, many of these questions may not apply to each specific piece, and you may think of other questions that will help you in making this first compilation of information about your drawing.

Critical Assessment

After letting the drawing speak to you and after having asked some nonjudgmental questions about it, you are ready to make a *critical assessment*. It is time to ask questions that pass judgments on the piece.

To communicate your ideas and feelings in a clearer way, you should know what statements you want to make. Does the drawing do what you meant it to do? Does it say something different—but perhaps equally important—from what you meant it to say? Is there confusion or a contradiction between your intent and what the drawing actually says? There may be a conflict here because the drawing has been done on an intuitive level, while the meaning you are trying to verbalize is on a conscious level. Might the drawing have a better message than your original intended message?

Can you change or improve the form to help the meaning become clearer? Remember, form is the carrier of meaning. Separate the two functions of making and viewing. What is the message to you as viewer?

An important reminder: Go with your feelings. If you have any doubts about the drawing, wait until a solution strikes you; however, do not use this delay to avoid doing what you must to improve the drawing. Try something—even if the solution becomes a failure and the drawing is "ruined," you have sharpened your skills and provided yourself with new experiences. The fear of ruining what might be a good drawing can become a real block to later work. Be assertive; experiment; do not be afraid to fail.

Problems in an individual piece tend to fall within these five categories:

- inconsistency of style, idea, or feeling
- failure to determine basic structure
- tendency to ignore negative space
- inability to develop value range and transitions
- failure to observe accurately

Inconsistency refers to the use of various styles, ideas, or feelings within a single work. A number of techniques and several types of line may be employed within a single drawing, but the techniques and elements must be compatible with one another and with the overall idea of the drawing. Frequently an artist will unintentionally use unrelated styles in the same drawing; this results in an inconsistency that can be disturbing to the viewer. For example, a figure drawing may begin in a loose and gestural manner and seem to be going well. Suddenly, however, when details are stated, the artist feels insecure, panics, tightens up, and begins to conceptualize areas such as the face and hands. The style of the drawing changes—the free-flowing lines give way to a tighter, more constricted approach. As conceptualization takes the place of observation, the smooth, almost intuitive interrelationship of the elements is lost. The moment of panic is a signal for you to stop, look, analyze, and relax before continuing.

A frequent problem encountered in drawing is the *failure to determine basic structure*, to distinguish between major and minor themes. For example, dark geometric shapes may dominate a drawing, while light amoeboid shapes are subordinate. Although it is not necessary for every drawing to have a major and minor theme, in which some parts dominate and others are subordinate, it is important for the artist to consider such distinctions in the light of the subject and intent of a particular drawing. Details should overshadow the basic structure of a drawing only if the artist intends it. The organization of a drawing is not necessarily predetermined; however, at some point in its development, you should give consideration to the drawing's basic structure.

Human beings are object oriented and have a *tendency to ignore negative space.* We focus our attention on objects. A problem arises for the artist when the space around the object is ignored and becomes merely leftover space. It takes conscious effort to consider positive and negative space simultaneously. Sometimes it is necessary to train ourselves by first looking at and drawing the negative space. When we draw the negative space first, or when positive and negative space are dealt with simultaneously, there is an adjustment in both. In other words, the positive and negative shapes are altered to create interrelationships. There are times when only one object is drawn on an empty page. In these instances, the placement of the drawing on the page should be determined by the relationship of the negative space to the object.

One way to organize a drawing is by the distribution of values. Problems arise when students are *unable to develop value range and transitions.* For many students, developing a value range and gradual value transitions is difficult. The problem sometimes is a lack of ability to see value as differentiated from hue. At other times, it is failure to consider the range of value distribution most appropriate for the idea of the drawing. Too wide a range can result in a confusing complexity or a fractured, spotty drawing. Too narrow a range can result in an uninteresting sameness.

The final problem, *failure to observe accurately*, involves lack of concentration on the subject and commitment to the drawing. If you are not interested in your subject, or if you are not committed to the drawing you are making, this will be apparent in the work.

Once you have pinpointed the problem area, think of three or more solutions. If you are still afraid of ruining the drawing, do three drawings exactly like the problem drawing and employ a different solution for each. This should lead to an entirely new series of drawings, triggering dozens of ideas.

The failure to deal with this first category of problems—being unable to correct an individual drawing—can lead to an even greater problem—not being able to get started at all.

GETTING STARTED

There is a second type of artistic blockage, in some ways more serious than the first: the condition in which you cannot seem to get started at all. There are a number of possible solutions to this problem. You should spread out all the drawings you did over the period of a month and analyze them. It is likely that you are repeating yourself by using the same medium, employing the same scale, or using the same size paper. In other words, your work has become predictable.

When you break a habit and introduce change into the work, you will find that you are more interested in executing the drawing. The resulting piece reflects your new interest. A valid cure for being stuck is to adopt a playful attitude.

An artist, being sensitive to materials, responds to new materials, new media. This is a good time to come up with some inventive, new, nonart drawing tools. Frequently you are under too much pressure, usually self-imposed, to produce "art," and you need to rid yourself of this stifling condition. Set yourself the task of producing one hundred drawings over a 48-hour period. Use any size paper, any medium, any approach—and before you get started, promise yourself to throw them all away. This will ease the pressure of producing a finished product and will furnish many new directions for even more drawings. It may also assist you in getting over the feeling that every drawing is precious.

All techniques and judgments you have been learning are pushed back in your mind while your conscious self thinks of solutions to the directions. Your intuitive self, having been conditioned by some good solid drawing problems, has the resource of past drawing experience to fall back on. Art is constantly a play between what you already know and the introduction of something new, between old and new experience, the conscious and the intuitive, the objective and the subjective.

Art does not exist in a vacuum, and while it is true that art comes from art, more to the point is that art comes from everything. If you immerse yourself totally in doing, thinking, and seeing art, the well-springs soon dry up and you run out of new ideas. Exhausting physical exercise is an excellent remedy, as is reading a good novel, scientific journals, or a weekly news magazine. A visit to a natural history museum, a science library, a construction site, a zoo, a cemetery, a concert, a political rally—these will all provide grist for the art mill sooner or later. Relax; "invite your soul." Contact with the physical world will result in fresh experiences from which to extract ideas, not only to improve your art but to sharpen your knowledge of yourself and your relation to the world.

Keep a journal—a visual and verbal one—in which you place notes and sketches of ideas, of quotes, of what occupies your mind. After a week reread the journal and see how you spend your time. How does the way you spend your time relate to your artistic block?

Lack of authentic experience is damning. Doing anything, just existing in our complex society, is risky. Art is especially risky. What

do we as artists risk? We risk confronting things unknown to us; we risk failure. Making art is painful because the artist must constantly challenge old ideas and experiences. Out of this conflict comes the power that feeds the work.

An artistic block is not necessarily negative. It generally means that you are having growing pains. You are questioning yourself and are dissatisfied with your previous work. The blockage may be a sign of good things to come. It is probably an indication that you are ready to begin on a new level of commitment or concentration, or that you may be ready to begin a new tack entirely. When you realize this, your fear—the fear of failure, which is what caused the artistic block in the first place—is reduced, converted, and put to use in constructive new work.

GLOSSARY

Italicized terms within the definitions are themselves defined in the Glossary.

abstraction An alteration of *forms*, derived from observation or experience, in such a way as to present essential rather than particular qualities.

achromatic Relating to light and dark, the absence of *color*, as opposed to *chromatic* (relating to color).

actual texture The *tactile* quality of a surface, including the mark made by a tool, the surface on which it is made, and any foreign material added to the surface. See also *invented texture, simulated texture*.

aerial perspective The means by which atmospheric illusion is created.

aggressive line An emphatically stated *line*.

ambiguous space Space that is neither clearly flat nor clearly volumetric, containing a combination of both two- and three-dimensional elements.

amoeboid shape See *organic shape*.

analogous colors Colors adjacent to one another on the color wheel.

analytical line A probing *line* that penetrates space, locating objects in relation to one another and to the space they occupy.

anthropomorphism Ascribing human form or attributes to nonhuman forms.

arbitrary value *Value* that does not necessarily conform to the actual appearance of an object; the use of value based on intuitive responses or the need to comply with compositional demands.

assemblage A work of art composed of fragments of objects or *three-dimensional* materials originally intended for other purposes; the art of making such a work.

background See *negative space*.

base line The imaginary *line* on which an object or group of objects sits.

biomorphic shape See *organic shape*.

blind contour A contour exercise in which the artist never looks at the paper.

blurred line Smudged, erased, or destroyed *line*.

calligraphic line Free-flowing *line* that resembles handwriting, making use of gradual and graceful transitions.

cast shadow One of the six categories of *light*.

chiaroscuro Modeling, the gradual blending of light to dark to create a *three-dimensional* illusion.

chromatic Relating to *color*, as opposed to *achromatic* (relating to light and dark).

collage Any flat material, such as newspapers, cloth, or wallpaper, pasted on the *picture plane*.

color Visual assessment of the quality of light that is determined by its spectral composition.

color wheel A circular arrangement of twelve hues.

complementary colors Contrasting colors that lie opposite each other on the color wheel.

composition The organization or arrangement of the *elements of art* in a given work.

conceptual drawing A drawing that in its essential *form* is conceived in the artist's mind, rather than derived from immediate visual stimuli.

cone of vision Angle of sight.

constricted line A *crabbed*, angular, tense *line*, frequently aggressively stated.

content The subject matter of a work of art, including its emotional, intellectual, *symbolic*, thematic, and narrative connotations, which together give the work its total meaning.

contour line *Line* that delineates both the outside edge of an object and the edges of *planes*, as opposed to *outline*, which delineates only the outside edge of an object.

core of shadow One of the six categories of *light*.

crabbed line See *constricted line*.

cross-contour line *Line* that describes an object's horizontal or cross-contours rather than its vertical contours. Cross-contour line emphasizes the volumetric aspects of an object.

directional line See *organizational line*.

diptych A work in two parts.

elements of art The principal graphic and *plastic* devices by which an artist composes a physical work of art. The elements are *color*, *line*, *shape*, *texture*, *value*, and *volume*.

empty space See *negative space*.

expressive Dealing with feelings and emotions, as opposed to *objective* and *subjective*.

eye level An imaginary horizontal *line* parallel to the viewer's eyes.

field See *negative space*.

figure/field See *positive shape*.

figure/ground See *positive shape*.

foreground/background See *positive shape*.

foreshortening A technique for producing the illusion of an object's extension into space by contracting its form.

form In its broadest sense, the total structure of a work of art—that is, the relation of the *elements of art* and the distinctive character of the work. In a narrower sense, the *shape*, configuration, or substance of an object.

frottage A *textural* transfer technique; the process of making rubbings with graphite or crayon on paper laid over a textured surface.

fumage A *textural* technique that uses smoke as a medium.

geometric shape *Shape* created by mathematical laws and measurements, such as a circle or a square.

gestural approach A quick, all-encompassing statement of *forms*. In gesture the hand duplicates the movement of the eyes, quickly defining the subject's general characteristics—movement, weight, *shape*, tension, *scale*, and *proportion*. See *mass gesture*, *line gesture*, *mass and line gesture*, and *sustained gesture*.

grattage A textural technique that incises or scratches marks into a surface prepared with a coating, for example, gesso.

ground See *negative space*.

group theme Development of related works by members of the same schools and movements of art who share common philosophical, formal, stylistic, and subject interests.

highlight One of the six categories of *light*.

hue The characteristic of a *color* that causes it to be classified as red, green, blue, or another color.

illusionistic space In the graphic arts, a representation of *three-dimensional space*.

implied line A *line* that stops and starts again; the viewer's eye completes the movement the line suggests.

implied shape A suggested or incomplete *shape* that is "filled in" by the viewer.

incised line A *line* cut into a surface with a sharp implement.

indicative line See *organizational line*.

informational drawing A category of objective drawing, including diagrammatic, architectural, and mechanical drawing. Informational drawing clarifies concepts and ideas that may not be actually visible, such as a chemist's drawings of molecular structure.

intensity The saturation, strength, or purity of a color.

interspace See *negative space*.

invented texture An invented, nonrepresentational patterning that may derive from *actual texture* but does not imitate it. Invented texture may be highly stylized.

light In the graphic arts, the relationship of light and dark patterns on a *form*, determined by the actual appearance of an object and by the type and direction of light falling on it. There are six categories of light as it falls over a form: *highlight*, *light tone*, *shadow*, *core of shadow*, *reflected light*, and *cast shadow*.

light tone One of the six categories of *light*.

line A mark made by an implement as it is drawn

across a surface. See also *aggressive, analytical, blurred, calligraphic, constricted, contour, crabbed, implied, lyrical, mechanical,* and *organizational* line.

line gesture A type of gesture drawing that describes interior forms, utilizing *line* rather than *mass*. See *gestural approach.*

local color The known color of an object regardless of the amount or quality of light on it.

lyrical line A *subjective* line that is gracefully ornate and decorative.

mass In the graphic arts, the illusion of weight or density.

mass and line gesture A type of gesture drawing that combines broad marks with thick and thin lines. See *gestural approach.*

mass gesture A type of gesture drawing in which the drawing medium is used to make broad marks to create *mass* rather than line. See *gestural approach.*

mechanical line An *objective* line that maintains its width unvaryingly along its full length.

modeling The change from light to dark across a surface; a technique for creating spatial illusion.

monochromatic A color scheme using only one color with its various hues and intensities.

montage A technique that uses pictures to create a composition.

multiple perspective Different *eye levels* and perspectives used in the same drawing.

negative space The space surrounding a *positive shape;* sometimes referred to as *ground, empty space, interspace, field,* or *void.*

nonobjective In the visual arts, work that intends no reference to concrete objects or person, unlike *abstraction,* in which observed forms are sometimes altered to seem nonobjective.

objective Free from personal feelings; the emphasis is on the descriptive and factual rather than the *expressive* or *subjective.*

one-point perspective A system for depicting *three-dimensional* depth on a *two-dimensional* surface, dependent upon the illusion that all parallel lines that recede into space converge at a single point on the horizon, called the *vanishing point.*

optical color Perceived color modified by the quality of light on it.

organic shape Free-form, irregular *shape.* Also called *biomorphic* or *amoeboid shape.*

organizational line The *line* that provides the structure and basic organization for a drawing. Also called *indicative* or *directional line.*

outline *Line* that delineates only the outside edge of an object, unlike *contour line,* which also delineates the edges of *planes.*

papier collé The French term for pasted paper; a

technique consisting of pasting and gluing paper materials to the *picture plane.*

perspective A technique for giving an illusion of space to a flat surface.

photomontage A technique that uses photographs to create a composition.

pictorial space In the graphics arts, the illusion of space. It may be relatively flat or *two-dimensional,* illusionistically *three-dimensional,* or *ambiguous space.*

picture plane The *two-dimensional* surface on which the artist works.

planar analysis An approach in which *shape* functions as *plane,* as a component of *volume.*

plane A *two-dimensional,* continuous surface with only one direction. See also *picture plane.*

plastic In the graphic arts, the illusion of *three-dimensionality* in a *shape* or *mass.*

positive shape The *shape* of an object that serves as the subject for a drawing. The relationship between positive shape and *negative space* is sometimes called *figure/field, figure/ground, foreground/background,* or *solid/void* relationship.

primary colors Red, blue, and yellow.

private theme Development by an individual artist of a personal, sustained, related series of works.

proportion Comparative relationship between parts of a whole and between the parts and the whole.

reflected light One of the six categories of *light.*

saturation See *intensity.*

scale Size and weight relationships between *forms.*

schematic drawing A drawing derived from a mental construct as opposed to visual information.

scribbled-line gesture A type of gesture drawing using a tight network of tangled *line.* See *gestural approach.*

secondary colors Colors achieved by mixing primary colors; green, orange, and violet.

shadow One of the six categories of *light.*

shallow space A relatively flat space, having height and width but limited depth.

shape A *two-dimensional,* closed, or implicitly closed configuration. The two categories of shape are *organic* and *geometric shape.*

shared theme Thematic work in which the same images or subjects are used by different artists over a long period of time.

sighting The visual measurements of objects and spaces between objects.

simulated texture The imitation of the *tactile* quality of a surface; can range from a suggested imitation to a highly illusionistic duplication of the subject's texture. See also *actual texture* and *invented texture.*

simultaneity Multiple, overlapping views of an object.

solid/void See *positive shape*.

stacked perspective The use of stacked parallel base lines in the same composition.

structural line *Line* that helps locate objects in relation to other objects and to the space they occupy. Structural lines follow the direction of the *planes* they locate.

stylistic eclecticism The use side by side of varying philosophies, styles, techniques, materials, and subjects.

subjective Emphasizing the artist's emotions or personal viewpoint rather than informational content; compare *objective*.

sustained gesture A type of gesture drawing that begins with a quick notation of the subject and extends into a longer analysis and correction. See *gestural approach*.

symbol A *form* or image that stands for something more than its obvious, immediate meaning.

tactile Having to do with the sense of touch. In the graphic arts, the representation of *texture*.

tertiary colors Colors that result when a primary and a secondary color are mixed.

texture The *tactile* quality of a surface or its representation. The three basic types of texture are *actual, simulated,* and *invented texture*.

theme The development of a sustained series of works that are related by subject, that have an idea or image in common. See *private theme, group theme,* and *shared theme*.

three-dimensional Having height, width, and depth.

three-dimensional space In the graphic arts, the illusion of *volume* or volumetric space—that is, of space that has height, width, and depth.

three-point perspective A system for depicting *three-dimensional* depth on a *two-dimensional surface*. In addition to lines receding to two points on the horizon, lines parallel and vertical to the ground appear to converge to a third, vertical *vanishing point*.

triptych A work in three parts.

trompe-l'oeil The French term for trick-the-eye illusionistic techniques. See also *simulated texture*.

two-dimensional Having height and width.

two-dimensional space Space that has height and width with little or no illusion of depth, or *three-dimensional* space.

two-point perspective A system for depicting *three-dimensional* depth on a *two-dimensional* surface, dependent upon the illusion that all parallel lines converge at two points on the horizon.

value The gradation of tone from light to dark, from white through gray to black.

value scale The gradual range from white through gray to black.

vanishing point In *one-point perspective*, the single spot on the horizon where all parallel lines converge.

void See *negative space*.

volume The quality of a *form* that has height, width, and depth; the representation of this quality. See also *mass*.

SUGGESTED READINGS

Suggested Readings concentrate on contemporary art and artists.

Students may also find helpful such periodicals as *Art Forum, Art in America, Art International, Art Journal, Art News, Artweek, Contemporanea, Drawing, Flash Art, New Art Examiner,* and *October.*

Surveys and Criticism

Alloway, Lawrence. *American Pop Art.* New York: Macmillan, 1974.

American Abstract Drawing, 1930–1987. Little Rock: The Arkansas Arts Center, 1987.

American Drawings 1963–1973. New York: Whitney Museum of American Art, 1973.

Atkins, Robert. *Artspeak. A Guide to Contemporary Ideas, Movements and Buzzwords.* New York: Hacker Books, 1990.

Battcock, Gregory. *The New Art: A Critical Anthology.* New York: Dutton, 1973.

Battcock, Gregory. *Super Realism.* New York: Dutton, 1975.

Behr, Shulamith. *Women Expressionists.* New York: Abbeville Press: n.p., 1988.

Beier, Ulli. *Contemporary Art in Africa.* New York: Praeger, 1968.

Bown, Matthew Culleme. *Contemporary Russian Art.* New York: Philosophical Library, 1990.

Cathcart, Linda L. *American Still Life 1945–1983.* New York: Contemporary Arts Museum, Houston, 1983.

Clay, Jean. *Modern Art, 1890 to 1990.* New York: B.K., Sales, 1989.

The Comic Art Show. New York: Whitney Museum of American Art, 1983.

Cooper, Douglas. *The Cubist Epoch.* New York: Praeger, 1971.

Danto, Arthur C. *The Philosophical Disenfranchisement of Art.* New York: Columbia University Press, 1986.

Danto, Arthur C. *The State of the Art.* New York: Columbia University Press, 1987.

Davis, Douglas. *Artculture: Essays on the Post-Modern.* New York: Harper and Row, 1977.

Dennison, Lisa. *New Horizons in American Art.* New York: Solomon R. Guggenheim Museum, 1989.

Directions '86. Washington, D.C.: Hirshhorn Museum and Sculpture Gardens, 1986.

Drawings from the Permanent Collection. Fort Worth: n.d.

Drawings: Recent Acquisitions. New York: Museum of Modern Art, 1967.

Drawn-Out. Washington, D.C.: The Corcoran Gallery of Art, 1987.

Face. Little Rock, Arkansas: Arkansas Arts Center, 1988.

The Figure. Little Rock, Arkansas: Arkansas Arts Center, 1988.

A Forest of Signs, Art in the Crisis of Representation. New York: The

Museum of Contemporary Art, 1989.

Gilmour, Pat, and Anne Willsford. *Paperwork*. Sidney: Australian National Gallery, 1990.

Foster, Hal, ed. *The Anti-Aesthetic: Essays on Postmodern Culture*. Port Townsend, Washington: Bay Press, 1983.

Fox, Howard N., Miranda McClintic, and Phyllis Roxenzweig. *Content, A Contemporary Focus 1974–1984*. Washington, D.C.: Smithsonian Institution Press, 1984.

Godfrey, Tony. *Drawing Today, Draughtsmen in the Eighties*. Oxford: Phaidon, 1990.

Godfrey, Tony. *The New Image: Painting in the 1980's*. New York: Abbeville Press, 1986.

Gottlieb, Carla. *Beyond Modern Art*. New York: Dutton, 1976.

Great Drawings of All Time, III. French 13th Century to 1919. New York: Shorewood, 1962.

Heller, Reinhold. *Art in Germany 1909–1936. From Expressionism to Resistance*. New York: Milwaukee Art Museum, 1990.

Heller, Reinhold. *Brucke, German Expressionists Prints* from the Granvil and Marcia Specks Collection. Evanston, Illinois: Northwestern University, 1989.

Horst, De la Croix, and Richard G. Tansey. *Gardner's Art Through the Ages, 8th Ed*. New York: Harcourt Brace Jovanovich, 1986.

Humphries, Lloyd. *Art of Our Time: The Saatchi Collection*, Vols. 1–4. New York: International Publishing, Inc., 1985.

Krantz, Les, ed. *American Artists*. Chicago: American References, 1989.

Krantz, Les, ed. *The Chicago Art Review*. Chicago: American References, 1989.

Krantz, Les, ed. *The California Art Review*. Chicago: American References, 1989.

Krantz, Les, ed. *The New York Art Review*. Chicago: American References, 1989.

Lauter, Estella. *Woman as Mythmakers*. Bloomington, Ill. Indiana University Press, 1984.

Lippard, Lucy. *From the Center*. New York: Dutton, 1976.

Lippard, Lucy. *Six Years: The Dematerialization of the Art Object*

from 1966 to 1972. New York: Praeger, 1973.

Lipman, Jean, and Richard Marshall. *Art About Art*. New York: Dutton/Whitney Museum of American Art, 1968.

Lucie-Smith, Edward. *Art in the Seventies*. Ithaca, New York: Cornell University Press, 1980.

Lucie-Smith, Edward. *Art Now*. Secaucus, New York: Morrow, 1989.

Modern Latin American Painting, Drawings and Sculpture. New York: Sotheby, 1989.

The Monumental Image. Rohnert Park, California: Sonoma State University, n.d.

Newman, Charles. *The Post-Modern Aura*. Evanston, Ill.: Northwestern University Press, 1985.

Norris and Benjamin. *What is Deconstruction?* Great Britain: St. Martin's Press, 1988.

100 European Drawings. New York: Metropolitan Museum of Art, 1964.

Princus-Witten, Robert. *Postminimalism*. New York: Out of London Press, 1977.

Plagens, Peter. *Sunshine Muse*. New York: Praeger, 1974.

Plous, Phyllis, and Mary Looker. *Neo York*. Santa Barbara: University Art Museum, 1989.

Raven, Arlene, et al. eds. *Feminist Art Criticism: An Anthology*. Ann Arbor, Michigan: UMI Research Press, 1988.

Revelations. Little Rock: Arkansas Arts Center, 1984.

Rose, Barbara. *Drawing Now*. New York: Museum of Modern Art, 1976.

Risatti, Howard, ed. *Postmodern Perspective: Issues in Contemporary Art*. Englewood Cliffs, New Jersey: Prentice Hall, 1990.

Selz, Peter. *Art in Our Times: A Pictorial History 1890–1980*. New York: Harcourt Brace Jovanovich, Inc. Abrams, 1981.

75th American Exhibition. Chicago: The Art Institute of Chicago, 1986.

Smagula, Howard. *Currents: Contemporary Directions in the Visual Arts*. Englewood Cliffs, N.J.: Prentice Hall, 1983.

Stebbins, Theodore E. *American Master Drawings and Watercolors: A History of Works on Paper from Colonial Times to the Present*. New York: The

Drawing Society, 1976.

Steinberg, Leo *Other Criteria: Confrontations with Twentieth-Century Art*. New York: Oxford University Press, 1979.

Szabo, George, et al. *Landscape Drawings of Five Centuries, 1400–1900*. New York: Metropolitan Museum of Art, 1989.

Tomkins, Calvin. *Post-to-Neo, The Art World of the 1980's*. New York: Henry Holt, 1989.

Tucker, Marcia. *Bad Painting in "Bad" Painting*. New York: New Museum, 1978.

Tuchman, Maurice, ed. *The Spiritual in Art—Abstract Painting 1890–1985*. New York: Abbeville Press, 1986.

Varnedoe, Kirk, and Adam Copnick. *High and Low: Modern Art and Popular Culture*. New York: Abrams, 1990.

Varnedoe, Kirk, and Adam Copnick, eds. *Modern Art and Popular Culture: Readings in High and Low Art*. New York: Abrams, 1990.

Waldman, Diane. *British Art Now: An American Perspective*. New York: Solomon R. Guggenheim Museum, 1980.

Waldman, Diane. *New Perspectives in American Art*. New York: Solomon R. Guggenheim Museum, 1983.

Wallis, Brian, ed. *Art After Modernism. Rethinking Representation*. Boston: New Museum of Contemporary Art, 1985.

Whitney Museum's Biennial Catalogs. New York: Whitney Museum of Art, 1981, 1983, 1985, 1987, 1989, 1991.

Wilkins, David G., and Bernard Schultz. *Art Past/Art Present*: New York: Abrams, 1990.

Works on Paper. Washington, D.C.: Smithsonian Institution Press, 1977.

Women Choose Women. New York: Worldwide Books, 1973.

Color

Albers, Josef. *Interaction of Color*, rev. ed. New Haven, Conn: Yale University Press, 1972.

Birren, Faber. *Principles of Color*. New York: Van Nostrand Reinhold, 1969.

Doyle, Michael E. *Color Drawing*. New York: Van Nostrand Reinhold, 1981.

Fabri, Frank. *Color: A Complete Guide for Artists*. New York: Watson-Guptill, 1967.

Itten, Johannes. *The Art of Color*. New York: Van Nostrand Reinhold, 1974.

Poling, Clark V. *Kandinsky's Teaching at the Bauhaus: Color Theory and Analytical Drawing*. New York: n.p., 1986.

Perspective

D'Amelio, Joseph. *Perspective Drawing Handbook*. New York: Leon Amiel, 1964.

Dubery, Fred, and John Willats. *Perspective and Other Drawing Systems*. New York: n.p., 1983.

Perspective Drawing: A Point of View. Englewood Cliffs New York: Prentice-Hall. 1988.

Powell, William. *Perspective*. New York: W. Foster, 1989.

Walters, Nigel V., and John Bromham. *Principles of Perspective*. New York: Watson-Guptill, 1974.

Works on Individual Artists

Robert Arneson

Benezra, Neal. *Robert Arneson, A Retrospective*. Des Moines, Iowa: Des Moines Art Center, 1986.

John Baldessari

Tucker, Marcia, and Robert Pincus-Witten. *John Baldessari*, New York: The New Museum, 1981.

Jennifer Bartlett

Goldwater, Marge. *Jennifer Bartlett*. New York: Abbeville Press, 1990.

Russell, John. *Jennifer Bartlett: In the Garden*. New York: Abrams, 1982.

Georg Baselitz

Corral, Maria, and Elvira Maluquer. *Georg Baselitz*. Madrid: Fundacion Caja de Pensiones, 1990.

Leonard Baskin

Baskin: Sculpture, Drawings and Prints. New York: Braziller, 1970.

Romare Bearden

Romare Bearden: The Prevalence of Ritual. New York: Museum of Modern Art, 1971.

Joseph Beuys

Adriani, Götz, Winfried Konnertz, and Karin Thomas. *Joseph Beuys: Life and Works*. Woodbury, New York: Barron's Educational Series, 1979.

Joseph Beuys: The Secret Block for a Secret Person in Ireland. New York: Museum of Modern Art, 1974.

Paul Cézanne

Chappeuis, Adrien. *The Drawings of Paul Cézanne*. Greenwich, Conn.: New York Graphic Society, 1973.

Christo

Schellman, Jorg, and Josephine Benecke, eds. *Christo Prints and Objects*. New York: Abbeville Press, 1987.

Francesco Clemente

Bastian, H., and W. M. Faust. *Clemente, Chia, Cucchi*. Bielefeld, 1983.

Percy, Ann, and Raymond Foye. *Francesco Clemente*. New York: Rizzoli, 1990.

Joseph Cornell

Waldman, Diane. *Joseph Cornell*. New York: Braziller, 1977.

Joseph Cornell. Museum of Modern Art. 1990.

Jóse Luís Cuevas

Carlos Fuentes. *El Mundo de Jóse Luís Cuevas*. New York: Tudor, 1969.

Willem de Kooning

Cummings, Paul, et al. *Willem de Kooning: Drawings–Paintings–Sculpture, New York–Berlin–Paris*. New York: Whitney Museum of American Art, 1983.

De Kooning: Drawings/Sculptures. New York: Dutton, 1974.

Alberto Giacometti

Fletcher, Valerie J. *Giacometti*. Washington, D.C.: Smithsonian Institution Press, 1988.

Giacometti, Alberto. *Giacometti, A Sketchbook of Interpretive Drawings*. New York: Abrams, 1967.

Lamarche-Vadel, Bernard. *Alberto Giacometti*. Secaucus: n.p., 1984.

Arshile Gorky

Seitz, William C. *Arshile Gorky: Paintings, Drawings, Studies*. New York: Arno Press, 1972.

Juan Gris

Rosenthal, Mark. *Juan Gris*. Berkeley, 1983.

Red Grooms

Tully, Judd. *Red Grooms and Ruckus Manhattan*. New York: Braziller, 1977.

George Grosz

George Grosz. *Love Above All, and Other Drawings: 120 Works by George Grosz*. New York: Dover, 1971.

David Hockney

Tuchman, Maurice, and Stephanie Barron. *David Hockney: A Retrospective*. New York: Museum of Modern Art, 1988.

Hans Hofmann

Goodman, Cynthia, ed. *Hans Hofmann*. New York: Whitney Museum, 1990.

Jenny Holzer

Waldman, Diane. *Jenny Holzer*. New York: Abrams, 1990.

Yvonne Jacquette

Yvonne Jacquette. Catalog with essay by Carter Ratcliff. New York: Museum of Modern Art, 1990.

Jim Dine

Gordon, John. *Jim Dine*. New York: Praeger/Whitney Museum of American Art, 1970.

Shapiro, David. *Jim Dine: Painting What One Is*. New York: Abrams, 1981.

Richard Diebenkorn

Richard Diebenkorn, Paintings and Drawings, 1943–1980. Buffalo, N.Y.: Rizzoli for Albright-Knox Art Gallery, 1980.

Jean Dubuffet

Drawings, Jean Dubuffet. New York: Museum of Modern Art, 1968.

Marcel Duchamp

Marcel Duchamp. New York: Museum of Modern Art and Philadelphia Museum of Art, 1973.

Baruchello, Gianfranco, and Henry Martin. *The Imagination of Art (How to Imagine and Why Duchamp)*. Kingston, N.Y.: McPherson, 1986.

Baruchello, Gianfranco, and Henry Martin. *Why Duchamp: An Essay on Aesthetic Impact*. Kingston, N.Y.: McPherson, 1985.

Eric Fischl

Eric Fischl. An Interview with Donald Kuspit. New York: n.p., 1987.

Eric Fischl. New York: Art in America/ Stewart, Tabori, and Chang, 1990.

Vernon Fisher

Vernon Fisher. La Jolla, Calif.: La Jolla Museum of Contemporary Art, 1989.

Jasper Johns

Castleman, Riva. *Jasper Johns: A Print Retrospective*. New York: Museum of Modern Art, 1986.

Francis, Richard. *Jasper Johns*. New York: Abbeville Press, 1984.

Rosenthal. *Jasper Johns Work Since 1974*. Philadelphia: Philadelphia Museum of Art, 1988.

Ellsworth Kelly

Ellsworth Kelly: Works on Paper. New York: Abrams for the Fort Worth Art Museum, 1987.

Käthe Kollwitz

Hinz, Renate, ed. *Käthe Kollwitz: Graphics, Posters, Drawings*. New York: Pantheon, 1987.

Anselm Kiefer

Rosenthal, Mark. *Anselm Kiefer*. New York: Te Neues, 1988.

Barbara Kruger

Linker, Kate. *Lover for Sale: The Words and Pictures of Barbara Kruger*. New York: Abrams, 1990.

Rico Lebrun
Rico Lebrun: Drawings. Berkeley: University of California Press, 1968.
Sol Lewitt
Minimalism. Seattle: University of Washington Press, 1990.
Fernand Léger
Fabre, Gladys C., Barbara Rose and Marie-Odile Briot. *Léger and the Modern Spirit, An Avant-Garde Alternative to Non-Objective Art.* Houston: Museum of Fine Arts, 1983.
Fernand Léger. New York: The Museum of Modern Art (International Council), 1976.
Roy Lichtenstein
Waldman, Diane. *Roy Lichtenstein.* New York: Abrams, 1971.
David Macaulay
Macaulay, David. *Great Moments of Architecture.* Houghton Mifflin, Boston, 1978.
Henri Matisse
Matisse as a Draughtsman. Greenwich, Conn.: New York: Graphic Society/ Baltimore Museum of Art, 1971.
Helmut Middendorf
Wildermuth, A., and W. M. Faust. *Helmut Middendorf.* Groninger, 1983.
Henry Moore
Garroued, Ann, ed. *Henry Moore Drawings.* New York: n.p., 1988.
Henry Moore's Sheep Sketchbook. London: Thames-Hudson, 1980.
Giorgia Morandi
Vitale, Lamberto. *Giorgio Morandi.* 2 vols. Florence, Italy. Ufizzi, 1983.
Robert Morris
Minimalism. Seattle: University of Washington Press, 1990.
Elizabeth Murray
Graze, Sue, and Kathy Halbreich. *Elizabeth Murray Paintings and Drawings.* New York: Museum of Modern Art, 1987.
Claes Oldenburg
Baro, Gene. *Claes Oldenburg: Prints and Drawings.* London: Chelsea House, 1969.

Haskell, Barbara. *Claes Oldenburg: Objects into Monument.* Pasadena, Calif.: Pasadena Art Museum, 1971.
Oldenburg, Claes. *Notes in Hand.* New York: Dutton, 1971.
Philip Pearlstein
Philip Pearlstein Watercolors and Drawings. New York: Alan Frumkin Gallery, n.d.
Pablo Picasso
Picasso: His Recent Drawings 1966–68. New York: Abrams, 1969.
Jackson Pollock
Friedman, B. H. *Jackson Pollock: Energy Made Visible.* New York: McGraw-Hill, 1972.
Robert Rauschenberg
Kotz, Mary Lynn. *Rauschenberg: Art and Life.* New York: Abrams, 1990.
Robert Rauschenberg: Work from Four Series. University of Washington Press for Contemporary Arts Museum, Houston, 1990.
Larry Rivers
Hunter, Sam. *Larry Rivers.* New York: Abrams, 1969.
Rivers, Larry. *Drawings and Digressions.* New York: Clarkson Potter, 1979.
David Salle
Irving, Fiona. *David Salle.* Philadelphia: University of Pennsylvania Contemporary Art, 1986.
Lucas Samaras
Samaras, Lucas. *Samaras Pastels.* Denver: Denver Art Museum, 1981.
Georges Seurat
Franz, E., and B. Growe, eds. *Georges Seurat.* Bielefeld, 1983.
Julian Schnabel
Schnabel, Julian. *Works on Paper, 1975–1988.* New York: Te Neues, 1990.
Ben Shahn
Morse, John D. *Ben Shahn.* New York: Praeger, 1967.
Robert Smithson
Robert Smithson: Drawings. New York: The New York Cultural Center, 1974.
Saul Steinberg
Rosenberg, Harold. *Saul Steinberg.* New

York: Knopf, 1978.
Pat Steir
Arbitrary Order: Paintings by Pat Steir. Houston: Contemporary Arts Museum, 1983.
Donald Sultan
Donald Sultan. New York: Museum of Contemporary Art, Chicago, and Abrams, 1987.
Wayne Thiebaud
Tsujimoto, Karen. *Wayne Thiebaud.* San Francisco: San Francisco Museum of Modern Art, 1985.
Wayne Thiebaud Survey 1947–1976. Phoenix, Ariz.: Phoenix Art Museum, 1976.
Jean Tinguely
Hulten, K. G. Pontus. *Jean Tinguely: Meta.* Greenwich, Conn.: New York Graphic Society, 1975.
Mark Tobey
Rathbone, Eliza E. *Mark Tobey.* Washington, D.C.: National Gallery of Art, 1986.
Andy Warhol
McShine, Kynaston. *Andy Warhol: A Retrospective.* New York: Museum of Modern Art, 1989.
Neil Welliver
Neil Welliver, Watercolors and Prints, 1973–78. New York: Brook Alexander, n.d.
Tom Wesselmann
Tom Wesselmann: The Early Years/ Collages 1959–62. Long Beach: California State University Art Galleries, 1974.
Paul Weighardt
Paul Weighardt Retrospective. Gemalde Aquarelle Zeichnungen Duck: Druckhaus Maack G. Ludenscheid, 1972.
Terry Winters
Plous, Phyllis. *Terry Winters, Painting and Drawing.* Santa Barbara: University Art Museum, 1987.
William T. Wylie
Wylie Territory. Minneapolis, Minn.: Walker Art Center, 1979.

PHOTOGRAPHIC

SOURCES

The authors and publisher wish to thank the custodians of the works of art for supplying photographs and granting permission to reproduce them. Photographs have been obtained from sources noted in the captions, unless listed below. Photographers and copyrights are also credited. Numbers in boldface denote figure numbers in text.

Chapter 1 1: (c) Photo Archives Editions ARTHAUD, Paris. **2:** Photo: Tseng Kwong Chi. **6:** Photo by Gianfranco Gorgone. **7:** (c) Photo RMN, Paris. **10:** (c) 1992 ARS, NY/SPADEM, Paris. **13:** Reprinted with permission of McGraw-Hill Book Company from *Morris' Human Anatomy*, Schaeffer, 10th edition, Philadelphia: The Blackiston Co., 1942. **14:** Photo: Eeva-Inkeri. **17:** (c) The Estate of Keith Haring, 1991. Photo: Ivan Dalla-Tana.

19: (c) 1992 Claudio Bravo/VAGA, NY. **20:** Photo: Geoffrey Clements. **22:** (c) 1992 ARS, NY/SPADEM, Paris. **23:** Constance Lebrun Crown, Santa Barbara, California. **25:** Photo: Nathan Rabin. **26:** (c) Neil Welliver/VAGA, NY. **28:** Photo: Arthur Siegel. **31:** Photo: Robert E. Mates and Paul Katz. **35:** (c) 1992 VAGA, NY/Beeldrecht, Netherlands. **36:** Richard Smith.

Chapter 2 37: (c) 1992 VAGA, NY/Bilde-Kunst, Germany. **38:** Claes Oldenburg. **39:** Texas Fine Arts Association, Austin, Texas. **44:** Solomon R. Guggenheim Museum, New York. **45–54:** Photos by Danielle Fagan, Austin, Texas. **56:** Leo Castelli Gallery, New York. **58:** Walker Art Center, Minneapolis. **59:** Photo by Eric Pollitzer, Hempstead, NY/Paula Cooper Gallery, New York. **60:** (c) 1992, NY/ADAGP, Paris. **61:** Photo by Pramuan Burusphat. **62:** Mac Adams. **63:** Photo by Rudolph Burkhardt, New York. **64,**

66, 67, 69, 70: Photo by Danielle Fagan, Austin, Texas. **65:** (c) 1992 ARS, NY/ADAGP, Paris. **68:** Photo by Pramuan Burusphat.

Part II 73: Sonnabend Gallery, New York. **74:** Sue Hettmansperger. **75:** Margo Leaven Gallery, Los Angeles. **78:** (c) 1992 ARS, NY/ADAGP, Paris. **79:** (c) ARS, NY. **82:** Photo by Rick Gardner/Texas Gallery, Houston. **84:** (c) 1992 Frank Stella/ARS, N.Y. **85:** Photo by Alan Zindman/Mary Boone Gallery, New York.

Chapter 3 88: Metro Pictures, New York. **94:** Photo by Frank J. Thomas, Los Angeles. **95:** University Art Museum, University of California, Santa Barbara. **97:** Reprinted with permission of Mrs. Nelli Wieghardt. **99:** Photo by Jerry L. Thompson, Amenia, New York. **100, 101:** Photos by Dottie Allen. **102, 104, 105:** Photos by Praumuan Burusphat. **103:** (c) 1992 Rufino

307

Tamayo/VAGA, NY. **108, 109:** Photos by Danielle Fagan, Austin, Texas. **114:** Photo by Robin Smith Photography Ltd., Christchurch, New Zealand. **115:** (c) 1992 Edward Ruscha/VAGA, NY. **119, 121:** Photos by Pramuan Burusphat. **122, 123, 125:** Photos by Danielle Fagan, Austin, Texas.

Chapter 4 128: (c) Photo by Dottie Allen. **131:** Photo by M. Lee Fatheree/Beth Van Hoesen. **134:** Photo by Kenneth Karp, New York. **135:** Photo by Eric Pollitzer, Hempstead, New York. **137:** (c) 1992 Robert Rauschenberg/VAGA, NY. **140:** Constance Lebrun Crown, Santa Barbara, California. **141:** Photo by Danielle Fagan, Austin, Texas. **142, 144–146, 148, 149:** Photos by Pramuan Burusphat. **150:** Photo by Danielle Fagan, Austin, Texas. **152:** Allan Frumkin Gallery, New York. **154–157:** Photos by Praumuan Burusphat. **158, 159:** Photos by Danielle Fagan, Austin, Texas. **161:** Photo by Dottie Allen. **165:** Photo by Geoffrey Clements, Staten Island, New York. **166, 168, 169:** Photos by Pramuan Burusphat. **167:** Photo by Dottie Allen.

Chapter 5 171: Photo by Dottie Allen. **172:** Rhona Hoffman Gallery, Chicago. **173:** (c) 1992 Succession H. Matisse/ARS, N.Y. **174:** (c) 1992 The Estate of Ben Shahn/VAGA, NY. **175:** (c) 1992 VAGA, NY/Bilde-Kunst, Germany. **178 180, 196, 197, 199, 200:** (c) 1992 ARS, N.Y./ADAGP, Paris. **183:** Douglas M. Parker Studio, Los Angeles. **186:** Walker Art Center, Minneapolis. **189, 193, 207:** Photo by Danielle Fagan, Austin, Texas. **190, 198, 203:** Photos by Dottie Allen. **191, 192, 194:** Photos by Pramuan Burusphat. **202:** (c) 1992 ARS, N.Y. **206:** Photo by Barney Burstein, Boston.

206: Photo by Barney Burstein, Boston.

Chapter 6 211: Photo by D. James Dee. **212:** Photo by W. Staehle. **213:** Photo by Danielle Fagan, Austin, Texas. **214:** Photo by William H. Bengston/Phyllis Kind Gallery, Chicago. **215:** The Solomon R. Guggenheim Museum, New York. **216:** Staempfli Gallery, New York. **217:** (c) 1981 Alan Magee. **218:** (c) 1992 ARS, NY/ADAGP, Paris. **222:** Photo by Pramuan Burusphat. **223:** (c) 1986 James Rosenquist/VAGA, NY. **224:** Photo by Pramuan Burusphat. **226:** (c) 1992 ARS, N.Y. **231:** Photo by David Wharton/The Modern Art Museum of Fort Worth, Texas. **232:** Photo by Pramuan Burusphat. **233, 236:** Photos by Danielle Fagan, Austin, Texas. **235:** (c) 1986 Robert Rauschenberg/VAGA, NY.

Chapter 7 Pl. 6: Photo by Otto E. Nelson, New York. **Pl. 8:** Photo by Schopplein Studio SFCA/Morgan Gallery, Kansas City, Missouri. **Pl. 9:** Douglas M. Parker Studio, Los Angeles.

Chapter 8 239: ARCO Center for Visual Art, Los Angeles. **241–244:** Photos by Danielle Fagan, Austin, Texas. **245:** Photo by Dottie Allen. **246, 247:** from *Great Moments in Architecture* by David Macaulay. Copyright (c) 1978 by David Macaulay. Reprinted with permission of Houghton Mifflin Company. **248:** (c) 1969 David Hockney. **253:** (c) 1991 VAGA, NY/SIAE, Rome. **255:** Photo by Dottie Allen. **258:** from *Great Moments in Architecture* by David Macaulay. Copyright (c) 1978 by David Macaulay. Reprinted with permission of Houghton Mifflin Company. **259:** (c) 1992 ARS, NY/ADAGP, Paris.

Chapter 9 262: Photo by Dottie Allen. **263, 268, 272, 276:** Photo by Pramuan Burusphat. **265:** (c) 1992 ARS, NY. **267:** (c) 1992 ARS, NY/ADAGP, Paris. **271:** Photo: Michael Tropea. **278:** Photo by Bevan Davies, New York. **280:** Photo: D. James Dee, New York. **284, 287:** Photos by Dottie Allen. **288, 289:** Photos by Danielle Fagan, Austin, Texas.

Chapter 10 291, 292: Leo Castelli Gallery, New York. **293, 294:** Sidney Janis Gallery, New York. **295:** Photo by Dottie Allen. **296:** Photo by Susan Einstein/Hunsaker-Schlesinger Gallery, Los Angeles. **297, 298, 299:** Photos by Pramuan Burusphat. **300–303:** Photos by Dottie Allen. **306:** (c) 1992 ARS, NY/ADAGP, Paris. **307:** (c) 1992 ARS, NY/SPADEM, Paris. **309:** (c) 1992 The Estate and Foundation of Andy Warhol/ARS, NY. **310:** Photo: Steve Lopez. **311:** Photo: D: James Dee, New York. **312:** (c) 1992 Larry Rivers/VAGA, NY. **313:** Giraudon/Art Resource, New York. **306:** Reproduced with permission of Forum Gallery, New York. **317:** Robert Miller Gallery, New York.

Chapter 11 319, 320: (c) 1992 Robert Morris/VAGA, NY. **323:** Guerilla Girls West, San Francisco. **325:** (c) 1992 VAGA, NY/Bilde-Kunst, Germany. **327:** Photograph by David Heald. Photograph (c) 1990 The Solomon R. Guggenheim Museum. **333:** Photo: David Reynolds. **335:** Photo: Manuel "Memo" Cavada. **336:** Photo: D. James Dee, New York. **339:** Photo: Zindman/Fremont, New York. **343:** Photo: Zindman/Fremont, New York.

Practical Guides PG 1–5: Photos by Pramuan Burusphat. **PG 19:** (c) 1992 ARS, NY/SPADEM, Paris.

INDEX

Page numbers in italics refer to
 illustrations.

Abstract Expressionism, 61–62, 142,
 178, 252, 255
Abstraction, in Post-Modernism, 271–
 272
Abyi, Michael, *The Twins Who Killed
 Their Father Because of His
 Properties*, 155, *156*
Acetate, 281–282
Acrylic paint, 279
Actual texture, 150–153, 155, 157
Adams, Mac, *Study for Three-Part
 Poison*, 44–45, *44*
Addams, Charles, *Embellished Elevation
 of the Carnegie Mansion*, 10–11, *10*
Additive materials to create texture,
 158–163
Aerial perspective, 88, 190–191
Aggressive line, 137
Albers, Josef, 178
Allegory, in Post-Modernism, 260–261

Allen, Dottie, *Hard Choices/All There Is*,
 148, *148*
Amán-Jean, 7
Ambiguous space, 56, 57–58, 89, *89*,
 105
Amoeboid shapes, 67
Analogous color scheme, 172
Anatomical illustrations, 11, *11*
Anker, Suzanne, 271
Antholt, Sharron, *Tracing a Stranger
 Self*, 110–111, *110*
Ant's-eye view, 187, 202
Appropriation, 160, 244–246, 259–260
Artistic blocks, breaking, 293–298
Assemblage, 146, 158, 160–162, 163
Audience, 18–20
Avalos, David, *Border Fence as Moebius
 Strip*, 266, *266*
Azaceta, Luis Cruz, *Deadly Rain*, 11, *11*

Bad Painting style, 124–125
Baldessari, John, *A Different Kind of
 Order (The Thelonius Monk Story)*,
 272, *272*
Bartlett, Jennifer, *White House*, 66, *66*

Base line, 38, 188–190
Baselitz, Georg, 257
Baskin, Leonard, *Egyptian Ballet—Horns
 and Hands*, 70, *70*
Bauermeister, Mary, *Drawing No. 16,
 Three Pergaments*, 95–96, *96*
BAW/TAF. *See* Border Art Workshop/
 Taller de Arte Fronterizo (BAW/TAF)
Bearden, Romare
 Eastern Barn, 167, *167*
 Interior with Profiles, 69, *69*
Betti, Claudia, *The Origins*, 138–139,
 139
Beuys, Joseph, *Eurasia*, 257, *258*
Biomorphic shapes, 67
Bird's-eye view, 187
Blackwell, Tom, *Hi-Standard's Harley*,
 62–63, *62*
Blind-contour exercises, 50–53, 54. *See
 also* Contour line
Blurred line, 141–143
Bond paper, 276
Bonnard, Pierre, 136
Border Art Workshop/Taller de Arte
 Fronterizo (BAW/TAF), 265–266

Borofsky, Jonathan, 255
 *I Dreamed a Dog Was Walking a
 Tightrope at 2,445,667 and
 2,044,554*, 261, 288, *288*
 Stick Man, 125, *125*, 261
Braque, Georges, 9
 Musical Forms, 241, *242*
 Still Life on a Table, 153, *154*
Bravo, Claudio, *Pamela*, 16, *16*, 18
Brown, Roger, *Celebration of the
 Uncultivated—A Garden of the Wild*,
 151, *151*
Brushes, 279
Butterworth, Elizabeth, *Scarlet Macaw*,
 171, *181*

Calligraphic line, 137–140
Carter, Clarence, *Siena*, 80, 81, 97
Casebere, James, *Boats*, 97, 100, *101*
Cast shadow, 104, *105*, 108–109
Caswell, Stuart, *Chain Link Disaster*,
 212–213, *213*
Celmins, Vija, *Untitled (Big Sea #1)*,
 212, *213*
Cézanne, Paul, 60
 View of a Bridge, 8, *8*
Chalks, 278
Chamois skin, 279
Charcoal, 277–278
Charcoal paper, 276
Charcoal pencil, 277
Chase, Louisa, *Untitled*, 138, *138*
Chiaroscuro, 104
Chicago, Judy, 257
China markers, 278
Christo, *Whitney Museum of American
 Art Packed*, 12, *12*
Cinematic compositions, 222–224
Clemente, Francesco, 257
 Non Morte di Eraclito, 224, *225*, 261
Close, Chuck, *Emily/Fingerprint*, 15, *15*,
 104
Coe, Sue, *Wheel of Fortune . . . Today's
 Pig Is Tomorrow's Bacon*, *264*, 265
Collage, 8–9, *9*, 77, 145, 158, 159, 162–
 163
Color. *See also* Value
 analogous color scheme, 172
 color media, 169–170
 color schemes, 172–174
 color wheel, 171, *180*
 color-field composition, 183
 complementary color scheme, 172,
 173–174
 early influences on contemporary
 attitudes toward, 177–178, 183
 hue and, 170
 intensity and, 170–171
 local color, 171
 monochromatic color scheme, 172,
 173

optical color, 171
primary colors, 171
problems concerning, 170, 171, 175,
 178, 183
response to, 168–169
secondary colors, 171
spatial characteristics of, 184
spatial function of, 175–176
symbolic color, 183
terminology concerning, 170–171
tertiary colors, 171
warm and cool colors, 174–175, 184
Color-Field artists, 178, 183
Color-field composition, 183
Color media, 169–170
Color schemes, 172–174
Color wheel, 171, *180*
Colored oil sticks, 278
Commercial tactics, in Post-Modernism,
 262–263
Complementary color scheme, 172, 173–
 174
Composite shape problem, 74, *74*
Compressed charcoal, 277
Computer-generated images, 4, 237–239
Conceptual Art, 254
Conceptual drawing, 13–14
Condé, Miguel, *Untitled*, 153–154, *154*
Constricted line, 137
Construction paper, 276
Conté crayons, 102, *102*, 278
Contemporary art. *See* names of specific
 artists and schools of art
Continuous-field compositions, 212–214
Continuous-line-drawing exercises, 46–
 48, 54
Contour line
 blind-contour exercises, 50–53, 54
 contour with tone, 133
 cross-contour, 133
 exaggerated contour, 130
 examples of, 127–128
 outline compared with, 50, *51*
 problems concerning, 129–133
 quick contour, 131–132
 slow contour, 129
 steps in drawing, 128–129
 student works, *128*, *130*, *131*, *132*
Conventionalized texture, 158
Cool colors, 174–175, 184
Corbin, Tarrence, *Cluster: Tristan und
 Isolde*, 67, *68*, 71
Core of shadow, 104, *105*, 108–109
Cornell, Joseph, *Setting for a Fairy Tale*,
 161, *161*
Corrigan, Dennis, *Queen Victoria
 Troubled by Flies*, 217–218, *217*
Crayons, 278
Crimmins, Gael, *Spout*, *236*, 237
Critical assessment, of drawings, 295–
 296

Cross-contour line, 133
Cross-hatching, 98, 231–232
Cubism, 60–61, 145, 161, 241, 252
Cucchi, Enzo, 257
Cuevas, José Luís, *Autoretrato como
 Rembrandt*, *94*, 95
Cursive line, 137–140

Dadaism, 158–159, 161, 265
Daumier, Honoré, *The Riot Scene*, 32–
 33, *33*
De Chirico, Giorgio, *The Mystery and
 Melancholy of a Street*, 198 199,
 199
De Kooning, Willem, *Woman*, 142, *142*,
 226
DeForrest, Roy, 255
Degas, Edgar, *The Tub*, 6, *7*
Delacroix, Eugene, *The Constable of
 Bourbon Pursued by His Conscience*,
 32, *32*
Diebenkorn, Richard
 Ocean Park #21, 170, 173, 174–175,
 180
 Untitled, 125, *125*
 Untitled (Girl Looking in Mirror), 71,
 72
Dine, Jim, *Charcoal Self-Portrait in a
 Cement Garden*, 161, *161*
Diptych, 224
Drawing. *See also* Gesture drawing; and
 names of specific artists
 artistic blocks and, 293–298
 computer-generated images as, 4, 237–
 239
 contemporary perspectives on, 8–9
 correction of problem drawing, 293–
 296
 critical assessment of, 295–296
 getting started on, 297–298
 history of, 3–4, 6–7
 informational drawing, 12
 materials for, 275–280
 objective drawing, 9–16
 overview of subject and treatment of,
 20–27
 pictorial recording, 14–16
 presentation method for, 281–286
 purposes of, 4
 schematic drawing, 13–14
 sketchbook drawings, 287–292
 subjective drawing, 9–11, 17
 types of, 4
 viewing audience for, 18–20
Drawing board, 280
Dry mounting, 282–283
Dubuffet, Jean
 Storm on the Steeple, 214, *214*
 Subway, 137, *138*
Duchamp, Marcel, *La Mariée Mise a Nu
 par Ses Celibataires*, 135, *135*

Dufy, Raoul, *The Yellow Violin*, 136–137, *136*

Dürer, Albrecht, *Young Hare*, 92, *92*

Earthworks, 254
Edge, dominance of, 209–212
Egyptian mural, 200–201, *201*
Einstein, Albert, 61
Empty space, 73. *See also* Negative space
Enclosed invented positive and negative shapes, 77
Environmental Art, 254
Erasers, 278–279
Erasing, and value, 97
Erdle, Rob, *Tetuan*, 222, *223*
Ernst, Max, *"...hopla!hopla!...,"* 61
Ethnicity, in Post-Modernism, 265–267
Expressionism, 178
Expressive uses of value, 111–116
Eye level, 186–188, 189–190
Fagan, Danielle, 102, *102*, 104, *105*
Fish Book, 238, *238*
Fahlström, Öyvind
Notes (150 Persons), 218, *218*
Performing Krazy Kat III, 200–201, *201*
Falsetta, Vince, *Untitled*, 119, *119*
Fauves (Wild Beasts), 177, 252
Felt-tip markers, 279
Feminist art, 255–256
Ferriss, Hugh, *Study for the Maximum Mass Permitted by the 1916 New York Zoning Law, Stage 4*, 197–198, *197*
Figure/field, 73
Figure/ground, 71, 73
Fischl, Eric, *Birthday Party*, 268–269, *268*
Fisher, Vernon
Breaking the Code, 162, *162*
Movements Among the Dead, 267–268
Projects: Vernon Fisher, 267–268, *267*
Fixative, workable, 280
Flack, Audrey, *Dolores of Córdoba*, 167, *167*
Flat or shallow space, 56
Fleps, Peter, *North*, 269, *269*
Floyd, Rick
blind contour by, *52*
continuous-line drawing by, 47, *47*
gesture drawings by, *35*
organizational-line drawing by, 49, *50*
The Whole Battle of Splinters, 226, *226*
Foreground/background, 73
Foreshortening, 203–204
Form, 208
Formalism, 254
Francesca, Piero della, *236*, 237
Frottage, 164
Fumage, 153

Gandolfi, Gaetano, *The Marriage Feast at Cana*, 31–32, *32*
Gardner, Frank, *Mother and Child*, 248–249, *249*
Garet, Jedd, *Pagoda*, 271, *271*
Gauguin, Paul, *Yellow Christ*, 183
Gault, Sandy, *Torture XXVIIe: Something for Piyapong*, 210, *210*
Geometric shapes, 67–69, 75–76
German Expressionism, 31, 178
Gesture drawing
benefits of, 53–54
definition of, 28–29
examples of, 29–34, *35-36*
general instructions before beginning to draw, 34
guidelines for, 45–46
line-gesture exercises, 39–40
mass- and line-gesture exercises, 41–42
mass-gesture exercises, 37–39
scribbled-line gesture exercises, 42–43
student work, *43*
sustained-gesture exercises, 44–45
types of, 34, *35, 36*
Giacometti, Alberto
Diego's Head Three Times, 42–43, *43*
Standing Female Nude, *122*, 123
Still Life, *48*, 49
Walking Man, *122*, 123
Gianakos, Steve, *Gorillas #10*, 133, *134*
Gilbert and George, 265
Gillespie, Gregory, *Myself Painting a Self-Portrait*, 246–247, *246*
Giovanopoulous, Paul, *Apple-Léger*, 243, *243*, 244
Glue, 280
Goldstone, Harmon, *Embellished Elevation of the Carnegie Mansion*, *10*, 11
Golub, Leon, *White Squad II*, *264*, 265
Góngora, Leonel, *Transformation of Samson and Delilah into Judith and Holofernes*, 227, *227*
Goya, Francisco de, *The Family of King Carlos IV*, 19, *20*
Graphite sticks, 278
Grattage, 137
Grid compositions, 221–224, 227–228
Gris, Juan
Personnage Assis, 128, *128*
Portrait of Max Jacob, 127–128, *127*
Grosz, George, *Exploiters of the People*, 121–122, *121*, 265
Ground, 71. *See also* Figure/ground
Grünewald, Matthais, 231, 232, 233, 244
Guerrilla Girls, *256*, 257
Gum erasers, 278
Guston, Philip
Dial, 255, *255*
The Studio, 255, *255*

Handwriting, 137–140
Haring, Keith, *Untitled* (Mickey Mouse), 14, *14*
Harrington, Susan
blind contour by, *52*
gesture drawings by, *36*
organizational-line drawing by, 49, *50*
Passim, *112*, 113
Hauptman, Susan
Line Drawing #46, 216, *216*
Still Life, 93, *94*, 95
Heeks, Willy, 271
Heizer, Michael
Circular Surface Displacement, 6, *6*
45°, 90°, 180° Geometric Extraction Study #1, 176, *182*
Hesse, Eva, *Untitled*, 67–68, *68*
Hettmansperger, Sue, *Untitled*, 56–57, *57*
Hierarchical space, 55–56, *56*
Highlight, 104, *105*, 108–109
Hockney, David
Celia-Inquiring, 140–141, *140*
Henry Geldzahler and Christopher Scott, 194, *194*
Hollegha, Wolfgang, *Fruits*, 33–34, *33*
Holzer, Jenny, *Selections from Truisms*, 262–263, *263*
Horizon line, 191
Hue, 170
Humor, in Post-Modernism, 262
Hurson, Michael, *Room Drawing (Overturned Chair)*, 41–42, *42*

Illusionistic space, 56
Implied line, 140–141
Impressionism, 6–7, 58–59, 145, 177
Incised lines, 118–119
India ink, 279
Indiana, Robert, *The Great American Dream*, 164–165, *164*
Informational drawing, 12
Inks, 279
Insets, 226–227
Intensity, 170–171
Interchangeable positive and negative shapes, 75
Interspace, 73. *See also* Negative space
Invented texture, 153–155, 157, 167
Inverted negative shapes, 76
Irony, 262
Isaacson, Marcia, *Bellsmith's Family Members*, 141–142, *141*

Jacquette, Yvonne, *Airplane Window*, 209–210, *209*
Jenney, Neil, 211, 255
Window #6, 78–79, *79*, 270
Johns, Jasper, 254
Cup 2 Picasso/Cup 4 Picasso, 57–58, *58*

Flag, 39, *39*
Untitled, 231–234, *232–233*, 244
0 through 9, 46, *47*

Kandinsky, Wassily, 177–178
Katz, Alex, *Homage to Frank O'Hara:*
 William Dumas, 211, 218–219, *218*
Kelly, Ellsworth, 211
Kiefer, Anselm, 257, 258
 Shulamite (Sulamith), 146–147, *146*,
 258, 261
Kim, Tschang-Yeul, *Waterdrops #23*,
 152, 153
Kline, Franz, *Untitled*, 62, *62*
Kneaded erasers, 278
Kogge, Robert, *Untitled*, 90–91, *91*
Kollwitz, Käthe, *Self-Portrait with a*
 Pencil, 29, *29*
Komar and Melamid, *Winter at*
 Bayonne, 265, 266–267, *266*
Koryusai, Isoda, *A Courtesan Playing the*
 Samisen, 59
Kosuth, Joseph, 263
Kruger, Barbara, *Untitled (When I Hear*
 the Word Culture I Take Out My
 Checkbook) 159–160, *160*, 263

Lamination, 282
Landscape, 269–270
Lanyon, Ellen, *Endangered*, 149, *149*,
 261
Lebrun, Rico
 Maria Luisa (after Goya), 19–20, *20*
 Portrait of a Man, 98, *99*
Léger, Fernand, *Three Women*, 82–83, *82*
Leslie, Alfred
 Alfred Leslie, 106, *106*
 Raising of Lazarus, 105, *106*
Levi, Joseph, *Still Life with Matisse &*
 Leonardo, 244–245, *244*
Levine, Sherrie, 260
Lewitt, Sol, *Wall Drawing Part Two with*
 Ten Thousand Lines 12" Long, 124,
 124
Lichtenstein, Roy
 Bull I, 24, *25*
 Bull III, 24, *25*
 Bull VI, 24, *25*
 Tablet, 23–24, *24*
Light
 categories of, 104, *105*, 108–109
 value used to describe, 104–109
Line
 blurred line, 141–143
 calligraphic line, 137–140
 constricted, aggressive line, 137
 contour line, 127–133
 cursive line, 137–140
 determinants of line quality, 118–126
 handwriting, 137–140
 implied line, 140–141

importance of, 117
lyrical line, 136–137
mechanical line, 133–135
problems concerning, 129–133, 135–
 137, 139–140, 141, 143
spatial characteristics of, 144
structural line, 135–136
student works, *128*, *130*, *131*, *132*,
 136, *143*
types of, 126–143
Line-gesture exercises, 39–40
Linear perspective
 horizon line and, 191
 one-point perspective, 192–195
 problems concerning, 192, 194–199
 three-point perspective, 192, 197–199
 two-point perspective, 192, 195–197
 vanishing point and, 191–192
Lithographic crayons, 278
Lithographic pencils, 278
Liu, Hung, *Trauma*, 219–220, *219*
Local color, 171
Longo, Robert, 258, 259
 Men Trapped in Ice, 226, *226*, 259
 Untitled, 71, *72*
Losada-Stevenson, Josefa, *Dreaming*
 Picasso 1, 4, *5*
Lostutter, Robert, *Emerald Bird on*
 Sunset, 216–217, *216*
Lyrical line, 136–137

Macaulay, David
 Fragments from the World of
 Architecture, 202, *202*
 Locating the Vanishing Point, 192, *193*
Magee, Alan, *Smoke Balls*, *152*, 153
Manet, Edouard, 163
 Olympia, 245, *245*, 259
Martinez, Lydia G., *Untitled*, 107, *107*
Mass, definition of, 80
Mass- and line-gesture exercises, 41–42
Mass-gesture exercises, 37–39
Materials
 brushes, 279
 chalks, 278
 charcoal, 277–278
 crayons, 278
 drawing board, 280
 erasers, 278–279
 graphite sticks, 278
 inks and pens, 279
 for matting, 283–284
 nonart implements, 280
 paint, 279
 paper, 275–277
 pencils, 278
 rubber cement, 280
 sponges, 280
 supplies, 279–280
 turpentine, 279
 white glue, 280

workable fixative, 280
Matisse, Henri, 136, 173
 Nude in the Studio, 120, *120*
Matting, 283–285
Mechanical line, 133–135
Merz, Mario, 257
 Animale Terrible, 31, *31*
 Unreal City, Nineteen Hundred Eighty
 Nine, 260, 261
Meza, Guillermo, *Giantess*, 97–98, *97*
Middendorf, Helmut, 257
Milhoan, Ronald, *Windowcase*, 88, *88*
Miller, Melissa, *The Ark*, 261, *261*
Minimalism, 63–65, 124, 254
Mixtec panel, 55, *56*
Modeling, 82–83, 87–88
Modernism, 6–7, 125, 188, 252–255, 264
Mondrian, Piet, *Composition in White,*
 Black and Red, 24, 26, *27*
Monochromatic color scheme, 172, 173
Montage, 158, 159
Moore, Henry
 Family Group, 81, *81*
 Reclining Figure, 122–123, *122*
 Row of Sleepers, 104, 122–123, *122*
 Sheep Drawing 40, 37–38, *38*
Morandi, Giorgio, *Nature Morte au Gros*
 Traits, 98, *98*
Morris, Robert, 211, 255
 Battered Cubes, 252–253, *253*
 Enterprise (Burning Planet Series), 252–
 253, *253*
Motif, development of, 240–241
Motion, in gesture drawing, 40
Multiple perspective, 199–200
Munch, Edvard, *The Scream*, 65
Murray, Elizabeth, 211
 Art Part, 208, *209*
Mussoff, Jody, *Atlas*, 223–224, *224*, 228
Myth, in Post-Modernism, 260–261

Neel, Alice
 Andy Warhol, 17, *17*
 Carmen and Baby, 248, *248*
Negative spaces, 37, 43, 71–73, 77, 296
Neo-Expressionism, 146–147, 178, 257–
 258
Neo-Naïve style, 124–125
New Imagism, 124–125, 255
Newman, Barnett, 183
Newsome, Victor, *Untitled*, 123, *123*
Newsprint, 276
Nine Pairs of Divinities, 55, *56*
Noland, Kenneth, 211
Nutt, Jim, 255
 Thump and Thud, 154–155, *155*, 211

Object, as distinct genre, 147–148
Objective drawing, 9–16
Oginz, Richard, *When Clients Come to*
 Call, 186, 187, 246

Oil sticks, colored, 278
Oldenburg, Claes, 9
 *Building in the Form of an English
 Extension Plug*, 234, *235*
 Floating Three-Way Plug, 215–216, *215*
 Ketchup + Coke Too?, 288, *289*
 Plan for Vacuum Cleaner, 113–114,
 113
 *Proposed Colossal Monument for Park
 Avenue: Good Humor Bar*, 234, *234*
 *Proposed Monument for Toronto:
 Drainpipe*, 29, *30*
One-point perspective, 192–195
Opposites, series of, 236–237
Optical color, 171
Organic shapes, 67–69
Organizational-line drawing exercises,
 48–50, 54
Outline, compared with contour line,
 50, *51*
Overlaid images, 65–66, 125–126, *126*,
 219–220

Paint, 279
Paladino, Mimmo, *Dedalus*, 118, *118*
Paper, for drawing, 275–277
Papier collé, 159, 162
Pastels, 278
Pearlstein, Philip, *Female Model on
 Ladder*, 102–103, *102*
Pen points, 279
Pencils, 278
Penck, A. R., 257
 T.III, 56, *57*
Pens, 279
Perception, space, 70
Performance Art, 257
Perspective
 aerial perspective, 190–191
 base line and, 188–190
 definition of, 186
 eye level and, 186–188, 189–190
 foreshortening and, 203–204
 linear perspective, 191–199
 multiple perspective, 199–200
 one-point perspective, 192–195
 problems concerning, 189–190, 191,
 192, 194–199, 202, 204
 stacked perspective, 200–202
 student works, *190*, *200*
 three-point perspective, 192, 197–199
 two-point perspective, 192, 195–197
 vanishing point and, 191–192
Photomontage, 159
Photorealism, 15, 62–63, 178, 254
Picasso, Pablo, 173
 An Anatomy, 289, *290*, *291*
 Bottle, Glass and Violin, 9, *9*, 241, *242*
 *Jeune Homme au Masque de Taureau,
 Faune et Profil de Femme*, 19, *19*,
 120

Pictorial recording, 14–16
Picture plane
 arrangement of images on, 215–221
 cinematic compositions, 222–224
 confirming the flatness of, 211–212
 contemporary approaches to, 208–221
 continuous-field compositions, 212–
 214
 crowding of, 217–218, 221
 definition of, 71
 divided picture plane, 224–226
 division of, 221–229
 dominance of the edge, 209–212
 filling the picture plane, 218–219, 221
 grid compositions, 221–224, 227–228
 inset images on, 226–227
 linear sequence in, 229
 overlayed or superimposed images on,
 219–220
 problems concerning, 211–212, 214,
 227–229
 segmented picture plane, 223–224
 shape of, 77–79
 shaped picture planes, 211
 stopped-frame compositions, 222–224
 student works, *212*, *215*, *220*, *228*
Piehl, Walter, Jr., *The Merry-Go-Round*,
 40, *40*
Piene, Otto, *Smoke Drawing*, 151–152,
 152, 153
Pink rubber pencil erasers, 278–279
Pinruethai, Suthat, *Pom Pom*, 30–31, *30*
Plagens, Peter, *Untitled*, 70, *71*
Planar analysis, 81, 84–85
Plane. *See also* Picture plane
 definition of, 80
 problems concerning, 84–88
 shape as, 80–83
 value used to describe, 101
Plastic envelopes, 282
Pointillism, 104
Political themes, in Post-Modernism,
 263–265
Polké, Sigmar, *Untitled*, 262, *262*, 271
Pollock, Jackson, *Composition*, 212–213,
 213, 222
Pop Art, 160–161, 178, 241, 253–254
Popular tactics, in Post-Modernism, 262–
 263
Positive space, 71–73
Post-Impressionism, 7, 58, 59–60, 177
Post-Modernism
 abstraction in, 271–272
 appropriation and recontextualization
 in, 259–260
 definition of, 252–253
 divided picture plane in, 224–225
 early development of, 254–258
 ethnicity in, 265–267
 European influences on, 257–258
 feminist art as influence on, 255–256

 humor and irony in, 262
 landscape, 269–270
 myth and allegory, 260–261
 narrative content in, 267–269
 overlaid images in, 65–66, 125–126
 popular or commercial tactics in, 262–
 263
 precursors of, 253–254
 social and political themes in, 263–
 265
 subject matter and strategies of, 258–
 272
Prehistoric drawing, 3, *3*
Presentation methods
 acetate, 281–282
 dry mounting, 282–283
 lamination, 282
 matting, 283–285
 plastic envelopes, 282
 selection of, 286
Primary colors, 171
Problem drawing, correction of, 293–
 296

Rainer, Arnulf, *Christus*, 169, 172, *179*
Ramos, Mel, *Manet's Olympia*, 245, *245*,
 246
Rauschenberg, Robert, 254
 Canto XXI, *164*, 165
 Untitled (Combine), 97, *97*
Recontextualization, 259–260
Reductivism, 63–65, 254
Reflected light, 104, *105*, 108–109
Renaissance, 3–4, 145, 186, 237
Ripps, Rodney, 271
Rivera, Diego, *Study for a Sleeping
 Woman*, 83, *83*
Rivers, Larry, *I Like Olympia in Black
 Face*, 163, *244*, 245–246, 259
Rockeburne, Dorothea, *Stele*, 63, *63*
Rohner, George, *Drowned Man*, 203, *203*
Rosenquist, James, *Iris Lake*, 155, *156*
Ross, Sy, *Untitled*, 149–150, *149*
Rossetti, Dante Gabriel, 163
Rothko, Mark, 183
Rubbed planar drawing, 85, *86*, 87
Rubber cement, 280
Rubbings, 97, *164*–165
Ruscha, Edward
 Chop, 82, *82*
 Double Standard, 195, *196*

Sale, Teel, *Polar States*, 91, *92*
Sale, Tom, *Self-Study Primer*, 235–236,
 235
Salle, David, 258
 Barking Salts, 259–260, *259*
 The Mother Tongue, 65, *65*
 Zeitgeist Painting #4, 225–226, *225*
Sánchez, Juan, *Bleeding Reality: Así
 Estamos*, 168–169, 174, *179*, 265

Scaggs, Don, *Diary 17/18: Dad's Chuckles*, 217, *217*
Scharf, Kenny, *Untitled (Fun)*, 3, *4*
Schematic drawing, 13–14
Schnabel, Julian, 258
 Satin Francis in Ecstacy, 147, *147*, 158, 261
Schonzeit, Ben, *Ice Water Glass*, 23–24, *24*
Schwitters, Kurt, *Merzzeichnung 75*, 158–159, *159*
Secondary colors, 171
Segmented picture plane, 223–224
Seurat, Georges, 104
 At the "Concert European," 7, *7*
 La Parade, 96–97, *96*
 Sunday Afternoon on the Island of La Grande Jatte, 59–60, *59*, 174
Shadow, 104, *105*, 108–109
Shahn, Ben, *Ed Murrow Slaying the Dragon of McCarthy*, 121–122, *121*
Shallow space, 56
Shape
 collaged negative spaces, 77
 composite shape problem, 74, *74*
 enclosed invented positive and negative shapes, 77
 geometric positive and negative shapes, 75–76
 geometric versus organic shapes, 67–69
 interchangeable positive and negative shapes, 75
 inverted negative shapes, 76
 modeling and, 82–83, 87–88
 negative space and, 37, 43, 71–73
 of picture plane, 71–79
 planar analysis, 81, 84–85, *85*
 as plane and volume, 80–88
 positive space and, 71–73
 problems concerning, 74–77, 79, 84–88
 rubbed planar drawing, 85, *86*, 87
 student works, *74–77*, *79*, *84–86*
 suggested or implied shape, 70
 two-dimensional, 89
Shapiro, Miriam, 211
 Collaboration Series: Mary Cassatt and Me, 256, *257*
Siegel, Irene, *Unmade Bed, Blue*, 21, *22*
Simulated texture, 153, 157, 167
Sketchbook drawings, 287–292
Sketches, 4, *5*
Smith, Richard, 211
 Large Pink Drawing, 26, *27*
 The Late Mister, 119, *119*
Smithson, Robert, *The Spiral Jetty*, 20–21, 288–289, *289*
Smudging, and value, 97
Social Realism, 267
Social themes, in Post-Modernism, 263–265

Soderquist, Ellen, *Fragment I: She Went This Way*, 111, *112*, 113
Solid/void, 73
Souza, Al, *Arc de Triomphe*, 125–126, *126*
Space. *See also* Color; Line; Shape; Texture; Value
 Abstract Expressionism and, 61–62
 ambiguous space, 56, 57–58, 89, *89*, 105
 Cubism and, 60–61
 flat or shallow space, 56
 hierarchical space, 55–56, *56*
 illusionistic space, 56
 importance of, 185–186
 Impressionism and, 58–59
 Minimalism and, 63–65
 negative space, 37, 43, 71–73, 77, 296
 perception and omitted segment of shape, 70
 Photorealism and, 62–63
 positive space, 71–73
 Post-Impressionism and, 58, 59–60
 Post-Modernism and, 65–66
 Surrealism and, 61
 value used to describe, 110–111
Spero, Nancy, *Thou Shalt Not Kill*, 264, 265
Sponges, 280
Stacked perspective, 200–202
Steinberg, Leo, 254
Steinberg, Saul, *Main Street*, 13–14, *13*
Steir, Pat
 Chrysanthemum, 222, *223*
 Three Green Days, 221–222, *222*
Stella, Frank, 211, 267
 Diavolozoppo, 64–65, *64*, 209
 Protractor Series, 243
Stopped-frame compositions, 222–224
Straight, Robert, *Crossfire*, 95, *95*
Structural line, 135–136
Structure
 problems with, 296
 value and, 100–101
Subjective drawing, 9–11, 17
Subjects, overview of, 20–21
Suggs, Don, *Proprietary View (Mount Shasta)*, 269–270, *270*
Sultan, Donald, *Black Tulip*, 73, *73*
Superimposed images, 219–220
Surrealism, 61, 164
Symbolic color, 183
Symbolic texture, 158

Tamayo, Rufino, *The Water Carrier*, 76, *76*
Tanning, Dorothea, *Monkey 5*, 172, 175–176, *181*
Tápies, Antoni, *Lit Noir*, 123, *123*
Tepper, Irving, *Third Cup of Coffee*, 77–78, *78*

Teraoka, Masami, *Samurai Businessman Going Home*, 21, *22*, 137
Tertiary colors, 171
Texture
 actual texture, 150–153, 155, 157
 additive materials to create texture, 158–163
 assemblage, 158, 160–162, 163
 collage, 158, 159, 162–163
 conventionalized texture, 158
 examples of, 146–150
 experimentation with, 145–150
 invented texture, 153–155, 157, 167
 montage, 158, 159
 papier collé, 159, 162
 photomontage, 159
 problems concerning, 155, 157–158, 162–163, 165–166
 rubbings, 164–165
 simulated texture, 153, 157, 167
 spatial characteristics of, 166–167
 student works, *157*, *163*, *166*
 symbolic texture, 158
 traditional categories of, 150–158
 transferred texture, 164–166
 twentieth-century textures, 158–166
Thematic drawings
 computer-generated images in, 237–239
 definition of, 230
 development of, 250
 development of motif, 240–241
 form development of, 241
 group themes, 241–243
 individual themes, 231–241
 problems concerning, 236–241, 243, 249
 reasons for development of, 230–231
 series of opposites, 236–237
 shared themes, 244–249
 student works, *237*, *239*, *240*
 transformation, 237–239
 visual narration in, 239–240
Thiebaud, Wayne
 Candy Ball Machine, 170–171, 176, *180*
 Corner Apartments (Down 18th Street), 187–188, *187*, 202
 Rabbit, 92–93, *92*
Three-point perspective, 192, 197–199
Tinguely, Jean, *Study of Machine*, 18, *18*
Tobey, Mark, *Remote Field*, 138, *139*
Tonal drawings, 109, *109*
Tondo, 119, *119*
Transferred texture, 164–166
Transformation, in thematic drawings, 237–239
Treatment, overview of, 23–27
Triptych, 224, 226
Trompe-l'oeil technique, 153
Turpentine, 279
Two-point perspective, 192, 195–197

Value. *See also* Color
 arbitrary use of, 98–100
 categories of light, 104, *105*, 108–109
 in creation of abstract patterns, 115–116
 definition of, 90, 170
 descriptive uses of, 100–111
 examples of, 90–95
 expressive uses of, 111–116
 functions of, 93
 light described by, 104–109
 problems concerning, 98–101, 103–104, 106–109, 111, 114–116
 range and transitions of, 296
 space described by, 110–111
 spatial characteristics of, 116
 structure described by, 100–101
 student works, 99, *100*, *101*, *103*, *107*, *108*, *109*, *110*, *114–116*
 tonal drawings, 109, *109*
 used subjectively, 114–115
 value reduction, 106–107
 value reversal, 113–114
 ways of creating, 95–98
 weight described by, 101–104
Value reversal, 113–114
Value scale, 90, *91*, 109, *109*
Van Gogh, Vincent, 183
 Grove of Cypresses, 158, *159*

Van Hoesen, Beth, *Sally*, 93, *93*
Vanishing point, 191–192
Viewing audience. *See* Audience
Villéglé, Jacques de la, *Metro Saint Germain*, 160, *160*
Villon, Jacques, *Baudelaire avec Socle*, *134*, 135
Vine charcoal, 277
Visual literacy, 272
Visual narration, in thematic drawings, 239–240
Volume
 definition of, 80
 problems concerning, 84–88
 shape as, 80–83
Vuillard, Edouard, 136

Warhol, Andy, 254
 Green Coca-Cola Bottles, 241, *242*
 Myths, 262, *262*
Warm colors, 174–175, 184
Warshaw, Howard, *Red Man*, 111, *111*
Way, Andrea, *Shots*, 63–64, *64*
Weight, value used to describe, 101–104
Welliver, Neil
 Brown Trout, 155, *155*
 Cedar Water Pool, 20, 21
Wesselmann, Tom, 211
 Still Life #50, 242

Whiddon, Henry, *Grass Series: SEBO*, 150–151, *150*
White glue, 280
White plastic erasers, 279
Wieghardt, Paul, *The Green Beads*, 72, 73
Winters, Terry, 271, *271*
Workable fixative, 280
Wright, Dmitri, *Untitled*, 73, *73*
Wybrants, Sharon, *Self-Portrait as Superwoman (Woman as Culture Hero)*, 23, *23*
Wyeth, Andrew, *That Gentleman*, 5, 18
Wylie, William T., 9
 Familiar Forms, 41, *41*
 Mr. Unatural Eyes the Ape Run Ledge, 126, *127*
 Nothing Conforms, 247, *247*
 Your Own Blush and Flood, 172–173, *182*

Youngblood, Judy, *Foreign Correspondents*, 188–189, *188–189*

Zuccaro, Federigo, *Emperor Frederic Barbarossa before Pope Alexander III*, 55–56, *56*

631